Double Duce
and the WDH stories

by
AARON
COMETBUS

"DOUBLE DUCE" WAS ORIGINALLY PUBLISHED AS COMETBUS #42. THE WDH STORIES ORIGINALLY APPEARED IN COMETBUS #32, 35, 37, 38, 41, 43, AND 45.

COVER ART BY FLY!

PUBLISHED AND DISTRIBUTED BY LAST GASP OF SAN FRANCISCO
777 FLORIDA ST.
SAN FRANCISCO, CA. 94110
WWW. LASTGASP. COM

ISBN 0-86719-586-X

FIRST PRINTING 2003
SECOND PRINTING 2005

Contents:

Double Duce

1. Double Duce

SLUGGO AND I ALWAYS STUCK TOGETHER THROUGH TOUGH TIMES. WHEN TIMES WERE GOOD, OR ONLY TOUGH FOR ME, I DIDN'T SEE HIM AS OFTEN. NOW THAT HIS SQUAT AND HIS ROMANCE HAD FALLEN APART, I SAW HIM EVERY DAY.

WHEN WE DECIDED TO GET A NEW PLACE TOGETHER, THE FOUNDATION OF OUR FRIENDSHIP BECAME THE FOUNDATION OF OUR HOUSE. AS LONG AS WE WERE BOTH DEPRESSED AND ALONE, IT WOULD HOLD TOGETHER.

IT WAS GOING TO BE WAREHOUSE OR OFFICE SPACE, SINCE NEITHER OF US COULD AFFORD RENT ON A PLACE FIT FOR LIVING. I FOUND A STOREFRONT FOR RENT, BUT THEN DECIDED AGAINST IT. A RATHER NOTORIOUS LIQUOR STORE WAS RIGHT NEXT DOOR. DEALING WITH THE GUN-TOTING FREAKS WHO RAN THE PLACE AND THE ASSHOLES WHO HUNG OUT FRONT SEEMED LIKE TOO MUCH HASSLE. WE'D ALREADY BEEN THROUGH IT ONCE BEFORE.

THE LANDLORD AGREED WITH OUR COMPLAINTS, AND SUGGESTED WE LOOK AT ANOTHER PROPERTY HE OWNED.

HE LED US UP THE STAIRS, ABOVE THE STORE-FRONT, TO A DINGY TWO-ROOM APARTMENT. BIG FRONT WINDOWS LOOKED OUT ONTO UNIVERSITY AVENUE. FROM THE BACK DOOR WE COULD SEE THE ROOF OF THE JUNKPILE, OUR OLD HOUSE, JUST HALF A BLOCK AWAY. EVEN UNCOMFORTABLE MEMORIES ARE COMFORTING IN THEIR FAMILIARITY.

THE APARTMENT HAD A BATHROOM, KITCHEN, AND BACKYARD. WE HAD NEVER HAD THOSE THINGS, EXCEPT FOR A KITCHEN, ONCE. BEST OF ALL, AND RAREST, THE PLACE WAS STILL UNDER THE OLD RENT CONTROL LAWS. WE SAID, WE'LL TAKE IT.

THE APARTMENT WAS CHEAP BY ANYONE'S STANDARDS. UNFORTUNATELY, WE WERE CURRENTLY OPER-ATING FAR BELOW OUR OWN STANDARDS. WE COULDN'T AFFORD THE PLACE ALONE. A QUICK REVIEW OF OUR FRIENDS SHOWED THAT WE HATED, AND COULDN'T LIVE WITH, EVERY SINGLE ONE. EXCEPT FOR WILLEY,

AND HE ALREADY HAD A PLACE, WHICH I WAS
PRESENTLY SUBLETTING.
 I SUGGESTED LITTLE G. SLUGGO WAS HESITANT
ABOUT THE IDEA. I SAID, SURE HE'S A FUCKUP, BUT HE
HAS RENT MONEY, WHICH IS MORE THAN YOU CAN
SAY FOR EITHER OF US.

2. Little Suicide

 ALL MY GUY FRIENDS ARE, LITERALLY, SOME-
WHERE BETWEEN A BABY AND AN OLD MAN. BUT
WITH LITTLE G YOU COULD SEE THE CROSS SO CLEARLY,
EVEN IN THE WAY HE LOOKED. CLEVER AND HAND-
SOME LIKE AN OLD MAN BUT TOTALLY FRESH,
INNOCENT, AND PLAYFUL LIKE AN INFANT. IT WAS
ALMOST AS IF THERE WAS NO IN-BETWEEN. A
GRANDFATHER AND GRANDSON SHARING THE SAME
BODY AND THE SAME LIFE. WISE BEYOND HIS YEARS,
BUT ALWAYS DOING STUPID THINGS WHEN HE WAS
"OLD ENOUGH TO KNOW BETTER".
 HIS NAME WAS COLIN, BUT, FOR SOME REASON,
EVERYONE CALLED HIM "LITTLE G". I CALLED HIM
"LITTLE SUICIDE". NOT JUST BECAUSE HE WAS SHORT
AND HAD A DEATHWISH, BUT BECAUSE, IN REALLY
CELEBRATING AND EMBRACING LIFE, YOU HAVE TO
SORT OF EMBRACE DEATH TOO, OR AT LEAST
RECOGNIZE THE ONGOING NO-WIN BATTLE AGAINST
IT. EVERY DAY LIVING IS A DAY CLOSER TO DEATH,
A LITTLE SUICIDE.
 HE CALLED ME NEARLY EVERY DAY, ASKING
DIRECTIONS OR ADVICE WHICH I KNEW HE WOULDN'T
FOLLOW. OUR CONVERSATIONS WERE CUT SHORT OR
MOMENTARILY STALLED WHILE LITTLE G GOT MUGGED,
THREATENED, OR SHOT AT. HE WAS ON A ROADTRIP
WITH HIS FRIENDS JED AND JOSH MANN, SORT OF A
SIGHTSEEING TOUR OF EVERY DANGEROUS NEIGHBOR-
HOOD IN THE COUNTRY, CALLING ME FROM PAYPHONES
ALONG THE WAY. FOR ONCE, I WAS THE ONE WHO
WAS SAFE AND WARM AT HOME.
 4:30 A.M. AND I WAS BACK AT WILLEY'S AFTER
A MISERABLE AND DISAPPOINTING NEW YEAR'S EVE.
I HAD GOTTEN DRUNK, DEPRESSED, UNDRESSED, AND
WAS JUST BEGINNING TO SURRENDER TO SLEEP WHEN
THE BUZZER RANG. I LOOKED OUT THE WINDOW AND
THERE WAS JED, JOSH, AND LITTLE G. WHEN HE SAID
HE'D BE THERE TO MOVE IN AT THE BEGINNING OF THE
MONTH, HE WASN'T FOOLING AROUND.
 THEY ASKED IF I WANTED TO GO OUT TO THE

WATERFRONT. THAT WAS AN OLD TRADITION OF MINE,
SPENDING NEW YEAR'S EVE ON THE WATERFRONT,
BUT I HAD FINALLY GIVEN UP ON IT, AND MY OLD
FRIENDS, AND HUMANITY IN GENERAL EARLIER
THAT NIGHT. THE ARRIVAL OF THESE NEW FRIENDS
WAS A SMALL MIRACLE, JUST IN TIME TO SAVE MY
RUINED NIGHT AND GIVE ME HOPE FOR THE YEAR
AHEAD.

JED AND JOSH MANN FINISHED UP THEIR
ROADTRIP ON NEW YEAR'S DAY, HITCHING HOME TO
EUREKA. SLUGGO SHOWED UP AND WE BROUGHT
LITTLE G OVER TO CHECK OUT OUR NEW HOME. HE'D
NEVER LIVED AWAY FROM EUREKA, OR EVEN HAD
HIS OWN PLACE BEFORE.

3. Raise the Roof

THERE WAS THE SMALL MATTER OF DIVIDING UP
SPACE. LITTLE G GOT THE BIG FRONT ROOM BECAUSE
HE PAID THE MOST RENT. ONE ROOM WAS LEFT,
REALLY JUST A HALLWAY BETWEEN THE FRONT
ROOM AND FRONT DOOR. I SAID, "I'LL TAKE THAT".

SLUGGO SAID, "WHAT DO YOU MEAN, YOU'LL TAKE
THAT? WE'RE GOING TO HAVE TO SHARE THE
HALLWAY".

"NO", I SAID, "THAT". I POINTED TO A DOUBLE-
LOCKED TRAPDOOR IN THE CEILING.

"WHAT IF THERE'S NOTHING UP THERE, NOT
EVEN ROOM TO SLEEP?"

"WHATEVER IT IS", I SAID, "I'LL TAKE IT".

WHEN THE LOCKS WERE CUT OFF, THE TRAPDOOR
OPENED INTO A FOLD-OUT LADDER, AND I WALKED
SMUGLY UP INTO MY NEW ROOM. I SMASHED MY
HEAD ON THE RAFTERS AND GOT A FACE FULL OF
SPIDER WEBS, BUT STILL, I COULD TELL I HAD LUCKED
OUT. THE ATTIC WAS HUGE, TWICE AS BIG AS ALL
THE OTHER ROOMS COMBINED.

IT STRETCHED OUT ABOVE OUR PLACE, AND
ABOVE OUR NEIGHBORS ACROSS THE HALL. THAT
WAS THE ONLY DRAWBACK WITH THE ATTIC. NO ONE
WAS SUPPOSED TO BE UP THERE, AND OUR NEIGHBORS
HAPPENED TO BE THE SAME GUN-CRAZY BROTHERS
WHO RAN THE LIQUOR STORE. I COULD SMELL THEIR
FOOD COOKING RIGHT BELOW ME, AND HEAR EVERY
SCRATCH, FART, OR PUKE. BUT IF THEY HEARD MINE,
THEY WOULD REALLY RAISE THE ROOF.

SO, NO TALKING, NO WALKING IN SHOES, NO RADIO
EXCEPT A FAINT HUM. BY NECESSITY, MY ROOM HAD

TO BE THE QUIET AND PEACEFUL ONE, AND I WAS
GLAD FOR THE OFFICIAL EXCUSE.

4. Decorating

I MADE A BIG FUSS ABOUT DECORATING.
"YOUR ENVIRONMENT CAN EITHER INSPIRE OR
SUPPRESS YOUR CREATIVITY", I SAID. "YOU BECOME
A REFLECTION OF YOUR SURROUNDINGS".

I SPOKE WISTFULLY ABOUT THE OLD HOUSE-OF-
KRUSTEAZ, WHICH WILLEY AND I HAD COVERED
FLOOR TO CEILING WITH ART, PHOTOS, RACKS OF
USEFUL TOOLS AND SUPPLIES. IT REALLY HAD HELPED
CREATE A HIGHLY INSPIRED, PRODUCTIVE ENVIRON-
MENT AND MAKE THE PLACE FEEL LIKE IT WAS
REALLY OURS.

SO FAR ALL WE HAD DOWNSTAIRS AT DOUBLE DUCE
WAS A LOT OF BLANK WALLS WITH A FEW CURTAINS
TACKED UP IN THE HALLWAY AND SLUGGO HIDING
BEHIND THEM TRYING TO SLEEP. IT DIDN'T FEEL
WARM OR HOMEY AT ALL. NO SOUL. SO, I ASSIGNED
EVERYONE A ROOM TO DECORATE WITH SOMETHING
THEY FOUND EXCITING.

SLUGGO GOT THE HALLWAY BY THE DOOR, AND
WORDS OF WISDOM. LITTLE SUICIDE GOT THE BATH-
ROOM, AND PUBLIC TRANSPORTATION. AT THE END OF
A MONTH THERE WERE A COUPLE FORTUNE COOKIE
FORTUNES UP, AND ONE BART CARD.

FOR MY PART, I MADE LIFE-SIZED POSTERS FOR
THE KITCHEN. INDIVIDUALS WHOSE WRITING, ART, OR
MUSIC HAD BEEN INSPIRATIONAL, WHOSE VERY LIVES
HAD BEEN INSPIRATIONAL. MORE THAN THAT, THEY
WERE PEOPLE WHO KNEW HOW TO LOOK BOTH BRILL-
IANT AND DANGEROUS WHEN POSING FOR A PHOTO.
I PUT THEM UP AS REMINDERS. WHAT POINT WAS
THERE IN LIVING IF YOU DIDN'T AT LEAST TRY TO BE
AS COOL AS YOUR HEROES? WE DIDN'T STAND A
CHANCE AT SUCH GREATNESS, IF ONLY FOR THE
FACT THAT NO ONE WAS AROUND TAKING PICTURES.
THAT WAS IMPORTANT, NOT JUST FOR POSTERITY,
BUT FOR IMMEDIATE SELF-AWARENESS. LIKE THE
FIRST PHOTO YOU TAKE WITH A NEW LOVER WHO
YOU'RE STILL NOT SURE ABOUT.

5. Eau Claire

FANZINES AND TRAVELING HAD BEEN MY WHOLE LIFE, PRETTY MUCH. WRITING ABOUT MISERABLE THINGS IN A WAY THAT MADE OTHER PEOPLE THINK THEY WERE EXCITING. IF SOMETHING TERRIBLE HAPPENS, WRITE IT DOWN, OR LEAVE TOWN. THAT WAS MY WAY OF COPING, AND MY COMMON BOND WITH BOTH SLUGGO AND LITTLE G. IT WAS HOW WE HAD ALL MET.

I CAUGHT A RIDE ONCE FROM CHICAGO TO MINNEAPOLIS, AND THE RIDE ENDED HALFWAY IN BETWEEN, IN EAU CLAIRE, WISCONSIN. WE WERE STRANDED THERE FOR A FEW DAYS WHILE WAITING FOR THE RADIATOR TO BE FIXED. SLUGGO WAS ANOTHER PASSENGER IN THAT CAR. A SCRAWNY GUY WITH LARGE PURPLE HAIR AND A SCHLITZ T-SHIRT WHICH HADN'T BEEN TAKEN OFF OR WASHED IN TWO YEARS, HE TALKED OBSESSIVELY ABOUT CLEVELAND, OHIO. AT FIRST IMPRESSION, A CARTOON CHARACTER WHICH HAD BEEN LEFT UNDER A ROCK AND GOTTEN MOLDY. WE HIT IT OFF IMMEDIATELY.

BACK IN BERKELEY, SLUGGO INVITED ME TO MOVE INTO HIS HOUSE, THE JUNKPILE, WHICH WAS CONVENIENTLY ON RENT STRIKE. THERE WERE FOUR LINES MARKED ON THE WALL, ONE EACH FOR ME AND THE OTHER THREE VISITORS IN THE FOUR MONTHS SLUGGO HAD LIVED THERE ALONE. BY THE TIME WE'D BOTH GOTTEN CHASED OUT, THERE WERE HARDLY ANY WALLS LEFT, AND ALL THE PEOPLE I'D BROUGHT OVER GOT CHASED OUT TOO. BUT I LEFT ALONE, AND SLUGGO LEFT WITH SAL.

NOW THINGS HAD COME FULL CIRCLE. FANZINES AND TRAVELING HAD DESTROYED SLUGGO, AND DECAPITATED HIS ROMANCE. WHAT HAPPENED WAS, SAL STARTED DOING HER OWN FANZINE, WRITING THE STORIES OF THEIR TRAIN HOPPING TOGETHER AND EDITING OUT SLUGGO JUST AS HE HAD FAILED TO MENTION HER. EVERYONE LOVED SAL'S FANZINE, AND USED SLUGGO'S TO WIPE THEIR ASS.

NOW WE WERE STARTING OUT IN A NEW HOUSE, ONE WE WERE TRYING TO BUILD INSTEAD OF DESTROY. SOMEWHERE WHERE WE COULD GET WORK DONE. BUT WE HAD NOTHING TO PUT IN THE HOUSE EXCEPT OUR FUCKING FANZINES. SLUGGO HAD SO MANY LEFT THAT HE BUILT A FULL-LENGTH BED OUT OF THE BOXES. WITH MY UNSOLD COPIES, THERE

WAS ENOUGH FOR A KITCHEN TABLE. LITTLE G,
WHOSE MAGAZINE WAS ALSO LITTLE, ONLY HAD
ENOUGH TO BUILD A FOOTSTOOL.

6. Bart Police

THE BART STATION WAS CLOSE ENOUGH THAT I
COULD HOP THE GATES AND OUTRUN BART POLICE TO MY
HOUSE. THE ONLY PROBLEM WAS, SLUGGO KEPT BREAK-
ING OUR PHONE SO THE RINGING DIDN'T WAKE HIM UP.
TO MAKE A CALL, I HAD TO CHANGE CLOTHES, PUT ON
A DISGUISE, AND GO BACK TO THE BART STATION TO
USE THE PAYPHONE THERE. THE CITY HAD GOTTEN RID
OF ALL THE OTHER PAYPHONES IN THE NEIGHBORHOOD
IN ORDER TO CUT DOWN ON CRIME AND DRUG DEALING.
REALLY SMART. THERE WAS STILL JUST AS MUCH
CRIME, BUT NO PHONES TO USE TO CALL FOR HELP,
OR, I GUESS, TO CHAT WITH FRIENDS WHILE YOU
WAITED TO GET RIPPED OFF.
SOMETIMES WHILE I WAS ON THE BART PAY-
PHONE, SLUGGO WOULD RUN BY ON HIS WAY HOME,
CHASED BY BART POLICE, AND WOULD HAVE TO
PRETEND NOT TO RECOGNIZE ME. ONE TIME, I
COULD HEAR HIM COMING, AND THE BART ATTENDANT'S
VOICE OVER THE INTERCOM: "ATTENTION BART POLICE,
WE HAVE A FARE EVADER AND HE'S RUNNING LIKE
A COWARD OUT THE GATE". SO, I GOT OFF THE PHONE
QVICK, AND CHASED HIM HOME MYSELF. IT TOOK HIM
THREE BLOCKS TO REALIZE I WASN'T A COP, AND
ONLY BECAUSE COPS DON'T YELL, "STOP RIGHT THERE
YOU LITTLE NEW WAVE HO, OR WE'LL SHIP YOU
BACK TO CLEVELAND."
ON SUNDAY NIGHTS WHEN THE ASHBY FLEA
MARKET WAS ALL OVER, SLUGGO AND I WOULD GO UP
AND SCAVENGE FOR LEFTOVERS TO FURNISH OUR
HOUSE. WE'D RIDE BACK WITH THEM, CARRYING
THEM OVER THE BART GATES, LEAVING A TRAIL
OF GARBAGE ALL THE WAY HOME WITH THE
BART POLICE IN HOT PURSUIT.

7. Bad Fanzines

LITTLE G LOVED TO TALK TO AND BEFRIEND
STRANGERS. HE HAD CHUTZPAH AND AN INFECTIOUS
WARMTH THAT PEOPLE REALLY RESPONDED TO. EVEN
THE MOST BLOODTHIRSTY, THIEVING CREEP TOOK A

LIKING TO LITTLE G, AND GENERALLY THOSE WERE
THE PEOPLE HE LIKED BEST.

THROUGH HIS OUTGOING FRIENDLINESS AND
TENDENCY TO WANDER AND LOITER AROUND, WE
EVENTUALLY GOT TO KNOW EVERYONE IN THE NEIGH-
BORHOOD. THE THREE BROTHERS WHO LIVED ACROSS
THE HALL BEGAN TEACHING LITTLE G HOW TO SPEAK
FARSI. HE HUNG OUT WITH THEM LISTENING TO
INDIAN MUSIC WHICH SOUNDED SUSPICIOUSLY LIKE
THE BAD BRAINS. THEY WOULD ALSO COME OVER
OCCASIONALLY TO VISIT, WITH GUNS, THREATENING
TO KILL US FOR BEING TOO LOUD. JUST AS OFTEN,
THEY STOPPED BY TO OFFER US SOME TANDOORI,
OR TO BORROW A CUP OF SUGAR. BASICALLY YOU
COULD TELL THEY LIKED US, AND IT WAS ALL
NEIGHBORLY.

THE BOTTOM DWELLERS HUNG AROUND OUTSIDE
THE STORE LOOKING THREATENING AND WASHING A
CAR WINDOW ONCE IN A WHILE. THEY LIVED ON A
STEADY DIET OF CISCO MIXED WITH UNSWEETENED
KOOL-AID. WE GOT TO KNOW THEM TOO, AND
ACHIEVED A POSITION OF MUTUAL RESPECT. THERE
WAS A CERTAIN LAISSEZ-FAIRE ATTITUDE IN THE
NEIGHBORHOOD, A CODE OF SECRECY OF SORTS, JUST
LIKE EVERYWHERE IN BERKELEY EXCEPT A LITTLE
SEEDIER. KEEP YOUR DISTANCE. DO YOUR OWN THING.
DON'T ASK, DON'T TELL.

IN OUR CASE, THE MUTUAL RESPECT WAS BACKED
UP BY THE COMMON NEIGHBORHOOD KNOWLEDGE THAT
THE LIQUOR STORE OWNERS, OUR NEIGHBORS, HAD
ENOUGH FIREPOWER TO LIQUIDATE EVERYTHING
WITHIN A MILE RADIUS. ENOUGH TO BLOW THE WIN-
DOWS OUT OF THE COMPETING LIQUOR STORE A BLOCK
AWAY, WHICH THEY HAD DONE ONCE OR TWICE, FROM
THE CONVENIENCE OF THEIR LIVING ROOM. WE
DIDN'T HAVE TO LOCK THE DOOR, BECAUSE THE
BOTTOM DWELLERS KNEW NOT TO EVEN OPEN THE
ALLEY GATE WHICH LED UP TO OUR PLACE.

OUR NEW FRIENDS AND SURROUNDINGS WERE
INCORPORATED INTO OUR MONDAY NIGHT BAD FANZINE
READINGS. SPOKEN WORD PERFORMANCES OF THE
FAVORITE EMBARRASSING, GUSHY, HEINOUSLY SELF-
ABSORBED MAGAZINES WE GOT IN THE MAIL, WITH
THE CHARACTERS AND SITUATIONS REPLACED WITH
THOSE FROM OUR OWN LIFE. THE LIQUOR STORE
OWNERS AND THEIR ROMANTIC TANGLES, OR THE
WINDEX GUY'S HEART-RENDING CONFESSION OF SELF-
DOUBT. ABSOLUTELY CISCO. CRACKHEAD LOVE IS.

WE WASHED DISHES WITH BAD FANZINES. WE
NAILED THEM TO THE WALL AND STRAINED THEM

THROUGH THE PASTA MAKER. OUR OWN SELF-ABSORBED FANZINES WERE SPARED THE HUMILIATION, THOUGH WE DID SPEND LESS AND LESS TIME WORKING ON THEM.

ONE FANZINE WAS LOCAL AND SO OFFENSIVE THAT I HAD TO RIP UP THE ADDRESS TO KEEP SLUGGO AND LITTLE G FROM CARRYING THROUGH THEIR THREAT TO FIND THE EDITOR AND BREAK HIS HANDS. I GAVE IN TO PEER PRESSURE THOUGH, AND FORMED AN UNRULY VIGILANTE MOB WHEN THE NEXT ISSUE ARRIVED AND THERE WAS SOMETHING IN IT ABOUT ME.

8. Poster Boy

A NEW GUY SHOWED UP IN BERKELEY AND MADE THE MISTAKE OF HIS LIFE. STEALING THE HIDEOUS POSTER OFF THE DONUT SHOP WALL, HE PROBABLY THOUGHT HE WAS BEING CLEVER. WE CONSIDERED IT A PERSONAL AFFRONT. A DECLARATION OF WAR. HE MIGHT AS WELL HAVE BROKEN INTO OUR HOUSE AND STOLE OUR PRIZED POSSESSION, SO THAT'S WHAT WE DID IN RETURN.

SAL TRICKED POSTER BOY INTO GIVING HER A TOUR OF HIS HOUSE. WHILE SHE DISTRACTED HIM, SLUGGO AND LITTLE SUICIDE SNUCK IN AND RETRIEVED THE POSTER. MISSION ACCOMPLISHED. IT WAS RETURNED TO ITS FRAME ON THE DONUT SHOP WALL AND WE LOOKED AT IT WITH NEW ADMIRATION. EVERYONE WAS HAPPY AND PROUD. EVERYONE BUT POSTER BOY.

POSTER BOY WAS LIVID AT BEING TRICKED, BETRAYED, ROBBED, AND MADE TO LOOK LIKE A SCHMUCK. POOR JERK, HE RETURNED TO THE DONUT SHOP, STOLE THE POSTER AGAIN, TOOK IT HOME, AND RIPPED IT UP INTO LITTLE BITS. OF COURSE, UNDER THREAT OF LIFE AND LIMB, HE SUBSEQUENTLY APOLOGIZED AND HANDED OVER THE DESECRATED POSTER.

LITTLE G DID A GREAT JOB OF PUTTING THE PIECES BACK TOGETHER WITH PAPER MACHE AND DUCT TAPE, AND ONCE AGAIN THE POSTER WAS RETURNED TO ITS PROPER HOME. THE DONUT SHOP WORKERS HADN'T NOTICED IT WAS MISSING, AND NOW DIDN'T SEEM TO NOTICE IT BEING SHREDDED AND PIECED BACK TOGETHER. THEY DIDN'T EVER SEEM TO NOTICE ANYTHING, WHICH WAS WHY WE LOVED THEM LIKE FAMILY.

9. Scene Report

WE SAT AROUND PLANNING AWKWARD DINNER PARTIES. THE IDEA WAS TO INVITE A GROUP OF PEOPLE OVER FOR DINNER WHO HAD BEEN SECRETLY SELECTED BECAUSE OF THEIR CLASHING IDIOSYNCRASIES AND BAD COMMUNICATION SKILLS. ONE FRIEND WHO MUMBLED INCOHERENTLY, ONE WHO BABBLED ENDLESSLY ABOUT NOTHING, AND ONE WHO WAS HALF-DEAF AND TERRIBLY IMPATIENT. THEY WOULD NEVER SUSPECT THAT AS THE HOSTS WE HAD NOT ONLY PLANNED IT, BUT WERE WORKING TO BRING OUT AND REINFORCE THEIR DIFFERENCES.

WE LONGED FOR A BOAT, SO WE COULD INVITE FRIENDS TO AWKWARD BOATING TRIPS. UNLIKE THE DINNER PARTIES, THERE WOULD TRULY BE NO ESCAPE. WE WOULD INVITE THREE FRIENDS WHO ALL NEEDED TO BE THE CENTER OF ATTENTION. THREE PEOPLE WHO WERE AS DIFFERENT AS COULD BE, WITH NO COMMON GROUND.

OF COURSE, IT MIGHT JUST AS WELL HAVE BEEN THE THREE OF US. OUR COMMON GROUND HAD BEEN THE LOCAL PUNK SCENE AND OUR PLACE IN IT, AND SUDDENLY THE RUG WAS JUST PULLED OUT FROM UNDER US. IT HAD JUST SHATTERED INTO A MILLION LITTLE FRAGMENTS THE YEAR BEFORE, AND NONE OF THEM WERE PART OF OUR LIVES, NOR CONSIDERED US A PART OF THEIRS.

EVERYTHING WE HAD DONE, OUR FANZINES AND ROMANCES AND EVERY LITTLE ASPECT OF OUR DAILY LIVES HAD BEEN PART OF A LARGER FRAMEWORK, A WEB. NOW WE LOOKED FOR THE FRAMEWORK, THE SCENE WE HAD ALWAYS TAKEN FOR GRANTED, BUT IT WAS NOWHERE TO BE FOUND. WE WERE ON OUR OWN. THERE WAS NO LARGER PURPOSE, NO ROMANTIC IDEAL, NO DISTRACTION FROM THE DESPERATION AND FUTILITY OF OUR OWN LIVES. WE WERE THE AWKWARD DINNER PARTY, AND OUR HOUSE WAS THE BOAT.

10. Vantastic

SLUGGO HAD ADAPTED WELL TO THE CHANGES. HE'D GIVEN UP HIS HOBO LIFESTYLE, CHANGED HIS CLOTHES, AND STARTED HIS OWN BIKE MESSENGER

COMPANY, OF WHICH HE WAS THE ONLY EMPLOYEE. HE HAD BUSINESS CARDS AND AN ACCOUNT BOOK AND A PAGER AND EVERYTHING. IT WAS IMPRESSIVE. THE CITY OF BERKELEY USED HIM FOR DELIVERIES, AS WELL AS A LOCAL SOFTWARE DEVELOPER AND A FEW OTHER COMPANIES. I THINK IT WAS SLUGGO'S WAY OF PULLING HIS LIFE BACK TOGETHER. GETTING HEALTHY, ORGANIZED, AND INDEPENDENT.

WILLEY HAD GONE THE OPPOSITE DIRECTION, AND STARTED HANGING OUT AT BARS. I DIDN'T APPROVE. WE HAD GROWN UP WALKING THREE BLOCKS OUT OF OUR WAY JUST TO AVOID THE SCARY HICKS WHO WASTED THEIR LIVES AWAY IN THOSE VERY SAME BARS. NOW WILLEY WAS TURNING INTO ONE OF THOSE HICKS. HE WORKED A LOUSY JOB, GOT SHITFACED DRUNK EVERY NIGHT, DROVE LIKE A MANIAC IN HIS GAS-GUZZLING CAR, AND WHEN HE CALLED US, IT WAS USUALLY FROM JAIL.

HIS JOB WAS SORT OF A TAXI SERVICE FOR THE HANDICAPPED. DRIVING A HUGE VAN WITH A HYDRAUL-IC LIFT, DELIVERING PEOPLE IN WHEELCHAIRS TO PLACES THEY COULDN'T GET ON PUBLIC TRANSPORTATION. IT WOULDN'T HAVE BEEN A LOUSY JOB IF THE BOSS WASN'T INCOMPETENT AND DISHONEST, BUT SHE WAS, AND WILLEY WAS TOO CAUGHT UP IN THE WORK ETHIC AND BEING A GOOD SAMARITAN. HE HADN'T GOTTEN PAID IN MONTHS, BUT STILL WOULDN'T QUIT.

THE JOB DID HAVE FRINGE BENEFITS, FOR THE REST OF US IF NOT FOR WILLEY. SOMETIMES I COULD CONVINCE HIM TO BORROW ONE OF THE VANS AND GO DOWN TO THE WATERFRONT INSTEAD OF THE BAR. WE'D SIT ON THE HYDRAULIC LIFT WHILE IT WENT UP AND DOWN, DRINKING OUR BEER AND WATCHING THE TIDE COME IN. SORT OF THE "LOWRIDER AT THE DRIVE-IN" EFFECT. ALSO, WHEN LITTLE G'S CAR WAS BROKEN AND HE HAD TO GET TO SACRAMENTO FOR A DOCTOR'S APPOINTMENT, WILLEY COULD GIVE HIM A RIDE AND COUNT IT AS OFFICIAL BUSINESS.

11. Doctor Assisted L. Suicide

LITTLE G HADN'T ALWAYS BEEN ON CRUTCHES. BACK IN EUREKA HE WAS ALWAYS RUNNING, SKATING, BIKING ALL OVER TOWN. WHEN I CAME UP TO VISIT, WE WOULD RACE AROUND TO ALL THE DINERS AND LOUSY PARTIES AND THE APPLIANCE GRAVEYARD. PADDLE OUT ON THE TOXIC RIVER WITH HIS SISTER AND JOSH B IN A LEAKY TOY RAFT. FOLLOW THE KINETIC SCULPTURE

RACE WITH JED AS IT RODE ALONG THE HIGHWAYS, OVER BRIDGES, AND ALONG THE DUSTY STRETCH OF SAND DUNES, EVERYONE DRESSED UP AS INSECTS WHILE GETTING BIT BY REAL BUGS. NOWHERE WAS TOO FAR TO WALK.

WE STILL WENT ALL OVER TOWN, BUT NOW IT WAS IN A CAR, OR DOUBLING UP ON MY BIKE, LITTLE G ON THE SEAT HOLDING HIS CRUTCHES UP IN THE AIR. THE CRUTCHES WOULDN'T STOP HIM, BUT THEY DID SLOW HIM DOWN. HE DIDN'T WEAR THEM LIKE A HANDICAP, THOUGH. MORE LIKE A STYLISH HAT. WITH THE CRUTCHES LITTLE G HAD EVEN MORE CHARACTER, AND MORE INSTANT RAPPORT WITH STRANGERS. HE COULD USE THEM TO HIS ADVANTAGE. PEOPLE ARE LESS LIKELY TO BEAT UP SOMEONE ON CRUTCHES.

ON THE SURFACE, HE WAS HANDLING THE WHOLE THING WITH HUMOR, BUT I KNEW UNDERNEATH IT WAS LIKE A CAVITY IN HIS BRAIN. THE UNCERTAINTY OF EVER BEING ABLE TO WALK AGAIN, THE ENDLESS DOCTOR'S APPOINTMENTS AND OPERATIONS AND HOPE WHICH ALWAYS PROVED FALSE. THE PITY AND PATRON-IZING ATTITUDES, THE CONSTANT PAIN, AND THE PAIN PILLS HE WAS GETTING STRUNG OUT ON.

WHEN I'D LAST VISITED LITTLE G IN EUREKA, HE HAD BEEN WALKING, EVEN RUNNING. ON MY LAST NIGHT, HIS KNEE SUDDENLY STARTED TO HURT. MUST BE FROM WHEN I FELL ON THE RAILROAD TRACKS, HE SAID. I LEFT IN THE MORNING AND DIDN'T KNOW IT WAS ANY-THING MORE THAN THAT UNTIL HE SHOWED UP SIX MONTHS LATER, ON NEW YEAR'S EVE, ON CRUTCHES, WITH A MYSTERIOUS BONE DISEASE.

12. Business as Usual

ONE DAY SLUGGO WENT WALKING AROUND BY THE WATER BETWEEN THE RACE TRACK AND THE MARINA ON A PARTICULARLY LOW TIDE DAY. HE WAS SITTING ON TOP OF A HUGE PILE OF SEA GLASS WHEN A CALL CAME IN, A DELIVERY FOR THE CITY OF BERKELEY. JUST ONE HOUR TO WALK HOME, GET HIS BIKE AND LYCRA SUIT, GO UP TO ALLSTON & MILVIA AND UP FOUR FLIGHTS OF STAIRS, GET THE PACKAGE, AND RIDE ALL THE WAY TO THE FAR SIDE OF DOWNTOWN OAKLAND. HE MADE IT TO THE COURTHOUSE WITH EXACTLY ONE MINUTE TO SPARE. QUITTING SMOKING MAKES A LOT OF THINGS EASIER. AND SOME THINGS HARDER, YOU KNOW.

THERE WAS A CROWD OF PROTESTORS OUT FRONT, A FEW OF WHICH HE KNEW. THEY WERE STANDING AT THE DOORS, YELLING, "ONE, TWO, THREE, FOUR, FIVE, WE

CHARGE YOU WITH GENOCIDE". SLUGGO PICKED UP HIS
BIKE AND WALKED UP THE STAIRS, PAST THE PROTESTORS.
WHEN HE REACHED THE ENTRANCE, THE COPS OPENED
THE DOORS, ONE COP FOR EACH DOOR. WALKING
THROUGH THE DOORWAY, HE LOOKED BACK AND SAW
CHARLIE IN THE CROWD. CHARLIE RECOGNIZED SLUGGO,
EVEN WITH HIS "ALIEN BIKER FROM HELL" DISGUISE.
SLUGGO SAID CHARLIE WAS GASPING FOR AIR, TRYING
TO SPEAK, AND THE LOOK ON HIS FACE WHEN HE
REALIZED WHO HAD JUST BEEN GIVEN A RED CARPET
ENTRANCE TO THE EVIL CITY COURTHOUSE WAS WORTH
ABOUT ONE ZILLION FOOD STAMPS. REALLY.
 CHARLIE WAS THE GUY WHO HAD CONVINCED THE
BERKELEY POLICE TO TAKE PART IN LAST YEAR'S
"PUNKS VERSUS PIGS" VOLLEYBALL GAME, UNDER THE
AUSPICES OF A CHRISTIAN YOUTH GROUP FUNDRAISER.
CHARLIE CONSIDERED HIMSELF A MASTER OF DISGUISE,
A CUNNING CON ARTIST, THOUGH REALLY ANYONE
COULD SEE PAST HIS FAKE NAMES AND MOUSTACHES.
NO MATCH FOR SLUGGO, WHO WAS A NATURAL
CHAMELEON.
 ME AND LITTLE G WERE TALKING IN THE KITCHEN.
NEITHER OF US WERE IN A BAD MOOD, BUT FOR SOME
REASON WE BOTH HAD THE BURNING DESIRE FOR
VIOLENCE. BREAKING A BOTTLE OVER SOMEONE'S
HEAD WOULD BE A LOT MORE SATISFYING THAN
WRITING FANZINES.
 "IT'S MIDNIGHT, WILL YOU SHUT UP??", SLUGGO
YELLED. "I HAVE TO WAKE UP AT SEVEN A.M. TO
DELIVER THE MAIL TO THE EXPRESS".
 WE SHOOK OUR HEADS AND WHISPERED. FUCKING
YUPPIE.

13. Origins

 I ALWAYS THINK ABOUT THE WAY I FIRST
FOUND MY FRIENDS, THE LITTLE ACCIDENTS THAT
BROUGHT US TOGETHER. NOW I WAS THINKING
FURTHER BACK, TO THE DECISIONS AND MISTAKES
BEFORE WE EVER MET. OUR GRANDPARENTS ALL
GETTING OFF DIFFERENT BOATS AT THE SAME
HARBOR, BOATS FROM RUSSIA AND SCOTLAND,
ENGLAND AND ITALY. WANDERING AROUND
CONFUSED, STEPPING ON EACH OTHER'S TOES,
TRYING TO FIND THE RIGHT ROADS TO CLEVELAND,
DETROIT, AND EUREKA SO THEY COULD GET SOME
FAMILIES STARTED. DOING THEIR BEST TO SETTLE
FAR APART AND KEEP THEIR LIVES HONEST AND

CLEAN SO THAT SOMEDAY THEIR GRANDCHILDREN WOULD BE UPSTANDING AMERICANS AND NOT SCUMBAGS LIVING TOGETHER IN ONE FUCKED-UP HOUSE IN BERKELEY. DESPITE THEIR BEST INTENTIONS, AND WITHOUT REALIZING IT, WE HAD BECOME A FAMILY OF OUR OWN.

THERE WERE ALSO THE IN-LAWS AND CRAZY RELATIVES WHO CAME TO STAY AND PRACTICALLY MOVED IN. ACROPOLIS, WHO WAS ALWAYS BEING MISTAKEN FOR AN ENGLISHMAN. A LONG TIME AGO HIS FAMILY HAD COME FROM THERE, ON THE MAYFLOWER. THE TWO SISTERS, JODY AND JADINE, WHO CAME FROM A FAMILY LINE WHO HAD BEEN HERE LONG, LONG BEFORE THAT. RICHIE, WHOSE FAMILY WAS FROM IRELAND, BUT CAME TO BERKELEY A HUNDRED YEARS BEFORE ANY OF OURS, AND COULD BEAT ANY OF OUR LOCALISM WITH THE FACT THAT HIS GRANDMA RODE A DONKEY TO BERKELEY HIGH.

OF COURSE, COMPARING YOURSELF TO YOUR GRANDPARENTS IS SAFE AND COMPARING YOURSELF TO YOUR PARENTS IS SCARY, BUT IN MANY WAYS IT WAS EASIER TO SEE SIMILARITIES TWO GENERATIONS AWAY. THE PHOTOS OF GRANDPA SUICIDE, THE FAMOUS MOB BOSS, LOOKED SO MUCH LIKE LITTLE G THAT I BEGAN TO WONDER. IT WAS UNCANNY HOW THEY LOOKED IDENTICAL, WITH A HUGE GRIN ON THEIR FACES, WHEN BEING HANDCUFFED AND LED AWAY BY THE POLICE. SLUGGO, TOO, HAD MOMENTS WHEN HE RESEMBLED AN OLD MAN, AND IN GENERAL TENDED TO ACT LIKE ONE, BICKERING ENDLESSLY AND COMPLAINING ABOUT BACK PAIN AND EVERY ILLNESS IN THE BOOK. I HALF EXPECTED KIDS TO SHOW UP AT THE DOOR ONE DAY SAYING, "GRANDPA SLUGGO! WE'VE FINALLY FOUND YOU!!", THEN EXPLAINING TO US HOW HE HAD ESCAPED FROM THE OLD FOLKS HOME. THAT WOULD EXPLAIN THE CONSTANT MOVING, THE COMPLETE CHANGES IN LIFESTYLE, THE DUMB NICKNAMES.

OR PERHAPS I WAS UNWITTINGLY IN THE MIDDLE OF A WITNESS RELOCATION PROGRAM. "LITTLE" SUICIDE AND "NO THUMBS" SLUGGO RECAST AS TEENAGE PUNKS IN BERKELEY, WHERE NO ONE WOULD EVER THINK TO LOOK FOR THEM.

14. Crutches

SLUGGO WENT TO A DINER TO DO SOMETHING HE HAD NEVER DONE BEFORE. THE WAITRESS CAME AND

SMILED AT HIM. SHE ASKED, "ARE YOU WRITING A LOVE LETTER?" SLUGGO TURNED RED AND SAID YES. I GUESS PEOPLE CAN JUST SENSE THAT SORT OF THING.

OUR FAVORITE DONUT SHOP CLOSED DOWN. SO MUCH FOR ALL THE DIFFERENT PLANS WE'D MADE TO MEET THERE IN TEN, TWENTY, THIRTY YEARS. I WENT AND STOLE EVERYTHING THAT WASN'T BOLTED DOWN. COFFEE CUPS, LIGHTBULBS, SUGAR SHAKERS, THE PIECED-TOGETHER POSTER. EVEN THE BATHROOM KEY. SAL ALMOST MADE IT OUT THE DOOR WITH A TABLE AND CHAIRS. SLUGGO SAVED A FULL CUP OF COFFEE, SKATED ALL THE WAY BACK TO OUR HOUSE CARRYING IT, AND PUT IT IN THE FREEZER. PART OF THE DONUT SHOP WOULD LIVE ON THROUGH CRYOGENICS. IN TEN YEARS WE MIGHT NOT BE ABLE TO GO THERE, BUT WE COULD CREATE A PASSING REPLICA. UNFORTUNATELY, SLUGGO ALSO SAVED HIS SCORPION IN THE FREEZER, PERCHED ON TOP OF THE FROZEN COFFEE, AND WHEN OUR POWER GOT SHUT OFF, THE TWO BECAME ONE.

SLUGGO, LITTLE G, AND I DROVE OUT TO THE CITY. ONE OF LITTLE G'S CRUTCHES WAS BROKEN, SO HE WANTED TO STOP SOMEWHERE AND BUY A NEW ONE. ME AND SLUGGO NIXED ALL THE THRIFT STORES HE POINTED TO CUZ THEY WERE HIP VINTAGE PLACES WHICH PROBABLY SOLD CRUTCHES FOR FORTY DOLLARS EACH AS FASHION ACCESSORIES. FINALLY, WE STOPPED AT SOME LITTLE OLD-FASHIONED PHARMACY. I WAS SKEPTICAL, BUT ONCE INSIDE, THE PHARMA- CIST LED US DIRECTLY TO A SPECIAL CRUTCH RENTAL BOOTH. HE FITTED LITTLE G FOR A PAIR AND SAID IF HE ONLY NEEDED THEM FOR THE DAY, THERE WOULD BE NO CHARGE.

WOW. I HAD NEVER HEARD OF CRUTCH RENTALS BEFORE.

15. Frail Eels

SLUGGO'S NEW GIRLFRIEND VANESSA WAS REALLY, REALLY LOUD. LATE AT NIGHT THE HOUSE WOULD BE DEAD QUIET EXCEPT FOR HER HOWLING AND, OCCAS- IONALLY, A TINY RUSTLING SOUND LIKE SOMEONE BLINKING. SLUGGO. HE KEPT UP THE FACADE OF PRIVACY AGAINST ALL ODDS. IT WAS SILLY, BECAUSE DUCE WAS A BIG HOUSE, BUT THE WALLS WERE AWFULLY THIN.

WHEN THE SCREAMING HAD MOMENTARILY SUBSIDED, I WOULD HEAR WHISPERING. IT WAS LITTLE G IN THE KITCHEN, "HEY, DOES ANYONE HAVE

A CIGARETTE THEY CAN SPARE?"
"YES", I WOULD WHISPER, SITTING AT MY DESK IN THE ATTIC AT THE OPPOSITE END OF THE HOUSE. "COME UP AND GET IT."
SLUGGO WOULD WHISK VANESSA IN AND OUT OF THE HOUSE SO FAST THAT WE BARELY SAW HER. BUT, WE HEARD HER.
"HEY, PHONE CALL FOR YOU, SLUGGO", I'D SAY. "ONE MORE POSER HOBO CALLING FOR TRAIN HOPPING ADVICE. HEY, HAS ANYONE SEEN SLUGGO? I COULD'VE SWORN HE WAS HERE A FEW MINUTES AGO. VANESSA, WHAT ARE YOU DOING IN THERE? IT SOUNDS TERRIBLE. SLUGGO WILL BE MAD IF YOU'RE MESSING WITH HIS CAT."
WHEN LITTLE G AND JODY FIRST GOT TOGETHER, THEY MADE NO PRETENSE OF BEING SECRETIVE ABOUT IT. IN THE MORNING WHEN HE CALLED OUT FOR A LIGHT, I BROUGHT IN A HUGE POT FILLED WITH LIGHTER FLUID. HE INVITED ME TO SIT DOWN AND SMOKE WITH THEM. EVEN WITHOUT THE THREE FOOT FLAMES, I COULD SEE THEY WERE GLOWING.
EVERYONE HAS A RIGHT, AND A REASON, TO DO IT THEIR OWN WAY, BUT I LIKE IT WHEN PEOPLE ARE ABLE TO SHARE THAT MOST PRIVATE PART OF THEIR LIVES. I LIKE SEEING THE CHARM AND WARMTH IT BRINGS OUT. NOT JUST SEX, BUT ROMANCE, AND THE CRAZY MIX OF EMOTIONS THAT COME WITH IT.
TOO MUCH ENERGY FOCUSED IN ON ITSELF DESTROYS ITSELF, IN RELATIONSHIPS ESPECIALLY, SO IT'S GOOD SOMETIMES TO HAVE AN OUTSIDE PARTY AROUND TO BOUNCE THAT ENERGY OFF OF. I LIKE BEING THAT OUTSIDE PARTY, THE THIRD WHEEL. I LIKE THE WAY I CAN TEAM UP WITH THE GIRLFRIEND TO TEASE MY FRIEND, OR TEAM UP WITH MY FRIEND TO HELP HIM OR HER IMPRESS THE GIRL. I JUST FIGURE, IF YOU'RE GOING TO SHARE THE BAD TIMES WITH YOUR FRIENDS, YOU SHOULD ALSO SHARE THE GOOD. IF YOU'RE GOING TO COME TO ME LATER WHEN YOU GET DUMPED AND NEED TO BE CHEERED UP, COME SHARE A LITTLE OF THE HAPPINESS FIRST.

16. Judgement Day

IT WAS EASY TO PASS JUDGEMENT ON MY FRIENDS, FUN TOO, SO THERE WAS NO END TO TALK-

ING SHIT ABOUT WILLEY'S BARS AND SLUGGO'S
ROMANCE. THEN, ONCE A WEEK, WHEN NO ONE
WAS LOOKING, I SNUCK OFF TO A BAR TO TRY TO
COURT A GIRL.

THIS BAR WAS EVEN WORSE THAN THE HICK
PLACES, BECAUSE IT PUT ON ALL SORTS OF AIRS
ABOUT BEING CULTURAL AND SOPHISTICATED. I
KNEW IT WAS WRONG, BUT IT WAS A SECRET, AND
THE BEERS WERE ONLY ONE DOLLAR, AND I GOT
TO SEE ALL THE OLD PUNKS I NEVER SAW AT
SHOWS ANYMORE AND PRETEND TO YUK IT UP WITH
THEM WHILE I LOOKED OUT OF THE CORNER OF
MY EYE AT THE GIRL.

IGNORING A GIRL TO TRY TO GET HER TO PAY
ATTENTION TO ME HAD NEVER WORKED BEFORE,
BUT IN THIS CASE IT SEEMED TO BE WORKING,
SO I KEPT ACTING LIKE I WAS HAVING FUN
WITHOUT HER. THE MORE I IGNORED HER, THE
MORE OF A FUSS SHE MADE OVER ME, AND THEN
THE LATER I WOULD BE TO FRIDAY NIGHT BAND
REHEARSAL.

THOROUGHLY DRUNK, MY HEAD SWIMMING
WITH BEER AND THOUGHTS OF HER, I WOULD HOP
ON MY BIKE AND RACE TO BERKELEY BART,
USUALLY MISSING THE HAIRPIN TURN ONTO
SHATTUCK FROM HASTE AND CRASHING INTO THAT
TREE ON THE SIDEWALK. IT WAS COMFORTING
THOUGH, RUNNING INTO THAT SAME TREE EVERY
WEEK, SEEING THE WORDS "SAN FRANCISCO" FLASH
OVERHEAD ON THE BART SIGNS, WATCHING OUT
THE WINDOW AS THE CITY SKYLINE CAME INTO
VIEW IN THE DUSKY TWILIGHT.

I'D POUND ON DRUMS AND SCREAM FOR A FEW
HOURS AND THEN RETURN HOME TO HASSLE SLUGGO.
THE BIG PICTURE WAS A MESS, BUT THE DAYS, AND
DAY TO DAY WAYS, WERE COMFORTABLE IN THEIR
PREDICTABILITY. COMING UP OUR STAIRS, I COULD
HEAR VANESSA INSIDE, CONJURING UP SATAN, BUT
COULDN'T HEAR SLUGGO IN THERE EXCEPT FOR
A LITTLE SCRATCHING.

"WHAT ARE YOU DOING IN THERE, SLUGGO?",
I'D SAY. "WRITING IT ALL DOWN?"

17. Third Wheels

THERE'S A CERTAIN SPECIAL RELATIONSHIP
BETWEEN YOU AND THE LOVERS OF THE PEOPLE YOU
LIVE WITH. YOU SHARE THE SAME SPACE AND A LOT

OF THE SAME PROBLEMS. YOU REASSURE, COUNSEL,
AND EXPLAIN TO THEM AS WELL AS YOUR ROOMMATE
WHEN EITHER ARE HAVING TROUBLE. YOU KNOW
EACH OTHER ALMOST INTIMATELY, ESPECIALLY
WHEN LIVING IN CLOSE QUARTERS, BUT YOU KEEP
A RESPECTFUL DISTANCE AWAY EMOTIONALLY,
SOCIALLY, AND PHYSICALLY. ONE OF THE BEST
THINGS ABOUT GOING OUT WITH SOMEONE IS
GETTING TO BE PART OF THEIR WORLD, INCLUDING
THE MICROCOSM OF IT, THEIR HOUSE. THERE'S A
CERTAIN INFIDELITY IN THE WAY YOU KNOW EACH
OTHER'S FRIENDS THAT IS SO COOL, AND SO FRAGILE,
THAT IT CAN'T REALLY BE ADMITTED, AND SHOULD
NEVER BE TAKEN ADVANTAGE OF. IT'S THE FEAR
WE ALL HAVE, ESPECIALLY IF, LIKE ME, YOU'VE
EVER COME HOME FROM THE LIBRARY TO FIND
YOUR ROOMMATE AND GIRLFRIEND GIVING EACH
OTHER HEAD IN THE BATHROOM.
 BUT I NEVER HAD THAT PROBLEM, OR ANY
PROBLEM AT ALL WITH RESPECT AND CROSSING
SOCIAL LINES, WHETHER ROMANCE OR FRIENDSHIP,
WITH SLUGGO, LITTLE G, OR ANY OF THE FUTURE
DOUBLE DUCE ROOMMATES. I NEVER EVEN HAD
PROBLEMS WITH MY SPACE BEING INVADED OR
MY ROOM AND THE THINGS IN IT GETTING BORROW-
ED OR DESTROYED. NOT UNLESS I LEFT TOWN,
AT LEAST. OUR LIFE TOGETHER TURNED INTO A
DISASTER AREA, BUT THERE WAS ALWAYS AN
INVISIBLE SPACE AND RESPECT KEPT PURE FOR
THE THINGS YOU CARED ABOUT AND LOVED.
 SLUGGO WOULD ARGUE THE POINT, OF COURSE,
BECAUSE EVERYONE WHO CAME OVER GOT DRUNK,
KNOCKED DOWN HIS MAKESHIFT WALLS, AND RUINED
HIS RECORDS. ALSO, BECAUSE I LIKED TO DROP THE
FIVE-FOOT LIGHT-UP SHEPHERD I STOLE FROM THE
LOCAL NATIVITY SCENE DOWN INTO SLUGGO'S ROOM
AT INOPPORTUNE TIMES.
 AT ANY RATE, MY ROOMMATES BOTH RESPECTED
MY PRIVATE SPACE, AND WITHOUT A GIRLFRIEND OF
MY OWN TO SHARE OUR LIFE WITH, I COULD ONLY
PLAY THIRD WHEEL. THEY BOTH HAD GIRLFRIENDS,
AND I HAD A FANZINE.
 MORE THAN THAT, THEY WERE CONTENT WITH
A SIMPLE LIFE OF FRIENDSHIP, DRUGS, ROMANCE,
AND HANGING OUT. THEY BOTH GAVE UP ON THEIR
FANZINES AFTER PUTTING OUT THIN ISSUES WITH
ONE TENTH THE CONTENT AND INSPIRATION OF
THEIR PAST WRITING. SLUGGO'S WAS THE SHORT
STORY OF BECOMING DISILLUSIONED WITH TRAVELING,

FRIENDS, AND PUNK. LITTLE G'S WAS ABOUT LYING
AROUND TAKING PILLS, DRINKING BEER, AND HAVING
TO LISTEN TO SLUGGO AND VANESSA THROUGH THE
THIN WALLS.
 I DIDN'T UNDERSTAND HOW THEY COULD
JUST SHED ALL THE AMBITIONS AND VALUES WE
HAD SHARED, AS IF THEY HAD BEEN AN UNWANTED
BURDEN ALL ALONG. HOW THEY COULD CHANGE THEIR
WHOLE LIVES AS FAST AND UNEXPECTEDLY AS I
CHANGED MY MOODS. ALL HIGHS AND LOWS, WITH
NOTHING IN BETWEEN.

18. Changes

 SLUGGO WAS STILL RUNNING HIS BIKE MESSENGER
COMPANY AT THE TIME. HE WAS SOBER, QUIET, BUSIN-
ESSLIKE, AND SAID WE WERE THE ONES WHO WERE
TOO LOUD ALL THE TIME.
 NO ONE KNEW WHAT HAD PROMPTED HIM TO GET
OBSESSED WITH BICYCLES AND BECOME A SMALL
BUSINESSMAN, NEITHER DID WE KNOW WHAT HAD
ONCE PROMPTED HIM TO GET OBSESSED WITH TRAINS
AND BECOME A HOBO. WHETHER IT WAS BIKES,
BUMS, GIRLS, GUNS, FIATS, FANZINES, OR ART SCHOOL,
SLUGGO WAS ALWAYS IMMERSED IN SOMETHING
SINGLE-MINDEDLY, AND HIS CHANGES OF MIND AND
LIFESTYLE CAME SUDDENLY AND THOROUGHLY.
 WE WERE SHOCKED BY THE SUDDEN CHANGES,
BUT SLUGGO LOOKED AT US AS IF WE WERE THE
ONES WHO WERE INSANE. AS FAR AS HE WAS
CONCERNED, HE HAD BEEN AN AUTO MECHANIC OR
A NEW WAVE HOOKER ALL HIS LIFE, EVEN IF WE
HAD ONLY NOTICED THAT MORNING. IT WASN'T
THAT HE CHANGED, ONLY THAT HE FORGOT
COMPLETELY WHO HE WAS EVERY SIX MONTHS.
 SO, WHEN I CAME HOME LATE ONE NIGHT,
THE HOUSE WAS TRASHED, AND SLUGGO, LYING
DRUNK ON THE FLOOR WITH A CIGARETTE AND
LITTLE SUICIDE, SAID HE HAD SOLD ALL HIS FANCY
BIKES, HIS BUSINESS, AND HIS LIZARD SUIT,
ALL I COULD SAY WAS, "OF COURSE".

19. On Top of the World

 EVERYTHING WAS COLD AND DUSTY AND I WAS
REALLY SICK. NOT JUST FOR DAYS OR WEEKS BUT FOR

WHAT SEEMED LIKE YEARS. FOR ENTIRE LIFETIMES.
BIRTH DEATH BIRTH DEATH, AND I WAS REINCAR-
NATED EVERY TIME AS A GRUMBLING SICKLY JERK
LIVING IN A GLOOMY ATTIC. I LISTENED TO SAD SONGS
AND WAITED FOR THE PHONE CALL FROM THE GIRL
I LIKED, WHO NEVER CALLED. I LISTENED TO SAD
SONGS AT TOP VOLUME TO TRY TO DROWN OUT THE
HOWLING SOUNDS OF THE COUPLE IN THE ROOM
UNDERNEATH ME. MY TAPE DECK WAS NOT AS LOUD
AS THEY WERE. AFTER A WHILE THEY GOT TO LIKE
THE SAD SONGS I PLAYED, SO THEY WENT AND BOUGHT
THE RECORDS AND LISTENED TO THEM EVERY TIME
THEY FUCKED.

LATE AT NIGHT SLUGGO AND LITTLE G CAME UP
TO THE ATTIC SEPARATELY TO COMPLAIN ABOUT EACH
OTHER, THEN THE NEXT DAY, EVERY DAY, THEY WERE
INSEPARABLE. LITTLE G SAT IN HIS EASY CHAIR FISH-
ING OUT THE WINDOW FOR BOTTOM DWELLERS,
USING CIGARETTES FOR BAIT. SLUGGO LAUGHED UNTIL
HE COUGHED, THEN STARTED LAUGHING AGAIN,
THEN COUGHING. HE ATE MY FOOD WHILE I WAS
ASLEEP, WAS "TOO BROKE" TO BUY FOOD FOR THE
HOUSE, THEN WENT OUT TO FANCY RESTAURANTS
WITH VANESSA. LITTLE G WENT OUT WITH JODY,
AND I STAYED UP IN THE ATTIC CRYING MY EYES OUT.
WHAT A TERRIBLE TIME.

I DREAMED RESTLESS DREAMS OF LIVING
TOGETHER BACK IN EARLIER, MYTHICAL TIMES.
NOT OUR OWN MYTHICAL GOOD OLD DAYS, BUT OLD
DAYS OF ROMANS AND CAVEMEN WHICH SEEMED
JUST AS FAR OFF. I DREAMED OF THE THREE OF US
LIVING IN A BUS STATION SOMEWHERE. EVEN THE
DREAMS WERE POLLUTED WITH JEALOUSIES AND
TRAGEDIES. SOMETIMES, WHEN I WAS LUCKY, I
DREAMED OF EVENTS IN MY LIFE, HOW THEY MIGHT
HAVE BEEN, INSTEAD OF A DISASTER.

A FRIEND CAME TO VISIT ME AND SAID BEING IN
MY ATTIC WAS LIKE BEING INSIDE SOMEONE'S BRAIN.
ALL THE DARK AND DUSTY CORNERS AND COBWEBS.
ALL THE LISTS OF DREAMS AND SNAPSHOTS OF OLD
MEMORIES AND FILE CABINETS FULL OF ANXIETIES
ALL ORGANIZED AND WITHIN EASY REACH. A
CONTROL ROOM WITH ME IN CONTROL. I LIKED
THAT IDEA. I WONDERED IF IT WAS THE CONTROL
ROOM FOR MY BRAIN OR SOMEONE ELSE'S. I
PRETENDED IT WAS SOMEONE ELSE'S BRAIN, AND
THAT MADE ME FEEL MUCH BETTER.

20. The Great Divide

WHATEVER HAPPENED TO YOURS TRULY?
NOW I'M SO SPUN, SO HIGH STRUNG
THAT I CAN'T EVEN SLEEP
I JUST LIE IN BED AWAKE
GRINDING DOWN MY TEETH
GET BACK UP TO GO BACK OUT
AND WALK THE SAME OLD STREETS
ALWAYS SEARCHING, SOMETHING MISSING
NEVER SATISFIED

WHATEVER HAPPENED TO YOU?
NOW YOU LAUGH AT HOW YOU USED TO CARE
YOU LAUGH AT HOW YOU TRIED
YOU TALK ABOUT HOW YOU WEREN'T ALWAYS
TIRED ALL THE TIME
YOU LAUGH AT HOW WE'RE GOING NOWHERE
AND THEN YOU ASK ME WHY
WE NEVER DO ANYTHING FUN ANYMORE
WELL WE'RE NOT MUCH FUN ANYMORE

WHATEVER HAPPENED TO YOU AND ME?
WHATEVER HAPPENED TO OUR COMMUNITY?
DO YOU THINK THAT
WE'LL GO DOWN IN HISTORY?
OR WILL WE JUST BE FORGOTTEN
I DON'T WANT TO BE FORGOTTEN
I'M SO SCARED OF BEING FORGOTTEN
THAT'S MY PROBLEM, I'M SO SCARED

WE USED TO SAY LOOK BOTH WAYS
BEFORE YOU CROSS OUR PATH
NOW WE BOTH TURN AWAY
AND THERE'S NOTHING LEFT
TO BRIDGE THE GAP
BETWEEN
WHATEVER HAPPENED TO US

DO YOU THINK THAT IT'S TOO LATE
TO START OVER AGAIN?
YOU SAY YOU'RE TIRED OF HAVING TO
START OVER AGAIN
THAT'S YOUR PROBLEM, YOU'RE SO TIRED
THAT'S MY PROBLEM, I'M SO SCARED
THAT IT'S TOO LATE, IT'S TOO LATE
IT'S TOO LATE TO START OVER AGAIN

part

2

21. It's All Good

THE HOUSE HAD DEGENERATED INTO A MESS OF PILLS, BROKEN BOTTLES, BROKEN CHAIRS, CRUTCHES, AND DYING PETS. I WAS GOING OUT EVERY DAY TO DEAL WITH OTHER PROBLEMS, VERY SERIOUS ONES. MY MOM IN THE HOSPITAL ON MEDICATION WHEN SHE WISHED SHE COULD BE ALERT AND ACTIVE. MY DAD DRINKING TOO MUCH TO DEAL WITH THE GRIEF. IT MADE ME SICK TO COME HOME AND SEE MY ROOMMATES PURPOSELY FUCKING THEMSELVES UP WITH PILLS, BOOZE, AND ANY KIND OF SELF-DESTRUCTION THEY COULD GET THEIR HANDS ON. PURPOSELY SABOTAGING THEIR OWN LIVES WHEN I WAS TRYING SO HARD TO MAINTAIN MINE AND HOLD ONTO THE RAPIDLY DETERIORATING LIVES OF MY PARENTS.

MY LIFE WAS A MESS, MY HOUSE WAS A WRECK, AND EVERYONE AROUND ME WAS EITHER DRUNK OR ON PILLS. DEALING WITH IT ALL DROVE ME TO DRINK TOO, WHICH WAS SORT OF FUNNY. ONE OF THOSE JOKES WHEN THERE'S NOTHING ELSE LEFT TO LAUGH AT.

THOSE TIMES WERE NOT WITHOUT THEIR FUN, THEIR EXTREME MOMENTS OF CLOSENESS AND COMFORT, JUST LIKE IN ANY DISASTER. BUT IT WAS A DISASTER, AND I WAS TRYING TO KEEP A CALM HEAD AT GROUND ZERO.

TO BE FAIR, LITTLE G HADN'T CHOSEN THE PATH OF SELF-DESTRUCTION. IT HAD BEEN FOISTED ON HIM WITH THE KNEE PROBLEMS WHICH KEPT HIM ON CRUTCHES, ON PAIN MEDICATION, AND IN AND OUT OF EXPLORATORY SURGERY THAT NEVER YIELDED ANY REAL RESULTS. ON CRUTCHES, ON PILLS, AND AWAY FROM MOST OF HIS FRIENDS, LITTLE G'S OPTIMISM AND SELF-ESTEEM WERE BOTH LOW. HIS NATURAL SELF-DESTRUCTIVE STREAK HAD BEEN STRONG ENOUGH BEFORE, AND NOW THERE WAS NOTHING TO COUNTER IT.

AS FOR SLUGGO, HE JUST LIKED ALL THE EXTRA PILLS AND BEER WHICH WERE SUDDENLY AROUND. HE WAS HAVING FUN.

22. Playing Hero

I'D BEEN UP ALL NIGHT AND HALF THE DAY
TRYING TO COMFORT SLUGGO. IT WAS EXHAUSTING.
"SLUGGO, ALL OF US ARE A LITTLE BIT CRAZY", I
SAID. "IT'S NOTHING TO WORRY ABOUT."
"I'M CRAZY. GREAT. REALLY GREAT. WHAT WILL
I DO NOW THAT I'VE LOST MY MIND?"
"LOOK, YOU LOST YOUR MIND YEARS AGO, AND
THERE'S NOTHING TO DO NOW BUT ENJOY IT. SO YOU'RE
A LITTLE CRAZY, SO WHAT? IT'S BETTER THAN BEING
NORMAL. CRAZY PEOPLE CAN DO ANYTHING THEY
WANT. JUST THINK, ANYTHING YOU WANT TO DO, YOU
CAN DO. FUN."
BUT ALL SLUGGO WANTED TO DO WAS SIT IN THE
CORNER OF HIS ROOM BABBLING ABOUT HOW HE'D
LOST HIS MIND. WE JUST WENT IN CIRCLES AS THE
HOURS PASSED.
AROUND NOON, RAMSEY STOPPED BY. DOCTOR
RAMSEY, EXPERT ON MENTAL HEALTH AND PHAR-
MACEUTICALS, WHOM I HAD VISITED MANY TIMES
OVER THE YEARS IN MENTAL WARDS AND DRUG
TREATMENT CENTERS.
"RAMSEY, I'VE LOST MY MIND", SLUGGO SAID.
THE DOCTOR TOOK ONE LOOK AT SLUGGO AND
ASKED, "DID YOU TAKE ANY ACID?"
I THOUGHT MAYBE HE WAS GOING TO WRITE
A PRESCRIPTION.
"YES", SLUGGO SAID. "TWO HITS".
"THEN DON'T WORRY, YOU'RE NOT CRAZY. IT'S
JUST THE DRUGS".
"NOT EVEN A LITTLE BIT CRAZY?"
"NOT EVEN A TINY BIT", RAMSEY SAID."YOU'RE
TOTALLY ONE HUNDRED PERCENT SANE. PERFECT-
LY NORMAL".
"HEY RAMSEY, LET'S GO GET A BEER", SLUGGO
SAID, SMILING, WHILE HE STOOD UP AND WALKED
AWAY. "I FEEL SO MUCH BETTER NOW THAT YOU
SHOWED UP. ALL NIGHT LONG AARON HAS BEEN
TELLING ME I'M CRAZY".
WELL, THAT WAS THE LAST STRAW FOR ME.
I DECIDED TO GO GET A BEER TOO. IN SEATTLE.
FUCKING ASSHOLES. I PACKED A BAG AND HEADED
TO THE BUS STATION. EVEN A WEEK OUT OF TOWN
WOULD DO WONDERS.
ON MY WAY DOWN SAN PABLO, I CAME ACROSS
A DOZEN SQUAD CARS WITH LIGHTS FLASHING. THEY

WERE BUSTING THE 54TH STREET SQUAT, WHERE
MY OLD PEN-PAL THEODOTIA WAS STAYING.

I WALKED IN, PAST THE COPS, PAST ALL THE
SQUATTERS RUSHING TO ROUND UP THEIR PATCHES AND
PUPPIES, AND UP THE STAIRS TO THEODOTIA'S ROOM.
NOTHING SHORT OF A SHOOTOUT COULD FAZE ME NOW.
I CALMLY GATHERED UP THEODOTIA AND HER
WORLDLY POSSESSIONS AND TOOK THEM OUT TO
COFFEE. I GAVE HER THE KEY TO MY HOUSE AND
TOLD HER SHE COULD STAY THERE WHILE I WAS
GONE.

"YOU SAVED MY LIFE", SHE SAID. "HOW CAN I
EVER REPAY YOU?"

I SAID, "NO, REALLY, PLEASE DON'T THINK OF
IT LIKE THAT".

23. Vermin

I MANAGED TO PRY THEODOTIA OFF MY BED,
GET HER OUT OF THE ATTIC AND DOWN THE LADDER
TO THE MAIN FLOOR, BUT COULDN'T FIND A WAY TO
GET HER OUT THE FRONT DOOR. SHE DISAPPEARED
INTO THE CORNERS AND CABINETS OF OUR HOUSE
AND BUILT LITTLE NESTS THERE. WE COULD HEAR
RUSTLING AND SEE RED EYES GLOWING IN THE
DARK. SOMETIMES WE DIDN'T SEE HER FOR A DAY OR
TWO, BUT WE KNEW SHE WAS THERE. UNDER THE
TABLES, UNDER THE BED, IN THE PILES OF GARBAGE.

IN THE MORNINGS I COOKED A BIG BREAKFAST
FOR EVERYONE AND WE ATE IN THE BACKYARD.
ME, SLUGGO, LITTLE G, PLUS THEIR TWO GIRLFRIENDS
AND THE TWO GIRLFRIENDS' FOUR FRIENDS. THEY
HAD ALL ADOPTED OUR HOUSE AS A CRASH PAD.
THAT WAS FINE, EXCEPT WHEN THEY SCREAMED
AT THE TOP OF THEIR LUNGS WHILE TAKING SHOW-
ERS TOGETHER AND THE NEIGHBORS SHOWED UP
SCREAMING TOO, WAVING THEIR ARMS AND GUNS,
COMPLAINING ABOUT "THE LITTLE MONKEYS".

THE MORNING BREAKFASTS FAILED TO LURE
THEODOTIA OUT OF HIDING. SHE LIVED OFF IDEAS,
NOT FOOD. LATE AT NIGHT IN THE KITCHEN TRYING
TO HAVE A PERSONAL TALK WITH LITTLE G, I
WOULD BE MOMENTARILY STUMPED BY AN EMOTION
OR IDEA FOR WHICH THERE WAS NO WORD. NONE
THAT I KNEW, AT ANY RATE. A SURPRISINGLY LOUD
AND CLOSE VOICE WOULD BREAK THE SILENCE.
THEODOTIA.

"AN IMPETUOUS IMPULSE BECKONS ME TO INTERRUPT YOUR REPARTEE. PAY NO MIND TO THE GAWKING IDIOT IN THE CORNER, CITIZENS, SHE IS ONLY HERE TO EDIFY AND VILIFY THE PLETHORA OF PLEBS. BUT I DIGRESS. THE WORD YOU ARE LOOKING FOR, AND ONE WELL KNOWN TO THE AFOREMENTIONED SPEAKER, IS DISCONSOLATE".

MAYBE IT WAS IMPOSSIBLE TO KEEP A CLEAR HEAD AND A CLEAN LIFE LIVING ON TOP OF A LIQUOR STORE, WITH TWO ROOMMATES IN A RACE TOWARDS OBLIVION AND AN INVISIBLE HOUSE GUEST WHO ALWAYS CORRECTED YOUR DICTION. AS THE DAYS PASSED, THEODOTIA'S OLD NICKNAME, "VERMIN", STARTED TO SEEM MORE OMINOUS, AS NICKNAMES USUALLY DO.

24. Misery Loves Company

I HAD STARTED TO TAKE DOWN MY WALL POSTERS IN THE KITCHEN FOR SAFEKEEPING WHILE I WAS IN SEATTLE, BUT LITTLE G BEGGED ME NOT TO. "DON'T WORRY, I'LL LOOK AFTER THEM", HE SAID. THE ONLY REMAINS I FOUND WERE A FEW BURNT SCRAPS IN THE BACKYARD. IT WASN'T ANYTHING AGAINST ME OR THE POSTERS, JUST THAT NATURAL URGE TO DESTROY. ESPECIALLY TO DESTROY SOMETHING CREATIVE, MEANINGFUL, OR OUT OF PLACE.

AFTER THAT, EVERYTHING WENT WITH ME EACH TIME I LEFT ON A TRIP. STILL, I CAME HOME TO FIND SOMETHING NEW MISSING OR DESTROYED. THE FEW THINGS I COULDN'T PACK. MY ROOM, THE WALLS, THE REFRIGERATOR. NOW WE NO LONGER NEEDED TOILET PAPER, BECAUSE THERE WAS NO MORE TOILET.

I LEFT TOWN FOUR MORE TIMES THAT SUMMER, SOMETIMES FOR A FEW WEEKS AND SOMETIMES JUST FOR A WEEKEND. EVERY TIME I RETURNED, SOMEONE NEW HAD MOVED IN. FIRST IT WAS JED, LITTLE G'S OLD PAL FROM HOME, THEN THEODOTIA. WE HAD FINALLY MANAGED TO KICK HER OUT A MONTH EARLIER, BUT SHE CAME BACK TO VISIT ONE DAY AND WENT UP TO THE ATTIC WITH JED. NEITHER CAME OUT FOR THREE DAYS STRAIGHT, AND BY THEN IT WAS TOO LATE TO KICK HER OUT AGAIN.

NEXT WAS SEAN, THE ALCOHOLIC ELECTRICIAN

WHO WAS TEACHING WILLEY THE TRADE, AND THEN
WILLEY HIMSELF. HE'D FINALLY DECIDED TO GIVE
UP HIS APARTMENT ONCE AND FOR ALL.

I ARRIVED HOME TIRED FROM A LONG TRIP
AND FOUND THE HOUSE FILLED WITH BROKEN
GLASS WHICH NO ONE HAD BOTHERED TO CLEAN
UP. SLUGGO SAID IT WAS WILLEY'S DUTY, BECAUSE
HE WAS THE NEW ROOMMATE AND THE ONE
WHO HAD THROWN WALTER THROUGH THE KITCHEN
WINDOW. I KNEW THERE HAD TO BE A GOOD
STORY BEHIND THIS ONE. I WAITED FOR WILLEY
TO GET HOME SO HE COULD TELL ME EXACTLY
HOW IT HAPPENED.

"WELL, WALTER WAS STANDING THERE, AND I
WAS STANDING HERE", WILLEY SAID. "SO I RAN UP
AND GRABBED HIM AND TOSSED HIM THROUGH
THE WINDOW HEADFIRST, AND HE LANDED ON
THE BACK PORCH."

"NO", I SAID. "I MEAN, WHY DID IT HAPPEN?"
"OH, IT JUST SEEMED LIKE THE RIGHT THING
TO DO AT THE TIME".

25. Running Tab

JED, THEODOTIA, SEAN, AND WILLEY HAD ALL
BUILT ROOMS IN THE ATTIC, OR TAKEN OVER EACH
OF THE NEW ROOMS I BUILT. NOW THERE WERE
FIVE OF US IN WHAT HAD ONCE BEEN MY ROOM.
THE GLOOMY LONELINESS OF THE ATTIC WAS NOW
FILLED WITH NOISE, LIGHT, AND WARMTH. I GAVE UP
ON TRYING TO WALK SOFTLY AND KEEP QUIET. NOW
WE YELLED AND STOMPED AND EVEN THREW SEAN
THROUGH THE THIN FLOORBOARDS. HE CAME OUT
ON THE OTHER SIDE, IN A SHOWER OF PLASTER, NEXT
TO SLUGGO WHO WAS MAKING TEA IN THE KITCHEN.

INSTEAD OF GETTING MORE DEATH THREATS
FROM THE NEIGHBORS, WE GOT MORE FRIENDSHIP
AND WARMTH. THE MORE WE FUCKED UP, THE MORE
THEY LIKED US. EVERY NIGHT AFTER CLOSING UP THE
LIQUOR STORE, THEY CAME OVER TO VISIT. TO SIT
AROUND AND DRINK WITH US, SAYING WE WERE
CRAZY, BUT SEEMING SAD TO SAY GOODNIGHT. THEY
WANTED TO MOVE IN TOO. THEIR PLACE WAS IDENT-
ICAL TO OURS, WITH ALMOST AS MANY PEOPLE PLUS
MORE BOOZE AND GUNS, BUT LESS LOVE AND LESS FUN.

THE NEIGHBORS LET US KEEP A RUNNING TAB
AT THE LIQUOR STORE, AND WOULD EVEN TAKE

PHONE ORDERS AND DELIVER TO OUR DOORSTEP IF
WE WERE GOING TO BE OUT PAST THE STORE'S 2:00
A.M. CLOSING. WE DIDN'T HAVE TO WORRY ABOUT
THEM ANYMORE, OR THEIR GUNS. WE ONLY HAD TO
WORRY ABOUT EACH OTHER.

SLUGGO WAS WALKING TO THE BATHROOM
ONE NIGHT WHEN BLAM! A BULLET WHIZZED
RIGHT BY HIS HEAD.

"WHOOPS! SHIT! SORRY ABOUT THAT", LITTLE G
SAID. HE WAS SITTING IN THE KITCHEN WITH A RIFLE
ON HIS LAP. "I WAS JUST TRYING TO CLEAN IT OUT."

ONCE WAS BAD ENOUGH, BUT A WEEK LATER
THE SAME EXACT THING HAPPENED TO WILLEY.

26. Bringing the War Home

I WENT TO BRUSH MY TEETH AND FOUND THAT
ALL THE TOOTHBRUSHES HAD BEEN MELTED DOWN
INTO ONE PLASTIC BLOB. I DIDN'T EVEN ASK. I DIDN'T
CARE. IT WASN'T THAT I WAS OBLIVIOUS, BECAUSE I
WAS MORE AWARE THAN EVER BEFORE. I WAS
STARTING TO COME OUT OF THE FOG. I'D BEEN TO HELL
AND BACK, AND AFTER THE WORST THINGS THAT CAN
HAPPEN TO YOU HAPPEN, EVERYTHING ELSE SEEMS
INCONSEQUENTIAL.

TURNED OUT LITTLE G AND SLUGGO WERE
RESPONSIBLE FOR MY TOOTHBRUSH BEING TURNED
INTO MODERN ART. THEY WERE ALWAYS WAGING WAR
AGAINST EACH OTHER, AND IN A PARTICULARLY
CUNNING MOVE, LITTLE G HAD SHAVED OFF ALL THE
BRISTLES ON SLUGGO'S TOOTHBRUSH. SINCE LITTLE G
PREFERRED USING SOMEONE ELSE'S TOOTHBRUSH
THE SAME WAY HE PREFERRED WEARING SOMEONE
ELSE'S CLOTHES OR SLEEPING IN SOMEONE ELSE'S
BED, SLUGGO HAD TO BURN THEM ALL TO GET EVEN.
THAT WAS FINE WITH ME. BURN DOWN THE WHOLE
HOUSE AND IT WOULD'VE BEEN FINE WITH ME.

SLUGGO SMASHED ALL THE DISHES SO LITTLE G
COULDN'T EAT, THEN LEFT THE BROKEN BITS ON
THE FLOOR. FINE WITH ME. LITTLE G PUT FIREWORKS
ON MY BIKE AND ALL AROUND THE ATTIC DOOR,
TRIGGERING LOUD EXPLOSIONS WHENEVER I TRIED
TO SNEAK OUT. I WAS JUST HAPPY TO FEEL WANTED,
HAPPY TO BE DISTRACTED FROM MY OWN THOUGHTS.
LUCKY TO HAVE ROOMMATES WHO WELCOMED ME
INTO THEIR LIVES AS EASILY AS I'D FOUND IT TO
DISMISS THEM FROM MINE.

SEAN GOT TO WORK AND HIS BOSS SAID,
"WHAT'S THAT ON YOUR TOOLBELT?". IN THE NIGHT
WHILE SEAN WAS SLEEPING, LITTLE G HAD ADDED
ON A CRACK PIPE AND SOME STINKBOMBS.

27. Fake Hix

OUT OF THE WHOLE GROUP, WILLEY AND SEAN
WERE THE ONLY ONES WHO WEREN'T, AND HAD
NEVER BEEN FANZINE EDITORS, WHICH MIGHT
EXPLAIN THEIR BOND. WE WOULD WRITE ABOUT
FRIENDSHIP, AND THEY WOULD FIGHT ABOUT IT. THEY
ASPIRED TO BE WISE. THAT JUST CAME NATURALLY
WITH EXPERIENCE. I ASPIRED TO BE SMART, WHICH
TOOK CONCENTRATED EFFORT AND STUDYING. THAT
WAS OUR CONFLICT, AND OUR CODEPENDENCE TOO,
BECAUSE I WAS NOT WISE AND THEY WERE NOT
SMART, AND YOU NEED A LITTLE OF BOTH TO GET BY.
SEAN HAD MET AN ELECTRICIAN AT THE BAR,
AND BECAME HIS APPRENTICE. IN TURN, WILLEY
BECAME SEAN'S APPRENTICE. NOW THEY HAD A TRADE
AND A VALID EXCUSE TO ACT LIKE REDNECKS AND
BLOW UP SHIT. THEY EVEN HAD A GOOD SIDE
BUSINESS, TRADING CARS FOR JAIL TIME. HOWEVER,
THEY WERE HICKS THE SAME WAY LITTLE G WAS A
GANGSTA. DRESSES LIKE A HICK, TALKS LIKE A HICK,
SMELLS LIKE A HICK, BUT STILL, NOT QUITE A HICK.
A CHARACTER ACTOR ENJOYING HIS ROLE BUT
NEVER REALLY GETTING LOST IN IT. LIKE SLUGGO,
NOT QUITE FITTING INTO A NEW ROLE. YOU COULDN'T
TELL HOW MUCH WAS REAL AND HOW MUCH WAS
PARODY, OR IF THEY EVEN KNEW FOR SURE.
I WANTED A NEW LIFESTYLE TOO, A NEW LEASE
ON LIFE, BUT COULDN'T MAKE THAT CHANGE. I WAS
STILL PAYING OFF AN OLD DEBT. SOUNDS DUMB, BUT
PUNK HAD SAVED MY LIFE, AND PART OF BEING A
PUNK FOR ME WAS TAKING ON THE RESPONSIBILITY
TO GIVE SOMETHING BACK. SAVE SOMEONE ELSE'S
LIFE AND SAFEGUARD MY OWN. I HAD A LOT OF
WORK TO DO.
SOME FIND REDEMPTION THROUGH LOVE, SOME
THROUGH HARD WORK, AND SOME THROUGH SUFFER-
ING. I READ THAT SOMEWHERE. IT SOUNDED TOO
SIMPLISTIC, UNTIL I LOOKED AROUND MY HOUSE.

28. Meetings

MY PARENTS MET IN THE FIFTIES, AT A RESTAURANT NEAR THE COLLEGE IN DETROIT. MOM SAID TO HERSELF, "WHAT AN ATTRACTIVE LOOKING GUY." SHE SAID TO HIM, "MIND IF I SIT WITH YOU?". DAD WAS ENGROSSED IN HIS BOOKS AND NOTEBOOKS, AND DIDN'T EVEN LOOK UP. HE FROWNED AND GROWLED, "SUIT YOURSELF."

JED'S PARENTS MET IN THE SIXTIES, AT A FLEA-INFESTED HIPPIE CAFE IN EUGENE. DAD WAS SELLING ACID. MOM WAS TRAVELING THE COUNTRY SELLING COOKIES.

THIRTY YEARS LATER WE WERE IN THE KITCHEN TOGETHER. I HOVERED OVER MY BOOKS AND NOTEBOOKS, FOREHEAD FURROWED AND A HUGE MUG OF COFFEE IN MY PAW. JED BOILED FLOUR AND HOVERED OVER ME, ASKING STUPID QUESTIONS. FOR SOMEONE WHO DIDN'T DO DRUGS, HE SURE TALKED A LOT ABOUT A LOT OF FREAKY BULLSHIT.

"WILL YOU JUST SHUT UP AND SIT DOWN," I YELLED. "YOU'RE MAKING ME NERVOUS."

29. Crushes

IT WAS FUNNY TO WATCH THE WAY EVERYONE INTERACTED. JED AND LITTLE G SMILED AND LAUGHED TOGETHER, OR SUDDENLY GOT INCREDIBLY ANNOYED AND IMPATIENT WITH EACH OTHER, OVER THINGS NO ONE ELSE UNDERSTOOD OR EVEN NOTICED. THEY KNEW EACH OTHER TOO WELL TO TRICK, LIE TO, BLUFF, OR IGNORE THE OTHER, BUT THEY TRIED TO ANYWAY, ALMOST CONSTANTLY. THEY DROVE AROUND OR WALK-ED AROUND WITH SLUGGO, ALL ARGUING AND COMPLAIN-ING AND RUNNING INTO AS MUCH BAD LUCK AS THEY COULD FIND OR INVENT. ALL THAT MELODRAMA EXHAUSTED ME, BUT FOR THEM IT WAS A SENSE OF PURPOSE AND SATISFACTION.

WILLEY AND SEAN FOLLOWED EACH OTHER AROUND THE SAME WAY, CRUSHED OUT, BUT ONLY IN A PLATON-IC SENSE. GOING TO WORK, GOING TO BARS, WRECKING CARS, GETTING THROWN IN JAIL. THEY FASHIONED THEMSELVES THE RESPONSIBLE ONES. AN HONEST DAY'S WORK FOR AN HONEST DAY'S PAY. A FIRM HANDSHAKE. YOU CAN'T TEAR A MAN AWAY FROM HIS

ROOTS OR HIS LAND. SONS OF INTELLECTUALS, BOTH RAISED IN THE CITY, THEY SHUNNED BOOK LEARNIN' AND HIGH FALUTIN' CITY WAYS. THEY KNEW A LOT ABOUT A LOT OF THINGS. THE COPS CAN TAKE AWAY MY DRIVER'S LICENSE BUT THEY CAN'T TAKE AWAY MY HONOR, MY CAR, OR MY BEER.

SIX PUNKS WITHOUT A SCENE. THREE FANZINE EDITORS WITHOUT FANZINES. TWO ELECTRICIANS WITHOUT ELECTRICITY, AFTER TRYING TO BYPASS OUR METER AND ACCIDENTALLY BLOWING IT UP. ONE BIKE MECHANIC WHO SHRUGGED AT OUR PILES OF BROKEN BIKES. ONE JEWISH BERKELEY KID TO INTELLECTUALIZE IT ALL.

WAS IT A HOUSE, OR THE ANSWER TO SOME LIGHTBULB JOKE? MAYBE A RECIPE? AND IF SO, FOR WHAT?

THEODOTIA WAS THERE TOO, BUT IT WASN'T AS EASY TO SEE WHERE SHE FIT IN. MY OLD PEN-PAL? JED'S GIRLFRIEND? IT WAS MORE COMPLICATED THAN THAT.

30. Theodotia

THEODOTIA WAS THE ONLY GIRL WHO LIVED AT OUR HOUSE, AND I THINK SHE ENJOYED BEING HOUSE MATRIARCH. SHE GROWLED AT OTHER GIRLS WHO CAME OVER. BUT SHE ALSO GROWLED AT NO ONE IN PARTICULAR AND TALKED TO THE WALLS, SO IT WAS HARD TO TELL EXACTLY WHAT SHE ENJOYED. WE DID KNOW THAT SHE LIKED TABASCO SAUCE. SHE DRANK IT AS IF IT WAS BEER, DOWNING WHOLE BOTTLES IN ONE GULP.

THEODOTIA SCAMPERED THROUGH THE WRECKAGE LOOKING LIKE A PUNK EWOK. SHE DIDN'T PAY RENT, BUT TOOK TO CLEANING THE PLACE AS A WAY OF EARNING HER KEEP. WE BLEW UP THE TOILET, SMASH-ED MOST OF THE DISHES, THREW WALTER THROUGH THE WINDOW AND SEAN THROUGH THE UPSTAIRS FLOOR, AND THEODOTIA CLEANED UP OR FIXED MOST OF THE DAMAGE. WHEN I TOSSED A RECORD IN THE OVEN TO UNWARP IT AND THE HOUSE FILLED WITH CAUSTIC BLACK SMOKE, THEO WAS THE ONE WHO STAYED INSIDE CHIPPING BURNT VINYL OUT OF THE OVEN WHILE THE REST OF US COVERED OUR MOUTHS AND EVACUATED TO THE BACKYARD. NONE OF US CARED IF THE PLACE WAS CLEAN, AND IN FACT IT MADE ME KIND OF NERVOUS, BUT WE COULDN'T TELL IF SHE WAS

TRYING TO BE USEFUL OR IF SHE JUST LIKED THE
PLACE CLEAN. WE TOLD HER NOT TO CLEAN, BUT SHE
CONTINUED EVEN MORE OBSESSIVELY.

THEODOTIA WAS PRETTY AMAZING, BUT ALSO
PRETTY EASY FOR US TO MAKE FUN OF AND TAKE FOR
GRANTED, AND WE'D BEEN DOING THAT TOO MUCH
LATELY. NOW WE WANTED TO GIVE HER A TOKEN OF
OUR APPRECIATION. WE COULDN'T AFFORD TO BUY
TABASCO SAUCE, SO WE WERE TRYING TO FIGURE OUT
SOMETHING ELSE TO DO FOR THEO. I SUGGESTED THAT
WE PICK FLOWERS. SLUGGO SHOT THAT DOWN. "YOU
FOOL," HE SAID, "EVERYONE KNOWS THAT CRUSTY GIRLS
DON'T LIKE FLOWERS."

"EVERYONE LIKES HAVING FLOWERS PICKED FOR
THEM", I INSISTED, CONVENIENTLY FORGETTING THE
GIRL I ONCE PICKED FLOWERS FOR WHO ONLY LATER
ADMITTED THAT SHE HATED PEOPLE WHO KILL LIVING
THINGS. AT ANY RATE, WE DECIDED THAT FLOWERS,
LOTS OF THEM, WOULD BE OUR MISSION FOR THE NIGHT.
AS EXTRA INCENTIVE WE SPLIT UP INTO TWO TEAMS,
EACH WITH ONE CAR. ME AND SLUGGO VERSUS SEAN
AND WILLEY, WITH A FORTY OF SHITTY BEER WAGERED
ON THE OUTCOME.

I'D BEEN ON THE FLOWER PICKING CIRCUIT MANY
TIMES AND WAS OVERCONFIDENT. ME AND SLUGGO
WENT OUT FOR COFFEE, STOPPED BY A SHOW, WALKED
AROUND, AND WITH ONLY AN HOUR LEFT, SET OUT SURE
WE WOULD WIN. WE HIT ALL THE CHURCHES AND THE
COUNTRY CLUB, BUT BECAUSE IT HAD RAINED THAT
NIGHT, MOST OF THE FLOWERS WERE CLOSED UP AND
UNIMPRESSIVE. THIS CALLED FOR DRASTIC MEASURES.
WE WENT TO PIEDMONT AND STRUCK PAYDIRT, EMPTY-
ING THE ENTIRE DUMPSTERS OF TWO FLORISTS INTO
SLUGGO'S CAR. NOW WE HAD THE OTHER TEAM
BEAT EASILY.

I HOPED ALL THE FLOWERS WOULD MAKE
THEODOTIA HAPPY. LATELY SHE HAD SEEMED EVEN
MORE DISMAL AND GRUMBLY THAN USUAL, AND I
DIDN'T KNOW WHY. WE HAD BEEN PEN-PALS FOR YEARS
AND NOW WE LIVED TOGETHER, BUT I STILL BARELY
KNEW HER. IN FACT, THE FUNNY THING WAS THAT
WHILE HER LETTERS WERE LONG AND FLOWING, SHE
RARELY SPOKE IN PERSON EXCEPT TO HERSELF. BUT IF
YOU ASKED HER FOR SOME ELUSIVE WORD OR OBSCURE
FACT YOU WERE SEARCHING FOR, SHE ALWAYS KNEW.

AT 2:00, ME AND SLUGGO DROVE UP TO THE
ENTRANCE TO THE DWIGHT WILDERNESS, OUR
RENDEZVOUZ POINT. SEAN AND WILLEY WERE
ALREADY THERE. WE GLOATED. TOP THIS, WE SAID,
OPENING THE TRUNK PACKED FULL OF BOUQUETS.

WE'LL TAKE A ST. IDES.

SEAN AND WILLEY SHOOK THEIR HEADS. THEY MOTIONED US OVER TO THEIR CAR. IT WAS FULL TO THE CEILING WITH BEAUTIFUL FRESH FLOWERS, THE EXOTIC EXPENSIVE KINDS. IT LOOKED LIKE THEY'D KNOCKED OVER A FLOWER STAND. TURNED OUT THEY HAD ACTUALLY KNOCKED OVER TWO FLOWER STANDS. WE OWED THEM A BEER.

BUT FIRST, THEODOTIA. WE CARRIED GARBAGE BAGS FULL OF FLOWERS AND SNEAKED UP THE STAIRS AND INTO THE KITCHEN, WHERE THEODOTIA WAS GRUMBLING TO A WALL. WE PROCEEDED TO DUMP FLOWERS OVER HER UNTIL SHE WAS NO LONGER VISIBLE. THE KITCHEN COUCHES WERE NO LONGER VISIBLE. THEO, WHO HATES EVERYTHING, WAS RADIANT. SHE WAS ROLLING AROUND IN THE PILES OF FLOWERS WITH A ROSE IN HER MOUTH, HAPPIER THAN I'D EVER SEEN HER.

FOR DAYS AFTER THAT, THEO WALKED AROUND PROUDLY WITH HER CHIN IN THE AIR. THERE WERE FLOWER ARRANGEMENTS EVERYWHERE, AND OUR HOUSE EVEN SMELLED NICE. ANOTHER GIRL CAME OVER AND DECIDED TO TAKE THE FLOWERS TO THE FLEA MARKET AND SELL THEM. WE ALL GROWLED AT HER UNTIL SHE LEFT.

31. In the Beginning

IT WAS GREAT TO LIVE WITH WILLEY AGAIN. I HAD KNOWN HIM THE LONGEST, FROM WAY BACK WHEN I WORKED AT THE COPY SHOP AND HE HUNG OUT AT THE CAFE ACROSS THE STREET. WHEN WILLEY WAS STILL IN HIGH SCHOOL, IN THE PROCESS OF GETTING THROWN OUT, AND HE JUST SAT AT THE CAFE DAY AND NIGHT SMOKING A LOT AND NOT SAYING MUCH. I TOLD HIM TO DROP OUT OF SCHOOL, LEAVE HOME, AND MOVE IN WITH ME.

WHEN WE PULLED UP AT THE HOUSE-OF-KRUSTEAZ WITH ALL HIS STUFF, THERE WAS A NOTE ON THE DOOR FROM MY OLD ROOMMATE:

AARON, EXPECT A VISIT AND INQUIRY FROM THE POLICE AS TO WHY YOU LIVE IN A WAREHOUSE NOT ZONED FOR HUMAN INHABITANCE. IF YOU DON'T THINK I'M SERIOUS, PLEASE TRY ME, OKAY? HAVE A NICE DAY.

OUR FIRST NIGHT LIVING TOGETHER, WILLEY'S FIRST HOUSE OF HIS OWN, AND WE WERE ALREADY THREAT-

ENED WITH EVICTION BEFORE WE MADE IT IN THE DOOR.

WILLEY USED TO COME HOME LATE, WHEN I WAS PLAYING DRUMS, POUNDING OUT RHYTHMS WHICH SOUNDED LIKE A RISING STORM, HAIL, AND FLASH FLOODS. THE SOUNDTRACK OF A BOAT ON THE OPEN SEA, OR A FAT MAN WALKING A SMALL DOG ON A SUNDAY MORNING. WHATEVER IT WAS, WILLEY WOULD MOVE ALONG WITH IT, SLITHERING ON THE FLOOR OR SNEAKING AROUND ON TIPTOES OR SMASHING HIS HEAD AGAINST THE WALL. THEN HE WOULD GO ABOUT HIS BUSINESS, SMOKING OR BUILDING STUFF OR LIGHTING FIRES, AND I WOULD PLAY ALONG TO THAT. FRIENDS WHO CAME OVER TO VISIT WERE CONFUSED WHEN I RESPONDED TO THEIR QUESTIONS WITH ROLLS AND FILLS AND WILLEY RESPONDED WITH SMOKE RINGS AND SMALL BLAZES.

I'D STOP PLAYING WHEN WILLEY WENT TO SLEEP. MAYBE DRINK A BEER, SHUFFLE SOME PAPERS FOR FIVE OR SIX HOURS, GO BACK OUT TO WALK AROUND. THEN I'D COOK BREAKFAST FOR BOTH OF US, SET IT OUT, AND START PLAYING DRUMS AND SCREAMING AS LOUD AS I COULD. WILLEY WOULD COME SHUFFLING OUT OF BED ALL BLURRY EYED, PICK UP HIS HARMONICA, AND START PLAYING ALONG.

THAT WAS OUR FIRST PLACE TOGETHER. THE WATERTOWER WAS THE SECOND, AND THAT WAS NICE TOO, UNTIL WE BURNED IT DOWN. WILLEY MOVED IN WITH RICK AND SHEN, AND I ENDED UP MOVING IN WITH SLUGGO. THAT WAS THE JUNKPILE. NEXT CAME HANNOVER STREET, CURFEW STREET, MY BUS, SLUGGO'S SQUAT, WILLEY'S APARTMENT. BETWEEN US WE HAD A LONG LEGACY OF HOUSES, AND A LARGE STACK OF EVICTION NOTICES.

32. Willey

WE USED TO SIT AROUND WILLEY'S KITCHEN LISTENING TO SCRATCHY RECORDS AND LOOKING OUT THE WINDOW. WHEN THE FOOD RAN OUT, RICK COOKED UP A BUNCH OF SPICES IN A PAN, JUST SPICES, AND ATE THAT. JULIA CAME OVER AND BAKED LANDFILLBERRY PIE. SHE BROUGHT A CAKE FOR WILLEY'S BIRTHDAY WITH ROMAN CANDLES INSTEAD OF REGULAR ONES. FLAMES LEAPT SIX FEET FROM THE CAKE, BUT AFTER PUTTING OUT THE FIRE WE STILL TRIED TO EAT IT. BAD IDEA. I PUT THE CAKE IN A PLASTIC

BAG AND NAILED IT TO THE WALL, AND THERE IT
REMAINED UNTIL WILLEY'S NEXT BIRTHDAY.
WE SAT AROUND IN THE KITCHEN DRINKING SOME-
THING THAT WAS PART COFFEE AND PART SOMETHING
ELSE. SOME KIND OF WOOD. IT MADE YOU FEEL
DEEPLY SATISFIED, BUT DEEP IN SOME KIND OF OTHER
WAY TOO. IT MADE YOU FEEL HOLLOW. AS LONG AS
YOU SAT IN THE KITCHEN DRINKING IT YOU WERE KING
OF THE WORLD, BUT THE MINUTE YOU STRAYED FAR
FROM THE PERCOLATOR YOU BECAME A LIFELESS
SHELL, A SHADOW. I DON'T KNOW WHAT THE HELL
THAT STUFF WAS, BUT IT WAS GOOD. THERE WAS ONLY
ONE STORE WHERE IT COULD BE FOUND. EVENTUALLY
THEY RAN OUT AND NEVER HAD IT AGAIN, AND WE
STARTED LEAVING WILLEY'S KITCHEN AND GOING BACK
OUT INTO THE WORLD.
WE PLAYED BASKETBALL UP AT THE OLD BLIND-DEAF
SCHOOL, IN THE COURT THAT HADN'T BEEN USED SINCE
THE SCHOOL CLOSED DOWN, TEN YEARS BEFORE. I
CHASED WILLEY DOWNCOURT THROUGH THE SWAMP. HE
LOST ME IN THE SANDTRAP BUT MISSED HIS SHOT, AND
I CAUGHT THE BALL ON THE REBOUND. MEMBERS OF
WILLEY'S TEAM SWUNG DOWN FROM THE TREES,
SWINGING AT ME WITH BRANCHES. MEMBERS OF
BOTH TEAMS FLEW BACK AND FORTH ACROSS THE
COURT AS OLD TOYS, SCHOOLBOOKS, AND THE BASKET-
BALL FLEW THROUGH THE AIR. WILLEY WAS ON MY
TAIL AS I CUT THROUGH THE FIELD OF BAMBOO. I
WAITED IN AMBUSH, PULLED BACK A LONG STALK, AND
KNOCKED WILLEY OUT COLD. UNGUARDED, I SANK THE
BASKETBALL RIGHT THROUGH THE SPOT ON THE BACK-
BOARD WHERE A HOOP HAD ONCE BEEN. TWO POINTS.
I ASKED WILLEY TO REPEAT STORIES HE'D ALREADY
REPEATED A HUNDRED TIMES. SOMETIMES I WOULD
JUST TELL HIS STORIES. HOW I WHISKED THE GIRL
OFF HER FEET AND ONTO A TRAIN AND WE ENDED UP
IN ALASKA IN A ROCK QUARRY, CAMPING OUT WITH
ALL THE OTHER PEOPLE UNABLE TO FIND WORK
ON A FISHING BOAT. ENDED UP OUT ON THE FROZEN
TUNDRA WITH NOTHING BUT SNOW AS FAR AS THE EYE
COULD SEE, HIDING FROM THE HURRICANE IN OUR
LITTLE TENT, HUDDLED TOGETHER WITH JUST ONE OF
THOSE TINY LITTLE CHEMICAL HEATING PADS TO
KEEP US WARM. ENDED UP NOT WITH THE GIRL BUT
BY MYSELF, LOST IN THE OLYMPIC FOREST FOR DAYS
WITH NO COMPASS OR FOOD, UNTIL A RANGER CAME
AND RESCUED ME. ENDED UP TRYING TO GET TO MEXICO
BUT MAKING IT NO FURTHER THAN THE BACK OF THE
EL PASO GREYHOUND STATION, CAMPED OUT WITH ALL

THE TAXI DRIVERS. I LIKED TELLING HIS STORIES
BECAUSE I DIDN'T HAVE TO WORRY ABOUT THE
DETAILS AND SEQUENCE OF EVENTS LIKE I DID
WHEN I TOLD MY OWN.

WILLEY DIDN'T COMPLAIN ABOUT MUCH, BUT THERE
WAS ONE THING THAT AROUSED ALL HIS HATRED.
"CAFES" WHERE YOU COULDN'T BUY A CUP OF COFFEE.
HE TALKED ABOUT IT INCESSANTLY. WHEN A NEW
ONE OPENED UP RIGHT IN HIS NEIGHBORHOOD, HE WENT
IN TO CHALLENGE THEM. HE SAT RIGHT DOWN
AMONG THE FANCY DINNER CROWD AND WHEN THE
WAITER CAME, WILLEY DEMANDED COFFEE. REGULAR
COFFEE, NO FANCY BULLSHIT. THE WAITER WAS
CONFUSED. HE SHUFFLED AROUND NERVOUSLY, THEN
FLED BACK TO THE KITCHEN. WILLEY WAS SMUG. HE
FELT THE FULL SENSE OF VICTORY THAT YOU ONLY
FEEL WHEN PROVING SOMETHING TRIVIAL AND MEAN-
INGLESS. BUT HIS VICTORY WAS SHORT-LIVED. THE
WAITER RETURNED AND INSTEAD OF USHERING
WILLEY OUT THE DOOR, HE LED HIM BACK THROUGH
THE KITCHEN TO THE CHEF AND THE CHEF'S PERSON-
AL COFFEEMAKER. WILLEY SAT AROUND DRINKING
A COUPLE POTS OF COFFEE WITH THE CHEF, WHO
SEEMED LIKE A PRETTY DECENT GUY. WILLEY WAS
DEFEATED AND YET, THEY DIDN'T CHARGE HIM FOR
THE COFFEE, SO HE COULDN'T REALLY COMPLAIN.

SOMETIMES THE PHONE RANG, AND SOMETIMES
THE DOORBELL, FOUR FLIGHTS DOWN. ONE DAY THE
DOORBELL RANG AND WILLEY STUCK HIS HEAD OUT
THE WINDOW TO THROW DOWN THE KEYS. OUTSIDE
THE FRONT DOOR WAS A CAMERA CREW, WITH
CAMERAS ALL POINTED UP AT HIM. IT WAS THE
NEWS TEAM FROM A LOCAL TELEVISION STATION.
THEY STARTED YELLING QUESTIONS UP AT WILLEY.
THEY HAD GOTTEN THE WRONG APARTMENT NUMBER
OR THE WRONG ADDRESS, BUT NO MATTER WHAT
WILLEY SAID, THEY REFUSED TO BELIEVE HIM. WE
TURNED ON THE TELEVISION THAT NIGHT AND, SURE
ENOUGH, THERE WAS SILENT FOOTAGE OF WILLEY,
STICKING HIS HEAD OUT THE WINDOW, DENYING
EVERYTHING. OVER THE PICTURE, A REPORTER'S VOICE
INTONED, "SMALL LICENSED ARMS DEALERS MAY BE
SELLING GUNS NEXT DOOR TO YOU! EYEWITNESS NEWS
CREW SPECIAL REPORT AT ELEVEN".

SLUGGO AND SAL WERE WITH US TOO, HALF THE
TIME. THEY WERE IN LOVE, THOUGH NO ONE EVEN
KNEW THEY WERE GOING OUT UNTIL ONE DAY THEY
ANNOUNCED THEY HAD BROKEN UP. THEY WERE LIKE
TWO LITTLE PEAS IN A POD, ALWAYS RUNNING AND

RIDING AND BUILDING AND DOING THE MOST AMAZING
THINGS, THEN RETURNING FROM THEIR ADVENTURES
AND CURLING UP TOGETHER TO SLEEP AT THEIR
SQUAT OR IN WILLEY'S TINY CLOSET.
 ALTHOUGH IT WASN'T THAT LONG AGO, I ALWAYS
THINK OF SLUGGO AND SAL IN LOVE AS THE TIME
THE WORLD WAS YOUNG AND NOTHING WAS IMPOSS-
IBLE. IT WAS AN INTOXICATING FEELING, BUT ONE WE
GREW OUT OF, OUT OF NECESSITY, AND GOING BACK TO
IT NOW WOULD BE ABOUT AS MUCH FUN AS GOING
BACK TO CHILDHOOD. ONLY LOOKING BACK ON IT DOES
THEIR ROMANCE AND WILLEY'S APARTMENT SEEM
TO SUM UP A WHOLE ERA AND THE SPIRIT BEHIND
IT. WHEN THEY BOTH ENDED IT WASN'T SAD, JUST
TIME FOR SOMETHING NEW.

33. Enter Jagoff

 EVERYONE WAS CRUISING AROUND DRINKING
ONE NIGHT AND DECIDED TO STOP BY JESSE'S PLACE.
WILLEY WAS IN ONE OF HIS PROUD, STUBBORN LONER
MOODS. THEY WERE BECOMING INCREASINGLY COMMON.
HE GRABBED A FEW BEERS AND STAYED OUT ON THE
STREET WHILE EVERYONE ELSE WENT IN.
 HE SAW SOMEONE TWO BLOCKS DOWN, SITTING
NEXT TO A BUILDING. THAT WAS ODD. EVEN IN THE
MIDDLE OF THE DAY JESSE'S NEIGHBORHOOD WAS
USUALLY DESERTED, NO ONE AROUND EXCEPT A FEW
FACTORY WORKERS, AND NOW IT WAS 3:00 IN THE
MORNING. SOME HOMELESS GUY, WILLEY FIGURED.
MAYBE A KINDRED SPIRIT. HE WALKED DOWN TO
SAY HELLO AND OFFER THE GUY A BEER.
 WILLEY WAS SURPRISED TO SEE THAT IT WAS A
YOUNG GUY, WITH GREASY, SLICKED-BACK HAIR.
WILLEY SAID, "YOU WANT A BEER?", AND THE GUY
SAID A BUNCH OF WEIRD BULLSHIT. HE HAD THIS
HORRIBLE WAY OF TALKING. WILLEY WAS IMMED-
IATELY ANNOYED, AND ANNOYED AT HIMSELF FOR
HAVING GONE TO TALK TO THIS FAKE HOBO GUY
INSTEAD OF STICKING WITH HIS FRIENDS. BUT IT
WAS 3:00 IN THE MORNING, SO HE INVITED THE GUY
TO COME UP TO JESSE'S AND JOIN THE PARTY.
EVERYONE AT THE PARTY WAS ALSO REALLY ANNOYED
BY THE GUY AND HIS ENDLESS BABBLING WHICH
DIDN'T MAKE ANY SENSE, BUT THEY BROUGHT HIM
BACK TO OUR HOUSE ANYWAY.
 HE SAT IN THE BIG EASY CHAIR IN LITTLE G'S ROOM,

JUST SAT THERE FOR FOUR OR FIVE DAYS, STARING
OUT THE WINDOW WITH HIS DEAD FISH-OUT-OF-WATER
EYES. EVERY HOUR AND A HALF HE WOULD GO DOWN-
STAIRS TO THE LIQUOR STORE AND GET A BOTTLE OF
BEER, A BAG OF CHIPS, AND AN ICE CREAM BAR.
EVENTUALLY, THERE WAS A KNEE-HIGH PILE OF
GARBAGE SURROUNDING THE CHAIR. EMPTY BOTTLES
AROUND THE FRONT, PILES OF CHIP BAGS AND ICE
CREAM WRAPPERS ON EACH SIDE. THEN ONE DAY HE
GOT UP TO GO TO THE LIQUOR STORE AGAIN, BUT
NEVER CAME BACK.

AFTER JAG HAD BEEN GONE FOR A WHILE,
EVERYONE STARTED TO MISS HIM. HE HADN'T TALKED
AT THE WRONG TIMES, OR BUTTED INTO ANYONE'S
BUSINESS. BESIDES OCCASIONAL TORRENTS OF WEIRD
BULLSHIT WHICH EVERYONE WOULD IGNORE, HE
HADN'T TALKED AT ALL. THE IDEAL HOUSEGUEST.
AFTER JAG HAD LEFT, EVERYONE REMINISCED
FONDLY ABOUT HOW YOU COULD HEAR HIM EVERY
TIME HE GOT UP TO GO TO THE LIQUOR STORE,
BECAUSE HE HURT HIMSELF EVERY TIME. HIT HIS
HEAD ON THE CEILING, TRIPPED OVER EVERYTHING,
FELL DOWN THE STAIRS. WHATEVER HAPPENED
TO THAT GUY?

34. Past Lives

SLUGGO, LITTLE G, WILLEY, AND SEAN. I HAD
KNOWN THEM ALL SEPARATELY, LONG BEFORE THEY
MET EACH OTHER. NOW THEY WERE INSEPARABLE,
WHILE I, BY MY NATURE, REMAINED A LITTLE
DETACHED. A SHARED HISTORY KEPT ME FROM
MAKING A FRESH START, BUT IT ALSO GAVE ME A
DEEPER UNDERSTANDING, AND A CERTAIN SECURITY.
I'D ALWAYS WORRIED ABOUT LOSING MY PAST, OR
LOSING TOUCH WITH IT, BUT NOW I COULD LAUGH.
EVEN A TRIP DOWN TO THE KITCHEN BROUGHT ME
THROUGH SO MANY DIFFERENT PLACES AND TIMES.
PERHAPS A DEAD-END ROAD, BUT IT WAS MINE.

I THOUGHT OF STANDING IN A FIELD WITH
SLUGGO WATCHING THE WISCONSIN SUN GO DOWN,
SLEEPING UNDER THE OREGON FREEWAY OVERPASS
WITH LITTLE G. CAMPING OUT IN THE WATERTOWER
AND ON THE WATERFRONT WITH WILLEY, AND
WALKING AROUND LATE AT NIGHT WITH SEAN
WHEN HE WAS FIGHTING WITH HIS OLD GIRLFRIEND
AND HAD TO SLEEP IN THE CATHOLIC SCHOOL DOG-
HOUSE. NOW WE WERE ALL TOGETHER UNDER THE

SAME ROOF. NOW WE WERE GOING NOWHERE, BUT NOWHERE WAS BETTER THAN GOING TO PORTLAND OR EAU CLAIRE.

THE PAST TAUGHT ME NOT TO ACCEPT EVERY-THING AS IT APPEARED ON THE SURFACE. SEAN AND WILLEY HADN'T ALWAYS BEEN HICKS. SLUGGO AND LITTLE G HADN'T ALWAYS BEEN ON DRUGS. THEODOTIA HAD ONCE BEEN A PRODUCTIVE, SANE HUMAN BEING. ALL THAT HAD CHANGED, BUT I KNEW IT COULD CHANGE AGAIN. I'D EVEN MET JAG LONG BEFORE WILLEY BROUGHT HIM OVER, AND KNEW THAT EVERY CITY IN THE MIDWEST HAD ITS OWN LEGEND ABOUT THE TIME HE FREAKED OUT THERE. AND RAMSEY, HIS CLEAN CLOTHES AND NICE HAIRCUT DIDN'T FOOL ME. I REMEMBERED THE TIME WE MET. HE WAS NAKED, ON ACID, TURNING BLUE FROM STICKING HIS HEAD IN THE FREEZING BAY. WORST OF ALL, HE HAD COME UNINVITED AND HADN'T EVEN BROUGHT ME A BIRTHDAY PRESENT.

35. A Visit with Ramsey

I PAGED WILLEY AND HE PICKED ME UP OUTSIDE THE U.C. THEATER. IT WAS IN THAT SHORT-LIVED, GLORIOUS PERIOD AT DUCE AFTER WILLEY GOT A MOTORCYCLE AND BEFORE HE GOT A GIRLFRIEND.

WILLEY HAD ALWAYS BEEN GOOD LOOKING IN A BOYISH SORT OF WAY, BUT ONE DAY THAT FALL HE STOOD UP STRAIGHT, CUT HIS HAIR, GOT PANTS AND A LEATHER JACKET THAT ACTUALLY FIT, AND, NEVER MIND ALL THAT, SUDDENLY GOT VERY HANDSOME AND SELF-POSSESSED. I KNEW IT WOULDN'T BE LONG BEFORE A GIRL POUNCED ON HIM. IT WAS ONLY A WEEK, AND HER NAME WAS RACHEL. THE STRANGE THING ABOUT THOSE DUCE BOYS, WHEN THEY GOT INTO A RELATIONSHIP THEY NEVER GOT OUT OF IT AGAIN, AT LEAST NOT FOR LONG. IT SEEMED LIKE ONE DAY RACHEL WAS MAKING EYES AT WILLEY, JODY AT LITTLE G, THEODOTIA AT JED, ANGELA AT SEAN, AND VANESSA AT SLUGGO, AND FROM THEN ON, FOR TIME ETERNAL, I PRETTY MUCH HAD FIVE EXTRA ROOMMATES.

IT WAS AN INDIAN SUMMER AND I HAVE TO SAY, I WAS LOOKING PRETTY SHARP TOO. WARM DAYS AND AUTUMN LEAVES AND NEW HOPE FOR THE WORLD DO A MAN GOOD, AND LIGHTEN HIS STEP, AND ARE GOOD FOR A BOY TOO, AND ESPECIALLY SOMETHING

IN BETWEEN A MAN AND A BOY, WHICH IS WHAT WE BOTH WERE, CRUISING AROUND ON WILLEY'S MOTORCYCLE.

WILLEY TOLD ME THE NEWS. RAMSEY, THE LAST PERSON IN THE WORLD WHO STILL LIVED AT HOME, HAD FINALLY MOVED OUT ON HIS OWN. WELL, SORT OF. HE HAD MOVED OUT OF HIS PARENTS' HOUSE AND IN WITH HIS GIRLFRIEND. STILL, IT WAS AN EXCITING EVENT WORTH CELEBRATING. WE DECIDED TO PAY HIM A VISIT. RAMSEY HADN'T INVITED US, BUT THEN AGAIN, WE HAD NEVER INVITED HIM EITHER.

RAMSEY LOOKED A LITTLE WORRIED. HE STOOD IN THE DOORWAY WANTING TO BLOCK IT, BUT NOT DOING A VERY GOOD JOB. "UM, GUYS, IT'S A LITTLE LATE", HE SAID. "ELEVEN O'CLOCK".

HE FOLLOWED US AROUND NERVOUSLY AS WE SURVEYED THE PLACE. JUST A COMPUTER, A WEIRD CHAIR, A FEW SPONGES, A FUTON, AND SOME MUSTARD. STILL, A NICE ENOUGH SET-UP. SORT OF THE STANDARD OVERPRICED STUDENT APARTMENT CONVERTED-BASEMENT DEAL.

"CONGRATULATIONS, RAMSEY", WE SAID, SHAKING HIS HAND. "WE BROUGHT SOME BEER OVER TO CELEBRATE WITH YOU".

"OH, NO THANKS, REALLY. NO, REALLY. COULD YOU TALK A LITTLE QUIETER? THERE'S NEIGHBORS, YOU KNOW. DON'T SIT THERE. I'M ACTUALLY SORT OF BUSY RIGHT NOW".

"YOU KNOW, RAMSEY", I SAID, AS I OPENED A BEER AND MADE MYSELF COMFORTABLE ON THE KITCHEN COUNTER. "ME AND WILLEY WERE JUST TALKING ABOUT HOW GREAT IT WILL BE NOW THAT YOU FINALLY GOT YOUR OWN PLACE FOR US TO VISIT. THINK OF ALL THE FUN STUFF YOU'VE DONE AT ALL OUR DIFFERENT HOUSES."

"LIKE RUINING THE COFFEEMAKER AND BLENDER TRYING TO MAKE DMT", WILLEY SAID.

"USING MY BED FOR SEX AND LEAVING THE USED CONDOMS IN IT", I ADDED.

"PISSING IN THE CORNER OF MY ROOM".

"SHOWING UP AT FIVE A.M. WITH A PSYCHOPATH AND A TANK OF NITROUS, THEN PASSING OUT COLD".

"MOVING IN WITHOUT ASKING".

THAT ONE WAS THE FUNNIEST, AND WE STOPPED TO LAUGH. ME AND WILLEY, NOT RAMSEY. FOR YEARS RAMSEY HAD PRACTICALLY LIVED AT OUR HOUSES, BUT ALWAYS HAD HIS PARENTS TO GO BACK TO WHEN IT WAS TIME TO SLEEP, EAT, OR STUDY. FINALLY HE DECIDED TO ACTUALLY MOVE IN WITH

US, AT DOUBLE DUCE. WITHOUT BOTHERING TO CHECK WITH ANYONE, HE STAKED OFF A ROOM IN THE ATTIC AND MOVED HIS STUFF IN. WE DIDN'T MIND, OR PARTICULARLY NOTICE A DIFFERENCE. BUT RAMSEY DID. TWENTY FOUR HOURS LATER HE MOVED OUT. HE COULDN'T TAKE IT. HE SAID, "I DON'T KNOW HOW YOU GUYS LIVE LIKE THIS. IT'S INSANE."

HE LEFT ALL HIS STUFF AT OUR HOUSE, FOR WEEKS. OUT OF RESPECT FOR RAMSEY, WE DIDN'T SMASH OR SMOKE ALL HIS POSSESSIONS. INSTEAD, WE BENT THEM INTO FREE-FORM SCULPTURES AND HUNG THEM FROM TELEPHONE POLES ALONG THE ROUTE RAMSEY TOOK TO SCHOOL.

"WHAT ABOUT THE TIME YOU USED MY LIGHTER TO BURN DOWN THE MENTAL WARD IN AN ESCAPE ATTEMPT?", I SAID. "AND WHEN YOU DOSED MY ENTIRE BIRTHDAY PARTY?"

"THE TIME YOU AND LINDA GOT TOGETHER IN MY CAR", WILLEY SAID. "ON THE SIDE OF THE ROAD, ON THE WAY BACK FROM RENO, IN THE HUNDRED DEGREE HEAT, WITH ALL OF US POUNDING ON THE WINDOWS AND YELLING FOR YOU TO LET US IN, WHILE YOU BOTH JUST IGNORED EVERYONE AND WENT ON FUCKING FOR AN HOUR? NOW THAT YOU TWO HAVE MOVED IN TOGETHER, AND IN SUCH A NICE PLACE, IT'S REALLY AN HONOR TO BE ABLE TO COME AND VISIT AND BE WELCOMED".

THERE WAS MORE TO SAY, BUT NO ONE TO SAY IT TO. RAMSEY HAD FINALLY MANAGED TO PUSH US OUTSIDE AND BOLT THE DOOR.

36. Slogans

MY ROOMMATES RECITED QUOTES AND JOKES FROM STALE OLD PUNK MOVIES. THEY REPEATED STORIES OF PEOPLE THEY HAD NEVER MET AND SANG ALONG WITH SONGS ABOUT PLACES THEY HAD NEVER BEEN. ANCIENT BANDS WERE TREATED LIKE CLOSE PERSONAL FRIENDS, AND CLOSE FRIENDS WERE TREATED LIKE IRRELEVANT, PLAYED OUT GARBAGE. ENOUGH WAS ENOUGH. I CALLED EVERYONE INTO THE KITCHEN FOR A SERMON.

"FELLOW ROOMMATES, THE TIME HAS COME FOR US TO MAKE OUR OWN SONGS AND OUR OWN SLOGANS! WE MUST SHAPE OUR OWN CULTURE AS MUCH AS IT SHAPES US! SELF-ACTUALIZATION IS THE KEY!

WE MUST REALIZE OUR OWN CREATIVE FORCE, STRIVE TO ARTICULATE AND DEVELOP OUR OWN CULTURAL IDENTITY! WITHOUT IT WE ARE ONLY GROPING BLINDLY IN THE DARKNESS!"

EVERYONE LOOKED AT ME WITH TIRED, WORRIED EYES.

"WHO AMONG US HAS BOUGHT A CLOCK ON HOLLYWOOD BOULEVARD THE DAY THEY LEFT? WHO KNOWS WHAT THE HELL "STEN GUNS IN KNIGHTS-BRIDGE" MEANS? WHICH OF YOU HAS THIRTY FIVE DOLLARS, A SIX-PACK, AND A GIRLFRIEND, YET DARES TO COMPLAIN ABOUT IT?"

THEY LAUGHED. I GLARED. THERE IS NOTHING FUNNY ABOUT PUNK.

"AND YET, YOU MOUTH THE WORDS. YOU SHOUT WITH INDIGNATION BUT WITHOUT UNDERSTANDING. ASK YOUR OPINION, YOU HEM AND HAW, YOU APOLOGIZE, YOU CHANGE THE SUBJECT. ASK YOU SOMEONE ELSE'S OPINION AND YOU ALL JOIN IN UNISON, IN A SIX-PART HARMONY. IT IS TIME TO SPEAK OUR MINDS!"

"WHAT ARE YOU TALKING ABOUT?", SLUGGO SAID.

"SHUT UP", I SAID.

"WE MUST WRITE THE STORY OF OUR OWN LIFE, AND PLAY THE SOUNDTRACK TO IT TOO! OUR CULTURE WILL DIE, NAY, IT IS ALREADY ON ITS DEATHBED, BECAUSE WE DO NOT INVEST OUR OWN LIFE IN IT! WE DO NOT INCLUDE OURSELVES IN THE HISTORY! WE DO NOT TAKE THE RESPONSIBILITY TO MAKE IT INTO SOMETHING WE CAN TRULY CALL OUR OWN! STAND UP AND MAKE YOUR HEROES PROUD! I NEED A RALLYING CRY! A FLAG TO UNITE US IN OUR DES-PERATE STRUGGLE TO STAY TRUE AND STAY TOGETHER! GIVE ME A SLOGAN!!"

WILLEY STEPPED FORWARD. HE SAID, "I DON'T HAVE A SLOGAN, BUT I DO HAVE AN ANALOGY".

"YES", I SAID.

"TRYING TO BUILD MY DREAMS WITH WHAT I HAVE NOW, IT'S LIKE BUILDING A FORTY-FIVE STORY HOUSE WITH THIRTY-FOUR BRICKS".

AND SO, THE LEGACY OF 'WILLEY'S DREAM HOME' WAS BORN.

IN THE FOLLOWING WEEKS, "45 STORY HOUSE, 34 BRICKS" T-SHIRTS COULD BE SEEN IN ABUNDANCE AROUND OUR HOUSE, AND "WDH" GRAFFITI GREW LIKE KUDZU ALL OVER TOWN. "WDH— IF IT ISN'T BROKEN, BREAK IT". "WDH—IF THE SHOE FITS, THROW IT AWAY".

WE MADE A SETLIST FOR THE WDH BAND:
① SMOKE ANOTHER CIGARETTE (OF YOURS)

②CAN I BORROW YOUR CAR (FOREVER)
③A GOOD THING IS BETTER THAN A GOOD
 IDEA (WORST THING POSSIBLE)
 WE EVEN HAD A THANK YOU LIST FOR OUR
FUTURE RECORD. ALL OF THE PEOPLE WHO HAD
MADE WILLEY'S FUTURE THE SORRY, BUT FUNNY,
JOKE WE KNEW ALL TOO WELL. THANKS WENT
OUT TO VICKI VANTASTIC, THE BOSS THAT RIPPED
WILLEY OFF FOR FIVE MONTHS WORTH OF BACK
WAGES. THREE TOWING COMPANIES WHO TOWED
HIS CARS AND NEVER GAVE THEM BACK. LOS
ANGELES CAR THIEVES WHO STOLE JESSE'S CAR,
WHICH WILLEY WAS BORROWING AT THE TIME.
JUPITER BAR FOR HAVING WILLEY ARRESTED
THREE TIMES FOR BREAKING THEIR STUPID
WINDOW ON HIS WAY HOME. LAST BUT NOT LEAST,
THANKS TO SAN FRANCISCO PARK POLICE FOR
HANDCUFFING WILLEY TO A BENCH AND THEN
GIVING HIM A TICKET FOR RESISTING ARREST.
 THE ONLY PROBLEM WITH THE BAND PART OF
OUR NEW MOVEMENT WAS THAT WE HAD ALMOST
NO EQUIPMENT OR TALENT, AND NO ACTUAL SONGS.
BUT WE TACKLED THOSE PROBLEMS ONE STEP AT
A TIME. LITTLE G BROUGHT HOME SOME DRUG
ADDICT THIEVES IN HOPES THAT THEY WOULD ROB
US, AND WHEN THEY DID INDEED TAKE LITTLE G'S
MOUNTAIN BIKE WITH THEM WHEN THEY LEFT,
THEY INADVERTENTLY PROVIDED US WITH THE
SUBJECT MATTER FOR THE FIRST WDH SONG:

 BOTTOM DWELLERS AND THE WDH CREW
 TWENTY FEET BETWEEN THE TWO
 TWENTY FEET THAT CAN'T BE CROSSED
 TWENTY FEET, A BIKE IS LOST

37. Jed

 JED DIDN'T HAVE A BAD THING TO SAY ABOUT
ANYONE. HE JUST RATTLED ON FOR HOURS TALKING
AROUND THE SUBJECT, DROPPING HINTS AND ASKING
QUESTIONS UNTIL YOU FIGURED OUT THE BAD THING
FOR HIM. THEN HE WOULD GO THROUGH GREAT
LENGTHS TO DENY IT.
 "DON'T YOU THINK, I MEAN I DON'T KNOW, I'M
PROBABLY WRONG, BUT I MEAN, NO, YOU KNOW HOW
IT IS FOR SOME PEOPLE, I'M NOT TRYING TO, LIKE,
CLAIM MY FAME ON THE MIKE, YOU KNOW, LIKE THE
FUCKING ULTIMATE, YOU KNOW, WHATEVER, LIKE,

WRITER OR SOMETHING, BUT DON'T YOU THINK, I MEAN, THE GUY AT AMOEBA, I GUESS HE'S PRETTY COOL".

"HE WOULDN'T TAKE YOUR FANZINE, EVEN ON CONSIGNMENT?", I SAID. "YEAH, THAT'S LAME".

"NO, THAT'S NOT WHAT I'M SAYING AT ALL", JED SAID.

IT WASN'T WHAT HE WAS SAYING, BUT IT WAS EXACTLY WHAT HE MEANT. THE VICTIM OF A NORTHERN CALIFORNIA UPBRINGING, JED COULDN'T STATE A FACT OR EVEN AN OPINION FOR FEAR THAT IT WOULD OFFEND AND OPPRESS SOMEONE. SPEAKING YOUR MIND WAS HATRED, HATRED WAS VIOLENCE, AND VIOLENCE WAS ALWAYS WRONG, ESPECIALLY IN SELF-DEFENSE. IT WAS A STRUGGLE JUST TO GET HIM TO APOLOGIZE AFTER, INSTEAD OF BEFORE, SOMETHING THERE WAS NO REASON TO APOLOGIZE FOR IN THE FIRST PLACE.

JED HAD AN INCREDIBLY STRICT MORAL CODE, BUT HE KEPT IT TO HIMSELF. YOU NEVER KNEW HIS RULES AND THE REASONING BEHIND THEM. LIKE MY COUSIN JANA WHO KEPT KOSHER, WHEN SHE SAID, "OH, LET ME DO THE DISHES", SHE REALLY MEANT, "DON'T TOUCH THE DISHES". JANA WOULD NEVER LET ME DO THE DISHES OR SERVE FOOD, AND JED WOULD NEVER SIT DOWN AND RELAX. BOTH MADE ME REALLY NERVOUS. FINALLY FIGURING OUT THE REASONS BEHIND THEIR STUBBORNESS DIDN'T MAKE ME LESS NERVOUS, BUT IT DID MAKE ME THINK THEY WERE LESS CRAZY.

JED HAD BEEN A VEGETARIAN ALL HIS LIFE, AND HE TOOK IT UPON HIMSELF WITH A KIND OF FANATICISM. YOU WOULD SEE HIM RIDING AROUND TOWN, STANDING STRAIGHT UP WITH HIS LEGS OUT, MAKING SURE NOT TO TOUCH THE LEATHER BICYCLE SEAT. JED WOULDN'T USE THE UPHOLSTERED CHAIRS OR COUCHES AT OUR HOUSE, PREFERRING TO SIT ON THE TABLE OR ON TOP OF THE FRIDGE. NO LEATHER GUITAR STRAPS, NO GLUESTICK, NO BEER WITH PICTURES OF HUNTERS ON THE LABEL, NO BOOKS ABOUT FISHERMEN. NO FOOD, ALMOST, SINCE ANYTHING MORE THAN TWO SYLLABLES ON A LIST OF INGREDIENTS WAS ASSUMED TO BE A MEAT BYPRODUCT, AND ANYTHING PROCESSED PROBABLY HAD FECES IN IT FROM RATS IN THE FACTORIES. INK AND GASOLINE WERE HIS TWO EXCEPTIONS TO THE RULE, NECESSARY EVILS WHICH HE STILL FELT GUILTY USING.

A STRICT MORAL CODE DOES NOT NECESSARILY LEAD TO PARANOIA, AN OVERACTIVE IMAGINATION, AND RIDICULOUS JUDGEMENTS AND ASSUMPTIONS. BUT, THERE'S AN UNDENIABLE CONNECTION. JED

ASSUMED THE WORST AT ALL TIMES. MAYBE, HE CONCEDED, THE WORLD WAS ONLY HALF ROTTEN. HE EVEN ONCE ADMITTED THAT IT MIGHT BE WRONG TO ALWAYS EXPECT SOMEONE WITH A GUN TO POP OUT OF THE BUSHES AND KILL HIM.

IT WAS EXHAUSTING BECAUSE JED WASN'T INTERESTED IN HAVING HIS FEARS CALMED OR SOOTHED. IT GOT OLD TRYING TO EXPLAIN THAT SEAN WEARING SLEEVELESS SHIRTS DID NOT, BY IMPLICATION, MAKE HIM A PERPETRATOR OF DOMESTIC VIOLENCE. JED LOVED TO TALK, BUT WASN'T MUCH OF A LISTENER. YOU WALKED AWAY SO BURNT OUT AFTER TALKING TO HIM, BUT JED BURNED ON AND ON.

HE WAS COMMITTED TO PACIFISM, YET EVERYTHING ABOUT HIM WAS SO STRONG AND FORCEFUL. EVERY GESTURE AND EVERY FEAR WAS EXAGGERATED. STILL, HE WENT OUT OF HIS WAY TO MAKE HIS FEARS WORSE, ALWAYS GOING TO THE MOST DANGEROUS PLACES, THE MOST UNCOMFORTABLE SPACES. IN HIS DUALITY HE WAS BOTH PARANOID AND COMPLETELY FEARLESS. PACIFIST, YET THE LAST PERSON YOU WOULD EVER WANT TO FIGHT, BECAUSE HIS DETERMINATION AND NERVOUS TENSION WERE UNSTOPPABLE.

THAT WAS JED. ONE OF THE MOST TIMID AND CARING PEOPLE I HAD EVER MET, ONE OF THE MOST OVERBEARING, CLOSE MINDED PEOPLE I KNEW. THE UNSTOPPABLE, UNGOVERNABLE, UNINTELLIGIBLE FORCE. JED.

38. Chowchilla

MY BIRTHDAY HAD TRADITIONALLY BEEN THE WORST, LONELIEST, MOST DAMAGING DAY OF THE YEAR NOT JUST FOR ME, BUT FOR ALL MY FRIENDS, WITH ORGANIZED GROUP SUFFERING ON THE SCALE OF THE LONG MARCH. BUT IN RECENT YEARS I'D TAKEN TO THE SAYING, "YOU COME INTO THIS WORLD ALONE AND LEAVE IT ALONE", AND BEGAN SPENDING MY BIRTHDAYS ALONE TOO. SLUGGO'S BIRTHDAYS TOOK OVER THE LEAD SPOT BY POWER OF SHEER POINTLESS AND RECKLESS EXCESS. HE HAD TAKEN TO THE SAYING, "YOU SPEND YOUR FIRST BIRTHDAY IN THE HOSPITAL, AND GO BACK AGAIN THAT SAME DAY EVERY YEAR".

HOWEVER, WE WERE HIT WITH A DOUBLE

WHAMMY WHEN JED MOVED IN, BECAUSE HE AND
LITTLE G HAD THE SAME BIRTHDAY. THAT MEANT
TWICE THE BAD LUCK, TWICE THE ARGUMENTS,
COPS, AND HORRIBLE DOOMED PLANS.

JUST AS SLUGGO'S IDEA OF A PARTY WAS
LOSING ALL SANITY AND MINE WAS LONELINESS
AND MISERY, LITTLE G AND JED'S BIRTHDAY PLANS
SEEMED DESIGNED TO EMBRACE AND MAGNIFY
ALL THE THINGS THEY LIKED TO COMPLAIN ABOUT.
STILL NOT AS HORRIBLE AS SLUGGO'S, IT WAS
MEMORABLE AND MISERABLE ENOUGH TO INSPIRE
A SECOND SONG. HIT IT, WILLEY.

1-2-3-4
WE'RE STUCK IN THE MUD
AND WE CAN'T GET THE CAR OUT
WE'RE STUCK IN THE MUD
TWENTY PEOPLE PUSHING BUT WE
CAN'T GET THE TIRES TO GRIP
ON A BACKROADS ROAD IN A HICK
TOWN GOING DOWN
ANOTHER FUCKED UP WDH ROADTRIP
NOW WE'RE IN THE HOTEL
WATCHING COUNTRY MUSIC T.V.
NOW WE'RE IN THE HOTEL
TWENTY PEOPLE SLEEPING ON TOP OF ME
WE'RE STUCK IN CHOWCHILLA
TOW TRUCK WON'T TOW THE CAR
WE'RE STUCK IN CHOWCHILLA
HICKS USED A CROWBAR
TO PRY OPEN THE TRUNK
THEY TOOK SLUGGO'S SHOES AND ALL MY JUNK
THEY STOLE OUR MONEY, STOLE OUR BEER
AND THAT'S WHY WE'RE STILL HERE
WE'RE STUCK IN THE MUD
IN THE CENTRAL VALLEY
WE'RE STUCK IN THE MUD
AND IT'S MY BIRTHDAY

39. No one Will Arrest Me

SEAN CLIMBED THE FIRE ESCAPE OF THE
TEN STORY BUILDING ACROSS THE STREET, TRYING
TO GET TO THE BILLBOARD UP ON TOP. WHEN HE
WAS HALFWAY UP, A COP CAR PULLED UP UNDER-
NEATH. IT STARTED SHINING SPOTLIGHTS AND
BARKING OVER THE LOUDSPEAKER. THEN BACKUP
CARS SHOWED UP ON THE SCENE, ONE AFTER

ANOTHER, UNTIL THERE WERE SEVEN COP CARS ALL WAITING FOR SEAN AS HE TOOK HIS TIME ON THE WAY DOWN. WHERE WOULD WE EVER COME UP WITH ENOUGH MONEY TO BAIL HIM OUT?

WE WATCHED FROM OUR WINDOW AS THE COPS STOOD IN A CIRCLE AROUND POOR SEAN, STANDING THERE WITH A BEER IN ONE HAND AND SPRAY-PAINT HANGING OUT OF HIS JACKET POCKET. THE TENSION BUILT UP FOR TEN MINUTES, AND THEN THE COPS DROVE OFF. SEAN WALKED BACK ACROSS THE STREET, UP THE STAIRS, AND IN OUR DOOR. WE WERE STUNNED.

"I TOLD THEM THERE WAS A DOMESTIC ARGUMENT AT MY HOUSE", HE SAID. "I NEEDED TO CLEAR MY HEAD, GIVE MY ROOMMATES SOME SPACE. THEY WERE VERY SYMPATHETIC".

JED WENT OUT TO SPRAYPAINT THE PARKING LOT WALL ON THE OPPOSITE CORNER. HE PACED AROUND FRANTICALLY, TWITCHING AND PEERING IN EVERY DIRECTION, TRYING TO LOOK CASUAL. IT WAS 3:00 IN THE MORNING AND JED LOOKED ANYTHING BUT CASUAL. HE DID A "W", THEN WALKED AROUND WHISTLING AND WAVING AT CARS. IT TOOK HIM FIVE MINUTES TO GET THE "D", AND STILL, IT LOOK-ED MORE LIKE A "C". HE WAS STARTING ON THE "H" WHEN WE SPOTTED A CRUISING COP CAR, AND YELLED OUT OUR PRE-ARRANGED WARNING SIGNAL. JED SMILED, DID A LITTLE DANCE FOR US, YELLED BACK SOMETHING UNINTELLIGIBLE, AND CONTIN-UED PAINTING. WE SCREAMED, "COPS, COPS".

FINALLY JED UNDERSTOOD, AND CAME RUNNING BACK ACROSS THE STREET. THE COP CAR HAD TO SWERVE OUT OF THE WAY TO AVOID RUNNING HIM OVER. INSTEAD OF TAKING THE SIDE STREET AND SNEAKING BACK AROUND, JED WALKED RIGHT IN OUR GATE, IN PLAIN VIEW. BUT THE COPS DIDN'T FOLLOW. THEY JUST DROVE AWAY.

LITTLE SUICIDE, DRIVING DRUNK AND A HUNDRED MILES AN HOUR AROUND OUR CORNER, SAW TWO COP CARS OUTSIDE THE LIQUOR STORE. HE SKIDDED OUT, JUMPED OUT OF HIS CAR, THEN LAY FACE DOWN WITH HIS HANDS BEHIND HIS BACK. BEER AND PILL BOTTLES TRAILED OUT THE OPEN CAR DOOR. HE STARTED RECITING HIS RIGHTS, SAYING, "I KNOW IT'S YOUR JOB, SO JUST GO AHEAD AND TAKE ME TO JAIL". THE COPS JUST PICKED HIM UP AND TOLD HIM TO GET HIS CAR OUT FROM THE MIDDLE OF THE INTERSECTION.

SEEING THE COP CAR PARKED RIGHT OUTSIDE

OUR HOUSE, SEAN THREW A FORTY-OUNCE
BOTTLE OUT THE WINDOW AND IT SMASHED OVER
THE HOOD. THE COP CAME UP THE STAIRS AND
YELLED AT SEAN, BUT DIDN'T EVEN SHOOT HIM.
TRY AS THEY MIGHT, SOME OF MY ROOMMATES
JUST COULD NOT GET ARRESTED.

MEANWHILE, WILLEY, SLUGGO, AND I WERE
ALL STOPPED SEPARATELY BY THE COPS WHEN JUST
WALKING AROUND MINDING OUR OWN BUSINESS. A
YEAR EARLIER WE HAD BEEN RIDING AROUND
OAKLAND TOGETHER AND GOT TICKETS FOR NOT
HAVING LIGHTS ON OUR BIKES. NOW THE UNPAID
TICKETS HAD TURNED INTO WARRANTS. NOW
ALL THREE OF US GOT THROWN IN JAIL.

40. Gun Control

I DIDN'T APPROVE OF LITTLE G EMBRACING
THE GANGSTER LIFESTYLE. I DIDN'T APPROVE OF
SEAN AND WILLEY WASTING THEIR LIVES AWAY
AT SHITTY JOBS AND IN SHITTY BARS, OR SLUGGO
SINKING INTO AN OBSESSIVE, PSYCHOTIC RELATION-
SHIP. I GUESS JED'S LIFESTYLE WAS THE ONLY ONE
I OFFICIALLY SANCTIONED, BECAUSE HE WAS SO
RELENTLESSLY DRIVEN IN EVERYTHING HE DID, AND,
LIKE ME, SUCH A WORKAHOLIC.

THAT WAS MY BIASED JUDGEMENT. YOU HAVE
TO DEVOTE YOURSELF TO CREATIVE EXPRESSION
AND ACTIVELY WORK HARD AT MAINTAINING IT.
EVERYTHING ELSE COMES NATURALLY, LIKE APATHY,
DRAMA, DANGER, ROMANTIC OBSESSION, AND
WASTED TIME. MY ROOMMATES KNEW WHAT I
THOUGHT, AND I KNEW WHAT THEY THOUGHT:
THAT YOU SHOULD LET THINGS HAPPEN NATURALLY.

I DIDN'T HAVE ANY GREAT FAITH IN NATURE,
OR THE NATURAL WAY OF THINGS. I LIKED SYSTEMS,
AND ORDER, AND THE POWER OF REASON AND
EFFORT. IN THE MIDST OF ALL THE CHAOS, I
LIVED A PRETTY QUIET, SIMPLE LIFE, MOSTLY DEVOT-
ED TO MY WRITING. THAT WAS MY IDEA OF HOW
TO LIVE, AND I LIKED TO THINK THAT I SET AN
EXAMPLE WHICH PROVED MY POINT MORE THAN
ANY PREACHING WOULD. BUT, AT THE SAME TIME,
I KNEW THAT LIFE WOULD BE A TOTAL DRAG IF
EVERYONE LIVED LIKE ME, OR EVEN EVERYONE I
LIVED WITH. I'M SUCH A CONTROL FREAK ABOUT
MY WORK, MY FRIENDS, AND MY ROMANCES THAT

IT WAS NICE TO LIVE IN A HOUSE WHICH WAS
OUT OF MY CONTROL.
 THE ONLY THING I ABSOLUTELY DID NOT
APPROVE OF WAS THE GUNS. THAT WAS UNDER-
STOOD BY MY ROOMMATES, AND EXCEPT ON NEW
YEAR'S EVE, THE GUNS WERE KEPT OUT OF MY
SIGHT. IT WASN'T MY PLACE TO IMPLEMENT A
"NO GUNS IN THE HOUSE" RULE. THERE HAD BEEN
ONE ONCE, BUT THINGS CHANGED EACH TIME I
LEFT TOWN AND RETURNED. I ACCEPTED THAT,
AND WAS HAPPY JUST TO BE WELCOMED BACK.
THEY COULD GO OUT SHOOTING NEWSPAPER
MACHINES AND TRAINS, OR STAY INSIDE SHOOTING
THE T.V. SET, VACUUM, TOASTER, JED'S COMPUTER,
AND BILLY'S NINTENDO WHEN IT WOULDN'T LET
LITTLE G WIN AT VIDEO BASEBALL. IT WASN'T MY
BUSINESS, AS LONG AS I NEVER HAD TO SEE IT.

41. Common Enemy

 THERE WAS STILL AN OCCASIONAL ACT OF
WAR, LIKE WILLEY FUNNELING BUTANE THROUGH
A LONG PIPE, LIGHTING THE OTHER END, AND
SHOOTING HUGE FIREBALLS INTO SLUGGO'S ROOM.
BUT, MOST OF THE WAR EFFORTS WERE REDIRECTED
AFTER THE HAIR LADY MOVED INTO THE STORE-
FRONT DOWNSTAIRS. FINALLY, A COMMON ENEMY.
 WELL, YOU KNOW, SHE STARTED IT. COMPLAINING
ABOUT THE NOISE, AND THE CAR PARTS IN THE
BACKYARD, AND SHIT. WHAT THE HELL? WE WERE
THERE FIRST.
 DOWNSTAIRS, FROWNING CUSTOMERS HAD THEIR
HAIR PERMED WHILE PLASTER RAINED DOWN
FROM THE CEILING IN TORRENTS AND THE HAIR
LADY SCREAMED AND CURSED. CUSTOMERS GOT
FACIALS WHILE THE OOZE FROM OUR REFRIGER-
ATOR LEAKED DOWN THE HAIR LADY'S WALLS.
WE COULDN'T HELP IT IF THE FRIDGE WAS DE-
THAWING AND ALL THE ROTTING FOOD WAS
CRAWLING OUT. OUR POWER WAS SHUT OFF, AND
THE HAIR LADY HAD CUT THE EXTENSION CORD
WE RAN INTO THE BACK OF HER PLACE.
 OUR TOILET WAS BROKEN TOO, SO MY ROOM-
MATES USED THE HAIR LADY'S MAIL SLOT. THAT
WAS A LITTLE TOO MUCH, AND TOO FAR, FOR ME,
SO I JUST STAYED UP IN THE ATTIC PISSING IN
BOTTLES, AND EVENTUALLY HAD ENOUGH MILK

CRATES FULL OF PISS BOTTLES TO BUILD AN
ENTIRE DESK.
 I BUILT A SEPARATE LITTLE OFFICE IN THE
UNUSED PART OF THE ATTIC WITH NO FLOORBOARDS.
WALKING ON THIN PLANKS AND WORKING AT A
SHAKY DESK MADE OF PISS BOTTLES MADE MY
WORK SEEM MORE RISKY AND EXCITING. LAYING
OUT A MAGAZINE BY CANDLELIGHT WAS MORE
ROMANTIC AND STONE-AGE. OTHER PEOPLE
WORRIED ABOUT KEEPING THEIR INTEGRITY. I
WORRIED ABOUT KEEPING MY BALANCE, AND
TRYING TO KEEP FROM LIGHTING MY MAGAZINE
ORIGINALS ON FIRE.

42. Jazz Appreciation

 LITTLE G DIDN'T LIKE HIS ROOM. IT WAS TOO
PRIVATE. HE LIKED BEING RIGHT IN THE MIDDLE
OF THINGS OR, IF POSSIBLE, IN THE WAY. HE LAY ON
THE FLOOR OR ON THE KITCHEN TABLE TRYING TO
SHOTGUN BEER AS WE STEPPED OVER OR ATE OUR
FOOD ON TOP OF HIM. SLUMBER PARTIES IN THE
KITCHEN, OR ANY OTHER EXCUSE TO BE IN CLOSE
QUARTERS FOR A LONG PERIOD OF TIME, WERE
CONSTANTLY INITIATED. IF WE SLEPT IN OUR OWN
BEDS, LITTLE G WOULD COME SLEEP IN BED WITH US.
 HIS NEW SCHEME FOR KEEPING EVERYONE
TOGETHER TWENTY-FOUR HOURS A DAY WAS NIGHT
CLASSES AT THE COMMUNITY COLLEGE. HE HAD
SIGNED UP BOTH SLUGGO AND JED. OFF THEY WOULD
DRIVE FOUR NIGHTS A WEEK TO PSYCHOLOGY
AND JAZZ APPRECIATION, RIGHT AT THE SAME
TIME SEAN AND WILLEY WERE GETTING OFF
WORK AND HEADING TO THE BAR.
 JED WAS ALWAYS JUMPING OUT OF THE
CAR ON THE WAY TO SCHOOL AND RUNNING OFF.
ME AND THEO DIDN'T HAVE TO DO ANYTHING THAT
EXTREME TO ESCAPE OUR FRIENDS. WE WERE
ALREADY OUTSIDERS. INTEGRAL PARTS OF THE
GROUP, BUT PREFERRING TO REMAIN ON THE FRINGES.
AT NIGHT WHEN EVERYONE ELSE CAME HOME
DRUNK AND SAT IN THE KITCHEN DISCUSSING
HONOR, VALOR, FRIENDSHIP, AND WHO THEY WOULD
TAKE A BULLET FOR, THEODOTIA HID IN THE
CORNER SCRAWLING IN HER JOURNALS AND I HID
IN THE ATTIC DRINKING COFFEE AND WORKING ON
MY MAGAZINE.

JED WAS ALWAYS DISAPPEARING, RUNNING
AWAY, NOT TO BE SEEN AGAIN FOR DAYS. HE HAD
A SECRET LIFE SOMEWHERE WHICH WE KNEW
NOTHING ABOUT. MARRIED WITH KIDS, OR AN
EXECUTIVE IN THE FINANCIAL DISTRICT, OR,
PERHAPS, A SUPERHERO. THEODOTIA, IN HER
WAYS, WAS EVEN MORE MYSTERIOUS. MONDAY SHE
MIGHT BE SWEEPING THE HOUSE, TUESDAY OUT
TURNING TRICKS AND ROBBING PEOPLE, AND
WEDNESDAY HARD AT WORK WRITING HER BOOK
ABOUT SEYMOUR KRIM AND TWO OTHER OBSCURE
PRE-BEATNIK BORING JEWISH HOMOSEXUAL
INTELLECTUALS. THAT MUCH MADE SENSE, BUT
WHERE DID SHE GO THE REST OF THE WEEK?

BUT THEO WAS A PRIVATE PERSON, AND HER
SECRETS WERE A NATURAL PART OF HER CHAR-
ACTER, NOT OUT OF CHARACTER LIKE WITH JED.
SHE DIDN'T TALK ABOUT HER DISAPPEARANCES,
BUT THEN AGAIN, SHE HARDLY SPOKE AT ALL.
IF SHE WASN'T AROUND THE HOUSE FOR MORE
THAN A WEEK, I COULD EXPECT A LONG OUT-OF-
TOWN LETTER AT MY P.O. BOX. THEN SHE WOULD
RETURN ONE DAY AS QUIETLY AND ABRUPTLY AS
SHE HAD LEFT.

I'D MADE A RULE FOR MYSELF TO KEEP FROM
DEGENERATING COMPLETELY. NO BEER OR SOCIAL-
IZING UNTIL SIX IN THE MORNING, WHEN THE
LIQUOR STORE OPENED BACK UP AND I HAD
FINISHED A SOLID NIGHT OF WORK. IT WAS A NICE
ROUTINE, JUST LIKE THE BAR FOR WILLEY AND
SEAN, SCHOOL FOR SLUGGO AND LITTLE G, AND
DISAPPEARING FOR JED AND THEODOTIA. A SYSTEM
OF CHECKS AND BALANCES BETWEEN WORK AND
PLAY, SOCIALIZING AND SOLITUDE. BUT, LIKE SOME
GROUPS OF WOMEN LIVING TOGETHER, OUR RHYTHMS
AND CYCLES STARTED TO MATCH UP. THE CHECKS
AND BALANCES STARTED TO FALL APART AS THEY
FELL INTO STEP.

WILLEY WENT TO COURT AND HAD TO MISS
WORK. SLUGGO DECIDED TO SKIP CLASS FOR A FEW
DAYS. LITTLE G CAME UP TO THE ATTIC AND CRAWL-
ED ON MY SHOULDERS WHILE I TRIED TO WRITE.
HE LAY ON MY DESK ASHING CIGARETTES ONTO MY
MAGAZINE ORIGINALS. I IGNORED HIM. I WAS
DIFFERENT. I WAS RESPONSIBLE. I WAS PROD-
UCTIVE. HOW LONG UNTIL SIX A.M.?

SEAN CAME HOME, HAVING WALKED HIS USUAL
DRUNKEN SHORTCUT HOME FROM THE BAR, THROUGH
THE BART TUNNELS. SLUGGO ARRIVED NEXT,

PANTING AFTER BREAKING THE BANK OF
AMERICA WINDOW WITH A WHISKEY BOTTLE.
IN HIS ARMS WAS WILLEY, WHO HE HAD CARRIED
ALL THE WAY HOME. TOO DRUNK TO RUN, OR EVEN
STAND, ON HIS OWN. JED SHOWED UP A WHILE
LATER, SHIRTLESS, AN ACOUSTIC GUITAR STRUNG
AROUND HIS NECK WITH OUR PHONE CORD. HE'D
GONE ON A LITTLE WALK, FOR THREE DAYS.

THEODOTIA HAD GIVEN UP ON CLEANING AND
WRITING HER BOOK, AND WAS NOW LOCKED IN THE
BATHROOM SHOOTING UP. AS FOR ME, I HAD
SMASHED EVERY CHAIR IN THE HOUSE, AND WAS
PRESENTLY EXPLODING PISS BOTTLES ON THE
STOVE WITH LITTLE G. AS WITH ALL MY OTHER
RULES FOR SELF-IMPROVEMENT AND SELF-
DISCIPLINE, I HAD MANAGED TO FIND A LOOPHOLE.
THE SIX A.M. DRINKING COULD GO ON UNTIL
FIVE A.M. THE NEXT DAY.

43. Rats

THEODOTIA AND JED, THEY WERE A STRANGE
MATCH. SHE SEEMED TO LOVE EVERYTHING HE
HATED, INCLUDING VIOLENCE, DRUGS, AND ARTICULAT-
ING AN IDEA. AND HE LOVED HER. THE WAY SHE
NEVER SLEPT, HER EYES GLOWED RED, AND SHE
LEVITATED IN THE DARK CORNERS OF OUR HOUSE
GRUMBLING TO HERSELF, WHO COULD BLAME HIM?
BUT WHO WOULD SAVE HIM?

ANY STRANGER COULD HAVE TAKEN ONE LOOK
AT THEODOTIA AND KNOWN SHE WAS ON DRUGS, BUT
WE HAD NEVER EVEN CONSIDERED IT. NOT HEROIN,
I MEAN. IT WAS ONE THING TO SELL WEED, SMOKE
CRACK, THROW BOTTLES AT COPS, AND SHOOT AT
YOUR ROOMMATES. THAT WAS NORMAL. BUT
HEROIN, THAT WAS BAD. EVERYONE HAS TO DRAW
THE LINE SOMEWHERE.

ONE DAY LITTLE G WAS IN SLUGGO'S ROOM,
JUST LYING THERE, AND ALL OF A SUDDEN HE
HEARD JED SCREAM. LITTLE G GRABBED THE
SHOTGUN, WENT RUNNING OUT, AND FOUND JED
FACE TO FACE NOT WITH A BURGLAR, OR THEODOTIA,
BUT WITH A FOOT-LONG RAT. IT HAD JUMPED OUT
OF THE BROKEN TOILET, FOUR FEET IN THE AIR,
WHILE JED WAS TAKING A PISS IN THE SINK.

JED WAS SCREAMING, SAYING, "KILL IT! KILL
IT!", WHICH WAS EVEN MORE SHOCKING THAN
THE SNARLING RAT.

LITTLE G SAID, "MAYBE WE SHOULD JUST THROW IT OUTSIDE OR FEED IT OR SOMETHING".
JED SAID, "NO! KILL IT! KILL IT! KILL IT!"
THEODOTIA APPEARED AND WAS SO EXCITED SHE WAS HOPPING UP AND DOWN LIKE A GNOME, GOING, "EH HEH! KILL IT! KILL IT! AHAHA!"
THE RAT SUDDENLY MADE A LUNGE AT LITTLE G, AND BOOM! HE PULLED THE TRIGGER. THE RAT WAS SPLATTERED INTO A MILLION PIECES, ALL OVER THE BATHROOM WALLS.
JED WAS SCREAMING AND SCREAMING, THEODOTIA WAS JUST LAUGHING. LITTLE G WAS ACTUALLY PRETTY FREAKED OUT BY THE WHOLE THING.

44. Embarcadero Night

WE WENT OUT ONE NIGHT WITH ERIC YEE. I HAD A DOLLAR, ENOUGH FOR BRIDGE TOLL, AND ERIC HAD A CAR. WE DECIDED TO DRIVE INTO THE CITY AND HIT THE EMBARCADERO FOUNTAINS. TWO TEAMS, TWO ON EACH TEAM, PLUS SLUGGO TO STAND THREE BLOCKS AWAY AND RUN FROM THE COPS.
ERIC AND I HIT THE OUTSIDE FOUNTAINS COMMANDO-STYLE, RUNNING UP AND DIVING STRAIGHT IN, MUCH TO THE SURPRISE OF THE FEW PASSING SHOPPERS. WE HAD CLEARED OUT EVERY-THING BUT A FEW MOLDY PENNIES BY THE TIME SECURITY SHOWED UP TO GIVE US THE BOOT. BACK AT THE RECONNAISSANCE POINT, WE DRIED OFF AND WAITED FOR THE OTHER TEAM.
TWO HOURS LATER LITTLE G AND JED SHOWED UP. THEY HAD GONE INSIDE THE HOTEL, TO THE FOUNTAINS WITH THE REAL CASH CROP. THE FANCY HOTEL, WITH TOURISTS AND LOUNGE BANDS AND LITTLE MEN IN SUITS WHO GO AROUND STAMP-ING DESIGNS IN THE SAND IN THE ASHTRAYS. TRUE TO THEIR NATURE, LITTLE G AND JED COULDN'T QUIT WHILE THEY WERE AHEAD. THEY HAD TO STAND IN THE FOUNTAIN GRABBING QUARTERS FROM AMONG THE TROPICAL FISH UNTIL THEY HAD GOTTEN EVERY SINGLE COIN. FIFTEEN MINUTES. ESCAPE MAY STILL HAVE BEEN A POSSIBILITY, BUT THEY CHOSE TO RUN PANIC-STRICKEN THROUGH THE HOTEL LOBBY.
PICTURE JED WITH HIS RAGGED BEARD AND

SIGNATURE "LOBOTOMY" HAIRCUT, WEARING AN
ORANGE DOWN VEST AND PLAID PANTS THAT
WERE JANGLING WITH FIVE POUNDS OF WET COINS.
LITTLE G, WITH BRIGHT RED HAIR AND A CIGAR-
ETTE DANGLING OUT OF ONE SIDE OF HIS MOUTH,
HOBBLING ALONG AT TOP SPEED ON HIS CRUTCHES,
THEN USING THEM TO SLIDE DOWN THE ESCALATOR
RAILS. SECURITY TACKLED THEM RIGHT BEFORE
THEY MADE IT OUT THE FRONT DOOR.

I PITIED THE POOR SECURITY GUARDS WHO HAD
TO INTERROGATE MY ROOMMATES IN THE HOTEL
BASEMENT. THERE WASN'T ANY POINT ASKING
JED QUESTIONS, BECAUSE HE WAS INCAPABLE OF
GIVING AN ANSWER. HE ONLY SPOKE IN QUESTIONS.
AS FOR LITTLE G, NOTHING MADE HIM HAPPIER
THAN GETTING INTERROGATED. HE WAS INCAPABLE
OF TELLING THE DIRECT TRUTH, EVEN IF IT WAS
THE EASIEST OR MOST CONVINCING EXPLANATION.

CASE IN POINT: OUR FATEFUL, LEGENDARY
OREGON HITCH. WHEN WE GOT STOPPED BY THE
COPS, LITTLE G HAD ONLY TO LIE AND SAY HE WAS
OF LEGAL AGE, AND WE WOULD HAVE BEEN OFF
THE HOOK. INSTEAD, HE LAUNCHED INTO A STORY
ABOUT HIS "ELUSIVE" UNCLE FRANK WHO WAS
SUPPOSED TO BE MEETING US. THE STORY WAS SO
LONG, SO FLAWED, AND SO TRULY BIZARRE THAT
THE COP, HIS ATTACK DOG, AND THE TWO BACKUP
SQUAD CARS WHO HAD SHOWN UP AS THE STORY
PROGRESSED WERE ALL SO CONFUSED THAT THEY
FINALLY JUST LET US GO.

HIS STORIES HAD THE SAME EFFECT ON THE
HOTEL SECURITY. THEY TRIED AGAIN TO GRILL JED,
NOT KNOWING THAT JED, AS A MATTER OF
PRINCIPLE, HATED TO TALK ABOUT MONEY, AND
THOUGHT HIS NAME WAS NO ONE'S BUSINESS BUT
HIS OWN. HE ANSWERED THEIR QUESTIONS WITH
HIS OWN, ABOUT THE RELATIVE WORTH OF
METAL AND THE ROLE NAMES AND NUMBERS
PLAY IN A SLAVE SOCIETY.

BACK ON THE STREET, THEY STILL HAD NINE
DOLLARS WORTH OF QUARTERS OUT OF THEIR
ORIGINAL SEVENTY FIVE, AND ERIC AND I HAD
ANOTHER SEVEN IN DIMES, NICKELS, AND
PENNIES. ENOUGH TO GET BACK TO BERKELEY,
GET TAKEOUT FOOD AT THE LATENIGHT CHINESE
PLACE DOWNTOWN, PLUS LEFTOVER CASH FOR
CIGARETTES AND A COUPLE BEERS. THE THREAT
OF EXTINCTION STAVED OFF YET ANOTHER DAY.

45. Friends & Family

THE IMPORTANT THING IS, THE DOUBLE DUCE CREW WERE MY ROOMMATES, NOT MY FRIENDS. IT WAS NICE IF THEY UNDERSTOOD ME, OR WORKED WITH ME ON MY PROJECTS, OR WANTED TO JOIN ME OUT ON THE TOWN, BUT I NEVER EXPECTED THOSE THINGS. I EXPECTED THEM TO LIVE WITH ME DAY IN AND DAY OUT, AND SHARE WITH ME THAT MOST PERSONAL TIME AND SPACE.

THEY WERE THE ONES WHO SAW ME MOST AND KNEW ME BEST, BUT THEY DIDN'T KNOW WHERE I WENT WHEN I WENT OUT, AND DIDN'T KNOW HALF THE PEOPLE I WENT TO MEET. A LITTLE BIT OF PRIVACY, A LITTLE BIT OF MYSTERY, A LITTLE BIT OF SELF-PROTECTION AFTER BAD EXPERIENCES IN THE PAST. MOSTLY, MY LIFE WAS JUST NATURALLY COMPARTMENTALIZED. MY SEPARATE WORLDS DIDN'T OFTEN CROSS, AND I NEVER MADE AN ATTEMPT TO CROSS THEM. THERE WERE ROOMMATES AND BANDMATES, FAMILY AND FRIENDS, BUSINESS PARTNERS AND ROMANCES, FORMER FRIENDS AND FORMER LOVERS, PENPALS AND PEOPLE ON THE STREET. EACH HAD A TIME AND PLACE IN MY LIFE, AND A SPECIAL UNIQUE RELATIONSHIP.

MY OLD GIRLFRIEND SAID IT BEST. SHE SAID, "YOU'D LIKE IT BETTER IF I WAS MORE LIKE YOUR SIDEKICK, WOULDN'T YOU? WE COULD WALK AROUND ALL NIGHT AND EXPLORE STUFF AND DRINK LOTS OF COFFEE AND BE LIKE PALS WHO SMOOCHED SOMETIMES. YOU'D LIKE THAT, WOULDN'T YOU? WELL, I'M NOT YOUR FUCKING SIDEKICK, I'M YOUR GIRLFRIEND, SO GET THAT STRAIGHT!"

IT WASN'T THAT SHE AND I COULDN'T WALK AROUND, EXPLORE STUFF, AND DRINK LOTS OF COFFEE, BECAUSE WE DID. I DID THOSE THINGS WITH MY DAD TOO, BUT HE IS MY ONLY DAD, AND SHE WAS MY ONLY GIRLFRIEND, SOMETHING SPECIAL AND UNIQUE AND TOTALLY DIFFERENT THAN WHAT I HAD GOING WITH ANYBODY ELSE. LABELS LIKE THAT CAN BE OPPRESSIVE, BUT FOR ME THEY TEND TO BE LIBERATING. ARTIFICIAL BOUNDARIES WHICH YOU CAN EXPAND ON OR JUST ENJOY.

THERE WERE MANY DIFFERENCES BETWEEN MY ROOMMATES AND MY FRIENDS. MOST OBVIOUSLY,

ALL BUT ONE WERE BOYS, AND MOST OF MY
FRIENDS WERE GIRLS OR WOMEN. ALSO, THEY
EXISTED AS A GROUP, WHILE MOST OF MY FRIENDS
WERE TOO INDIVIDUALISTIC, OR LIKE ME, TOO
DEMANDING AND INFLEXIBLE TO HANG OUT WITH
MORE THAN ONE PERSON AT A TIME.
THERE WERE A MILLION DIFFERENCES.
MY ROOMMATES WERE NOT UNDERSTANDING, BUT
THEY WERE FUN. MY ROOMMATES WERE HOME,
NOT ALWAYS OFF IN SOME FOREIGN COUNTRY OR
SHACK IN THE FOREST. MY ROOMMATES ACTUALLY
WANTED TO LIVE WITH ME, AND SHARE MY WORLD,
INSTEAD OF JUST HAVING ME OVER AS A VISITOR
IN THEIRS. AND SO, THOUGH I LOVED MY ROOM-
MATES, THEY WEREN'T MY FRIENDS, BUT
SOMETHING MORE.

46. L.G. Answers my Mail

HELLO DAVID: I RECEIVED YOUR LETTER AFTER
ANOTHER EXTENSIVE SHAMAN COURSE IN THE
BEAUTIFUL NEVADA NUCLEAR TEST BASIN. SORRY
ABOUT MY HANDWRITING BUT I RECEIVED A BAD
RADIATION BURN ON MY RIGHT HAND, SO I MUST
USE MY LEFT ONE.
ANYWAYS, Z. FITZGERALD WAS AN OLD FRIEND OF
MINE AND CONTRARY TO WHAT YOU BELIEVE, I
HAVE WRITTEN THREE AUTOBIOGRAPHIES ABOUT
THE LOST GENERATION AND I ADMIRE HEMING-
WAY'S ROGUISH TRAVEL HABITS. IF ONLY I COULD
HAVE HIS STAMINA, I MIGHT EVEN BE FAMOUS.
I HAVE A POINT OF CONTENTION WITH
YOUR USE OF THE WORD "ARTY". I HAPPEN TO
CONSIDER MYSELF QUITE "ARTY" AND WITHOUT
THIS TALENT I PROBABLY WOULD HAVE ENDED UP
IN LAW SCHOOL. ALSO, EVEN THOUGH WE ALL
KNOW RELIGION ISN'T EXACTLY NECESSARY, YOU
HAVE TO REMEMBER THAT MANY SICK AND
ELDERLY PEOPLE HAVE THEIR FAITH TO KEEP THE
LIGHT IN THEIR EYES AND INSPIRATION IN
THEIR SOULS.
AS IT CLEARLY STATES IN THE FINE PRINT OF
COMETBUS, I ABSOLUTELY DEAL WITH NO ORDERS.
YOU COULD WRITE TO MY PERSONAL MANAGER,
DAVILLE RIZZO FOR INFORMATION REGARDING
OLD RECORDS AND T-SHIRTS FOR SALE. HOPE TO
HEAR FROM YOU SOON.
LOVE, AARON

P.S.: DON'T BE SO HARD ON YOURSELF BUDDY;
YOU DON'T SEEM LIKE A "BLOWHARD" AT ALL.

47. Worst Thing Possible

SEEING THAT I HAD A NEW IDEA, MY
ROOMMATES HID IN THEIR ROOMS TRYING TO
AVOID ME. BUT THEY COULDN'T HIDE FOREVER.
I FINALLY CORNERED THEM ALL IN THE KITCHEN.
 "WHAT OTHER CULTURE IS SO CRITICAL OF
ITSELF?", I ASKED. "WHAT OTHER CULTURE
STRIVES TO BUILD UP TRADITIONS AND COSTUMES,
ONLY TO SHUN THEM? WOULD A SHIITE MUSLIM
HASTEN TO DENY THE EXISTENCE OF ALLAH?
WOULD A CHINESE HERBALIST SHIVER AT BEING
CALLED SUCH A NAME? AND YET, WE ARE PUNKS
AND WE JUMP THROUGH HOOPS TO DENY THE VERY
CULTURE FROM WHICH OUR DAILY LIFE REVOLVES.
WE USE THE WORD AS AN INSULT. WE ARE SO
QUICK TO GIVE AWAY AND AVOID THE THINGS
WHICH WE SHOULD PROTECT AND UPLIFT, GLORIFY
AND EXTOLL. NOW IS THE TIME TO TAKE THEM
BACK!
 "WE HAVE NO FOOD. THE WATER IS SHUT OFF.
THE PLUMBING IS DESTROYED. THE BACKYARD IS
PILED WITH BAGS OF OUR OWN SHIT. WE HAVE NO
HOPE AND NO FUTURE. AS NORMAL MEMBERS OF
SOCIETY, THESE THINGS ARE SIGNS OF FAILURE.
WE MAY AS WELL KILL OURSELVES. BUT AS PUNKS,
THESE THINGS ARE BADGES OF HONOR, THE
SUBJECT OF THE PROUDEST BOASTS. LET US
REMEMBER WHO WE ARE, AND THE FACT THAT
OUR FAILURE AND MISERY IS BUT A TRIBUTE TO OUR
CULTURE, THE LIFESTYLE OF THE TRUE BELIEVER.
 "LOOKING AROUND THIS ROOM, I SEE BROWN
HAIR AND MURRAY'S POMADE. I SEE ROGER
MILLER AND BLONDIE RECORDS. WHERE, PRAY TELL,
ARE THE FLIERS? THE HOMEMADE T-SHIRTS?
THE HAIRSPRAY, STUPID HAIRCUTS, AND UNNATUR-
AL COLORS? ALAS, BUT A FEW. FOR SHAME! WE
ARE FISH OUT OF WATER! WE DO NOT EVEN KNOW
HOW TO HANG OUT ON THE STREETCORNER ANY-
MORE! WE DO NOT DANCE AT THE SHOW. ALL I ASK
IS ONE MONTH DEVOTED TO GETTING BACK INTO
PRACTICE.
 "IN MY HAND, I HOLD A LETTER FROM SOME
PATHETIC, SNIVELING EAST COAST IDIOT ASKING

TO BUY A FEW OF MY RECORDS FOR A HUNDRED
DOLLARS. THANK YOU, LITTLE SUICIDE, FOR ARRANG-
ING THE TRANSACTION. PLEASE TAKE A BOW.
NOW, WITH THIS MONEY I PROPOSE TO ESTABLISH
A SPECIAL PUNK FUND. FOR SPECIAL THINGS ONLY,
NOT ORDINARY DAY-TO-DAY CRISIS. FOR HAIRDYE,
GEAR, GAS MONEY TO OUT-OF-TOWN SHOWS, A PUNK
PICNIC, AND PERHAPS EVEN A PUNK BOAT."
 EVERYONE'S EYES LIT UP. FINALLY THE POSSIBIL-
ITY OF A BOAT WHICH WASN'T JUST FIGURATIVE.

48. Punk Month

 THE PLAN WAS TO BUY GARRET'S BOAT.
GARRET WAS VANESSA'S BROTHER, AND SLUGGO
WAS VANESSA'S BOYFRIEND, AND ALL WAS COOL
AND GOOD FEELINGS WITH THE IN-LAW DISCOUNT
PRICE. UNFORTUNATELY, SLUGGO AND VANESSA
DECIDED TO BREAK UP, ONCE AGAIN. OH MAN, IT
WAS AGAIN AND AGAIN AND AGAIN WITH THEM.
THE DISCOUNT PRICE LEFT WITH VANESSA, AND
WE WERE LANDLOCKED.
 BUT WE WERE TIGHT LIKE NEVER BEFORE.
A DUMB IDEA OR LOSING CAUSE NEVER FAILED
TO BRING US TOGETHER IN FULL FORCE. BOOTS AND
BANDANAS, ANTHEMS AND DAYGLO HAIR, WE WERE
SPILLING OUT OF THE CAR AND ONTO THE STREET IN
EVERY HICKTOWN AROUND, ARMED WITH BIG CUPS
OF BEER AND STACKS OF MAGAZINES TO SELL FOR
MORE BEER MONEY. IT WAS NOTHING NEW:
SNEAKING IN TO THE SHOW, DRINKING IN THE
ALLEY, DRIVING AROUND. BUT WE DID IT WITH
NEWFOUND ENTHUSIASM. THE WDH FAMILY.
A WELL-OILED MACHINE.
 I'D NEVER SEEN A GROUP OF PEOPLE SO EAGER
AND SO DEDICATED. WILLEY TRADED MAGAZINES
FOR PILLS AND THEN SOLD THE PILLS. LITTLE G
TRADED MAGAZINES FOR WEED AND THEN OFFER-
ED TO SMOKE OUT ANYONE WHO BOUGHT A MAG-
AZINE. MAGAZINES WERE SELLING LIKE HOTCAKES.
IN THE ALLEY IN BACK OF THE CLUB I SAW JOEY
SHITHEAD. I WAS AWESTRUCK. FOR A GROUP OF
PEOPLE WITH NO HEROES, PUNKS SURE DO HAVE
A LOT OF GREAT HEROES. SLUGGO ASKED, "WHO
IS JOEY SHITHEAD?" I KICKED HIM.
 THIS WAS THE THIRD ROADTRIP PAID FOR BY
THE PUNK FUND. WE'D HAD AN EXCELLENT PICNIC

TOO, DOWN AT AQUATIC PARK, WITH FOOD FROM
THE EAST FOURTEENTH TACO TRUCK AND BEER
FROM OUR LOVING NEIGHBORS. WILLEY EVEN
MANAGED TO GET ARRESTED. SLUGGO PUT FLIERS
UP ALL OVER TOWN ANNOUNCING THE PICNIC. NOT
BEFORE, BUT AFTER IT WAS OVER, SO EVERYONE
WOULD KNOW THEY HAD MISSED A GOOD THING.
ELITIST, YEAH, BUT EVERYTHING GOOD IN PUNK
HAS ALWAYS BEEN ELITIST. IF YOU DON'T KNOW,
DON'T GO.
 THE NEXT STEP WAS ADDING IT UP, TAKING
IT NATIONWIDE. MOVING TO BAKERSFIELD TO LIVE
ON THE RANCH LITTLE G'S ELUSIVE UNCLE
FRANK OWNED. WE WOULD DRINK BEER AND
FUCK AND FIGHT AND WRITE IN THE DUSTY
TWILIGHT OF THE ORCHARDS, IN THE DRY CENTRAL
VALLEY HEAT WITH ITS MUSTY SMELL OF WALNUTS
AND OLIVES. WE WOULD GET THE BAND GOING FOR
REAL, AND TAKE IT ON TOUR. SETTLE IN A SMALL
TOWN IN THE MIDWEST. GET A LITTLE ARTIST
COLONY GOING. SLUGGO AND I PAINTING
PICTURES OF FIATS AND FANZINES, WILLEY AND
SEAN PAINTING PICTURES OF CONDUITS AND BEER.
JED COULD GET A JOB AS A CHEF, THEODOTIA AS A
SHRINK, AND LITTLE G AS A NUCLEAR PHYSICIST.
THERE WAS NO END OF GOOD IDEAS AND PLANS.
PUNK MONTH HAD ONLY JUST BEGUN. WHEN I
GOT BACK, IT WOULD BE A WHOLE NEW ERA.
 "IT IS JUST LIKE YOU TO CONVINCE US OF
SOME BULLSHIT IDEA", SLUGGO SAID, "AND THEN
LEAVE HALFWAY THROUGH IT".
 HE WAS WRONG, BUT I HAD TO LAUGH. IT
WASN'T MY FAULT I WAS GOING ON A LITTLE TRIP.

part

3

49. New Era

I CUT OFF ALL CONTACT WITH HOME WHILE I WAS AWAY. I ALWAYS DO. I HATE TO HEAR ABOUT THE EVENTS AND CONFLICTS THAT FROM A DISTANCE MAKE EVEN LESS SENSE THAN WHEN YOU'RE STUCK IN THE MIDDLE OF THE MESS. IT MAKES ME JEALOUS HEARING ABOUT THE LIFE THAT GOES ON WITHOUT ME, AND IT DID ESPECIALLY AT DOUBLE DUCE, BECAUSE THEIR LIFE WAS USUALLY MORE EXCITING WHEN I WASN'T AROUND TO PULL IN THE REINS.

THAT'S HOW IT SEEMED, ANYWAY. IF YOU'RE AT A LOUSY PARTY, AT LEAST YOU KNOW IT'S LOUSY. IF YOU SKIP IT, YOU NEVER KNOW WHAT YOU MISSED. THE EXAGGERATED SECOND-HAND STORIES SOUND SO GOOD. HAD I MISSED A GREAT PARTY, A HORRIBLE ONE, OR BOTH? WOULD IT HAVE BEEN BETTER IF I WAS AROUND, OR ONLY WORSE FOR ME?

WHEN THE TRAIN PULLED INTO BERKELEY, I RAN ALL THE WAY TO DUCE WITH MY RAGGED SUITCASE AND CYMBALS. MY PROUD HOMECOMING, ONCE AGAIN. BUT THERE WAS NO ANSWER WHEN I KNOCKED ON THE DOOR. IT WAS LOCKED. WHERE WAS EVERYBODY? THEY WERE SUPPOSED TO BE HOME. I MEAN, LITERALLY, THEY WERE THE SECURITY THAT I COULD LEAVE AND ALWAYS HAVE SOMETHING TO COME BACK TO.

WORRIED AND OUT OF BREATH, I ARRIVED DOWNTOWN AT THE CAFE. LITTLE G WAS THERE, EATING A BURGER AND READING ICEBERG SLIM.

"WHERE IS EVERYONE?", I SAID.

"JED'S OFF SOMEWHERE CHASING GIRLS", HE SAID, "AND JAG'S IN THE BATHROOM COMBING HIS HAIR. HE SHOWED UP RIGHT AFTER YOU LEFT TOWN".

"BUT WHERE IS WILLEY?"

"WILLEY GOT MAD AND MOVED TO NEW YORK".

"WHERE IS SLUGGO?"

"SLUGGO MOVED TO CLEVELAND. HE'S GOT A JOB, MAKING MONEY. WE'RE WORRIED ABOUT HIM".

"WHAT ABOUT THEODOTIA AND SEAN?"

"YOU DON'T WANT TO KNOW".

"HOW COULD EVERYTHING HAVE CHANGED THAT FAST?," I SAID. "IT'S ONLY BEEN TWO AND A HALF MONTHS! WHAT THE HELL HAPPENED WHILE I WAS GONE?"

50. Jag Speaks

"A FRIEND OF MINE WAS SUPPOSED TO HAVE SOME CUSHY RECORD LABEL JOB. HE WAS SUPPOSED TO HAVE ENOUGH MONEY TO BUY SOME SHITTY LITTLE CAR AND KEEP US ALIVE. DRIVE DOWN THE BAJA COAST AND WHEN THE CAR BROKE DOWN WE WERE GONNA BUILD A LITTLE CITY AND SPEND THE WINTER WRITING OUR NOVELS WE'D BEEN WORKING ON FOR A COUPLE YEARS. OF COURSE I GOT OUT TO CALIFORNIA AND HE WAS LIVING IN A TINY ONE-ROOM APARTMENT WITH THE WOMAN HE WAS IN LOVE WITH, AND OF COURSE HAD NO MONEY BECAUSE HE WASN'T WORKING ANYWHERE. I WAS SHIT OUT OF LUCK.

"THE NOVEL? I SAID FUCK IT. I'D BEEN COLLECTING VARIOUS WORK-IN-PROGRESS CHECKS FOR PUBLISHING BITS IN DIFFERENT JOURNALS UNDER THE EXPECTATION THAT I COULD ACTUALLY FINISH THE BOOK RATHER THAN JUST MILK IT FOR ALL THE CHECKS. WHEN I REALIZED THAT WE WEREN'T GOING TO MEXICO AND I PROBABLY WASN'T GOING ANY FURTHER SOUTH THAN SAN JOSE, I JUST SAID FUCK IT. I JUST KIND OF THREW IT OUT. I WENT LOOKING FOR LITTLE G.

"I KNOCKED ON THE DOOR. LITTLE G HOBBLED OVER TO THE DOOR AND SAID, "OH, SO YOU'RE MOVING IN?." BEFORE I HAD A CHANCE TO REPLY ANYTHING, HE SHOVED HANDFULLS OF PILLS AT ME AND ASKED ME TO TAKE THEM WITHOUT TELLING ME WHAT THEY WERE.

"A FRIEND OF MINE HAD TURNED ME INTO A CONSEQUENTIALIST AS FAR AS SOME SORT OF PHILOSOPHICAL OUTLOOK OR MEANS OF NAVIGATING LIFE, AND I THINK IT WAS AT THAT POINT THAT IT ACTUALLY MADE ITSELF MANIFEST IN THE IDEA OF KNOCKING ON A DOOR. JUST THE WHOLE THING WAS THERE. AT THAT POINT, FROM KNOCKING ON THAT DOOR, I REALIZED THAT'S WHERE I WAS AT, AND I COULDN'T REALLY ARGUE WITH THAT AT ALL, THAT'S WHAT I HAD TO DO. SEEING AS THOUGH GRAND SCHEMES AND PLANS HAD GOTTEN ME NOWHERE SPECIFICALLY AT THAT POINT.

"I WAS A FULL BLOWN CONSEQUENTIALIST AND THAT WAS WHERE I SHOULD BE FOR SOME REASON OR ANOTHER, WHICH WAS PROVEN OUT IN A BUNCH OF SITUATIONS WHERE I HAD TO KEEP LITTLE G IN FORM."

51. Jed Speaks

"THINGS CHANGED A LOT AFTER JAG MOVED INTO DUCE. HE ACTUALLY KIND OF BROUGHT IN A NEW ERA WITH HIM. EVERYTHING THAT WAS THERE BEFORE EITHER CHANGED OR ALMOST BECAME COMPLETELY DIFFERENT AND REARRANGED. I DON'T KNOW IF IT WAS EXACTLY JAG MOVING IN THAT CREATED ALL THE GARBAGE AND STUFF. IF IT WAS JUST AN EXTRA PERSON, OR AN EXTRA BODY, OR WHAT, OR ALL OF US CROWDED TOGETHER THAT MADE IT ALL THE MORE PRONE TO RAMPANT DISEASE.

"JAG WAS ALWAYS THERE FOR SOME REASON OR ANOTHER, COMBING HIS HAIR AND, I DON'T KNOW, GETTING ONE PERSON OR ANOTHER OUT OF TROUBLE. IT WOULD BE ME AND JAG AND NEXT THING I KNOW IT'S LIKE JAG LEAVING FOR FIVE MINUTES AND RUNNING BACK TO ME LIKE, OH SHIT, I GOTTA GO SAVE LITTLE G. OR LITTLE G WOULD COME BACK AND BE LIKE, I JUST GOT MUGGED DOWNTOWN. IT TOTALLY TOOK AWAY FROM THE WHOLE CALM OF EVERYTHING. SEEMED KIND OF DISMAL BUT WE HAD TO ALL STAY THERE BECAUSE WE DIDN'T KNOW WHAT ELSE TO DO. WE HAD TO START THINKING ABOUT OUR SURVIVAL AND STUFF. FLOSSING OUR TEETH. DEALING WITH THE IMPENDING DANGER OF ANOTHER FUCKED-UP SITUATION.

"I GOT IN A REALLY GOOD MOOD ONE NIGHT. I DON'T THINK I WAS ACTUALLY DRUNK OR ANYTHING, BUT I'D BEEN DRINKING. LITTLE G AND JAG WERE THERE AND THEY WERE JUMPING ON EACH OTHER, JAG WAS TRYING TO COMB HIS HAIR FOR LIKE AN HOUR, LITTLE G WAS JUMPING ON HIS BACK. I WAS JUST SITTING THERE TRYING TO FIGURE OUT HOW TO RECORD IT SO IT WOULDN'T BE LOST. BUT LIKE ALL THINGS, IT WAS EVENTUALLY LOST. I DON'T EVEN KNOW WHAT I DID, I JUST SAT THERE AND WATCHED IT. TRYING TO REMEMBER IT.

"AFTER A WHILE IT TURNED INTO A TOTALLY, ALMOST, NON-PRODUCTIVE ATMOSPHERE. BUT ONLY HALF THE TIME. I MEAN, THE REST OF THE TIME IT WAS GREAT. YEAH. WHEN JAG FIRST MOVED IN, I KIND OF KNEW HIM I GUESS BUT I HADN'T REALLY GOTTEN A CHANCE TO GET TO KNOW HIM. LITTLE G AND I DIDN'T REALLY FIGHT THAT MUCH, BUT JAG AND I JUST HAD, UH, POLITICAL DIFFERENCES. LIFE AND DEATH. IT DIDN'T COME TO ANY REAL HEADWAY SO WE HAD TO KIND OF GIVE UP.

"I THINK IF WE HAD KEPT THAT UP ANY LONGER, WE ALL WOULD HAVE PROBABLY ENDED UP GETTING KICKED OUT ON THE STREET. WE DID? OH YEAH, WE DID END UP GETTING KICKED OUT ON THE STREET."

52. Willey Speaks

"THEODOTIA WAS STILL LIVING THERE TOO. IT WAS REALLY HARD TO GET HER OUT, IT TOOK ABOUT TWO WEEKS, AND THE WHOLE TIME SHE WAS JUST FUCKING WITH JED. SHE WAS DRIVING EVERYBODY CRAZY.

"LITTLE G DIDN'T WANT TO TELL HER TO LEAVE, JAG DIDN'T WANT TO HAVE ANYTHING TO DO WITH IT. JED WOULDN'T DO IT EITHER, SO I HAD TO DO IT. I SAID, 'THEO, YOU GOTTA GO. YOU'RE FUCKING WITH JED TOO MUCH. CAN'T HAVE THIS. IT'S NOT MY BUSINESS ABOUT YOU TWO'S RELATIONSHIP, BUT THE FACT IS, ONE OF YOU HAS GOTTA GO, AND SO IT SHOULD BE YOU'.

"THE PLACE WAS A MESS. JUST DRINK AND LISTEN TO THE SAME RAP SONG OVER AND OVER, AND LITTLE G WOULD JUST SIT THERE LOOKING INSANE, LOADING AND UNLOADING GUNS ALL DAY. JAG WAS TOTALLY OUT OF HIS MIND, HOPING THAT BOOTLE BEETLES WOULD FIX HIS MIND A LITTLE BIT. BOOTLE BEETLES ARE THIS MEXICAN ALL-PURPOSE DRUG PILL. ASPIRIN, CAFFEINE, A BARBITUATE, AND SOME OTHER WEIRD THING. IT WOULD MAKE YOU SO CONFUSED THAT YOU COULDN'T EVEN SAY A SENTENCE.

"JAG WAS GETTING UP TO WHERE HE WAS TAKING NINE OR TEN OF THEM A DAY. HE'D TAKE MORE AND MORE EVERY DAY TO TRY TO FIX HIS MIND. I GUESS IT ALWAYS FELT LIKE HE WAS ON THE VERGE OF SOME BREAK-THROUGH BECAUSE HE'D JUST START SCREAMING ALL THE TIME. HE'D BE JUMPING ALL OVER THE PLACE TRYING TO SAY SOMETHING. EVERYONE'S JUST, 'SHUT THE FUCK UP, JAG'.

"'NO, THE FUCKING INCONSISTENCIES OF THE HIDEOUS SHIT OF THE FUCKING...'. HE COULDN'T GET ANYTHING ACROSS. NO ONE COULD STAND HIM, SO HE'D JUST HIDE IN THE BATHROOM THE WHOLE DAY, ALL DAY, UNTIL IT WAS TIME TO DISTRIBUTE THE TWO BEERS A NIGHT.

"IT WAS TOO MUCH FOR ME. I COULDN'T TAKE IT. I COULDN'T GET MYSELF TO THINK STAYING THERE WOULD BE A GOOD THING. I COULDN'T CONVINCE MYSELF NO MATTER HOW MUCH I TRIED.

"LITTLE G TOTALLY RAN THAT WHOLE THING, WHO GOT TO EAT AND WHEN. HE WOULD GO OUT AND GET A GIANT BURGER AND BRING BACK A PACKAGE OF RAMEN FOR JED AND JAG TO SPLIT. AND A BIG FAT JOINT. ALL THEY DID WAS DRIVE AROUND AND SMOKE WEED. WEED FOR BREAKFAST, WEED FOR LUNCH, AND TWO CANS OF BEER FOR DINNER. JED WOULD GO OUT TO THE MARINA AND PICK

PLANTS. HE'D BOIL THEM UP AND MAKE SOUP FOR HIM
AND JAG. SOMETIMES THEY COULD PUT A BIT OF RAMEN IN.

"IMMEDIATELY AFTER AARON LEFT, SLUGGO WENT
OUT AND GOT A GLASS COFFEE TABLE AND A COUCH AND A
BUNCH OF SHITTY NEW WAVE RECORDS. AND A FUCKING
RED LIGHT BULB. TURNED AARON'S UPSTAIRS ROOM INTO
DEN OF INCREDIBLE SLEAZE. EVERYONE THAT WOULD COME
OVER, HE'D SAY, 'WANT TO COME UP AND LISTEN TO RECORDS?'.
NO ONE HAD ANY IDEA. I DON'T KNOW HOW THE FUCK IT
WORKED. EVERYONE WOULD COME OVER, 'OH SURE'. I TOOK
THE DOWNSTAIRS ROOM. I COULDN'T BE UP THERE FUCKING
LISTENING TO HIS FUCKING BULLSHIT RECORDS. HE'D PLAY
THEM SO LOUD, AND I'D JUST BE SITTING THERE, JUST,
'FUCKING SLEAZY PIECE OF SHIT'.

"HE'D GO UP THERE AND GET ALL DRUNK, SPILL PISS
BOTTLES, AND IT'D GO RIGHT THROUGH THE FLOOR INTO MY ROOM,
ONTO MY MATTRESS. I ALMOST HIT HIM. I PUSHED HIM UP
AGAINST THE WALL, AND I WAS READY IF HE LIFTED ONE
HAND TO ME. I HATED THAT GUY.

"I DON'T KNOW WHY IT AFFECTED ME SO MUCH, BUT, MAN,
IT WAS BAD. I'D PUT ALL THIS WORK INTO THE PLACE,
GETTING EVERYTHING TURNED ON AND WORKING AGAIN.
WE'D HAVE A LITTLE GOOD THING GOING. IT TURNED INTO
SLUGGO DOING HIS DRUNKEN NEW WAVE SHITHOLE PLACE.
CAR PARTS IN THE KITCHEN AND NEVER TAKING THEM OUT,
SO YOU COULDN'T EVEN WALK AROUND. I DIDN'T WANT TO BE
IN MY ROOM, UNDERNEATH SLUGGO'S ROOM, LISTENING TO
HIS FUCKING NEW WAVE RECORDS.

"NO MORE FIATS IN THE KITCHEN, I TRIED TO TELL SLUGGO.
ONE WEEK AND THEN WE GET THEM OUT. COULDN'T GET THE
FIATS OUT. I GOT SO FRUSTRATED I COULDN'T STAND IT.
IT WAS EVEN WORSE THAN THE JUNKPILE.

"SLUGGO WENT OUT AND BOUGHT SOME LEATHER PANTS
THAT WERE WAY TOO SMALL FOR HIM. HE WOULD WALK
AROUND WITH HIS LEATHER JACKET WITH NO SHIRT ON
UNDERNEATH, AND LEATHER PANTS THAT WERE TOO SMALL
FOR HIM. THEY STARTED HANGING OUT WITH THE GAY
PROSTITUTES WHO ALL HUNG OUT AT THIS ONE SPOT
AT THE MARINA.

"SLUGGO WENT TOTALLY INSANE. JUMPED IN THE
FOUNTAIN AT THE MARINA. HIS PANTS WERE SOME WEIRD
LEATHER SHIT THAT SHRANK EVEN MORE WHEN THEY
GOT WET. THEY DYED HIM BLUE TOO. HE TURNED TOTALLY
BLUE, COULDN'T GET HIS PANTS OFF CUZ THEY HAD SHRANK
TOO MUCH. SO THEY HAD TO CUT OFF HIS PANTS AND HE'D
THROWN AWAY ALL HIS OTHER CLOTHES. HE CUT OFF HIS
PANTS AND RAN AROUND THE HOUSE NAKED. THAT WAS
THE END OF SLUGGO."

53. Sluggo Speaks

"I HAD TO QUIT MY JOB AT THE ART IMPORT RIPOFF
STORE BECAUSE I HURT MY BACK. CARRYING TOO MANY
CHILEAN WALKING STICKS. SO I HAD TO SIT AROUND THE
HOUSE FUCKED UP ON PILLS FOR MONTHS. YEAH, I WAS ON
WORKER'S COMP. GETTING PAID TO SIT AROUND ON PILLS.
IT WAS PRETTY SAD. I HAD A LAWNCHAIR SET UP AND I
JUST SAT IN MY LAWNCHAIR WITH PILLS BY MY SIDE
LOOKING AT THE BROKEN FIATS. I HAD THREE OF THEM
OUTSIDE AND TWO INSIDE AND ONE OF THEM COULDN'T BE
MOVED, JUST A BODY SHELL WITH NO TIRES AND NO ENGINE.

"I WAS JUST INTO LISTENING TO RECORDS. I FIXED UP
MY ROOM REALLY REALLY NICE, CARPETED IT. I DIDN'T
EVEN KNOW WHAT I WANTED TO DO AT ALL. NO DUMB PLAN.
I WASN'T GOING TO SCHOOL, OR WORKING, OR ANYTHING.
I DIDN'T EVEN HAVE A GIRLFRIEND. I THINK I PLAYED
GUITAR A LOT, I WANTED TO PLAY MUSIC BUT NO ONE WAS
INTERESTED.

"WILLEY WOULD COME HOME FROM WORKING FOR LIKE
TEN HOURS FOR ONE DOLLAR AND COMPLAIN ABOUT HOW I
WASN'T A GOOD WORKING MAN ANYMORE. HE'D ACTUALLY BE
GONE SUNRISE UNTIL 1:00 A.M. AND COME BACK WITH HARDLY
ENOUGH MONEY FOR RENT. HE'D SUNK ALL HIS MONEY INTO
THIS CAR RICHARD GAVE HIM. HE WAS GROUCHY, LIKE
USUAL. HIS WORKING MODE, YOU KNOW WHAT I MEAN. HIS
WORKING MAN'S MOOD. I WAS JUST KIND OF WASTING
TIME, BUT ACTUALLY MAKING MORE MONEY ON THE FIAT
PARTS THAN WILLEY GOT FROM HIS SCUMBAG BOSS, OR FROM
DIGGING DITCHES FOR HIS MOM. I TRADED THIS GUY AT THE
FIAT STORE ON SAN PABLO A FIAT ENGINE FOR A GUITAR
AMP, AND I SOLD A COUPLE FIATS TOO.

"THE ONES WE DIDN'T SELL WE, WELL, WE TOOK WILLEY'S
CAR, IT WAS A COP CAR, WITH NO LICENSE PLATES. WE TIED
A ROPE AROUND IT. THE FIAT THAT HAD NO WHEELS, NO
TIRES, NOTHING BASICALLY, WE FILLED IT FULL OF GARBAGE,
PILED SIX FEET HIGH INTO THE AIR. IT WAS A CONVERT-
ABLE, AND WE TIED IT UP TO WILLEY'S CAR WITH A ROPE.
ME AND LITTLE G DID THIS. LITTLE G WAS ALL LOC'ED OUT.

"WE DRAGGED IT WITH WILLEY'S CAR. SPARKS WERE
FLYING, AND IT WAS MAKING THIS AMAZINGLY HORRIBLE
NOISE. IT WAS REALLY, REALLY LOUD. WE DRAGGED IT
AROUND THE CORNER INTO A FIVE-MINUTE ZONE IN FRONT
OF THIS AD AGENCY, THIS REALLY NICE BUILDING. THEN WE
LOOKED BACK AND REALIZED WE'D GOUGED OUT THE CEMENT
ALL THE WAY FROM THE FRONT OF THE HOUSE TO THE CAR.
WE HAD TO GET OUT OF THERE, BUT WE COULDN'T UNTIE

THE ROPE CUZ THE KNOT WAS TOO TIGHT. WE TRIED SAWING
IT WITH OUR KEYS. THEN THE COPS STARTED COMING. WE
COULD SEE THE COPS UP THE STREET. SO WE START
BURNING IT WITH OUR LIGHTERS, BURNING THE ROPE. THE
ROPE'S BURNING, WE HOP IN WILLEY'S CAR, AND WE JUST
TOOK OFF, LOOKING AT THE COPS IN THE REAR-VIEW MIRROR.
AND WE DID IT TWICE, THE SAME THING, THE SAME PLACE,
TWO DIFFERENT CARS. EXCEPT THE NEXT TIME WE DIDN'T
USE A ROPE, WE JUST PUSHED IT THERE THEN WAITED FOR
THE COPS TO COME, AND WHEN THEY DID WE JUST ASKED
THEM, 'WHAT HAPPENED HERE? WHAT'S GOING ON?"

54. Willey Again

"THEY USED TO GROW WEED IN THERE, IN DOUBLE DUCE,
THE PEOPLE BEFORE US. THEY HAD A SECRET LITTLE
ROOM BLOCKED OFF IN THE ATTIC. THE WHOLE TIME WE
LIVED THERE, I'D SEE COPS PARKED ACROSS THE STREET.
I THOUGHT MAYBE THEY WERE JUST TAKING A BREAK.
AFTER A WHILE THEY WERE JUST IN FRONT OF OUR
PLACE, THEY WEREN'T REALLY TAKING A BREAK EITHER.
THEN THERE STARTED BEING MORE OF THEM, WHERE
SOMETIMES THERE'D BE THREE COP CARS DIRECTLY IN
FRONT OF OUR PLACE, STAKING IT OUT I GUESS.
"SO, WE STARTED FUCKING WITH THEM A LITTLE BIT.
LITTLE G WOULD PULL UP IN THIS BIG FANCY CAR, IT
TOTALLY LOOKED LIKE A DRUG DEALER CAR, WITH FOUR
PEOPLE IN IT AND THREE PEOPLE ALREADY OUTSIDE THE
HOUSE. IT LOOKED LIKE A FANCY DRUG DEALER CAR
PULLED UP AND A BUNCH OF PEOPLE GOT OUT AND GOT ALL
BUSY. THEN THE LIGHT WOULD TURN GREEN AND THE
TRAFFIC WOULD GO BY, IN BETWEEN THE COPS AND US.
WHEN IT HAD PASSED, ALL THE PEOPLE WOULD BE GONE
COMPLETELY, AND SO WOULD THE CAR. THE COPS GOT
REALLY PISSED OFF AT THAT ONE.
"THE NEXT NIGHT THERE WAS TEN OF THEM, AND THEY
ALL JUST SWOOPED IN ON US AND STARTED THROWING
EVERYBODY ON THE GROUND. I SAID, YOU CAN'T DO THIS
SHIT, DON'T THROW MY FRIENDS ON THE GROUND IN FRONT
OF MY HOUSE. WE'RE GOING INSIDE. YOU HAVE NO BUSINESS
FUCKING WITH US. SO, THEY PUNCHED ME IN THE FACE
AND TOLD ME TO GET ON THE GROUND, AND I DIDN'T WANT
TO GET ON THE GROUND.
"THE COP HIT ME AGAIN AND TRIED TO THROW ME ON
THE GROUND. JED CAME UP BEHIND HIM AND PUSHED THE
COP OVER ME, SO HE WAS ON THE GROUND, WITH ME ON TOP
OF HIM. HE WAS FREAKING OUT, AND THE OTHER COPS

STARTED FREAKING OUT, THROWING PEOPLE ON THE GROUND.
IT WAS A BIG MESS. HAULED ME AND JED OFF TO JAIL.
"AFTER THAT, I WAS PRETTY WELL DONE WITH THE
PLACE. I DIDN'T WANT TO LIVE THERE ANYMORE. I LEFT,
WENT TO NEW YORK".

55. Sluggo Again

"IF YOU WENT OUT AT ALL, YOU'D COME BACK TO FIND JAG
IN YOUR ROOM WITH ALL YOUR SHIT LYING AROUND. JAG
LIVING IN YOUR BED, AND THE ROOM IS REARRANGED. HE'D
STEAL YOUR MONEY TO BUY FOOD, AND EAT IT ALL BEFORE
YOU GOT HOME. HE ACTUALLY TRIED TO MOVE INTO MY ROOM
WHEN I WAS GONE FOR THREE DAYS. SPILLED BEER ALL
OVER MY BLANKETS. EVEN USED ALL THE CONDOMS. I CAME
HOME AND HE HAD ALL MY GUNS OUT. WE COULD HEAR IT ALL
THE WAY OUT ON THE STREET, JAG SCREAMING. HE WAS LYING
IN THE MIDDLE OF THE FLOOR SCREAMING AND THERE WAS
TWENTY FOUR EMPTY TALL CANS ALL OVER THE HOUSE, AND
THERE'S ALL THESE GUNS AND AMMO EVERYWHERE, AND HE'S
LYING ON TOP OF THE RIFLE SCREAMING TO HIMSELF, AND
HE SAID THE LANDLORD HAD BEEN OVER EARLIER THAT DAY.
I HAD TO CALL THE LANDLORD AND WORK IT OUT CUZ THE
LANDLORD WAS SO FREAKED OUT.
"I JUST GOT REALLY SICK OF EVERYTHING ONE DAY.
I HAD A BAD FEELING. IT WAS EASY TO GET A BAD FEELING
LIVING IN THAT PLACE WITH EVERYBODY. AND EVERYBODY WAS
BROKE AND MAD AND THE LANDLORD'S SON AND THE NEIGH-
BORS KEPT COMING OVER TO YELL AT US. WILLEY WAS MAD
AT EVERYBODY FOR SOMETHING, JAG WAS INSANE, AND
LITTLE G KEPT SHOOTING THINGS. IT GOT TO ME, SO I DECIDED
TO LEAVE. MY MOM WANTED ME TO COME VISIT.
"NO, I HADN'T LOST MY MIND. I LOST MY MIND AFTER I
GOT TO CLEVELAND. I WAS ACTUALLY PRETTY HAPPY EN ROUTE.
IT TOOK A WEEK, WEEK AND A HALF TO GET THERE CUZ I
DROVE A FIAT AND IT BROKE DOWN HALF THE WAY THERE.
IT EXPLODED IN WISCONSIN AND I HAD TO HAVE IT TOWED
THE REST OF THE WAY".

56. Jag Again

"SLUGGO WAS THE ONLY ONE WHO HAD A CONSTANT
STREAM OF CASH OTHER THAN JED'S FIRST OF THE MONTH
BUSINESS, WHICH WAS USUALLY GONE BY THE SECOND
WEEK OF THE MONTH FROM SHELL GAMES ON BUSSES,
ALL-NIGHT KENO BINGES AT COLONIAL DONUTS, AND THAT

SORT OF THING. HE HAD THE GAMBLING BUG. WHEN
SLUGGO LEFT, THAT WAS OUR LAST TIE TO SANITY, OR SOME-
THING THAT RESEMBLED IT. JUST CUZ HE HAD LITTLE
SITUATIONS HE HAD TO FUNCTION IN OUTSIDE THE IMMEDIATE
PROXIMITY OF DOUBLE DUCE AND THE BLOCK SURROUNDING
IT. HE GOT INTO HIS LAST FIAT AND DROVE OFF ONE DAY.
TEN MINUTES LATER LITTLE G AND I WERE REALLY
WONDERING WHY WE HADN'T GOTTEN IN THE CAR WITH HIM.

"THERE WERE NO DAYS. THE NIGHTS WERE ALL SPENT
DRIVING AROUND IN A CLOUD OF SUBSTANCE-INDUCED
MINIMUM AWARENESS OF OUR SITUATION, AND ATTEMPTING
TO DRAG OTHER PEOPLE INTO IT. NOT ONLY FOR OUR HOPE-
FUL AMUSEMENTS, BUT FOR OUR FURTHER DISTANCING
OURSELVES FROM THE SITUATION WE WERE IN. IT SEEMED
TO WORK FAIRLY WELL.

"OH MAN. FUCK. WHEN JED WOULD GET CHECKS. HE'D
HAVE TO HIDE IT FROM LITTLE G, HE'D HIDE HIS MONEY IN
VARIOUS LITTLE NICHES IN DOUBLE DUCE. WHEN JED WAS
GONE LITTLE G AND I WOULD BE DIGGING THROUGH EVERY-
THING LOOKING FOR JED'S LITTLE STASHES OF CASH.
AND THE SAD THING IS, THE MONEY HE DIDN'T LOSE
GAMBLING, HE'D PROBABLY LOSE FROM HIDING IT AND NOT
BEING ABLE TO FIND IT AGAIN. HE FOUND TWO HUNDRED HE
HAD STASHED AWAY MONTHS LATER, BUT HE WAS STILL
COMPLAINING ABOUT THE OTHER SIX HUNDRED OR SO THAT
NEVER DID TURN UP, OF WHICH MAYBE A THIRD OF THAT
LITTLE G AND I HAD FOUND.

"I BROKE MY LEFT FOOT ON THE SECURITY GUARD'S
HEAD AT THAT GREEN DAY SHOW AT KAISER CENTER. SO
TWO THIRDS OF DOUBLE DUCE WAS ON CRUTCHES, AND WE
WERE ABLE TO CONVINCE JED TO CRUTCH AROUND FOR A
DAY HOLDING HIS LEFT FOOT UP TOO. THE LANDLORD WAS
ALWAYS UNCOMFORTABLE WITH US BEING ON CRUTCHES
BECAUSE OF LACK OF INSURANCE LIABILITY, AND
WHATNOT. THE FACT THAT WE WERE ALWAYS FUCKED UP
ALL THE TIME AND FALLING. NOT JUST ON THE STAIRS,
BUT EVERYWHERE ELSE. CRUTCHING AROUND EVERY-
WHERE, AND LITTLE G WOULD PAY ME IN RAMEN TO
DRIVE THE CAR AROUND WHEN HE WAS TOO FUCKED UP.
JED WAS ALWAYS JUMPING OUT OF THE ROLLED DOWN
CAR WINDOW AT THIRTY MILES AN HOUR TRYING TO GET
AWAY FROM WHAT HE WAS AWARE HE WAS GETTING
PULLED INTO.

"WE'D HAVE TO ACTUALLY PHYSICALLY FORCE JED TO
COME ANYWHERE WITH US, HE'D ALWAYS HAVE TO BE
GOING FINDING SOMEONE, EVEN IF THEY WERE LIKE
SIX THOUSAND MILES AWAY AND HE HADN'T SEEN THEM
IN EIGHT YEARS, HE'D STILL GO TRY TO FIND THEM.

'JED, THIS PERSON LIVES IN PORTLAND AND YOU
HAVEN'T SEEN THEM IN SIX YEARS'

'I KNOW, I DON'T CARE, I'M GONNA GO TAKE THE BUS'
'JED, YOU DON'T HAVE ANY MONEY'
'UM, I'M GONNA GO HOME AND LOOK FOR MONEY I HID'
"LITTLE G AND I WOULD LOOK AT EACH OTHER AND
TASTE THE GIANT BURGERS WE'D BEEN EATING FOR
THE LAST COUPLE DAYS.
'JED, YOU CAN'T GET OUT OF THE CAR, WE'RE GOING
THIRTY MILES AN HOUR'
"HE'D TRY TO ROLL DOWN THE WINDOWS, WE'D LOCK
THE WINDOWS. HE'D TRY TO OPEN THE DOOR, I HAD THE
POWER LOCKS ON. HE'D GET ALL FREAKED OUT.
"WE'D HUNT HIM DOWN WHEN HE DISAPPEARED. WE
HAD JED HUNTS ORGANIZED FAIRLY REGULARLY. WE'D
TRAIL BEHIND HIM GOING TWO MILES AN HOUR. WATCH
HIM RUN BACK AND FORTH ACROSS THE STREET AND DO
SOMERSAULTS, AND HE'D WALK IN THE MIDDLE OF THE
STREET ON A HORIZONTAL PLANE WITH THE STREET.
I CAN'T DESCRIBE IT. SIDESTEPPING."

57. Jed Again

"THINGS JUST DIDN'T SEEM TO BE THAT GREAT FOR
SOME REASON. I GUESS LITTLE G DIDN'T WANT TO STAY
MUCH LONGER. WE WERE ALL GOING TO GET A NEW
HOUSE OR SOMETHING.
"IT WAS JUST ME AND LITTLE G SITTING THERE
WONDERING WHAT WE WERE GONNA DO IN A SIX
BEDROOM HOUSE. WITH JAG RUNNING AROUND SCREAM-
ING AND YELLING ABOUT FOOD OR SOMETHING. WE ALL
GATHERED IN THE HALLWAY ONE NIGHT AROUND A CAN
OF BEANS WITH A HAMMER AND SPENT ABOUT TWO
HOURS BREAKING IT OPEN. WE HADN'T EATEN ANYTHING
FOR MAYBE THREE OR FOUR DAYS.
"LITTLE G? YEAH, I GUESS HE DID HAVE MONEY.
I DON'T KNOW WHY WE WERE STARVING, OR WHY WE
DIDN'T HAVE ANY FOOD. I CAN'T REALLY REMEMBER.
WE HAD ONE ROOM WE'D SIT IN ALL THE TIME, TALK
ABOUT HOW MISERABLE WE WERE, BUT THEN AGAIN,
HOW GREAT IT WAS. TALK ABOUT WHAT WE WERE
GONNA HAVE TO DO TO SUCCESSFULLY LIVE TOGETHER.
AS OPPOSED TO, NOT JUST TRYING TO WRITE NOVELS,
OR ANYTHING LIKE THAT, I MEAN, THAT WAS JUST
SOMETHING THAT WAS IMPORTANT I GUESS. THINGS
LIKE GETTING JOBS THAT WE'D NEVER GET. JAG NEVER
GOT A JOB WHILE HE LIVED THERE, AND NEITHER DID I.
AND NEITHER DID LITTLE G.
"WE JUST CHASED EACH OTHER AROUND THROWING
WATER ON EACH OTHER AND LOCKING EACH OTHER OUT

OF THE HOUSE. WE FIGURED WE'D HAVE A COUPLE OF WEEKS BEFORE SLUGGO GOT BACK FROM CLEVELAND AND WILLEY GOT BACK FROM NEW YORK, AND AARON GOT BACK FROM WANDERING AROUND."

58. Return to the Fold

I'D LEFT BERKELEY BECAUSE I NEEDED MY INDEPENDENCE, AND RETURNED BECAUSE I FOUND OUT I NEEDED SOMETHING MORE THAN THAT. I'D CRAWLED BACK INTO TOWN SO LONELY AND WEARY AND ONLY HALF-HUMAN.

IF ONLY IT WASN'T ALWAYS A CHOICE BETWEEN TWO EXTREMES. BEING ALONE AND LOST, OR HAVING TO SURRENDER MYSELF TO THE GROUP. BUT THIS TIME IT WAS AN EASY CHOICE. I'D MISSED THAT COMRADARIE, AND FEELING OF COMMUNITY, SO BAD. THE EASY ACCEPT-ANCE, THE EASY LAUGHTER. EVEN THE CONSTANT CRISIS AND STRESS. IT MADE ME FEEL USEFUL. LITTLE SUICIDE'S LITTLE NORTH KOREA. JAG GEMSTONE AND HIS THREE-RING JONESTOWN. THE MIND CONTROL AND SCARCITY, THE ARMS BUILDUP AND SIEGE MENTALITY. IT FELT BETTER THAN AARON'S LONERS-ONLY LIFE RAFT, WHICH IS WHERE I'D BEEN ALL WINTER.

SLUGGO HAD GONE TO CLEVELAND TO CLEAR HIS HEAD, SAVE UP A TON OF MONEY, AND FIX HIS CAR. WILLEY HOPPED TRAINS TO MINNEAPOLIS FOR SHEN'S WEDDING, THEN TOOK GREYHOUND TO NEW YORK. WE KNEW THEY WOULDN'T LAST LONG EITHER.

AFTER MONTHS OF WORKING AT A CLEVELAND NEWS-PAPER, SLUGGO WAS IN DEBT, AND HIS CAR AND HIS MIND WERE STILL HOPELESSLY BROKEN. WILLEY WAS EXHAUSTED FROM HIS JOB AT THE STRAND BOOKSTORE, HAULING HUGE BOXES OF BOOKS AROUND IN THE FREEZING COLD. EVERYONE WHO COMES TO NEW YORK DOES TIME AS A PROSTITUTE OR AT THE STRAND, SO THEY SAY, AND THE DIFFERENCE IS NEGLIGIBLE.

ONE DAY WILLEY GOT A CALL. IT WAS JED AND LITTLE G, SAYING COME ON HOME. HE SAID, OKAY, SOUNDS GOOD. I'LL BE THERE IN TWO WEEKS. SLUGGO CAME BACK A MONTH LATER TO FIND THAT HIS WELCOME HOME PARTY HAD ALREADY BEEN GOING FOR THREE DAYS, AND ERIC YEE WAS ALREADY IN JAIL AS A RESULT.

EVERYONE WAS RETURNING TO THE FOLD. BESIDES THEODOTIA AND SEAN, THAT IS. NEITHER WAS PARTIC-ULARLY WELCOME. THEY HAD CROSSED THE LINE. TOO DRUGGED OUT AND INSANE EVEN FOR US. THEODOTIA WAS TOTALLY OUT OF THE PICTURE. SEAN STILL STOPPED

BY, BUT HE HAD HIS OWN PLACE NOW, AND KEPT A HEALTHY DISTANCE.

LITTLE G SAID OUR TIME AWAY FROM EACH OTHER HAD BEEN "A SEASON TO LET THE CROPS FALLOW". TRULY, THE SEPARATION HAD BEEN A NECESSARY ONE. A CHANCE FOR EVERYONE TO PURSUE THEIR OWN SELF-INDULGENT PLANS WITHOUT THE CHECKS AND BALANCES, THE ARGUMENTS AND ACCIDENTS OF THE REST OF THE GROUP. WILLEY'S WORKMAN IDEAL, SLVGGO'S ESCAPE FANTASY, LITTLE SUICIDE'S DEATHWISH, JAG'S CONSEQUEN-TIALISM, MY LONER ROMANTICISM, AND JED'S OBSESSIVE CHASE. EVERYONE'S DREAMS SOUNDED GREAT WHEN HELD UP AS MORAL HIGH GROUND AGAINST THE REST OF THE GROUP, BUT ALONE THEY WERE JUST LONELY AND DUMB PLANS. WE NEEDED EACH OTHER.

MAYBE WDH WERE ALWAYS GOING TO BE MY ROOM-MATES AND TRUE FRIENDS THE SAME WAY THAT BERKELEY WAS ALWAYS GOING TO BE MY CITY. IT WASN'T A MATTER OF LIKING OR HATING EITHER ONE. THAT DIDN'T MATTER. I WAS PART OF THEM. EVEN IF WE DIDN'T ALWAYS SHARE THE SAME GOALS, WE SHARED THE SAME LIFE. WE FIT TOGETHER, LIKE LOVERS PAST THE NERVOUS AND AWKWARD STAGE. WE WORE EACH OTHER DOWN, BUT ALSO NOURISHED EACH OTHER. BEING AWAY FROM WDH AND BERKELEY, I HAD SOME PEACE OF MIND, BUT NO SOUL.

I HAD IT ALL FIGURED OUT. I WAS LOGIC AND A SENSE OF PURPOSE. WILLEY WAS HONOR AND STUBBORN RESOLVE. JED WAS RAW ENERGY, IMPULSIVENESS, AND SPONTANEITY. JAG WAS ATTRITION, CONFUSION, AND STRESS. SLUGGO WAS THE WIND, CHANGING WITH THE WEATHER. LITTLE G WAS LOVE AND LOVE OF LIFE, WHICH INCLUDED SELF-DESTRUCTION AND LOVE OF DEATH. ALONE, OR IN THE WRONG COMBINATIONS, WE WERE AT BEST USELESS AND BORING. AT WORST, WALKING TIMEBOMBS.

59. Malaise

"MALAISE" WAS SLUGGO'S OLD FANZINE. THE WRITING WAS SO HONEST IT ALMOST MADE YOU EMBARRASSED. NOT HONEST LIKE REVEALING TERRIBLE SECRETS AND PSYCHOTIC EMOTIONS, BUT LIKE REVEALING SIMPLE HOPES AND UNSWERVING FAITH IN HUMANITY. ISSUE SIX WAS SLUGGO'S TOUR DE FORCE. A WHOLE YEAR OF WRITING AND PASTING AND CUTTING AND SAVING UP MONEY FOR THE PRINTER. WORKING AT THE SHOP BY DAY AND AT HIS

SQUAT BY NIGHT WHILE THE PIGEONS AND PEACOCKS
STARED, THE CRACKHEADS STOLE HIS BIKE, AND SAL
TWISTED THE SCREWS ON HIS BROKEN BRAIN. A
HUNDRED PAGES OF SWEAT AND BLOOD, A THOUSAND
DOLLARS FOR PRINTING, AND SIX BILLION PEOPLE IN THE
WORLD, ALL OF WHOM COMPLETELY IGNORED OR
REJECTED SLUGGO'S MASTERPIECE WHEN IT DID
FINALLY HIT THE STANDS.

STUCK WITH BOXES AND BOXES OF HIS OWN UNABASHED
AND UNANSWERED LOVE LETTER TO AMERICA, SLUGGO
GREW BITTER. HENCE, MALAISE NUMBER SEVEN: EIGHT
THIN PAGES OF DISILLUSIONMENT WITH AMERICA, AND
GENERAL REGRET. HE HADN'T DONE AN ISSUE SINCE.

SLUGGO HAD LEFT TO CLEVELAND WARNING EVERY-
ONE NOT TO TOUCH THE BOXES OF MALAISE. TEN BOXES
FULL OF THE DREADED ISSUE NUMBER SIX, THEY WERE
HIS BED IF NOTHING ELSE. JAG LATER CLAIMED THAT
IT WAS JED'S IDEA TO START SELLING THEM ON THE
STREET. THAT SEEMS UNLIKELY, BUT REGARDLESS, JAG
WAS THE ONE WHO TURNED STREET SELLING INTO A
STEADY, PROFITABLE BUSINESS. HE SUBCONTRACTED ALL
THE CRUSTIES ON TELEGRAPH, GOT THEM SELLING
MALAISE FOR A SMALL CUT OF THE PROFITS. THEY GOT TO
KEEP TWENTY FIVE CENTS OF THE TWO DOLLAR COVER
PRICE IF THEY SOLD FIVE, FIFTY CENTS IF THEY SOLD TEN.
THE REST WENT TO THEIR PIMP, JAG.

JAG, JED, AND LITTLE G WERE AMAZING SALESMEN.
THEY COULD CONVINCE ANYONE OF ANYTHING. WITH
NO EXPENSES TO COVER, THEY WERE ROLLING IN PROFITS,
SUPPORTING THEMSELVES ENTIRELY FROM MALAISE
SALES. SLUGGO WAS FURIOUS WHEN HE RETURNED TO
FIND THAT HIS BED WAS GONE, BUT HE WAS ALSO
AMAZED. THEY HAD MANAGED TO SELL EIGHT HUNDRED
COPIES OF A YEAR-OLD FANZINE WHICH SLUGGO COULDN'T
GET RID OF WHEN IT WAS NEW.

THEY HAD SOLD OFF ALL BUT TWO BOXES. THOSE WERE
PACKED IN THE CHAMP, LITTLE G'S CAR, ANTICIPATING
EVICTION. JAG, JED, AND LITTLE G WERE SO OBSESSED
WITH EVICTION AND HIDING FROM THE LANDLORD THAT
THEY IGNORED THE FACT THAT THE HOUSE HADN'T
ACTUALLY BEEN EVICTED YET. THEY HAD ALSO IGNORED
ALL THE PARKING TICKETS ON THE CHAMP, AND WHEN
THE CAR GOT TOWED, THERE WAS NO WAY TO RETRIEVE
ALL THE STUFF WHICH WAS PACKED IN IT. WILLEY'S NAME
WAS ON THE REGISTRATION, AND AT THE TIME, WILLEY
WAS STILL IN NEW YORK. WHEN THE CAR GOT COMPACTED,
SO DID EVERYONE'S PERSONAL POSSESSIONS. LITTLE G'S
STEREOS AND SEAN'S FISHING POLES. JED'S BACKPACK
AND WILLEY'S BRICK COLLECTION. SLUGGO'S FANZINES,

AND EVEN HIS FANG RECORD. EVERY POSSIBILITY OF
DISTRACTION OR SALVATION OR INCOME. ALL GONE.
NOW WE ALL CAME BACK TO A HOUSE EMPTY OF
EVERYTHING BUT THE GARBAGE AND JED'S BROKEN
SPEAKERS. RATHER THAN DEPRESS US, IT HAD A
CLEANSING EFFECT. WITH THE BURDEN OF HIS OLD
FANZINES GONE, SLUGGO EVEN STARTED FRESH, PUTTING
OUT AN UNEXPECTED AND INSPIRED ISSUE NUMBER
EIGHT, AND WE ALL WENT OUT ON THE STREET AND TO
THE SHOWS, TRADING MALAISE FOR BEER. IT WAS
PUNK MONTH AGAIN, RIGHT WHERE IT LEFT OFF, AS IF
EVERYTHING IN BETWEEN HAD NEVER HAPPENED.
JUST LIKE EVERY OTHER MORNING AFTER, THOSE
GUYS WERE TIGHT AND SHARP, FORGETTING AND FORGIV-
ING, WHILE I WAS STILL NURSING A HANGOVER.

60. Pets

WITH ALL THE CHANGES AT DOUBLE DUCE, THE
HOUSEPETS TOO ENDED UP WITH LESS THAN PERFECT
ACCOMODATIONS. BABUS WAS THE LUCKY ONE. SHE
MOVED IN WITH VANESSA WHEN SLUGGO LEFT TO
CLEVELAND. LITTLE G'S MOUSE AND WILLEY'S FISH
WERE NOT SO FORTUNATE.
FUNERAL SERVICES FOR THE MOUSE WERE HELD
OUTSIDE UNCLE EMIL'S CRABSHACK, THE DARK AND
CREEPY TEN-SEAT RESTAURANT ON OUR CORNER. IT WAS
THE ONLY PLACE IN THE NEIGHBORHOOD TO GET COFFEE
AFTER THE LAME CAFE TOLD US THAT "TEN CENT
TUESDAYS" WAS ACTUALLY ON MONDAY, THEN ON
WEDNESDAY, THEN ONLY ONCE A MONTH, AND FINALLY
JUST TOLD US TO GET THE HELL OUT OR THEY WOULD CALL
THE COPS. PLUS, OLD EMIL LET US SMOKE IN THERE WHEN
NO ONE ELSE WAS AROUND.
EVERYONE MADE SPEECHES, THEN POURED BEER
OVER THE GRAVE. EVEN SEAN, NOT USUALLY ONE TO GET
EMOTIONAL OR PART WITH A SIP OF HIS BEER, POURED
OUT HALF A BOTTLE. THEN EVERYONE HAD A MOMENT OF
SILENCE FOR ALVIN LEE, OUR OLD LANDLORD AT THE
JUNKPILE. HE HAD DIED TOO.
WHEN WILLEY LEFT TO NEW YORK, HE LEFT HIS FISH
IN THE CARE OF JADINE AND JODY. HE GOT BACK AND
SAID, HOW ARE YOU? HOW'S MY FISH? THEY WENT,
OH SHIT, WE FORGOT ALL ABOUT THAT GUY. WE JUST
PUT HIM IN THE CLOSET WHEN YOU GAVE IT TO US. WILLEY
WENT IN THE CLOSET AND IT WAS JUST SOUP.
POOR BABUS. SHE OUTLIVED THE REST, BUT NOT WITH

ALL HER FACULTIES INTACT. ONE DAY BABUS WAS ALL
ITCHY AND SCRATCHY, SO SLUGGO WENT OUT, BOUGHT FLEA
SPRAY, AND SOAKED HER WITH IT. FIVE MINUTES LATER
BABUS WAS THROBBING IN THE CORNER WITH FOAM
JUST POURING OUT OF HER MOUTH.

WILLEY SAID, "OH SHIT, WHAT'S WRONG WITH BABUS?"

SLUGGO SAID, "WHO KNOWS? SHE'LL PROBABLY GET
OVER IT. BABUS HAS ALWAYS BEEN A WEIRD CAT,
MAYBE SHE'S JUST FREAKING OUT RIGHT NOW."

WILLEY LOOKED AT THE FLEA SPRAY. IT WAS THE
REALLY STRONG STUFF. THE KIND MADE TO SPRAY ON
YOUR RUG, NOT YOUR CAT. POOR BABUS. EVER SINCE THAT
DAY, SHE HADN'T BEEN THE SAME. ONLY HALF A CAT.
SHE WALKED AROUND THE HOUSE FALLING OVER. DROP
HER AND SHE WOULD LAND ON HER BACK. WHENEVER
SLUGGO STARTED TO TALK ABOUT HAVING KIDS WITH VAN-
ESSA, I ONLY HAD TO POINT AT BABUS TO PROVE MY POINT.

61. Dream Theory in West Berkeley

I READ A REPORT WHICH CLAIMED THAT ANALYZ-
ING AND LEARNING FROM YOUR DREAMS WAS THE KEY
TO A HEALTHY, PEACEFUL SOCIETY. IF A PERSON
CHALLENGES OR ATTACKS YOU IN A DREAM, GIVE THAT
PERSON A PRESENT THE NEXT DAY, AND CONSIDER THEM
A SPECIAL FRIEND. DISCUSS ALL DREAMS WITH YOUR
FAMILY AT THE BREAKFAST TABLE. ALTHOUGH THE
REPORT WAS ABOUT MALAYA IN 1933, IT SOUNDED
SUSPICIOUSLY LIKE PRESENT-DAY EUGENE.

I IMAGINED LONG, WASTED DAYS BUYING PRESENTS
AND THEN TRYING TO TRACK DOWN THE VARIOUS
MOTHERFUCKERS WHO HAD PULLED KNIVES ON ME IN MY
SLEEP. HOW WOULD A UTOPIAN SOCIETY GROW OUT OF
MY DREAMS OF ENDLESSLY SEARCHING FOR SIZE
FIFTEEN SHOES, ONLY TO FIND SIZE SIXTEEN, OR OF A
TELEPHONE THAT ALWAYS RANG BUT COULD NEVER
BE ANSWERED? MY DREAMS WERE ANALOGIES, NOT
ANSWERS, FOR MY PROBLEMS.

THE DREAMS WERE SCRAWLED ALL AROUND MY
BED, CRAWLING UP THE WALL, ALL CRISS-CROSSED AND
COVERING EACH OTHER UP. I WROTE THEM DOWN
THINKING THEY WERE PROFOUND, THEN LOOKED AT
THEM LATER AND ALL THEY WERE WAS INDECIPHER-
ABLE. IT WAS THE SAME AS EVERYTHING I WROTE
DOWN. YOU WRITE NOT TO REMEMBER, BUT TO FORGET.
THOMAS WOLFE SAID THAT.

WE HAD A WHOLE HUGE HOUSE, EVERYONE HAD
THEIR OWN ROOM, BUT WE WOKE UP THE SAME AS
ALWAYS, NEXT TO EACH OTHER, CUDDLED UP IN A ROW.

LITTLE G BEGAN TELLING US HIS DREAM. IT WAS SOME
CRAZY, IMPOSSIBLE STORY, BUT I JUST LAUGHED. I
COULD IMAGINE GETTING CHASED BY A GANG OF
SHRINERS IN THOSE LITTLE CARS, BUT NOT HITCH HIKING
UP TO OREGON WITH UTRILLO AND KYLE, AND THAT HAD
REALLY HAPPENED TO US ONCE. NONE OF OUR DREAMS
WERE AS SCARY, TRIUMPHANT, OR RIDICULOUS AS WHAT
HAD HAPPENED IN REAL LIFE. THE TIME ME, JED, AND
LITTLE G WERE ESCORTED OVER THE SAMOA BRIDGE BY
A GIANT LADYBUG, A GILA MONSTER, AND TWO HIGHWAY
PATROL CARS, OR THE TIME JED AND WILLEY WERE
STUCK FOUR DAYS IN THE BERKELEY JAIL WITH ALL
THE INMATES CHANTING "FREE WILLEY".

LYING THERE TRADING OUR DREAMS, LAUGHING AT
THEM, WE WERE SHARING EACH OTHER'S HOPES, AND
AFTER ALL THAT'S WHAT OUR LIFE TOGETHER WAS ALL
ABOUT. BUT WE WERE ALSO LAUGHING AT EACH OTHER'S
FEARS, AND I LIKED THAT. MAYBE BETTER TO LAUGH AT
THE IRRATIONAL FEARS THAN TO TRY TO EXPLAIN AND
PROVE THEM ALL THE TIME. WHAT WOULD IT BE LIKE
IF WE COULD REALLY TRADE THEM, BE STUCK IN EACH
OTHER'S DREAMS? I WOULD BE AMAZED AND CONFUSED
BY THEIR WEIRD CAST OF IRRATIONAL FEARS, NOT
KNOWING I WAS SUPPOSED TO BE SCARED, AND THEY
WOULD PROBABLY HAPPILY HANG OUT AND DRIVE
AROUND WITH MINE. SIZE SIXTEEN SHOES WOULD JUST
BE A FUNNY THING FOR THEM TO FIND ON THE STREET,
NOT AN IRONIC SYMBOL OF NOT BEING ABLE TO GET
WHAT YOU NEED.

WILLEY TOLD HIS DREAM, A RECURRING ONE
ABOUT FLYING OVER THE ROCKIES, FROM ONE SIDE TO
THE OTHER, AND FINDING ALL HIS FRIENDS ON THE
OTHER SIDE. THERE THEY WERE, ALL TOGETHER. CHECK
THIS OUT, HE SAID, WE CAN FLY. I'LL SHOW YOU HOW.
JUST GO LIKE THIS. THEN HE TOOK OFF TO FLY, BUT
ENDED UP ALONE, STUCK IN A VENTILATION SHAFT.

I SAID IT REMINDED ME OF THE TIME WE WERE
ON THE U.C. THEATRE ROOF AND HE FELL OFF, INTO A
ROSEBUSH. WE DIDN'T NOTICE AND HE COULDN'T MOVE
OR SAY ANYTHING, LEST HE UPSET THE VICIOUS DOG WHO
WAS WAITING, DROOLING, DIRECTLY UNDERNEATH HIM.
AT WORST THE DOG WOULD EAT HIM ALIVE AND AT
BEST THE DOG WOULD START BARKING AND GET US ALL
ARRESTED.

WILLEY SAID IT REMINDED HIM OF THAT TOO,
ALTHOUGH ACTUALLY IT WAS ACROPOLIS AND NOT HE
WHO HAD FALLEN INTO THE ROSEBUSH. I LAUGHED AT
MY MEMORY, HOW IT DISTORTS OVER THE YEARS AND
THE DREAMS GET MIXED UP WITH REALITY. WILLEY

WASN'T EVEN THERE, BUT HAD HEARD ABOUT IT SO
OFTEN HE FELT LIKE HE WAS.
 I NEED TO LEARN TO LIVE, HE SAID.
 LEARN TO SOAR, I SAID.
 IT WAS TRUE, AND WE DIDN'T EVEN HAVE TO
LAUGH AND PRETEND TO BE EMBARRASSED.

62. Monterey

 SEAN WAS GOING TO BUY WILLEY'S CAR, AND WILLEY
WAS ON THE WAY TO MEET HIM, BUT JUST HAD TO DO
ONE THING FIRST. TAKE THE INCLINE AT AQUATIC
PARK GOING A HUNDRED MILES AN HOUR TO SEE IF HE
COULD GET ALL FOUR WHEELS OFF THE GROUND.
 WELL, ALL FOUR WHEELS MADE IT OFF THE GROUND,
FOR WHAT SEEMED LIKE AN HOUR, AND DIDN'T REALLY
COME BACK DOWN IN THE RIGHT ORDER. WILLEY HAD
TO WALK THE REST OF THE WAY TO SEAN'S NEW HOUSE,
AND WE HAD TO TOW ANOTHER WRECKED CAR TO THE
"NO DUMPING" ZONE BY THE RAILROAD TRACKS.
 ACROPOLIS AND I WALKED DOWN TO SPENGER'S FOR
A MIDNIGHT RENDEZVOUZ. WILLEY AND SEAN SHOWED UP
IN A NEW CAR, ONE THEY HAD JUST TRADED FOR SOME
ELECTRICAL WORK. WE HAD PLANNED ON GETTING
COFFEE SOMEWHERE, BUT THE REGULAR SPOTS WERE
GETTING SORT OF OLD, AND NOW THERE WAS A NEW
CAR WHICH NEEDED BREAKING IN. I SUGGESTED
ALAMEDA, OR EVEN DAVIS, BUT I KNEW THEY WOULDN'T
GO FOR IT.
 WILLEY AND SEAN SAID, "ALAMEDA? DAVIS?? HOW
ABOUT TIJUANA? L.A.? PHOENIX?"
 NONE OF THOSE PLACES SOUNDED GOOD FOR COFFEE,
AND I DIDN'T KNOW IF I COULD WAIT THAT LONG. WE
SETTLED ON MONTEREY, AND BEGAN OUR SLOW DESCENT
DOWN.
 PACIFIC GROVE WAS JUST AS BEAUTIFUL AND DREAM-
LIKE AS I REMEMBERED. I SLIPPED INTO A MEMORY
WHILE WALKING ALONG THE WATERFRONT, PAST THE
ROCK SCULPTURES AND DIFFERENT COLORS OF ICEPLANT.
WILLEY, SEAN, AND ACROPOLIS TRAILED BEHIND, THROW-
ING THINGS AT ME. ONE LONE SURFER WAS OUT ON
THE WAVES, AND BESIDES THAT THE BEACH WAS EMPTY.
 WE'D HAD A LONG NIGHT TRYING TO LOCATE AND
MURDER THE ANNOYING DISC JOCKEY FOR THE
SALINAS RADIO STATION. TRYING TO STAY AWAKE
DRINKING SOUR COFFEE AT BOB'S BIG BOY, WAITING FOR
OUR 6:00 A.M. BEER. NOW WE WERE AT THAT PERFECT

DELIRIOUS STATE, HALF WONDER AND HALF CONSCIOUS,
WITH THE SUN JUST STARTING TO CREEP OVER THE
HORIZON TO SHINE LIGHT ON OUR WEARY, GIDDY BROTHERHOOD.

TIME AND WATER, THE TWO GREAT EQUALIZERS.
SLOWLY BUT SURELY, UNAPOLOGETICALLY, WASHING
AWAY THE OLD AND GIVING NOURISHMENT FOR THE
NEW. ONCE FISH WALKED OUT OF THE OCEAN, AND IN ALL
THE YEARS SINCE, WE HAD ONLY MADE IT ABOUT
TEN FEET. NOW WE STOOD ON TWO LEGS AND CHASED
AFTER THE SWARMS OF TINY RAT-LIKE BIRDS WHO
ALSO RAN ALONG AFTER THE TIDE.

63. Based on a True Story

JED HAD BEEN WORKING ON HIS NOVEL FOR YEARS.
SOME SORT OF POST-APOCALYPTIC VISION STARRING A
FLEA NAMED IRVING. JED TOLD US THE PLOT AND
MADE REFERENCES TO THE MAIN CHARACTERS AS IF
THEY WERE OLD FRIENDS. WE COULD HEAR HIM IN HIS
ROOM, FURIOUSLY TYPING DAY AND NIGHT. BUT NONE
OF US HAD SEEN ANY TRACE OF THE NOVEL ITSELF,
AND HAD BEGUN TO DOUBT IT EXISTED OUTSIDE
JED'S BRAIN.

THEN, ONE DAY, HE SHOWED UP WITH COPIES OF THE
MANUSCRIPT. A HUNDRED AND TWENTY PAGES OF TINY,
TYPED PRINT. IT WAS REALLY GOOD, IF A LITTLE
OVERWHELMING.

"I'M ONLY A THIRD OF THE WAY DONE", JED SAID.

I AGREED. FIRST WRITING, THEN EDITING, THEN
PUBLISHING.

HE SAID, "NO, I MEAN, THAT'S ONLY THE INTRODUCTION.
I HAVEN'T STARTED ON THE STORY YET". THEN HE
WENT BACK INTO HIS ROOM TO START TAPPING AWAY
AGAIN.

JAG WAS A WRITER TOO. AT LEAST HE SAID HE
ONCE WAS. HE TALKED OF NOVELS HE'D WRITTEN,
OFFERS FROM PUBLISHERS AND WORK-IN-PROGRESS
CHECKS. WE DISMISSED HIS WRITING CAREER AS
ANOTHER SEMI-INCOHERENT JAGOFF RANT, JUST LIKE
HIS REFERENCES TO OSTRICH FARMS AND CHINESE
HERBALISTS. HE HAD ALL KINDS OF RIDICULOUS LIES
WHICH HAD BECOME STANDING JOKES AMONG THE
REST OF US.

ONLY MUCH, MUCH LATER DID WE START TO PIECE
THE DIFFERENT FRAGMENTS TOGETHER, ALONG WITH
REPORTS FROM HIS OLD FRIENDS, AND REALIZE THAT
ALL JAG'S STORIES WERE ACTUALLY TRUE. BASICALLY

TRUE, AT LEAST. HE REALLY HAD BEEN SENT, BY COURT
ORDER, TO LIVE ON AN OSTRICH FARM. HE REALLY HAD
BEEN RAISED BY BIKERS AND CHINESE HERBALISTS.
IT'S SAFE TO ASSUME JAG REALLY WAS A WRITER TOO,
BUT WHILE HE LIVED WITH US, NO ONE SAW HIM WRITE
DOWN A SINGLE WORD. NOT EVEN PHONE MESSAGES OR
APOLOGY NOTES WHEN HE ATE EVERY BIT OF OUR FOOD.

IT WAS ALWAYS DIFFICULT TO UNDERSTAND JED
AND JAG. WHERE THEY HAD BEEN, WHY THEY WERE
FREAKED OUT, WHAT THE HELL THEY WERE TALKING
ABOUT. NOT BECAUSE IT WAS THAT COMPLICATED, BUT
BECAUSE THEY PURPOSELY OBSCURED THE POINT.
WHENEVER POSSIBLE, JAG WOULD USE A BIG WORD
THAT NO ONE KNEW, OR PERHAPS ONE HE MADE UP,
RATHER THAN ONE WE WOULD UNDERSTAND. HE
MUMBLED STEADILY FOR HOURS, PUNCTUATED THE
MUMBLING WITH GROANS AND LOUD CURSES, AND
WOULD STOP SUDDENLY IF WE GOT CLOSE TO UNDER-
STANDING HIS POINT, SCREAMING, "FUCK! NO! AAAAUGH!
I CAN'T EXPLAIN! IT'S TOO MUCH!"

JED AND JAG WERE SIMILAR IN THAT THEY BOTH
LEFT OUT THE MAIN POINT OF THEIR STORIES AND
EXAGGERATED EVERYTHING ELSE RIDICULOUSLY. IT
WAS A LONG PROCESS TRYING TO PICK OUT THE POINT
AND RESCUE THE FACTS FROM THE CLUTCHES OF
DRAMATIC RECREATION. YOU HAD TO BE CAREFUL NOT
TO TAKE THEIR EXAGGERATIONS AT FACE VALUE
BECAUSE AGREEING WITH THEIR PARANOID DELUSIONS
AUTOMATICALLY TURNED THEIR FICTIONS INTO FACT.

SAY YOU STUB YOUR TOE. FOR A SPLIT SECOND, YOU
THINK IT'S BROKEN. IT MAY AS WELL BE BROKEN,
IT HURTS SO BAD. SAY JAG AND JED RUN OUT INTO
ONCOMING TRAFFIC AND ARE ALMOST HIT BY A CAR
WITH AN "END AFFIRMATIVE ACTION" BUMPER STICKER.
SINCE DEATH WOULD FEEL THE SAME WHETHER
ACCIDENTAL OR INTENTIONAL, THE CAR MAY AS WELL
HAVE BEEN TRYING TO KILL THEM. NAZIS DIDN'T
SUPPORT AFFIRMATIVE ACTION, SO THE DRIVER MAY AS
WELL BE A NAZI. INSTEAD OF CALMING DOWN AND
THINKING OUT A SITUATION, THEY SEIZE UPON THE
INITIAL PANIC AND ENLARGE UPON IT. REWRITE THE
SCENARIO AS TO BETTER FIT THEIR REACTION.

IF JAG'S TOES FEEL BROKEN, THEY ARE INDEED
BROKEN, AND MAYBE JED'S LEGS TOO. WHAT ELSE
BESIDES A FATAL DISEASE WOULD CAUSE THEM TO BE
IN SO MUCH PAIN? THEREFORE, JAG AND JED COME
HOME TO REPORT THAT THEY ARE DYING, BUT NOT IF
THE NAZIS MANAGE TO KILL THEM FIRST.

64. Missing Persons Bureau

IT'S EASY TO LOSE PEOPLE IN THE CRISSCROSSINGS OF TRAVEL AND TIME. CIRCUMSTANCES CHANGE, LIFESTYLES TOO, AND SOMETIMES EVEN NAMES. BUT I KEEP IN TOUCH, AND KEEP GOOD TABS. I ALSO KEEP THE SAME P.O. BOX. ALONG WITH LETTERS FROM MY OWN LONG LOST FRIENDS, I SOMETIMES GET LETTERS FROM STRANGERS LOOKING FOR FRIENDS THEY HAVE LOST. LIKE THIS ONE:

"YEARS AGO, IN HUMBOLDT COUNTY, I RENTED A CONVERTED CHICKEN SHACK, IN AN AREA SETTLED NINETY YEARS AGO BY DUTCH PEOPLE. THE NEARBY TOWN WAS MYER'S FLAT AND THE ROAD WAS CALLED DYERVILLE LOOP. IN THE MORNINGS THE FOG WOULD FILL THE VALLEY. THIS IS WHERE I MET DAN THE UNSILIENT AND HIS BROTHER DRONLIM.

"THEY WERE MY NEIGHBORS THERE AND A WELCOME REFRESHMENT FROM THE OFTEN TOO PREDICTABLE REDNECKS AND HIPPIES IN THE NEIGHBORHOOD. AT NIGHT DRONLIM'S AUTISTICLIKE DRUM SOLOS WOULD FILL THE CANYON ON OCCASION. DAN WAS ALWAYS STUDYING SOMETHING. THE LAND-LORDS DID NOT LIKE THEIR MOTHER, FOR REASONS I COULD NEVER FIGURE OUT. EVENTUALLY THEY WERE SORT OF EVICTED.

"AFTER THE EVICTED DAN, DRONLIM AND THEIR HIPPIE MOTHER LEFT, THE ENTIRE NEIGHBORHOOD WENT TO HELL, BECOMING A LIFELESS HILL OF CABIN AND TRAILER DWELLING SATELLITE T.V. WATCHERS. I SOON LEFT THE AREA FOR GOOD. DRONLIM SENT ME A ZINE HE PUT TOGETHER TWO YEARS AGO, BUT I WAS OUT OF THE COUNTRY AT THE TIME AND WAS NOT ABLE TO REPLY UNTIL HE HAD OBVIOUSLY MOVED FROM HIS EUREKA ADDRESS. DAN THE UNSILIENT USED TO BE IN EUGENE, AND WE HUNG OUT IN S.F. FOUR OR FIVE YEARS AGO WHEN HE WAS IN TOWN.

"IT WOULD BE GOOD TO KNOW THEY ARE DOING ALRIGHT, AND BETTER YET TO READ OR SEE SOME OF THEIR ART AND WRITING. PLEASE LET ME KNOW IF YOU KNOW WHERE EITHER OF THEM CAN BE CONTACTED.

"REGARDS, DE LA NORTE"

DRONLIM? YES, I'D SEEN HIM AROUND. HE WOULDN'T BE HARD TO FIND, SINCE WE LIVED IN THE SAME ATTIC. HEY JED, LETTER FOR YOU.

65. Temescal

JED WAS IN THE KITCHEN COOKING. COMBINING FLOUR, OLD COFFEE GROUNDS, CORN FLAKES, AND MEXICAN FRUIT DRINKS. BEETS, PEANUT SAUCE, RAMEN, AND PEPPERMINT SCHNAPPS. WHATEVER FOOD WAS LEFT IN THE HOUSE, HE WOULD PUT IT ALL IN A COFFEE CAN AND BOIL IT FOR HOURS UNTIL IT TURNED INTO A THICK PASTE. YOU SHOULD OPEN UP A RESTAURANT FOR PREGNANT WOMEN, I SAID. NO, IT'S GOOD, JED SAID. HE TOOK TWO BITES THEN LEFT THE REST OUT TO MOLD.

A HERD OF COCKROACHES STAMPEDED PAST ME, FOLLOWED BY A SWARM OF BEERFLIES, FOLLOWED BY LITTLE G SWINGING FLYSWATTERS AND LIGHTING EVERY-THING ON FIRE WITH AEROSOL CANS. I MADE MY WAY TO THE BACKYARD TO PISS, CAREFULLY STEPPING OVER PILES OF DRAIN UNCLOGGER WHICH LITTLE G HAD MANAGED TO GET EVERYWHERE BUT IN THE TOILET. IT HAD MELTED MOST OF THE CARPET, AND OUR SHOES.

SLUGGO WAS BACK TOGETHER WITH VANESSA AGAIN, AND OFF AT HER HOUSE. WILLEY WAS AT WORK, AT HIS NEW JOB DELIVERING PARTS FOR THE AUTO SUPPLY WAREHOUSE DOWN THE STREET. JAG WAS HIDING IN HIS ROOM, AS USUAL. I COULD HEAR HIM GROANING. CURLED UP AROUND HIS SOLE POSSESSION AND TRUE LOVE, THE SPACE HEATER. HE JUST LAY THERE ALL DAY WITH HIS FACE AN INCH AWAY FROM THE HEATER, SKIN TURNING ALL RED AND EYES BOILING OVER.

IT SEEMED LIKE EVERYBODY NEEDED A CHANGE OF SCENERY AND A LITTLE FRESH AIR. THE FOUR OF US HOPPED INTO LITTLE G'S NEW CAR. I SAID, "PULL OVER THERE", AND JUMPED OUT FOR A MINUTE, RETURNING WITH A FIVE-POUND BAG OF ORANGES. I GAVE DIRECTIONS, HEADING UP TOWARDS THE OAKLAND HILLS.

WALKING ALONG THE DIRT PATH, THEY LOOKED TERRIBLY UNCOMFORTABLE AND OUT OF PLACE. BUT THE SUN SHONE DOWN AND A COUPLE TURTLES PASSED BY, AND EVERYONE SLOWLY BUT SURELY STARTED TO LIGHTEN UP. LITTLE G STRIPPED DOWN AND JUMPED INTO THE WATER WHILE ME AND JED PLAYED CRUTCH BALL WITH THE ORANGES. JAG STAYED IN THE SHADE, IMMOBILE, GLOWERING. BUT YOU COULD TELL HE WAS RELAXING TOO, AGAINST HIS BETTER JUDGEMENT.

"HEY JAG", I SAID. "IT'S SPRING AGAIN".

HE SAID, "I KNOW. THESE ARE SO FRESH YOU CAN TASTE THE TREE".

66. This is Your Life

THE FRESH LIGHT OF SPRINGTIME BROUGHT OUT THE FLOWERS, THE BRIGHT COLORS, AND THE BEAUTIFUL GIRLS IN SLEEVELESS SHIRTS. NOT FAR BEHIND CAME MY CONFIDENCE, MY OPTIMISM, AND MY OWN SLEEVELESS SHIRTS. HYPNOTIZED BY THE SOUND OF TRAFFIC ROLLING IN LIKE THE TIDE, MY WALK UP UNIVERSITY AVENUE FELT JUST AS COMFORTING AND TRANQUIL AS A WALK ALONG THE WATERFRONT.

EVERYONE ON THE STREET WAS ALL SHINY, LIKE THEY'D JUST FINISHED HAVING SEX. PRANCING AND PROWLING INSTEAD OF THE USUAL AMBLE AND SHUFFLE. SAYING HELLO INSTEAD OF FUCK YOU, OR SPARE SOME CHANGE. WHO KNOWS WHERE THOSE KINDS OF MOODS AND THOSE KIND OF DAYS COME FROM, OR WHERE THEY GO.

THE COOK AT "FOOD TO GO" GAVE ME A BIG SMILE. AN OLD FRIEND, EVEN IF WE HAD NEVER SPOKEN. HE WAS THE DONUT SHOP GUY BACK WHEN WILLEY AND I WERE THE WATERTOWER GUYS LIVING IN THE DONUT SHOP PARKING LOT. IT WAS THE SAME BIG SMILE I'D BEEN GETTING ALL OVER TOWN, ONE THAT SEEMED TO REFER TO YEARS OF CHANGES AND STRUGGLES. IT SAID, WE HAVE MADE IT THROUGH TO A BETTER AND EASIER TIME. IF NOT BETTER OR EASIER, AT LEAST WE HAVE MADE IT THROUGH, AND IT'S GOOD TO SEE YOU, AND THAT'S WORTH SOMETHING. IT SAID, HOLD YOUR HEAD UP, CUZ THIS IS YOUR LIFE, WHETHER OR NOT YOU CHOOSE TO ACCEPT IT. FOR BETTER OR FOR WORSE. IN ALBANY OR IN BERKELEY.

EVERYONE HAD ALREADY POLISHED OFF TWO OR THREE LIME GIMLETS BY THE TIME I ARRIVED AT THE HOUSE OF ACROPOLIS FOR THE BIG SLIDE SHOW. THE MOOD WAS FESTIVE. TRULY, THIS WAS THE HOME I HAD MISSED WHEN I WAS AWAY.

WE SHOWED SLIDES OUT THE WINDOW, WITH THE HUGE WHITE BUILDING ACROSS THE STREET AS OUR SCREEN. ALL SORTS OF SLIDES WE HAD TAKEN OR FOUND. FIFTY FOOT PEOPLE OUTSIDE THIRTY FOOT HOUSES APPEARED WHERE NONE HAD PREVIOUSLY. STREET SCENES, COUNTRY BANDS, AND FOREIGN LANDS ALL CAME ALIVE, WITH PASSERBY ON THE STREET UNWITTINGLY JOINING THE PICTURE. JUST ONE MORE WAY OF PROJECTING OUR OWN IMAGE ONTO THE CITY.

67. How Berkeley Can You Be?

WHEN I CALLED THE LIBRARY INFO LINE TO GET DETAILS ABOUT THE PARADE, THEY LAUGHED AT ME. THEY SAID, "OH, THAT'S FUNNY. WHERE'D YOU READ THAT, IN THE EXPRESS?"

AS A MATTER OF FACT, I HAD READ ABOUT IT IN THE EXPRESS. DUH. I ALWAYS TAKE THINGS TOO LITERALLY. OH, A JOKE. I GET IT NOW. A "HOW BERKELEY CAN YOU BE" PARADE. THAT WAS FUNNY.

I PUT IT BEHIND ME, WITH ALL THE OTHER JOKES I HAD BECOME PART OF, AND FORGOT ABOUT IT. BUT THEN THE POSTERS STARTED APPEARING. IT MIGHT HAVE BEEN A BAD JOKE, BUT IT WAS GOING TO BE A REAL PARADE.

WAKING UP AT 10:00 ON A SUNDAY MORNING FOR PERHAPS THE FIRST TIME SINCE THE DAY I WAS BORN, I MADE MY WAY DOWNTOWN. BERKELEY HAD HOSTED RIOTS, MARCHES, AND CRITICAL MASS RIDES, EVEN HARE KRISHNAS ON ELEPHANTS, BUT NEVER AN OFFICIAL PARADE THAT I COULD REMEMBER. I DIDN'T WANT TO MISS IT.

A "HOW BERKELEY CAN YOU BE?" PARADE ON A SUNDAY MORNING, THAT WAS CERTAINLY A PARADOX. THE FOUR BLOCKS OF DOWNTOWN LOOKED EVEN MORE DEAD THAN USUAL. ONLY A FEW HUNDRED SCATTERED ONLOOKERS, ABOUT THE SAME NUMBER AS PANHAND-LERS ON ANY REGULAR DAY.

THE "FRIENDS OF THE LIBRARY" MARCHED BY DRESSED AS BANNED BOOKS. SMALL CHILDREN PASSED DRESSED UP AS INSECTS, LABELED "FBI", "CIA", AND "B OF A". EVERYONE HAD SMUG SMIRKS INSTEAD OF SMILES. THAT WAS PRETTY BERKELEY. TO CELEBRATE OUR MULTICULTURALISM, THEY HAD BORROWED THE BLACK COWBOYS FROM OAKLAND. THAT WAS VERY, VERY BERKELEY.

MOSTLY THOUGH, THE PARADE WASN'T ABOUT BERKELEY AT ALL. IT WAS ABOUT CELEBRATING WACKYNESS INSTEAD OF HONORING REAL DIVERSITY. FRISBEE-CATCHING DOGS AND LAWNCHAIR FOLDERS FROM PIEDMONT, HOW BERKEL-EY WAS THAT? BOYDE WON THE SLOW BIKE RIDING CONTEST, AND I HAD TO ADMIT THAT WAS PRETTY COOL, BUT WOULDN'T A SLOW SHOPPING CART RACE BETWEEN CAN COLLECTORS HAVE BEEN MORE APPROPRIATE? A RACE BETWEEN THE UNIVERSITY AND KEN SARACHAN TO SEE WHO COULD DEVELOP ON THE LAST VACANT LOT? A CONTEST TO FIND A PUBLIC SPACE NOT NAMED AFTER

MARTIN LUTHER KING, OR TO SEE WHAT MAGAZINE
WOULD GET YOU KICKED OUT FASTER FROM BETTY'S
OCEAN VIEW DINER?

I ARRIVED BACK AT HOME DISAPPOINTED BY THE
OFFICIAL PARADE BUT JUST IN TIME TO SEE OUR OWN
PARADE IN ITS SLOW, STEADY PROGRESS. MY ROOMMATES
WERE JUST STARTING TO WAKE UP. TWO KIDS OF SHRINKS,
TWO OF TEACHERS. FOUR DROPOUTS WHO WERE LOSING
THEIR MINDS. HOW BERKELEY CAN YOU BE? ESPECIALLY
ONCE YOU ADDED IN JAG'S MOM ON THE HOG FARM AND
JED'S MOM SELLING COOKIES ON TELEGRAPH.

SLUGGO CRAWLED OUT OF HIS ROOM CARRYING A
CANDLE. EXPLORING ALTERNATIVES TO TRADITIONAL
FOSSIL FUELS. JED USED THE PEDESTRIAN OVERPASS
OVER OUR OWN "LIVING" SOUNDWALL OF NATIVE PLANTS,
A MOLDY BARRIER OR "GREEN BELT" SEPARATING THE
BATHTUB FROM THE BATHROOM SINK. LITTLE G SAT
SMOKING IN THE REMAINS OF ONE OF SLUGGO'S "ART CARS,"
HANDICAPPED ACCESSIBLE AND BUILT ENTIRELY OUT OF
BROKEN PARTS. WILLEY WAS OUT IN THE BACKYARD
RECYCLING LAST NIGHT'S DINNER.

THERE WAS A KNOCK ON THE DOOR, AND WE ALL HID.
I LOOKED OUT THE GUN TURRET AND THERE STOOD
NORBERT WITH HIS BEARD AND BIG BAG OF MOLDY
BAGELS. BERKELEY'S VERSION OF THE EASTER BUNNY.

AH, HOME. WHERE ELSE DO HARE KRISHNA SWAMIS
GET ARRESTED FOR DRIVE-BY SHOOTINGS IN STOLEN
CARS? WHERE ELSE DOES THE UNABOMBER COME WHEN
IT'S TIME TO GET A PASSPORT? WHERE ELSE CAN YOU
GET CALLED A "BALD WHITE SNAKE" BY ELDRIDGE
CLEAVER JUST BECAUSE YOU CAN'T SPARE A QUARTER?
THAT'S RIGHT, ONLY IN BERKELEY, MY FRIENDS. HOW
BERKELEY CAN YOU BE?

JAG WAS "ON A JAG" AGAIN. HE GROANED AND SWORE
FROM HIS ROOM, SOMEWHERE UNDERNEATH THE PILES
OF BROKEN BIKES AND BROKEN AMPS, USED CONDOMS AND
USED AMMO. "FUCKING BROKEN BIKES, AAUGH! FUCKING
BROKE ASS BULLSHIT! LANDLORD! NO CIGARETTES! NO
MORE CRYPTIC MYSTIC BOTTOM DWELLER DEMAGOGUES!
HOW BERKELEY FUCK YOU! FUCK!!"

POOR JAG, HE JUST DIDN'T UNDERSTAND. AN
IGNORANT PRODUCT OF THE MIDWEST FARM BELT.
I SMILED DOWN ON HIM BENIGNLY. THAT WAS THE
GREAT THING ABOUT BERKELEY. EVERYONE HAD A RIGHT
TO THEIR OWN OPINION, AND TO HAVE THAT OPINION
IGNORED OR PATRONIZED AS DUE PROCESS ALLOWED.

WE ALL GRINNED AT EACH OTHER AS WE TIPTOED
THROUGH THE WRECKAGE. OUR OWN LITTLE PERFECT
SOCIETY, A MICROCOSM OF THE CITY OUTSIDE, AND
SIMILARLY IN COMPLETE DENIAL OF THE REST OF

THE WORLD. EVERYTHING WAS GOING SO WELL, AND
EVERYONE WAS SO UNDERSTANDING. WE WERE
PROGRESSING, OR AT LEAST LEARNING FROM OUR
MISTAKES, WHICH WE LIKED TO CALL "GOOD IDEAS"
SO AS NOT TO GIVE THEM A NEGATIVE CONNOTATION.

MORAL PURITY AND SELF-DECEPTION, THE PERFECT
BERKELEY COUPLE. WHAT OTHER CITY WITH NOT ONE
BUT TWO REACTORS WOULD HAVE THE VISION, OR THE
GALL, TO DECLARE ITSELF A "NUCLEAR FREE ZONE"?
YOU COULD SAY THAT WE IN BERKELEY FLAUNT OUR
CONTRADICTIONS, OR YOU COULD JUST CALL US HYPOCRITES.
BOTH ARE TRUE.

68. Letter of Recommendation

I WAS WARMING BACK UP TO SLUGGO. IT WAS
JUST LIKE WILLEY SAID. SLUGGO WAS SO DAMN LIKEABLE
WHEN HE WAS LIKEABLE THAT YOU FORGOT WHY YOU
COULD HAVE EVER HATED THE POOR GUY. HE WAS SO
HONEST AND QUIET AND SIMPLE, AND WHEN YOU WERE
WITH HIM YOU FELT LIKE HE WAS WITH YOU ONE
HUNDRED PERCENT. ANYWAY, SLUGGO HAD TURNED HIS
LIFE AROUND THIS TIME, FOR REAL. NO WDH TATTOO
FOR HIM, NO CRACK FOR BREAKFAST. HE WASN'T A
SCUMBAG LIKE THE REST OF US. HE WAS AN ART STUDENT.

TO WHOM IT MAY CONCERN:
I WOULD LIKE TO CONGRATULATE YOU FOR
WELCOMING SLUGGO BLACKHEAD TO YOUR SCHOOL.
I HAVE HAD THE PLEASURE OF KNOWING SLUGGO
AND THE HONOR OF GAINING AN UNDERSTANDING
OF HIS INNER DRIVE AND SOLID MORAL FIBER. I
HAVE BEEN TOUCHED BY SLUGGO'S HUMOR AND
COMPASSION; IMPRESSED BY HIS VAST ARTISTIC
ABILITIES AND INTERESTS; INSPIRED BY HIS
DETERMINATION TO EXPRESS HIMSELF CREATIVELY
AND LEND A HELPING HAND TO OTHERS IN THEIR
CREATIVE ENDEAVORS. I KNOW THAT HE WILL
BE A HARDWORKING, PRODUCTIVE STUDENT, AN
INSPIRATION TO HIS CLASSMATES AND
TEACHERS ALIKE.

AARON COMETBUS
SLUGGO'S FRIEND AND COWORKER

AFTER SLUGGO'S FIRST DAY OF SCHOOL, I WENT TO
MEET HIM FOR DINNER. A LITTLE CELEBRATION. I
WAITED ON THE CORNER OF EUCLID AND HEARST.
AND WAITED, AND WAITED, AND WAITED.

SLUGGO CAME HOME THE NEXT DAY, AND BOY WAS
HE PISSED. HE SAID, "WHY DID YOU FLAKE ON ME?"
 "I WAITED THERE FOR AN HOUR", I SAID, "AND YOU
NEVER SHOWED UP. YOU'RE THE ONE THAT FLAKED".
 "IT'S YOUR FAULT FOR NOT WAITING", HE SAID.
"I WAS THERE, JUST AN HOUR AND A HALF LATE. WHY
DIDN'T YOU JUST WAIT INSTEAD OF FLAKING ON ME?"
 SLUGGO CHIDED ME FOR NOT KNOWING HIM BETTER.
"WHEN HAVE I EVER FLAKED ON YOU?", HE ASKED.
"NAME ONE TIME. I HAVE NEVER, EVER FLAKED.
I'M NOT LIKE THAT".
 I KICKED MYSELF FOR BEING SO QUICK TO JUDGE
AND DISMISS, AS USUAL. HOW UNTHINKING OF ME.
REALLY. IN ALL OF THE TIME WE'D BEEN FRIENDS,
SLUGGO HAD NEVER FLAKED ON ME, NOT EVEN ONCE.
I HAD NEVER REALIZED THAT BEFORE.
 I APOLOGIZED. SLUGGO WAS RIGHT.
 ACTUALLY HE WAS WRONG, BUT IT TOOK MONTHS TO
REALIZE IT. HE HAD FLAKED ON ME AS MANY TIMES
AS THERE ARE STARS IN THE SKY. BUT THAT WAS HOW
IT WAS WITH SLUGGO. HE ALWAYS BELIEVED IN WHAT
HE SAID SO COMPLETELY, IT WAS ALMOST IMPOSSIBLE NOT
TO BE CONVINCED. HIS OWN AMNESIA WAS CONTAGIOUS.

69. WDH

 WE HAD STARTED THE BAND IN THE FALL. AT FIRST
IT WAS JUST SLUGGO AND I WRITING SONGS AND
PRACTICING THEM ACOUSTIC UP IN THE ATTIC. IT WAS
FRUSTRATING, BECAUSE SLUGGO FORGOT SONGS EVEN
FASTER THAN HE FORGOT HIS PERSONALITY. WITHIN A
FEW WEEKS WE HAD WORKED OUR WAY DOWN FROM
FOUR SONGS TO ONE. BUT, IT WAS A GOOD ONE.
 I BANGED ON PANS AND BITS AND PIECES OF DRUMS,
MOSTLY MARCHING DRUMS, IN THE CORNER OF THE
KITCHEN. SLUGGO, WILLEY, AND LITTLE G WERE A MESS
OF CORDS AND AMPS OF ALL SHAPES AND SIZES, ALL
SHORTING OUT AND BLOWING UP. IT WOULD HAVE BEEN
EXCESSIVE TO HAVE THREE GUITARISTS, IF NOT FOR
THE FACT THAT WITH BROKEN EQUIPMENT AND ALL
THREE WANDERING IN AND OUT OF REHEARSAL TO
GET CIGARETTES, ANSWER THEIR PAGERS, OR GO OFF
TO THEIR ROOM TO BROOD, THERE WAS USUALLY ONLY
ONE AUDIBLE GUITAR. AND JED, HE WAS SCRUNCHED UP
ON TOP OF THE FRIDGE RAPPING AND WILDLY GESTICULAT-
ING. HE WAS OFTEN SCRUNCHED UP THERE ON HIS
PERCH BABBLING ABOUT SOMETHING, SO IT SEEMED

NATURAL TO MAKE HIM THE SINGER. WE DIDN'T HAVE
A MICROPHONE, SO WE JUST PUT LOTS OF GAPS IN THE
SONG, TO CATCH A BIT OF WHAT JED WAS YELLING ABOUT.

THERE WERE TWO OR THREE REHEARSALS, AND
THEN CAME THE UPROAR. THE WAR OF INDEPENDENCE.
THE SEPARATION OF CHURCH AND STATE. THE WINTER
OF OUR DISCONTENT. NOW, IN THE RELATIVE CALM
AFTER THE STORM, WE WERE ALL COMING BACK
TOGETHER, AND DECIDED TO REALLY GET THE BAND
TOGETHER TOO. EVERYONE WENT OUT AND BOUGHT,
TRADED, OR STOLE REAL EQUIPMENT. THE CLUB WHICH
HAD KICKED US ALL OUT DECIDED TO LET US REHEARSE
THERE DURING THE WEEK. IT WAS WEIRD. JAG EVEN
WENT OUT AND GOT A BASS. HE LURKED OVER IT LIKE
A SPIDER WRAPPING A FLY.

REHEARSALS WERE AS CLOSE TO HOUSE MEETINGS AS
WE GOT IN THAT HOUSE. ALL THE MISUNDERSTANDINGS
AND COMMUNICATION PROBLEMS GOT TRANSLATED INTO
MUSICAL TERMS.

"JUST PLAY IT LIKE THIS", SLUGGO WOULD SAY.

EACH PERSON WOULD RESPOND WITH A DIFFERENT
WRONG NOTE.

"NO! NO! LIKE THIS!", SLUGGO WOULD SCREAM.

EVERYONE WOULD SCREAM BACK, "YOU JUST TOLD US
TO PLAY IT LIKE THIS! I WAS RIGHT BEFORE!"

WE WOULD YELL AT EACH OTHER, BUT THEN WE
WOULD SUDDENLY START YELLING TOGETHER, THE WAY
WE ALL SNORED TOGETHER AT HOME. YELLING ABOUT
OUR FRUSTRATIONS AND PROBLEMS AND HOPES, AND
ABOUT OUR NEIGHBORS, BACKED UP BY A WARM WAVE
OF GUITARS, A STEADY THROBBING BASS, AND POUNDING
DRUMS. RECLAIMING MUSIC IN ITS PUREST, MOST VITAL
FORM, AND MAKING IT OUR OWN.

OUR WAIL OF SUFFERING, OUR TALES OF GLORY,
OUR TICKET TO REDEMPTION. IT WAS NO SMALL THING.
THIS WAS THE FIRST BAND FOR EVERYONE EXCEPT
ME AND JED AND YOU COULD SEE THE PURE JOY OF
CREATION, AND THE SENSE OF FULFILLMENT AND
ACCOMPLISHMENT IT BROUGHT. BESIDES, THIS WAS THE
FIRST TIME ONE OF OUR PLANS HAD AMOUNTED TO
ANYTHING. WE WERE PROUD.

NORMAL BANDS PLAY FOR YEARS, THEN END UP
LIVING OR TRAVELING TOGETHER. THEY START WITH
MUSIC, THEN MOVE ON TO GETTING A NAME, COVERING
THE TOWN IN GRAFFITI, TRAVELING TOGETHER,
GETTING MATCHING TATTOOS, TRASHING EVERY PLACE
THEY STAY, OVERDOSING, HATING EACH OTHER, AND
BREAKING UP.

WDH TOOK THE OPPOSITE APPROACH. WE STARTED
AT THE END AND DID IT ALL BACKWARDS.

70. DTRT

DIG DITCHES ALL DAY LONG
FIVE CENTS PAY, BOSSMAN IS MOM

DO THE RIGHT THING, DO THE RIGHT THING

GO TO COURT, GO TO JAIL
LOANED JAMES MY MONEY FOR BAIL

DO THE RIGHT THING, DO THE RIGHT THING

GOTTA DO THE RIGHT THING, GOTTA GO TO THE BAR
GOTTA RENT BROKEN HOUSES, GOTTA BUY BROKEN CARS
GOTTA GO TO MONTANA WHERE I BELONG
BUT FIRST I GOTTA GET DRUNK AND I GOTTA FIGHT SEAN

GUNS IN BED, GUNS IN FRIDGE
WEST BERKELEY IS RUBY RIDGE

DO THE RIGHT THING, DO THE RIGHT THING

HATE MYSELF, HATE MY FRIENDS
PLAY FIRST CLASH ALBUM AGAIN

DO THE RIGHT THING, DO THE RIGHT THING
DO THE RIGHT THING!

71. Streetselling

SLUGGO HAD A NEW ISSUE, AND SO DID JED.
COPIES OF BOTH CAME OUT OF THE MACHINES AND
RIGHT OUT THE BACK DOOR AT SLUGGO'S NEW JOB,
THE ONE COPY PLACE IN BERKELEY NEITHER OF US
HAD WORKED. NOWADAYS I PAID TO HAVE MY MAGA-
ZINE PRINTED OFFSET, BUT STILL, I DONATED AN
EQUAL AMOUNT TO THE CAUSE. WE WERE ABLE TO
KEEP THE HOUSE STOCKED WITH FOOD FROM MAGAZINE
AND TAPE SALES ALONE, AND THAT CUT DOWN ON
BICKERING, IN THEORY AT LEAST.
JED WOULD GO OUT ON SELLING BINGES FOR
TWELVE HOURS AT A TIME, ARMED WITH A BAG OF
WDH TAPES AND A STACK OF FANZINES. EVEN WHEN
HE LEFT AT 3:00 A.M. ON A SUNDAY, HE WOULD RETURN
EMPTY HANDED. SOMEWHERE OUT THERE, THE LATE-
NIGHT WORLD OF TAXI DRIVERS AND PROSTITUTES WAS
LISTENING TO WDH AND READING OUR WRITING.
WDH DID A COUPLE SHOWS, BUT FOR ME THE

SHOWS WERE THE LEAST EXCITING PART OF PLAYING
MUSIC TOGETHER. WHAT WAS THE POINT? TRYING TO
WIN OVER A SKEPTICAL CROWD, TRYING TO IGNITE
THEM AND INVITE THEM TO REVEL IN THE RUIN OF OUR
LIVES, WHILE THEY JUST STOOD AND STARED BLANKLY.
ONE MORE BAND. ONE MORE GROUP STRUGGLING TO
BAND TOGETHER AND TURN OUR LIVES INTO A SONG.
REALIZING THE CROWD WAS RIGHT MADE ME APPREC-
IATE BANDS MORE THAN I HAD IN YEARS, BUT STILL,
THE SHOWS WERE MY LEAST FAVORITE PART. WE MADE
A POINT NOT TO SELL OUR TAPE AT THE SHOWS. YOU
COULD ONLY BUY IT FROM JED, ON THE STREET OR
ON BART.

MEANWHILE, I SOLD OFF MORE RECORDS AND SET
UP A SECOND PUNK FUND. THIS TIME WILLEY WAS
GOING TO BUY A BOAT, AND WE WERE GOING TO SPEND
SUNDAYS CRUISING DOWN THE ESTUARY, ONE BIG
FLOATING WDH PICNIC. THE PUNK FUND WOULD PAY
FOR LIFE JACKETS.

WE SPENT HOURS ARGUING WITH WILLEY ABOUT
CHRISTENING AND SPRAYPAINTING THE BOAT, AND
WHETHER OR NOT THAT WAS THE HONORABLE, RIGHT
THING TO DO, BUT OF COURSE WE NEVER DID END UP
GETTING A BOAT. THE PUNK FUND WENT TO MATCHING
YELLOW RAIN SUITS FOR WDH AND OUR WHOLE
EXTENDED FAMILY. JED, LITTLE G, AND I WERE
WEARING THEM WHEN, SICK OF WAITING, WE
RENTED A ROWBOAT AT LAKE MERRITT, ACCIDENTALLY
TIPPED IT, AND HAD TO BE RESCUED AND FISHED OUT
FROM AMONG THE GARBAGE AND DISEASE.

72. Giant Burger

"GET YOUR MOD GARBAGE ASS OUT OF THE
BATHROOM AND IN THE CAR ALREADY. DON'T YOU
THINK YOUR HAIR IS COMBED ENOUGH BY NOW?"

"WILL YOU FUCKING HOLD ON JUST A GODDAMN
MINUTE? GOD DAMN CULTURAL PHILISTINES! FUCK-
ING INTANGIBLE MISERIED SHITBAGS!"

"AARON, WHAT ARE YOU DOING UP THERE,
MAKING A LIST OF YOUR PISSBOTTLES? COME ON,
WE GOTTA GO!"

"WAIT, WAIT, I'M COMING TOO. JUST LET ME
FINISH CHANGING"

"CHANGING? WHAT ARE YOU CHANGING INTO
THIS TIME, SLUGGO?"

"SHUT UP, YOU FUCKING HICK. AT LEAST I
CAN READ."

"FINE, I'M LEAVING. I TOLD YOU GUYS I WAS GONNA GO, I GUESS I'LL JUST GO BY MYSELF".

"DO YOU HAVE ENOUGH GAS TO GET THERE THIS TIME? SERIOUSLY, LITTLE G, WE DON'T WANT TO HAVE TO PUSH THE CAR AGAIN".

"I JUST FILLED IT UP TWO HOURS AND ELEVEN MINUTES AGO".

"YEAH, I HAVE TO WORK IN THE MORNING. I CAN'T GET STRANDED ALL NIGHT IN ONE OF YOUR BULLSHIT SCHEMES THIS TIME".

"LOOK, I TOLD YOU, I JUST FILLED IT UP. DO YOU WANT TO GO OR NOT?"

"JED, COULD YOU SIT DOWN IN THE FUCKING SEAT? JUST SIT DOWN LIKE A NORMAL PERSON. JUST PRETEND, FOR ONCE".

"DO YOU THINK IT WOULD BE ALRIGHT TO EAT SPRAYPAINT? DO YOU THINK IF I WAS A FLEA, THEY WOULD LET ME HAVE A DRIVER'S LICENSE? DO YOU THINK, UM, YOU COULD STOP AT THIS LIGHT? I JUST REMEMBERED SOMETHING I HAVE TO DO".

"GODDAMN IT. WHAT THE FUCK. I THINK WE'RE OUT OF GAS. GET OUT AND PUSH WHILE I STEER".

part

4

73. Broken Speakers

THE TIGHTER WDH BECAME, THE MORE JUDGEMENTAL AND UNFRIENDLY EVERYONE WAS TO OUTSIDERS. EVEN JED BEGAN TO BAD MOUTH PEOPLE HE BARELY KNEW. LITTLE G WAS OUR ONLY BRIDGE, OUR ONLY STEADY CONNECTION TO THE REST OF HUMANITY. EVERYWHERE WE WENT, LITTLE G ESTABLISHED RAPPORT.

WHEN RACIST ASSHOLES SHOWED UP AT THE EAST FOURTEENTH TACO TRUCK, LITTLE G LET THE LOCALS BORROW HIS CRUTCHES. ALWAYS THOUGHTFUL AND GENEROUS, THAT'S THE KIND OF GUY HE WAS. WHEN THE LOCALS HAD FINISHED CHASING DOWN THE RACISTS AND BEATING THEIR BRAINS IN, THEY WIPED THE BLOOD OFF THE CRUTCHES AND THANKED LITTLE G PROFUSELY. AS SEAN WOULD SAY, "YOU GOTTA HAVE THE RIGHT TOOL FOR THE JOB".

THE DOCTORS HAD GIVEN HIM A LEG MACHINE, A BATTERY-OPERATED THING WHICH BENT HIS LEG BACK AND FORTH, AND HE LAY IN BED CURSING AND SMOKING WHILE THE MACHINE FOLDED HIM UP INTO A LITTLE PRETZEL. THERE WAS NO HOPE IN IT, HE SAID. WHY DON'T THEY JUST AMPUTATE THE LEG AND LET ME LIVE IN PEACE?

JAG, LITTLE G, AND I DROVE TO THE CITY FOR A SHOW ON SKID ROW, BUT STILL COULDN'T FIND IT AFTER A HALF HOUR OF CRUISING. WHEN THE FRUSTRATION REACHED A CRESCENDO, THEY SUNG A LITTLE DOUBLE DUCE DUET.

"AUUUUGH!" JAG SCREECHED.

"FINE! FINE! FINE!" LITTLE G YELLED. HE PULLED THE CAR UP ON A CURB AND HOPPED OUT. TALL AND GANGLY JAG GOT ALL BUG-EYED AND STRETCHED HIS ARMS OUT LIKE A FUCKING PTERODACTYL, LIKE THE WAY YOU'RE SUPPOSED TO SCARE OFF BEARS. LITTLE G FLAPPED HIS CRUTCHES UP AND DOWN LIKE EXCLAMATION POINTS, AND THEN THEY BOTH TURNED THEIR BACKS. JAG STORMED OFF, NOW A CROSS BETWEEN A PTERO-

DACTYL AND A TARANTULA. LITTLE G CRUTCHED
OFF FURIOUSLY IN THE OTHER DIRECTION, GOING
A MILLION MILES AN HOUR.
"NO! NO! BOYS! COME BACK!!", I YELLED
AS THEY BOTH FADED FROM VIEW.

74. 7" Lockdown

WE NEVER DID ANYTHING IN MODERATION,
OR IN A NATURAL WAY THAT MADE SENSE. WE
HAD TO MAKE EVERY LITTLE THING INTO A BIG
EVENT. NO NORMAL SURVIVAL INSTINCT OR
COMMON SENSE AT ALL. LIKE, WE WOULD FORGET
TO BREATHE, THEN SPEND A WHOLE DAY TOGETHER
PANTING. FORGET TO BLINK, THEN SPEND A WHOLE
WEEK JUST BANGING OUR EYES OPEN AND SHUT.
THERE WAS DEFINITELY SOMETHING WRONG, AND
IT WAS PROBABLY SOMETHING WE HAD FORGOTTEN
TO DO. NOT A COMPLICATED THING LIKE PAYING
OUR BILLS, BUT A SIMPLE THING NECESSARY FOR
HUMAN SURVIVAL. BUT, WHAT WAS IT? WE TRIED
EVERYTHING, ONE AT A TIME, IN EXCESS, TO
MAKE UP FOR LOST TIME.
WATER. WE HAD FORGOTTEN TO DRINK WATER.
HENCEFORTH, EVERYONE AT DUCE WAS REQUIRED
TO DRINK WATER AS IF IT WAS BEER, A GALLON
EVERY DAY.
COFFEE. WE HADN'T BEEN DRINKING ENOUGH
COFFEE. WHAT WERE WE THINKING? A TWENTY-
FOUR HOUR COFFEE PARTY FOLLOWED, AND ENDED
WITH SLUGGO PUKING IT ALL UP.
FOOD. ACTUAL, REAL, IDENTIFIABLE FOOD. WE HAD
FORGOTTEN ALL ABOUT THAT STUFF, TOO. NO ONE COULD
REMEMBER THE LAST TIME. SERIOUSLY. A WEEK-
LONG GLUTTONOUS FEAST PASSED, AND THEN WE
WENT ON TO SLEEP WEEK.
ONCE SLEEPING, COFFEE, AND WATER WERE
ALL TAKEN CARE OF, WE COULD FORGET ABOUT
THEM AGAIN. WE FORGOT ABOUT FOOD TOO,
EXCEPT FOR HAVING PIZZA DELIVERED TO CENTER
AND SHATTUCK DURING OUR SPECIAL TWENTY-FOUR
HOUR HANGING OUT DOWNTOWN.
WE HAD ALREADY SPENT A MONTH BEING
PUNKS, BUT THERE WAS ONE PART OF IT WE HAD
NEGLECTED: THE MUSIC ITSELF. MY SEVEN INCH
COLLECTION WAS IN STORAGE AT MY DAD'S. SINCE
YOU CAN'T EAT THEM, SMOKE THEM, OR PLAY

THEM WITHOUT ELECTRICITY, THERE WAS NO
REASON TO BRING MY RECORDS TO DUCE. BUT
ACROPOLIS STILL HAD POWER AT HIS PLACE, AND
THE KIND OF CONTROLLED ENVIRONMENT NECESS-
ARY FOR AN EXPERIMENT. I GOT A BRILLIANT NEW
IDEA. WE WOULD LISTEN TO MY RECORDS, EVERY
SINGLE ONE OF THEM. ALL IN ONE SITTING. A ONCE
IN A LIFETIME SEVEN-INCH LOCKDOWN.

TWENTY HOURS LATER WE EMERGED FROM
THE HOUSE OF ACROPOLIS WITH FRESHLY SHAVED
HEADS AND SUCH A FOUL, MEAN, LOW-DOWN AND
TIRED LOOK THAT EVEN ARMED GUARDS COULDN'T
STOP US. THE LOCKDOWN HAD ENDED WITH THE
KIND OF STUPID HEATED ARGUMENT WHICH
FINISHED OFF ALL OUR SPECIAL EVENTS, LEAVING
EVERYONE ANGRY AND DISAPPOINTED. WHY DID WE
ALWAYS OVERDO THINGS UNTIL THEY WERE NO
LONGER FUN?

IT WAS ALL SO POINTLESS. WE HADN'T EVEN
LISTENED TO ALL THE RECORDS. NO MATTER HOW
BAD SOMETHING IS, I HATE TO LEAVE IT
UNFINISHED.

"THAT WAS TERRIBLE", SLUGGO SAID. "THAT WAS
YOUR WORST IDEA YET. A ONCE-IN-A-LIFETIME
SEVEN-INCH LOCKDOWN. REALLY DUMB. AND
THE WORST PART IS, WE'LL PROBABLY DO IT
AGAIN, JUST TO SPITE OURSELVES. FUCK. WE'LL
PROBABLY DO IT AGAIN TOMORROW".

75. Good Business

MY ROOMMATES DIDN'T WANT TO HEAR ABOUT MY
FANZINE, AND I DIDN'T WANT TO HEAR ABOUT THEIR
JOBS EITHER. BAD ENOUGH TO SLAVE HALF YOUR LIFE
AWAY, EVEN IF IT IS SOMETHING YOU LOVE DOING.
WORSE TO SPEND THE OTHER HALF TALKING ABOUT IT.
SLUGGO'S CO-WORKER GOSSIP, WILLEY'S EXPLANATIONS
OF AUTO PARTS, LITTLE G AND JAG'S ILLEGAL BUSINESS
EMPIRE. IT WAS ALL THE SAME TO ME: TRIVIAL,
DEGRADING, AND A WASTE OF POTENTIAL. I WANTED
NO PART OF IT. BUT WITH LITTLE G, IT BECAME
IMPOSSIBLE TO AVOID.

HE'D BEEN BUYING WEED DOWN SOUTH AND GIVING
IT TO THE DRUG DEALER KIDS ON SAN PABLO TO SELL.
GIVING IT TO THEM UP FRONT, THEN SPLITTING THE
PROFITS EVENLY. LITTLE G THOUGHT THAT WAS ALL
GOOD BUSINESS, BUT WHEN ONE OF THE KIDS GOT

ARRESTED WITH HIS WEED, IT LOOKED REALLY SUS-
PICIOUS, LIKE A SET UP. THE JAIL GANGS HEARD
ABOUT IT, AND WE'RE PISSED. THEY SENT A MESSAGE
TO LITTLE G: GET OUT OF TOWN, FAST.

LITTLE G FREAKED OUT, STARTED TALKING ABOUT
HOW EVERYONE WAS GONNA GET MURDERED THAT
NIGHT IF WE DIDN'T ALL MOVE OUT. IF I HADN'T ALSO
BEEN FREAKING OUT, I WOULD HAVE PASSED OUT CIGARS.
AFTER YEARS OF TRYING, THE LITTLE GIGANTE HAD GIVEN
BIRTH TO AN HONEST-TO-GOD LIFE-THREATENING CRISIS.

WILLEY, ALWAYS A MAN OF REASON, WENT OUT TO
DISCUSS THE MATTER REASONABLY WITH THE BLACK
GUERILLA FAMILY. WE WERE STILL DIVIDING UP WILLEY'S
POSSESSIONS AMONGST OURSELVES WHEN HE RETURNED,
SAYING THE WHOLE THING HAD BEEN JUST A LITTLE
MISUNDERSTANDING. THE LOCAL BGF MEMBERS
THOUGHT WE WERE ALRIGHT, WILLEY SAID. THEY
WEREN'T THREATENING US AT ALL, JUST SAYING THAT
LITTLE G SHOULD BE MORE CAREFUL. FRIENDLY ADVICE.

76. Grandfathers

WILLEY WAS TALKING ABOUT HIS DREAMS AGAIN.
NOT HIS SLEEPING DREAMS, BUT HIS WAKING ONES,
WHICH ALWAYS MEANT TROUBLE. SOMETHING INSIDE
HIM KEPT TELLING HIM THAT EVERYTHING WAS WRONG,
WRONG, WRONG, AND HE WAS FUCKING UP, WASTING HIS
LIFE AWAY. MAYBE IT WAS HIS HEART, MORE LIKELY
IT WAS HIS GRANDFATHER, BUT THERE WAS A CON-
SERVATIVE STREAK A MILE WIDE DEEP INSIDE WILLEY.
IT SPOKE UP AT THE WEIRDEST TIMES, MORALIZING
AND JUDGING EVERYONE ACCORDING TO THE STRICTEST
PURITAN STANDARDS. NO ONE YET HAD BEEN KNOWN TO
PASS, BESIDES A FEW FARMERS IN IOWA, AND
WILLEY'S OLD ROOMMATE SHEN.

I GUESS ALL GUYS GO THROUGH A PERIOD OF BEING
SO JUDGEMENTAL THAT THEY ARE IMPOSSIBLE TO
DEAL WITH, I KNOW I DID, BUT GEEZ, WILLEY WAS
THE WORST. EVERY SINGLE THING YOU DID HAD TO GO
IN FRONT OF LORD WILLEY THE JUDGE, JURY, AND
JUSTICE SYSTEM.

WHAT A PAIN IN THE ASS. BUT, WE COULD JUST
AVOID WILLEY WHEN HE WAS IN ONE OF THOSE MOODS.
WILLEY COULDN'T AVOID HIMSELF. IT ECHOED IN
HIS HEAD.

"WHY CAN'T YOU BE MORE LIKE SHEN?", THE VOICE
SAID. "WHY CAN'T YOU SETTLE DOWN, RAISE A GOOD

FAMILY, LEARN A TRADE, AND DO SOMETHING
WORTHWHILE WITH YOUR LIFE? DO SOMETHING TO
MAKE YOURSELF PROUD, TO MAKE YOUR FATHER'S
FATHER PROUD. INSTEAD OF THIS. LOOK AT YOUR-
SELF, WILLEY, AND TELL ME THAT THIS IS SOMETHING
TO BE PROUD OF."

WILLEY STARTED TALKING AGAIN ABOUT MARRIAGE,
RAISING A FAMILY, AND MOVING TO MONTANA. OF
COURSE, THAT WAS MY WORST NIGHTMARE. MY
INNER GRANDFATHER HAD AN ENTIRELY DIFFERENT
TAKE ON THINGS. HE SAID THIS:

"FAMILY, AARON, IS NOT YOU AND A PUNK GIRL
IN A DUMPSTER. NEITHER IS IT ISOLATION AND SELF-
SUFFICIENCY ON A FARM IN BUMFUCK NOWHERE.
FAMILY IS THE GREAT FAMILY OF MAN. FAMILY
IS THE STRANGERS PASSING ON THE STREET IN THE
CITY, MUTUAL RESPECT AND SUBTLE INTERDEPENDENCE.
SETTLING DOWN MEANS BECOMING COMFORTABLE
WITH YOURSELF AND YOUR ROLE IN SOCIETY, NOT
SELLING OUT. WHY CAN'T YOU BE MORE LIKE GORKY?
FOCUS YOUR CREATIVITY TO GIVE BIRTH TO SOMETHING
YOU CAN BE PROUD OF, SOMETHING WHICH WOULD
MAKE YOUR POOR GRANDFATHER EMBARRASSED BUT
MAKE SOCIETY AS A WHOLE MORE UNDERSTANDING
AND INSPIRED?"

THE MORE I THOUGHT ABOUT IT, THE MORE I
REALIZED EVERYONE'S MIXED FEELINGS. EACH OF
US HAD A SEPARATE AGENDA UNFULFILLED BY
THE GROUP, AND AN OBNOXIOUS NARRATOR THAT
WENT WITH IT. "JUMP OFF A CLIFF", THE VOICE OF
REASON MIGHT SAY, AND YOU WOULD HAVE A HARD
TIME FIGHTING AGAINST IT. THERE WAS A NATURAL,
INSTINCTIVE DESIRE TO FOLLOW THAT VOICE.

SLUGGO HAD TWO VOICES, ONE FROM EACH SIDE
OF THE FAMILY, WHICH ACCOUNTED FOR HIS
CHANGES. ONE WAS A FRUMPY INTELLECTUAL
CITY DWELLER, AND THE OTHER, A SUBURBAN YUPPIE
SNOB. LITTLE SUICIDE'S VOICE SCOLDED HIM, SAYING:
"WHY CAN'T YOU BE A FAMOUS AND SUCCESSFUL
CRIMINAL INSTEAD OF THIS SLOPPY, TWO-BIT SHIT?"

77. Commitments

IT WASN'T THAT I WAS AGAINST JUST SETTLING
DOWN WITH A GIRL. WELL, OKAY, I WAS, TOTALLY, BUT
I WASN'T AGAINST SOME SORT OF ROMANTIC COMM-
ITMENT. WHAT I WAS REALLY AGAINST WAS SOME

PEOPLE SEPARATING ROMANCE FROM THE REST OF
THEIR LIFE WITH THE SECRET PLAN THAT WHEN
THE TIME CAME, THEY WOULD SEVER THEIR LIFE ON
THAT DOTTED LINE. IT WAS SO NATURAL FOR PEOPLE
TO MAKE A COMMITMENT, EVEN A LIFELONG COMMIT-
MENT, TO A RELATIONSHIP, BUT NEVER TO A FRIENDSHIP.
 I WANTED A COMMITMENT. IF WILLEY WAS
REALLY GOING TO MOVE TO MONTANA AND GET
MARRIED SOMEDAY, I WANTED TO DO EVERYTHING WE
COULD DO TOGETHER FIRST, INSTEAD OF REGRETTING IT
LATER. I WANTED TO MAKE A PLAN. FIVE YEARS TO
DO EVERYTHING WE HAD ALWAYS TALKED ABOUT
WANTING TO DO TOGETHER, AND THEN WILLEY COULD
GO OFF TO THE STICKS. GET IT OUT OF HIS SYSTEM,
AND GET SOMETHING TO BRAG ABOUT TO THE KIDS.
 WHAT I REALLY WANTED WAS TO LIVE TOGETHER
FOREVER, EVERY OTHER YEAR AT LEAST, NO MATTER
WHAT CHANGED IN OUR SEPARATE LIVES. THE
THOUGHT OF THAT KIND OF STABILITY WAS SO
EXCITING AND COMFORTING TO ME. ONE SHITTY
HOUSE TOGETHER WAS DEPRESSING. TWO WAS A
RELIEF, BECAUSE YOU DIDN'T TAKE THE PROBLEMS
AS SERIOUSLY THE SECOND TIME AROUND, AND KNEW
IT WAS ONLY A MATTER OF TIME BEFORE NUMBER
THREE. EVERY DOOMED SITUATION BECAME JUST ONE
MORE PROBLEM YOU EVENTUALLY OVERCAME.
 I THOUGHT WE SHOULD FIGHT AGAINST THE
VOICES IN OUR HEADS, DROWN THEM OUT WITH ONE
LOUD VOICE TOGETHER. HADN'T WE ALREADY PROVEN
THAT VOICE TO BE THE MOST LASTING AND TRUE?
WILLEY HAD HIS OWN IDEAS ABOUT HOW TO "DO THE
RIGHT THING", AND SO FAR ALL OF THEM HAD BEEN
WRONG. LEFT TO HIS OWN DEVICES HE WOULD SPEND
HIS WHOLE LIFE SEARCHING FOR A MILLION BRICKS
TO BUILD HIS STUPID DREAMS, WHEN WE ALL KNEW
THAT THIRTY FOUR WAS ALL HE'D REALLY NEED.
 AT LEAST WILLEY WAS HONEST ABOUT HIS GOALS,
AND I APPRECIATED THAT. NEARLY EVERYONE WAS
SECRETLY LOOKING TO DITCH OUT AND RAISE A
FAMILY IN ONE WAY OR ANOTHER, ESPECIALLY
SLUGGO, BUT THEY DIDN'T HAVE THE GUTS TO BE
HONEST ABOUT IT, AND THAT CAST A SHADOW ON
ALL OUR TALK. MAKING BIG PLANS FOR TOURS AND
OTHER TOWNS AND A FUTURE TOGETHER WAS ALL
A FARCE, THE MORE SO WITH EACH NEW PLAN,
WHEN NO ONE WOULD REALLY COMMIT TO EVEN THE
SMALLEST SCHEME. MAYBE IT WAS WEIRD TO TALK
ABOUT, BUT IT WAS WEIRDER NOT TO DISCUSS AT ALL.
IT WAS OBVIOUS THAT OUR LIVES WOULD BE LESS

FLEXIBLE IN THE FUTURE, AND THE TIME WAS NOW
TO TAKE ON THE WORLD TOGETHER, BEFORE EVERYONE
"ACCIDENTALLY" GOT MARRIED, OR GOT A CAREER,
OR GOT DEAD.

78. Little G's List

STAGES AND WAYS OF LIFE OVER THE LAST
YEAR AND MORE:

1. SURGERY
2. PAIN KILLERS
3. MOVING
4. DEGENERATING
5. GROWING UP
6. EMBARRASSING OURSELVES
7. BREAKING APART
8. COMING TOGETHER
9. TRYING TO FORGET
10. STRIVING TO REMEMBER
11. LYING TO SOCIETY
12. TALKING SHIT
13. DRINKING, DRUGS, ETC...
14. DRIVING
15. ON THE LAM
16. LOSING TRACK OF REALITY (INSANITY)
17. WEIRD CONSPIRACY THEORIES
18. GIRL TROUBLES
19. BOY TROUBLES
20. CAR TROUBLES
21. INHERENT FUCKED-UP NESS
22. SELF-EXPLANATORY
23. FAKE BIRTHDAY PARTIES
24. OVERDOSES
25. DELIRIUM
26. ATTEMPTING TO FIT IN
27. TRYING TO BREAK AWAY
28. THINKING WE'RE LEARNING (SOMETHING?)
29. MISSED DATES AND APPOINTMENTS
30. WISHING YOU HAD DITCHED FUKT UP APPOINTMENTS
31. EXTREME CASES OF LOW SELF-WORTH
32. SELLING DRUGS
33. B.G.F., HIT ON YOUR LIFE; SCARY
34. STAGNATION
35. SWEEPING RUGS; NO VACUUM
36. GETTING LOST
37. RUNNING INTO PEOPLE IN WEIRD PLACES
38. GETTING AWAY FROM COPS

39. SHITTY FANZINE READING
40. WORTHLESS FUCKING LIFE
41. GOOD SEX, BAD HANGOVERS
42. INSANE, LOW SELF, NO FRIEND
43. BEST FRIENDS
44. WARM, HAPPY FEELINGS INSIDE
45. TIRED OF WHEELCHAIRS AND BRAILLE
46. FUCK BANKS AND ATM MACHINES
47. DOWNTOWN BERKELEY
48. EAST OAKLAND
49. SMUGGLING DRUGS
50. UNWANTED BUGS
51. STUPID GUNS
52. STEALING THINGS
53. BEING RIPPED OFF
54. TRUSTING EVERYBODY
55. NEVER TRUST ANYONE
56. EUREKA
57. SISTER'S BAND
58. POP CULTURE: PUKE BUT INFLUENTIAL
59. APATHY
60. FUCK TELEGRAPH MOHAWK SHITZ
61. VIDEO GAMES
62. FRIENDS BECOMING ROCK STARS
63. CYNICISM TO THE FULLEST (SP.?) AMT.
64. GIANT BURGER
65. RENAISSANCE CAFÉ
66. RAMBLING BULLSHIT

79. Sluggo's List

67. GOTTA MAKE THAT MONEY MAN
68. GOTTA TAKE FROM EVERYONE
69. CHANGES
70. GUN RANGES
71. MOO-ROUNGE
72. MOO-PLEX
73. GOTTA GET DOWN FOR OUR THING
74. CRACKHEADS TOOK DAD'S WEDDING RING
75. BABUS
76. SCABUS
77. CAN'T GET ARRESTED
78. NO ONE WILL ARREST ME
79. DRIVING WITH SEAN
80. GETTING DRUGS FROM MOM

80. Trash

I'D HAD GIRLFRIENDS, BUT ALWAYS OUT OF TOWN, OR WHEN I LIVED AT OTHER HOUSES. NEVER WHEN I LIVED WITH WDH. I WAS ALWAYS THE THIRD WHEEL WHILE THEY FUCKED AND FOUGHT. ALWAYS THE COUNSEL WHEN THEY WENT THROUGH THE DRAMA OF GETTING TOGETHER AND BREAKING UP OVER AND OVER AGAIN.

NOW THERE WAS A LOCAL GIRL I WAS DEVELOPING A HUGE CRUSH ON, AND SHE WAS A FRIEND OF MY ROOMMATES. ADA. ONE NIGHT I PAGED SLUGGO, AND HE CALLED ME BACK FROM ADA'S HOUSE. HE WAS THERE WITH VANESSA, AND A SMALL PARTY WAS DEVELOPING. I RUSHED OVER, NOT WITHOUT ULTERIOR MOTIVES.

I WALKED INTO THE BACKYARD AND SAW ADA, STAGGERING AROUND SHITFACED DRUNK. SHE SAW ME AND HER EYES SPARKLED. SHE CAME OVER AND FELL ON ME.

"I KNOW HOW YOU ARE, DON'T TRY TO PRETEND", SHE SAID. "I KNOW ALL ABOUT YOU, YOU SLEAZY FUCK. YOU'RE TRASH. AND I'M TRASH TOO".

SHE TIGHTENED HER GRIP ON ME, CLOSED HER EYES, AND STUCK HER HEAD OUT LONGINGLY. I JUST LOOKED AT HER. SHE SAID, "KISS ME".

I WAS STUNNED. WHAT HAD JUST HAPPENED AND HOW HAD IT HAPPENED SO FAST? WHAT WAS I GETTING MYSELF INTO? IT WAS THE FIRST TIME ME AND ADA KISSED, BUT ALSO THE FIRST TIME WE HAD EVER TALKED.

SHE SAID, "KISS ME AGAIN", BUT I SAID NO. I SAID, I'LL KISS YOU TOMORROW WHEN YOU'RE NOT DRUNK. SHE WENT OVER TO THE CORNER OF THE ROOM, MUTTERING THAT I WAS A LYING JERK, AND IN TEN SECONDS SHE WAS FACE DOWN, PASSED OUT COLD. BUT THE NEXT NIGHT, AFTER THE BEACH PARTY, SHE CAME HOME TO DOUBLE DUCE WITH ME, AND WE STARTED KISSING AGAIN. THIS TIME SHE WASN'T DRUNK. I WAS.

81. Beach Party

IT WAS CONFUSING. WHEN I STOOD BACK FROM THE WHIRLWIND, I FELT LIKE I WAS MISSING OUT.

WHEN I IMMERSED MYSELF IN IT, I FELT LIKE I WAS GOING UNDER, GETTING SUCKED IN WAY TOO FAR AND FAST. NOW HERE WE ALL WERE ON THE WATERFRONT, HAVING A BIRTHDAY PARTY FOR LITTLE G AND JED, AND I JUST FELT ANGRY AND ALIENATED. IT DISGUSTED ME. WE COULDN'T EVEN HAVE FUN ANYMORE. IT HAD ALL BEEN SABOTAGED. EVERY STUPID LITTLE THING WAS A SIGN, AN ANALOGY FOR WHAT HAD GONE WRONG.

IT WAS LIKE THE BASKETBALL GAME ME AND WILLEY HAD TRIED TO PLAY THE WEEK BEFORE. JUST A QUICK LITTLE GAME OF ONE ON ONE. A LITTLE BONDING, A LITTLE MOVEMENT, A LITTLE TIME IN THE SUN. BUT A COUPLE OTHER PEOPLE ASKED TO PAIR OFF, AND WE DIDN'T WANT TO BE RUDE. PRETTY SOON A DOZEN MORE PEOPLE HAD JOINED IN AND THEN WE WERE PLAYING BY THEIR RULES. EVERYTHING WAS FAST, HARD, SELFISH. NO TEAMWORK OR TOGETHERNESS AT ALL. WILLEY AND I RAN BACK AND FORTH DOWNCOURT, BUT WE DIDN'T EVER GET THE BALL.

WDH HAD STARTED MANY YEARS BEFORE, DOWN ON THAT SAME STRETCH OF WATERFRONT, LONG BEFORE IT HAD A NAME. IT WAS JUST ME AND WILLEY, ONE ON ONE, RIGHT AFTER WE GAVE UP THE HOUSE OF KRUSTEAZ. OUT THERE AT THE EDGE OF A CLIFF, CAMPING OUT TOGETHER, LOOKING TOWARDS AN UNCERTAIN FUTURE. IT WAS THE BEST TIME OF MY LIFE. WE SET OUT FROM THERE, PICKING UP NEW PEOPLE ON THE ROAD, BUT LOSING SOME OF OUR CLOSENESS AND SENSE OF DIRECTION ALONG THE WAY.

WHAT WERE WE GOING TO DO, PLAY ALL BY OURSELVES FOR YEARS? NO, WE NEEDED OTHER PEOPLE. BUT HOW HAD IT COME DOWN TO THIS WORST CASE SCENARIO? OUR GAME HAD BEEN TAKEN OVER AND RUINED, AND IT WASN'T FUN ANYMORE. WE JUST SAT ON THE SIDELINES WATCHING AND TRYING TO GET OUR BASKETBALL BACK.

EVERYONE WAS EXAGGERATED, HIDEOUS CARICATURES OF THEMSELVES. JAG WAS CURLED UP IN THE WATER SCREAMING AND CRYING. LITTLE G WAS PASSED OUT FACE DOWN IN THE CAKE CATY HAD MADE. JED WAS BABBLING SOME BULLSHIT, AND SEAN WAS IN THE CAR DRINKING, COMPLAINING, AND WANTING A RIDE HOME. THERE WERE A DOZEN OTHER PEOPLE, ALL FREAKING OUT IN THEIR OWN FAMILIAR WAYS. EVERYONE BUT SLUGGO, WHO HAD LEFT EARLY WITH VANESSA WHEN THE PARTY STARTED TO SUCK, JUST AS HE HAD ONCE LEFT WITH SAL.

I DIDN'T KNOW WHO TO BLAME, EXCEPT EVERYBODY.

SLUGGO FOR LEAVING WITH A GIRL WHENEVER THINGS
GOT UNBEARABLE. JAG, JED, LITTLE G, AND SEAN FOR
ACTIVELY MAKING THINGS UNBEARABLE, OR AT LEAST
NEVER TRYING TO MAKE THINGS EASIER, SIMPLER,
SANER. JADINE, JODY, RAMSEY, ERIC, VANESSA, AND
COUNTLESS OTHERS WHO CAME OVER TO MAKE
THINGS WORSE AND THEN WENT HOME WHILE WE
WERE STUCK CLEANING UP THE MESS. I BLAMED
THEM MORE THAN ANYONE, BECAUSE WE HAD PROVID-
ED THE HOUSE, THE SCHEMES, THE SLOGANS, THE
SOUNDTRACK, AND THE EVENTS, AND THEY HAD
PROVIDED NOTHING, NOT EVEN HOPE. WE HAD RISKED
EVERYTHING, THEY HAD RISKED NOTHING. WORST
OF ALL, THEY HAD OFFSET OUR FRAGILE BALANCE.

I CHART MY COURSE COMPARING MYSELF TO
DIFFERENT PEOPLE AT DIFFERENT TIMES. THIS TIME
I PULLED WILLEY ASIDE.

"WILLEY," I SAID, "DO YOU THINK SOMEDAY THIS
WILL ALL BE OVER, AND IT WILL BE ME AND YOU
TOGETHER ON THE WATERFRONT AGAIN?"

"IT CAN'T LAST MUCH LONGER LIKE THIS," HE
SAID. "SOMETHING IS GOING TO CHANGE REALLY SOON.
SOMETHING BIG. I HAVE A FEELING."

82. Along the Way

THE FIRST CASUALTY OF DOUBLE DUCE HAD BEEN
SLUGGO, LOSING HIS MIND AND HAVING TO GO BACK TO
CLEVELAND TO RETRIEVE IT. NEXT WAS SEAN, WHO
JESSE SAVED WITH A ONE-WAY PLANE TICKET TO
HAWAII. SEAN COULDN'T BUY DRUGS THERE, AND BY THE
TIME HE HAD PICKED ENOUGH COFFEE TO PAY FOR A
RETURN FLIGHT, HE WAS ALL CLEANED UP. THEODOTIA
WAS THE ONLY ONE WHO HADN'T PULLED THROUGH.
SHE JUST SUNK DEEPER AND DEEPER INTO THE SHIT.

ONE LEAKY BOAT WITH TOO MANY CRAZY, SELF-
DESTRUCTIVE PEOPLE IN IT. FOR EVERY PERSON
BAILING WATER OUT, THERE WERE TWO DRILLING HOLES
IN THE BOTTOM OF THE BOAT. THEO WENT OVERBOARD
AND THERE WAS NOTHING WE COULD DO BUT WATCH
HER SINK. SHE HAD ONLY COME BACK TO VISIT ONCE,
AND ONLY TO TRY TO STAB JED WITH AN UMBRELLA.

POOR JED, HE WAS NEXT. THE MORNING AFTER
THE BEACH PARTY, HE GOT SOME REALLY TERRIBLE
NEWS. AS BAD AS IT CAN GET. THE CRISIS BROUGHT US
ALL CLOSER, AND EVERYONE RALLIED TO SUPPORT JED,
BUT IT WASN'T ENOUGH. HIS OVERACTIVE BRAIN

STARTED TO UNRAVEL, HIS EMOTIONS WENT INTO OVER-
DRIVE, AND HIS LOGIC WAS CONSUMED BY EVERY KIND
OF PARANOIA. WE TRIED TO TAKE CARE OF HIM, BUT
OUR UNSTABLE ENVIRONMENT WAS NO PLACE FOR
SOMEONE NEEDING CALM, STABILITY, AND PEACE OF
MIND. IT WASN'T THE RIGHT PLACE FOR JED AT ALL,
AND NEVER HAD BEEN. ON HIS WAY TO A QUIET, SOLITARY
LIFE IN THE WOODS, JED HAD STOPPED TO VISIT LITTLE G
AT DOUBLE DUCE, AND NEVER BEEN ALLOWED TO LEAVE.
NOW, IT WAS REALLY TIME TO LEAVE.

HE WAS GETTING WORSE BY THE MINUTE, AND SOME-
THING DRASTIC HAD TO BE DONE. I HATE TO ADMIT IT,
BUT WE WERE PREPARED TO RESTRAIN JED BY FORCE,
OR EVEN DRUG HIM IF NECESSARY, THOUGH THANK GOD
THAT WASN'T NECESSARY. WILLEY AND I TOOK HIM IN
THE VAN AND DROVE HIM UP TO EUREKA, TO LITTLE G'S
MOM, WHO WAS SORT OF A SURROGATE MOTHER TO JED.
HE DIDN'T WANT US TO LEAVE HIM THERE, BUT WE DID
ANYWAY. IT WAS TERRIBLE.

WILLEY AND I RETURNED TO BERKELEY SLEEPLESS
AND MISERABLE, WONDERING IF WE HAD MADE THE
RIGHT DECISION. HOPING IT WAS THE ULTIMATE ACT
OF FRIENDSHIP INSTEAD OF THE ULTIMATE BETRAYAL.

JED'S MOTHER CAME AND GOT HIM A WEEK LATER,
AND THEY DISAPPEARED INTO THE MOUNTAINS ON THE
CALIFORNIA-OREGON BORDER FROM WHICH THEY HAD
CAME. THAT WAS THE END OF JED.

83. Laid to Waste

WE HAD BEEN A FAMILY BEFORE, BUT I HAD
ALWAYS BEEN THE WEIRD UNCLE OR SOMETHING.
ALWAYS AN OUTSIDER. NOW I WAS AS WARM AND
WRECKED AND RUINED AS THE REST OF THE BOYS. ADA
HAD LEFT EARLY THE MORNING AFTER THE BEACH
PARTY. ACTING ALOOF AND A MILLION MILES AWAY,
SHE GATHERED UP HER CLOTHES. IT WAS AS IF
SPENDING THE NIGHT WITH ME HAD BEEN A BODILY
FUNCTION TO BE EMBARASSED ABOUT, OR LAUGHED AT.
SHE SAID SHE WOULDN'T BE CALLING.

IT HAD BEEN A WHILE SINCE I'D BEEN SKINNED,
SPLAYED, AND SCUTTLED SO SKILLFULLY. LAID TO WASTE
SO SIMPLY YET THOROUGHLY, AND BY SUCH A BEAUTIFUL
SOULFUL SWEET THING. THAT GODDAMN GIRL. WAS
THIS A TRICK TO CATCH ME IN HER TRAP? IF IT
WASN'T A TRICK, I WAS DOOMED, BECAUSE I HAD
FALLEN FOR IT IN A BIG WAY, AND FALLEN FOR HER.

WHEN WE LEFT DRIVING NORTH LATER THAT DAY,
JED WASN'T THE ONLY ONE WHO NEEDED TO GET OUT
OF TOWN TO CLEAR HIS HEAD. I HAD MY HANDS FULL
TRYING TO KEEP HIM CALM, TRYING TO COMFORT HIS
MISERY BUT CHALLENGE THE HURRICANE OF WORRIES
THAT CAME WITH IT. FACED WITH JED'S CRISIS, A
SERIOUS ONE WHICH I COULD ACTUALLY TRY TO HELP,
MY OWN HEARTACHE WAS PUT ON THE BACK BURNER.
BUT ON THE DRIVE HOME TWO DAYS LATER, TIRED AND
SORE AND GUILTY IN THE COLD VAN, MY THOUGHTS
TURNED BACK TO ADA. HER SMELL, HER VOICE, HER
EYES, AND THE REST. SO SHE WOULDN'T CALL? FINE,
NEITHER WOULD I, THE FUCKING TRAMP.

ARRIVING BACK IN BERKELEY, I WENT TO MY
P.O. BOX, AND THERE IT WAS, A BIG LETTER FROM HER.
I SWOONED AND SMILED SO WIDE THE TOP HALF OF
MY HEAD FELL OFF RIGHT THERE IN THE POST OFFICE
LOBBY. I WON'T BE CALLING. I GET IT NOW.

84. Knock on Wood

ADA AND I WERE TOGETHER, AND THE CLOSER
WE GOT, THE CLOSER I FELT TO BECOMING PART OF
THE WDH FAMILY IN A NEW WAY. WE HAD ALWAYS
SHARED A LIFE, BUT ONE DARK, PASSIONATE, PSYCHOTIC
PART OF IT WAS MISSING FOR ME. NOW I COULD COOK
BREAKFAST NOT ONLY FOR MY HUNGOVER ROOMMATES
AND THEIR GIRLFRIENDS, BUT FOR MY HUNGOVER
GIRLFRIEND AS WELL. WHEN WE ALL DROVE HOME
FROM A LONG MISERABLE NIGHT TOGETHER, ADA WOULD
COME ALONG, AND NOT EVEN AS AN OUTSIDER. THEN,
FOR A CHANGE, THEY WOULD HAVE TO LISTEN TO
ME FUCK. I TRIED TO BE EXTRA LOUD TO MAKE UP
FOR LOST TIME.

WHEN I TOLD MY FRIENDS HOW GOOD I FELT,
HOW PROUD AND LUCKY TO HAVE SUCH A GREAT GIRL
HANGING OUT WITH ME, THEY DIDN'T WANT TO KNOW.
GOOD NEWS LIKE THAT HAS TO BE A SECRET, OR
MASKED IN CYNICISM, OR SAVED FOR LATER IN HIND-
SIGHT WHEN EVERYTHING IS FUCKED UP.

I DIDN'T WANT TO WAIT TO COMPLAIN OR
REMINISCE ABOUT IT LATER, I WANTED TO SHOUT
IT OUT AND TELL THE WORLD. IF IT SHOULD HAPPEN
TO GO WRONG, LET THE WORLD LAUGH AT ME. NONE
OF THAT "DON'T SAY SOMETHING GOOD OR IT WON'T
HAPPEN" STUFF. NO KNOCKING ON WOOD, I WAS KICKING
DOWN THE FUCKING DOOR.

WHAT A PERFECT TIME FOR SOMETHING NEW,
A FRESH LIGHT TO SHINE INTO THE CORNERS OF MY
LIFE, AND OUR LIFE AT DOUBLE DUCE. WHAT A
TERRIBLE TIME FOR SOMETHING NEW, TRYING TO
BUILD IT UPON A FOUNDATION THAT WAS QUICKLY
ROTTING AWAY, A BEAUTIFUL PLANT GROWING IN A
PILE OF SHIT. HOW COULD I EXPLAIN ALL THE MIXED
FEELINGS, THE EXPECTATIONS AND DISAPPOINTMENTS,
THE JEALOUSIES AND ANIMOSITIES? THEN AGAIN,
WHAT MADE ME THINK SHE WAS AN ESCAPE FROM
THE STRESS AND CONFUSION, INSTEAD OF AN
INTEGRAL PART?

85. Love Stories

ADA AND VANESSA HUNG OUT DRINKING IN
SLUGGO'S ROOM WHILE SLUGGO AND I WORKED ON
SONGS UP IN THE ATTIC. THERE WAS NO MORE BAND
NOW THAT JED WAS GONE, BUT WE WROTE NEW
SONGS ANYWAY. MAYBE THEY WOULD LURE HIM BACK.
VANESSA INTERRUPTED US TO TELL ME TO COME
GET MY GIRLFRIEND. SHE HAD LIT SLUGGO'S BED ON
FIRE AND SPILLED BEER ALL OVER IT, THOUGH OF
COURSE NOT IN THAT ORDER. TOO PRACTICAL. NOW
ADA WAS PASSED OUT COLD, JUST A MUTTERING LUMP
OF DEAD WEIGHT, AND I HAD TO CARRY HER BACK UP
TO MY ROOM. IT WOULD HAVE BEEN ROMANTIC, IF
SHE HAD REMEMBERED WHO I WAS.
ADA SPRAWLED OUT IN MY BED SO THERE WAS
NO WAY FOR ME TO FIT IN IT. I TRIED TO HAUL HER
OUT OF THE WAY, BUT SHE WOULDN'T BUDGE. GRRR.
THIS GIRL WAS REALLY GETTING UNDER MY SKIN.
I HAD TO GO SLEEP IN JED'S OLD ROOM.
WHILE I WAS SLEEPING, MY ROOMMATES PAID A
FOUR A.M. VISIT TO LYLE PETERS. THEY STOOD OUT ON
THE STREET WITH RIFLES, IN MILITARY FORMATION,
WHILE SLUGGO MET LYLE AT THE DOOR AND
DECKED HIM. THE REASON? VANESSA HAD CHEATED
ON SLUGGO.
I WAS HORRIFIED TO HEAR ABOUT IT IN THE
MORNING, BUT ALONG WITH THE HORROR CAME A
WARM HAPPY FEELING OF JUSTICE. THAT KIND OF
VIGILANTE ATTITUDE WAS WRONG, YET LYLE WAS
WRONG TOO, AND I THOUGHT OF PEOPLE IN MY OWN
PAST WHO DESERVED A SIMILAR FOUR A.M. WAKEUP
CALL. OF COURSE VANESSA WAS ALSO WRONG, BUT
SLUGGO STILL BROUGHT HER OVER TO OUR HOUSE ALL

THE TIME. THERE WAS NO POINT INVITING MY
FRIEND LYLE OVER ANYMORE.

NOW THAT I COULD FINALLY BOND WITH MY
ROOMMATES ABOUT RELATIONSHIPS, ALL OF THEIRS
FELL TO PIECES. WILLEY AND RACHEL BROKE UP,
AS DID LITTLE G AND JODY, AND VANESSA AND SLUGGO
FOUGHT DAILY. SHE CAME OVER AND SMASHED EVERY
LAST SPECIAL LITTLE THING SHE HAD EVER GIVEN
HIM. WHEN SHE HAD LEFT, SLUGGO RETRIEVED ALL
THE PIECES FROM THE GARBAGE CAN OUTSIDE
AND PUT THEM BACK INSIDE HIS SPECIAL BOX.
EVERY DAY VANESSA CAME OVER, SMASHED IT ALL
INTO TINIER PIECES, AND TOSSED THE BOX INTO THE
GARBAGE CAN, AND EVERY DAY SLUGGO RETRIEVED
IT. AT THE END OF THE WEEK THERE WAS NOTHING
IN THE BOX BUT DUST, SO SLUGGO FINALLY SHRUGGED
HIS SHOULDERS AND LEFT IT ALL IN THE GARBAGE.
BIG MISTAKE. VANESSA CAME OVER, FOUND THE
BOX IN THE TRASH, AND DUMPED SLUGGO. OBVIOUSLY,
HE DIDN'T LOVE HER ANYMORE.

I CANCELLED PLANS WITH ADA TO WALK THE
TRACKS AND SMASH BOTTLES WITH SLUGGO. EVERY
NIGHT, WE WOULD WALK THOSE TRACKS. HE SAID,
"I HATE GETTING OLD."

POOR GUY. SOON, HE AND VANESSA WERE BACK
TOGETHER, AND MAKING PLANS FOR MARRIAGE.
I HATED THEM TOGETHER, BUT IN A WAY IT WAS
NOT SO BAD, BECAUSE HE WAS EVEN MORE OF A
JERK WHEN HE WAS ALONE.

86. Good Thing

DON'T GET MUCH HAPPINESS IN THIS LIFE
STEAL OURS, GIVE IT TO YOUR WIFE
YEAH, THAT'S RIGHT
GOOD THING, GOOD THING
THROW IT AWAY

TOGETHER WE COULD MAKE IT HAPPEN
ALONE WE COULD MAKE A FEW
LONELY PEOPLE WASTING OUR LIVES AWAY
GOOD THING, GOOD THING
WASTE IT, TRASH IT, THEN LAUGH AT IT
THROW IT AWAY

87. No Door

THE ELECTRICITY HAD BEEN TURNED OFF FOR A WHILE, AND NOW THE PHONE AND THE WATER TOO. THE STOVE WAS BROKEN. IT WAS DARK. EVERYTHING WAS GETTING A LITTLE GRIM, COMING IN FROM ALL SIDES, AND THERE WAS NO DOOR. LITTLE G HAD LOCKED IT MONTHS BEFORE DURING ONE OF HIS LANDLORD DRILLS, AND GIVEN JED THE ONLY KEY. JED WAS AGAINST KEYS, SO HE THREW IT AWAY. I CAME HOME FROM A LONG DAY AND HAD TO KICK IT IN.

LITTLE AGGRAVATIONS WERE BUILDING UP FAST, AND THE HUMOR OF IT ALL WAS WEARING THIN. WE WERE LIKE SANDCRABS, LITTLE G SAID, SNAPPING, COMING OUT OF OUR SHELLS, CONSTANTLY BICKERING, BADGERING, FIGHTING WITH EACH OTHER. THE TABLES HAD TURNED AGAIN AND NOW SOMETHING HAD TO CHANGE. EVEN THE BOTTOM DWELLERS WERE STARTING TO COMPLAIN, SAYING WE WERE RUINING THE NEIGHBORHOOD.

I DIDN'T WANT TO HEAR ANYONE COMPLAIN ABOUT HOW EVERYTHING WAS FUCKED UP, WHEN THEY HAD WORKED SO HARD TO MAKE IT THAT WAY. I DIDN'T WANT TO HEAR ANYONE'S SELF-PITY ABOUT HOW THEY HAD NO LIFE AND NO FRIENDS. IF THIS WASN'T A LIFE, AND WE WEREN'T FRIENDS, MAYBE IT WAS TIME TO THROW IT AWAY AND MOVE ON. EVERYONE HAD ALREADY TAKEN THAT ATTITUDE, BUT WAITED FOR SOMEONE ELSE TO ACT ON IT. THEY JUST KEPT LETTING THINGS, OR MAKING THINGS, GET WORSE. THE HONEYMOON HAD ENDED AND WE'D COME HOME TO END THE MARRIAGE TOO.

WHEN IT CAME TIME TO PAY RENT, HALF OF MY ROOMMATES DIDN'T HAVE IT. A RENT STRIKE IS A RENT STRIKE, BUT THIS WAS SOMETHING ELSE.

THEY DECIDED TO DRIVE TO VEGAS AND GO ALL OR NOTHING WITH WHAT RENT MONEY WE HAD. IF EVERYTHING WENT WELL, THERE WOULD BE ENOUGH CASH TO BUY THE WHOLE BUILDING PLUS THE LIQUOR STORE NEXT DOOR, AND NEVER HAVE TO PAY FOR BEER OR RENT AGAIN.

THERE ARE TWO SURE WAYS TO FAIL. ONE IS TO SET UNREALISTIC, UNATTAINABLE GOALS. THE OTHER IS TO DRIVE TO VEGAS WITH RAMSEY THE COMPULSIVE GAMBLER AND EIGHTY PILLS OF PRESCRIPTION SPEED. WHEN THEY RETURNED,

I COULD SEE THEY HAD SUCCEEDED IN FAILING.
IT LOOKED LIKE THE END OF DUCE.
 JAG AND SLUGGO LOOKED AT ME LIKE I WAS
A MORON. "WE KNEW THAT ALREADY", THEY SAID.
"WE DIDN'T HAVE TO DISCUSS IT."

88. Entropy

 PART OF THE NATURE OF PUNK IS CELEBRATING
YOUR FLAWS, PARADING YOUR IDIOSYNCRASIES.
BRINGING OUT YOUR BEST AND WORST QUALITIES AND
SEEING WHICH WILL DESTROY YOU FASTER. PUNK IS
ALL ABOUT TAKING THINGS TO AN EXTREME. FOR ME,
THE EXCITEMENT AND CONFLICT OF IT IS TRYING
TO FIND AN EXTREME THAT YOU CAN SUSTAIN.
WALKING RIGHT ON THE EDGE WITHOUT FALLING OFF.
FOR A LOT OF OTHER PEOPLE, IT'S DIFFERENT. ITS
ALL ABOUT GETTING TO THE EDGE SO THEY CAN JUMP
OFF, OR, MORE OFTEN, SO THEY CAN BEAT A HASTY
RETREAT AND THEN BRAG KNOWINGLY ABOUT HOW
THEY'D BEEN THERE ONCE.
 I GO SLOW AND STEADY, AND PEOPLE ARE ALWAYS
PASSING ME BY, LAUGHING ABOUT HOW CAUTIOUS AND
UPTIGHT I AM. THEN THEY PASS ME AGAIN ON THEIR
WAY BACK. I WANT TO EMBRACE LIFE IN ALL ITS
EXTREMES, BUT WHEN THE PEOPLE I'M WITH PUSH
TOO FAR TOO FAST, I GET WORRIED AND RESENTFUL.
WE AREN'T AFTER THE SAME THING AFTER ALL.
MY ROAD IS JUST A SHORTCUT FOR THEM ON THE
WAY TO TOTAL SELF-DESTRUCTION, OR A STOPOVER
BEFORE THEY TURN BACK AND SETTLE DOWN AND
STOP MOVING AT ALL. IN THEIR RACE TO THE EDGE
IN ORDER TO JUMP OVER OR TURN BACK, THEY TAKE
ME WITH THEM AND WASTE THE ENERGY THAT I
NEED FOR THE LONG RUN.
 WITH DOUBLE DUCE AND MY ROOMMATES THERE,
I COULD ALWAYS TELL WE WERE HEADED TOWARDS
THE EDGE. BUT I COULDN'T TELL WHAT EACH PERSON
WOULD DO WHEN HE GOT THERE. WHENEVER I
THOUGHT I HAD ONE OF THEM FIGURED OUT, SOMETHING
NEW WOULD COME UP TO MAKE MINCEMEAT OUT OF
MY INSIGHTS. I WAS TIRED OF TRYING TO FIGURE IT OUT,
AND TIRED OF TRYING TO PROTECT MYSELF AND MY
IDEALS FROM GETTING JADED AND DESTROYED. IT HAD
WORN ME DOWN PRETTY BAD. I'D ACTUALLY THOUGHT
GROUP IDENTITY AND STRENGTH COULD BE OUR SALVAT-
ION, OUR BOND, BUT IT HAD ONLY MADE US MORE SELF-
CENTERED AND XENOPHOBIC. THE WORST ASPECTS OF

GANG MENTALITY WITH NONE OF THE LONGTERM
DEVOTION. THEY THOUGHT WE SHOULD JUST LET THINGS
HAPPEN NATURALLY. ARTIFICIAL STIMULATION VERSUS
ENTROPY. I COULD SEE WHERE THINGS WERE HEADED
NATURALLY, AND IT WASN'T GOOD.

I THOUGHT JUST BY SHARING A LIFE TOGETHER
WE COULD FEND OFF THE DEMONS OF CYNICISM AND
LONELINESS. WE COULD CREATE A PRODUCTIVE ENVIRON-
MENT, AND SQUEEZE SOME HUMOR AND HOPE OUT OF
THE DAY-TO-DAY DESPERATION. BUT WHAT HAD IT ALL
REALLY ADDED UP TO? IT WAS ONE THING TO LAUGH AT
YOURSELF AND YOUR GOALS, AND DESTROY YOURSELF IN
LITTLE WAYS, BUT QUITE ANOTHER TO PURPOSELY FAIL,
TO TURN YOUR LIFE AND GOALS INTO A TOTAL JOKE
WHICH WASN'T EVEN FUNNY ANYMORE.

89. The Party's Over

THE SHOT FROM THE WINDOW WAS WHAT REALLY
USHERED IN THE END. WE HEARD IT UP IN THE ATTIC
LOUD AND CLEAR LIKE IT CAME FROM RIGHT IN FRONT
OF OUR HOUSE. I WAS THE CLOSEST TO THE TRAPDOOR,
SO I YELLED DOWN TO LITTLE G TO FIND OUT WHAT
WAS GOING ON. HE WAS THE ONLY ONE DOWNSTAIRS.
NO REPLY.

EVERYTHING IN THE HOUSE WAS DEAD QUIET AND
PITCH BLACK, REALLY EERIE. THE GUNSHOT WAS STILL
RINGING IN MY EAR, MIXED WITH THE SOUNDS OF
SOME COMMOTION OUT ON THE STREET. I WAS
WORRIED SOMETHING HAD HAPPENED TO OUR NEIGH-
BORS, OR TO ONE OF THE DWELLERS. I GOT MY
CANDLE AND STARTED DOWN THE LADDER TO CHECK
THINGS OUT, AND THAT'S WHEN A FLASHLIGHT
SHINED IN MY FACE AND SOMEONE YELLED, "FREEZE!"

COPS WERE IN THE HALLWAY AND THEY WERE
FREAKED OUT. IT WAS THE FIRST TIME I REALLY
WISHED WE STILL HAD A DOOR. I SAID, "I DON'T HAVE
TO COME OUT AND YOU CAN'T COME IN WITHOUT A
WARRANT".

THEY PUT THEIR HANDS ON THEIR GUNS, AND
STARTED SCREAMING, SO I CAME OUT, AND THEY
GRABBED ME.

A SHOWDOWN FOLLOWED, WITH MY ROOMMATES
ON ONE SIDE OF THE DOORWAY AND THE COPS ON
THE OTHER, TRYING TO LURE THEM OUTSIDE OR TRICK
THEM INTO GIVING PERMISSION TO ALLOW A SEARCH.
IT WENT ON AND ON, YELLING IN EACH OTHER'S FACES.

WITHOUT A LEGAL WAY TO ENTER, UNABLE TO
PROVOKE A FIGHT, AND WITH NO GROUNDS TO BOOK
ME, THE COPS FINALLY HAD TO ADMIT DEFEAT. BUT,
SPITEFUL CREATURES THAT THEY ARE, THE COPS DID
NOT TAKE THE LOSS WELL. THEY CALLED OUR LANDLORD
AND TOLD HIM TO EVICT US. DANGEROUS CRIMINALS,
THEY SAID. DRUGS. GUNS. IT WAS TRUE, BUT NONE
OF THEIR BUSINESS.

THE ONE TIME THE COPS ACTUALLY SHOW UP TO
ARREST US ALL, AND NO ONE WANTED TO BE ARRESTED.
IT WAS THE ONE TIME WE WERE INNOCENT. I THINK.

AFTER REPORTS OF A GUNSHOT, THE COPS HAD
ARRIVED ON THE SCENE TO FIND WITNESSES POINTING
UP AT OUR WINDOW, LITTLE G'S ROOM. WE HAD
HEARD THE GUNSHOT TOO, AND THE SOUND WAS
STARTLINGLY CLOSE, BUT NOT THAT CLOSE.

LITTLE G SWORE HE WASN'T THE ONE. I
BELIEVE IT, ALTHOUGH THERE WILL ALWAYS BE
A SHADOW OF A DOUBT. THE WHOLE THING IS
COMPOUNDED AND CONFUSED BY THE FACT THAT
LITTLE G HAD, FOR WEEKS, STUCK SPEAKERS OUT HIS
WINDOW AND PLAYED A LOOP TAPE OF GUNSHOTS.

90. Good Neighbors

OUR FIRST CONCERN DURING THE POLICE SHOW-
DOWN WAS NOT FOR OUR OWN WELL-BEING, BUT
FOR OUR NEIGHBORS. COPS IN THE HALLWAY WAS
UNWANTED ATTENTION WHICH PUT ALL THEIR ILLEGAL
OPERATIONS AT RISK. THIS WOULD MAKE THEM SAD,
WHICH WOULD MAKE US SAD, AND THEN THEY WOULD
SHOOT US.

ONCE THE COPS WERE GONE, TWO OF THE
BROTHERS CAME OUT OF THEIR PLACE AND INTO
OURS. WE ALL DUCKED.

"FUCKING ASSHOLES", THEY SAID. "NOT YOU, THE
COPS. DON'T LET THEM STAND IN THE HALL NEXT TIME,
TELL THEM IT'S PRIVATE PROPERTY. WE'LL FUCKING
KILL THEM, THOSE MOTHERFUCKERS. YOU ARE GOOD
NEIGHBORS TO US."

WE BREATHED A COLLECTIVE SIGH OF RELIEF,
THEN WENT ABOUT GATHERING EVERYTHING
ILLEGAL IN OUR HOUSE. A BURIAL MOUND APPEARED
IN THE BACKYARD. A SECOND VISIT FROM BERKELEY'S
FINEST SEEMED INEVITABLE.

WE'D BEEN GOOD NEIGHBORS, AND EVEN GOOD
TENANTS. UP UNTIL THAT MONTH, WE HAD ALWAYS

PAID THE RENT, AND PAID ON TIME. YES, WE'D TRASH-
ED THE PLACE, BUT NOT THAT BADLY. WE HAD NEVER
CALLED THE LANDLORD TO COMPLAIN OR ASK FOR
ANYTHING, AND HE'D NEVER HAD REASON TO COMPLAIN
EITHER. HE REALLY DID SEEM SAD TO HAVE TO
EVICT US.

91. Compromises

WHEN THE EVICTION NOTICE SHOWED UP, EVERY-
ONE HAD A FIELD DAY MAKING EXCUSES AND BLAMING
EACH OTHER. SLUGGO SAID IT WAS ALL SEAN'S
FAULT, THAT FAT HICK, FOR PISSING IN THE HAIR
LADY'S MAIL SLOT SIX MONTHS AGO.
I COULD SEE HE WAS TRYING TO CONFUSE THE
ISSUE, AND WORK THE MIND MELD TRICK ON ME AGAIN,
BUT I WASN'T HAVING ANY OF THAT. THE HAIR LADY
WAS THE LEAST OF OUR WORRIES, AND SEAN HAD
DONE THE LEAST DAMAGE AS FAR AS SHE WAS
CONCERNED.
"SLUGGO, DOES THIS LOOK FAMILIAR?", I SAID.
I TOOK THE HEAVY OFFICE CHAIR AND SMASHED
IT AGAINST THE FLOOR REPEATEDLY, CAUSING CEILING
PLASTER AND A COUPLE LIGHT FIXTURES TO RAIN
ON THE HAIR LADY'S CUSTOMERS DOWNSTAIRS.
SLUGGO SMILED GUILTILY.
STILL, SLUGGO DECIDED HE WAS THE RESPONSIBLE
ONE AND EVERYONE ELSE WAS A BARBARIAN. HE
WANTED TO CLEAN AND FIX THE HOUSE UP ALL NICE
BEFORE WE LEFT. EVERYONE ELSE WANTED TO
LEVEL THE PLACE DOWN TO THE GROUND. AS USUAL,
I TOOK THE MIDDLEGROUND AND SOUGHT TO BROKER
A COMPROMISE.
FAIR WAS FAIR. WE HAD PAID A FIVE HUNDRED
DOLLAR DAMAGE DEPOSIT AND WERE THUSLY
ENTITLED TO DO FIVE HUNDRED DOLLARS DAMAGE.
IT WASN'T RIGHT TO CREATE MORE DAMAGE THAN
THAT, BUT TO CLEAN AND FIX UP THE PLACE SO THAT
IT WOULD BE LESS WOULD BE RIPPING OURSELVES OFF.
SURVEYING THE HOUSE, WE WERE PLEASED TO FIND
THAT WE STILL HAD TWO HUNDRED DOLLARS CREDIT,
AND WASTED NO TIME GETTING EVEN.
NEXT, A COMPROMISE WAS REACHED ON THE
HOUSECLEANING ISSUE. EVERYONE WOULD CLEAN
OUT THEIR ROOMS THOROUGHLY, ON ONE CONDITION:
WE COULD PUT ALL THE RUBBLE IN ONE BIG HEAP,
IN SLUGGO'S ROOM.

CLEANING HOUSE WAS A MASSIVE TASK. WE HAD STARTED OUT WITH ALMOST NO POSSESSIONS, AND LOST MOST OF THOSE WHEN THE CHAMP GOT TOWED. BUT ALONG THE WAY WE HAD PICKED UP ALL THE LEFT-OVERS AT URBAN ORE AND THE ASHBY FLEA MARKET, STUFF SO WORTHLESS THAT THE RIPOFF JUNK DEALERS COULDN'T EVEN SELL IT. BROKEN CHAIRS, BROKEN ADDING MACHINES, AND JED'S MASSIVE COLLECTION OF BROKEN SPEAKERS. IT ALL WENT INTO SLUGGO'S ROOM ALONG WITH THE GARBAGE, PISS BOTTLES, CAR PARTS, DESKS, DRY WALL, AND ROTTING FOOD, PILED ALMOST UP TO THE CEILING, WHICH MADE GETTING UP AND DOWN FROM THE ATTIC A RISKY VENTURE.

ON THE LAST DAY OF CLEANING, THE LANDLORD SHOWED UP. THOUGH THERE WAS A CURTAIN HOLDING BACK THE SIGHT OF OUR GARBAGE HEAP, THERE WAS NOTHING TO HOLD BACK THE SMELLS AND SOUNDS OF ITS SLOW BUT STEADY DECOMPOSITION. THE LANDLORD KNEW US WELL ENOUGH TO GUESS. HE OFFERED A COMPROMISE. TWO EXTRA WEEKS, FREE OF CHARGE, IF WE WOULD BRING THE MOUNTAIN WITH US WHEN WE WENT.

92. House Meeting

I CALLED A HOUSE MEETING, A LAST-DITCH EFFORT AT HOLDING THINGS TOGETHER, BUT IT JUST UNDERSCORED WHAT A SAD JOKE THAT EFFORT WAS. EVERYONE WAS MORE INTERESTED IN BLAMING EACH OTHER FOR THE PROBLEM THAN TRYING TO FIGURE OUT ANY SOLUTION, AND WAS MAD AT ME FOR EVEN TRYING TO TALK ABOUT IT.

JAG DIDN'T EVER TRY TO FIX PROBLEMS, IT WASN'T HIS NATURE. LITTLE G WOULDN'T EVEN DISCUSS ANY-THING RATIONAL. SLUGGO COULDN'T HAVE CARED LESS. HE WAS LOOKING FORWARD TO FINALLY HAVING AN EXCUSE TO MOVE IN WITH VANESSA, OR MOVE AWAY WITH HER. AND WILLEY, HE WAS JUST ANGRY AND PROUD. HE WAS GOING TO MOVE TO MONTANA AND LIVE WITH HIS GRANDPARENTS ON THE FARM, OR MAYBE GET A NICE QUIET LITTLE HOUSE IN EL CERRITO WITH A WHITE PICKET FENCE. LIVE ALONE, OR WITH SEAN.

I PRESENTED A LIST OF SEVENTEEN OPTIONS. REALISTIC, IMMEDIATE ONES, RANGING FROM CAMPING OUT IN THE CARS TO MOVING INTO EITHER

OF TWO SQUATS IN THE CITY WHICH HAD INVITED US TO MOVE IN. ONE BY ONE, EACH OPTION WAS SHOT DOWN. WE DON'T WANT TO LIVE IN THE CITY. WE DON'T LIKE THOSE PEOPLE. TOO COMPLICATED.

IT WAS PRETTY EASY FOR EVERYONE TO SHOOT DOWN MY IDEAS AND NOT COME UP WITH ANY OF THEIR OWN. THEY SAID, WE'LL FIGURE IT OUT WHEN THE TIME COMES. WHY WORRY ABOUT IT NOW?

I DIDN'T UNDERSTAND. EVICTION WAS JUST DAYS AWAY. I WANTED TO STAY WITH WDH, EVEN IF I HATED THEM. THINGS DIDN'T HAVE TO BE GOOD, AS LONG AS WE WERE TOGETHER. BUT THERE WAS NOWHERE TO STAY, NOT EVEN A FEELING OF TOGETHER-NESS TO WARM AND SHELTER US LIKE A HOUSE.

I WANTED TO PUSH OUR LUCK AND PUT UP BARRICADES, WAIT TO BE FORCIBLY EVICTED. LET THE COPS CARRY US OUT. WE COULD USE THE CRISIS TO OUR ADVANTAGE, AS THE CATALYST WHICH FINALLY SENT US ON TO NEW AND BETTER THINGS. A WAKE-UP CALL, CALLING ON US TO USE OUR CRAZY ENERGY AND OUR TOGETHERNESS AS RESOURCES TO REALLY MAKE A LIFE FOR OURSELVES, ACCORDING TO OUR OWN RULES AND OUR OWN NEEDS. WE COULD FIND AND RESCUE JED, THEN BRING THE BAND ON THE ROAD, BOOKING SHOWS AND WORKING ODD JOBS AS WE WENT. OPEN UP OUR OWN SQUATS SO WE WOULD NEVER HAVE TO PAY RENT. BUILD OUR OWN HOUSE AND OUR OWN GOD DAMN CITY ON THE WATERFRONT. ANYTHING WAS POSSIBLE, AND EVEN EASY, AND WAS REJECTED IMMEDIATELY BY MY ROOMMATES. LIKE ALWAYS AT DUCE, DIFFICULT WAS EASY AND EASY WAS THE HARDEST THING IN THE WORLD.

I HAD TRIED TO KEEP EVERYONE TOGETHER, OR JUST KEEP UP MORALE, BUT THE HOUSE MEETING WAS THE END OF THE LINE FOR ME. I RESIGNED MY JOB AS HOUSE CHEERLEADER AND STARTED MAKING MY OWN ESCAPE PLANS.

93. Storm

LITTLE G ALWAYS SEEMED TO HAVE A DOCTOR'S APPOINTMENT OUT OF TOWN RIGHT WHEN THINGS WERE REACHING BREAKING POINT. IT WAS A COINCIDENCE, OF COURSE, BUT HE COULD LEAVE EARLY IN PREPARATION OR STAY LONGER FOR RECOVERY IF THE STORM HAPPENED TO BE A LITTLE OFF-SCHEDULE, AND JED OR JAG COULD ALWAYS JOIN HIM FREE ON THE GREYHOUND AS AN ATTENDANT. I ALSO LEFT

TOWN WHEN THINGS GOT UNBEARABLE, BUT THEY
HAD A LEGITIMATE EXCUSE. AND SO, WE WAVED
GOODBYE TO LITTLE G AND JAG.
 NOW THERE WERE ONLY THREE OF US LEFT, AND
WE HAD TO FINISH CLEANING UP THE MESS. SLUGGO
LAY ON THE FLOOR FEELING SORRY FOR HIMSELF,
JUST ONE MORE ART SCHOOL DROPOUT. WILLEY LAY
ON THE FLOOR WITH A WHISKEY BOTTLE, PASSED OUT.
I FELT LIKE I WAS STUMBLING THROUGH A STORM
ALL ALONE, THE LAST MAN STANDING. THEN I SAW
A FIGURE IN THE MIST. THE LAST PERSON I EXPECT-
ED TO STILL BE THERE WHEN THE STORM CLEARED.
 ADA AND I LOOKED AT EACH OTHER AND BOTH
SAID THE SAME THING. UH-OH.

94. The End.

 WE TOSSED EVERYTHING OUT THE WINDOW, ALL
THE GARBAGE, ALL THE BROKEN BOTTLES AND
BROKEN DREAMS. STRAIGHT OUT THE WINDOW AND
INTO THE BACK OF WILLEY'S DAD'S PICKUP TRUCK,
PULLED UP ONTO THE SIDEWALK. DROVE IT DOWN TO
THE RAILROAD TRACKS. BY NOW OUR WHOLE HOUSE
WAS DUMPED DOWN BY THE RAILROAD TRACKS, AND WE
MAY AS WELL HAVE MOVED IN THERE, BUT WILLEY AND
SLUGGO SAID NO TO THAT TOO.
 THIS WAS FAREWELL. WE DROVE OFF FROM DUCE
FOR THE LAST TIME. WILLEY AND I IN HIS DAD'S
PICKUP, SLUGGO IN HIS LAST FIAT, AND SEAN IN THE
REAR ON A MOTORCYCLE, MORE SENTIMENTAL THAN
HE LIKED TO LET ON. WE HADN'T GOTTEN A BLOCK
BEFORE WE SAW THE RED, WHITE, AND BLUE LIGHTS
FLASHING.
 THE SAME GODDAMN COPS. HADN'T THEY DONE
ENOUGH ALREADY? THEIR VENDETTA WAS SO OUT OF
HAND THAT THEY WERE HIDING AROUND CORNERS
JUST WAITING FOR US TO MAKE A MOVE. THEY SAW
THE LAST OF OUR POSSESSIONS PILED IN THE BACK OF
THE TRUCK, AND THEY SMILED.
 "LEAVING TOWN?", THEY SAID.
 "NO, OFFICERS", WE SAID, LINED UP AGAINST THE
WALL. "WE WOULD NEVER LEAVE BERKELEY. THIS
IS OUR HOME. WE'RE JUST GOING TO MOVE IN TO
A NEW PLACE".
 "OH REALLY", THEY SAID. "WHERE ARE YOU GOING TO?"
 THAT WAS THE QUESTION I'D BEEN ASKING ALL
ALONG, AND ONE NO ONE HAD AN ANSWER FOR.
WHERE ARE WE GOING? WHERE HAD WE GONE

WRONG? WHERE WOULD WE GO NOW THAT IT WAS ALL OVER? NOT JUST THE HOUSE, BUT EVERYTHING. REALLY OVER, NOT JUST ONE MORE PARTY WITH A TERRIBLE, DISAPPOINTING END. NO PHOTOS TO LOOK BACK ON, NO FUTURE TO LOOK FORWARD TO. I KNEW WE WERE NEVER GOING TO LIVE TOGETHER AGAIN.

BUT I WAS WRONG, SIX TIMES OVER, AND SLUGGO WAS RIGHT WHEN HE TOLD THE COPS, "YOU'LL FIND OUT SOON ENOUGH."

The WDH Stories

(before+after Double Duce)

The Watertower

ON MY FIRST DAY BACK HOME I WAS SO NERVOUS AND EXCITED
THAT I ACTUALLY STARTED SHAKING WHEN I FIRST SAW MY
FRIENDS. I'D BEEN TOO LONG WITH STRANGERS, TOO LONG WITH
INTROVERTED FOLKS WHO DIDN'T TALK MUCH AND LAUGHED
LESS. NOW I WAS BACK IN THE COMPANY OF OLD FRIENDS AND
EVERYONE WAS WONDERFULLY ANIMATED AND BOISTEROUS
AND OUTGOING. WE STAYED UP ALL NIGHT RUNNING AROUND
IN THE RAIN AND DANCING AND TACKLING EACH OTHER.
I LAUGHED SO MUCH IT HURT.

THAT FIRST NIGHT BACK WAS ALSO THE FIRST TIME I WENT
INTO THE OLD WATERTOWER. WILLEY AND RICK HAD FOUND
THE TRAPDOOR SIX WEEKS EARLIER WHEN LOOKING FOR A
PLACE TO BURY RICK'S DEAD FISH. SINCE THEN, THEY HAD
TURNED IT INTO SORT OF A CLUBHOUSE. THE WATERTOWER
HADN'T HELD WATER FOR YEARS. IT WAS SMALL, ABOUT THE
SIZE OF A SMALL SCHOOLBUS TURNED UPRIGHT. IT LOOKED
EVEN SMALLER FROM THE OUTSIDE, SO THAT NO ONE WOULD
SUSPECT A PERSON BEING INSIDE, MUCH LESS TEN CRAZY
PUNKS BEING INSIDE. BUT THERE WE WERE. FIVE OF US
SAT OR STOOD ON THE FLOOR, AND TWO OR THREE PERCHED
ABOVE ON THE RAFTERS. LYING ABOVE THEM IN HAMMOCKS
WERE RICK AND WILLEY. IT WAS WILLEY'S BIRTHDAY PARTY.

THE WATERTOWER WAS RIGHT IN THE MIDDLE OF A PARKING
LOT, DIRECTLY INBETWEEN TWO OF OUR FAVORITE ROTSPOTS.
ONE WAS A SHITTY ALLNIGHT DINER AND THE OTHER, A
MISERABLE HELLHOLE DONUT SHOP. WE'D STARED AT THE
WATERTOWER FOR HALF OUR LIVES. WE'D SEEN IT THROUGH
YELLOW SMOKY WINDOWS ON TOO MANY MORNINGS STILL
AWAKE FROM LAST NIGHT OR THE NIGHT BEFORE THAT.
WE'D SPENT WAY TOO MUCH OF OUR LIVES SITTING IN THE
PLASTIC SEATS, STARING OUT THE WINDOWS OF THE DINER
AND THE DONUT SHOP. WE HAD NICKNAMES FOR ALL THE
WORKERS AND LOCALS. WE'D MEMORIZED EVERY ANNOYING
SAPPY SONG ON THE RADIO IN BOTH PLACES. WE LIKED THE

DINER AND THE DONUT SHOP, BUT WE NEEDED A PLACE TO
CALL OUR OWN. MOST OF ALL, WE NEEDED A PLACE TO SLEEP.
WE'D JOKED ABOUT THE OLD WATERTOWER BEFORE, BUT IT
WASN'T UNTIL NOW THAT WE HAD A WAY IN.

AT THE END OF MY FIRST NIGHT BACK, ME AND WILLEY CRASHED
OUT ON A FRIEND'S FLOOR. THE SECOND NIGHT WE CAMPED OUT
ON THE WATERFRONT, USING HIS COLEMAN STOVE FOR HEAT
AND HOT TEA. THE THIRD NIGHT WE WENT BACK INTO THE
OLD WATERTOWER. IT WAS FREEZING COLD AND WE HAD NO
BLANKETS, BUT WE VOWED TO SLEEP THERE. WILLEY TOOK ONE
OF THE HAMMOCKS, BUT I LAY DOWN ON THE FLOOR CUZ I'M
SCARED OF THOSE THINGS.

WE FELL ASLEEP, BUT WERE WOKEN UP SOON AFTER FROM THE
NOISE OF OUR TEETH CHATTERING. AS MUCH AS WE TRIED, WE
COULD NOT GET BACK TO SLEEP. WE COULD SLEEP HERE IF WE
ONLY HAD SOME BLANKETS, WE SAID. AND SOME SWEATSHIRTS.
AND A SECOND PAIR OF PANTS FOR EACH OF US. AND SOME CANDLES.
AND A DECK OF CARDS. AND SOME KIND OF FOAM PAD OR MATTRESS.

WE DROPPED DOWN FROM THE TRAP DOOR AND WALKED UP THE
STREET LISTING OFF THINGS THAT WOULD MAKE THE WATER-
TOWER SLEEPABLE. LISTING OFF ALL THE COMFORTABLE
THINGS WE DIDN'T HAVE MADE US FEEL A LITTLE LESS
WIMPY FOR CALLING OFF OUR PLAN. WHAT COULD WE DO?
IT WAS FREEZING COLD, THE MIDDLE OF WINTER. SOMEHOW,
IT WAS ALWAYS THE MIDDLE OF WINTER WHEN ME AND
WILLEY ENDED UP HOMELESS AND LOOKING FOR A STEADY
PLACE TO SLEEP.

WE WALKED AND PRETENDED TO BE THINKING. WE WALKED
THE SAME FAMILIAR STREETS WE'D WALKED A THOUSAND
TIMES. THEN WE TURNED A CORNER AND THERE IN FRONT OF
A HOUSE WAS A HUGE PILE OF THE MOST INCREDIBLE TRASH.
EVERYTHING ON OUR LIST WAS IN THE PILE. CLOTHES, FOAM
PADS, CANDLES, EVEN A DECK OF CARDS. IT WAS TOO GOOD
TO BE TRUE. SINCE THEN, I HAVE BEEN IN THAT SAME
SITUATION MANY TIMES AND I HAVE TURNED SO MANY
CORNERS HOPING TO SEE THAT TRASH PILE AGAIN, BUT NO
SUCH LUCK. I GUESS IT WAS A ONE-SHOT DEAL. WE GREEDILY
STACKED UP THE LOOT AND WENT BACK TO THE WATERTOWER.
WE CRAMMED IT ALL IN THE TRAPDOOR, FOLLOWED IT UP,
AND HAPPILY DROPPED OFF TO SLEEP.

OUR SLEEP WAS BROKEN BY THE COLD, THAT TERRIBLE COLD
RIGHT BEFORE DAWN THAT ALWAYS CUTS RIGHT THROUGH
WHATEVER GEAR OR EXTRA CLOTHES YOU HAVE. WE WERE COLD

AND GROGGY BUT FEELING TRIUMPHANT. WE OPENED THE TRAP
DOOR AND LOOKED AROUND THEN QUICKLY JUMPED DOWN AND
ROLLED INTO HIDING POSITION IN THE BUSHES. THE WATER-
TOWER WAS ON THE BUSIEST STREET IN TOWN, AND IT ALSO
HAPPENED TO BE TWO BLOCKS FROM THE POLICE STATION. BUT
THEY NEVER CAUGHT US BECAUSE WE WERE SNEAKY BASTARDS
AND THEY WERE STUPID FAT LAZY JERKS. WE HID IN THE
BUSHES AND LAUGHED AT THE COPS AS THEY DROVE BY.
HA HA HA. WHO DID THEY THINK THEY WERE FOOLING? WE RAN
THE FUCKING TOWN.
 SO WE HAD OUR LITTLE NEIGHBORHOOD AND OUR PLACE RIGHT
IN THE HEART OF THE BEAST. WE DECORATED THE WALLS
AND ADDED BLANKETS AND ODD JUNK. WE SLEPT IN THE
WATERTOWER AND USED THE BATHROOM AT THE DONUT SHOP
AND HAD BREAKFAST AT THE DINER. WE SAT OUT ON THE
WATERFRONT AND RODE BIKES AND STARTED DOOMED ROMANCES
AND HAD THE BEST OF TIMES. THERE WAS SOMETHING
ELECTRIC IN THE AIR AND EVERYONE WAS EXCITED AND CRAZY
AND OUT ALL NIGHT EVERY NIGHT. IT WAS ONE OF THOSE
RARE TIMES YOU SAY "WE" INSTEAD OF "I" AND FEEL PART
OF SOMETHING BIGGER THAN YOURSELF.

Keep the Home Fires Burning

 CHRISTMAS EVE CAME, AND WITH IT, MY ANNUAL CHRISTMAS
CELEBRATION. "JEWS, RELIGIOUS OR NOT, SHOULD RESPECT
THE CHRISTMAS HOLIDAY", SAID THE ADVICE COLUMNIST IN
AN OLD COPY OF THE JEWISH DAILY FORWARD. "BUT TO
CELEBRATE IT WOULD BE LIKE DANCING AT A STRANGER'S
WEDDING". ALTHOUGH I LIKE THE IDEA OF DANCING AT A
STRANGER'S WEDDING, I STILL WOULDN'T THINK OF CELEBRAT-
ING CHRISTMAS THE TRADITIONAL CHRISTIAN WAY. MOST
JEWS GO OUT TO CHINESE FOOD AND MOVIES ON CHRISTMAS
DAY. IT IS ONE OF THE BIGGEST JEWISH TRADITIONS. BUT
I HAVE MY OWN CHRISTMAS TRADITION.
 EVER SINCE I WAS A LITTLE KID I'VE SPENT CHRISTMAS DAY
WALKING THE STREETS WITH ALL OF THE JEWS, MUSLIMS,
AND ATHEISTS, FEELING A COMMON BOND WITH ALL THREE.
IT IS ONE OF THE STRANGEST DAYS TO BE OUT WALKING
BECAUSE THE STREETS ARE WONDERFULLY QUIET AND
EMPTY, BUT THE FEW PEOPLE OUT ARE INCREDIBLY FREAKED
OUT AND MOODY. I GET FREAKED OUT AND MOODY TOO. I

LIKE HAVING A HOLIDAY WHICH IS GLOOMY AND HOPELESS INSTEAD OF THE USUAL FORCED FAKE HAPPINESS AND CHEER. EVERY YEAR, I LOOK FORWARD TO HAVING A MISERABLE CHRISTMAS. IF POSSIBLE, I STAY UP ALL NIGHT ON CHRISTMAS EVE SO AS TO BE ALL THE MORE MISERABLE AND EMOTIONALLY FRAGILE ON CHRISTMAS DAY.

THIS YEAR IT WAS HARDER TO BE MISERABLE, BUT I GOT IT AFTER A WHILE. I WALKED AROUND ALL DAY CHECKING OUT THE EMPTY STREETS AND MOODY FREAKS. THEN LATE AT NIGHT I MET UP WITH WILLEY AND THE OTHERS AT THE WATERTOWER. THE NIGHT BEFORE WE HAD FOUND A CHRISTMAS TREE AND SOMEHOW MANAGED TO PUSH IT UP THROUGH THE TINY TRAP DOOR. DURING THE DAY WHEN I WAS OUT WANDERING, THEY HAD DECORATED THE TREE USING DONUTS, ASHTRAYS, AND BEER CANS AS ORNAMENTS. NOW THERE WERE SIX OF US THERE PLUS TONS OF CLOTHES AND BLANKETS, TWO HAMMOCKS, ONE MATTRESS, AND A CHRISTMAS TREE. ALL THAT IN ONE WATERTOWER. IT WAS BIGGER THAN IT LOOKED FROM OUTSIDE, BUT STILL PRETTY DAMN SMALL.

MIDNIGHT PASSED AND IT WAS COLD AND WE WERE DRUNK AND I WAS STILL PRETTY MOODY AND EXHAUSTED FROM CHRISTMAS. WE DECIDED TO SPEND THE NIGHT AT SHEN'S HOUSE, WHERE THERE WAS HEAT AND SPACE. SO WE LEFT THE WATERTOWER. IN THE HURRY, WE FORGOT SOMETHING.

THE NEXT MORNING WE WERE IN THE DINER HAVING GREASY POTATOES AND GREASY COFFEE. IT WAS A WHILE BEFORE FLY LOOKED OUT THE DINER WINDOW AND DROPPED HER JAW. SHE POINTED AND WE ALL STARED IN DISBELIEF. THEN WE ALL LAUGHED NERVOUSLY. THEN WE STARED IN DISBELIEF AGAIN. THEN WE DECIDED IT WOULD BE BEST TO LAY LOW FOR A WHILE. WE HAD ACCIDENTALLY LEFT THE CANDLES BURNING IN THE WATERTOWER. THE CANDLES HAD LIT THE CHRISTMAS TREE WHICH HAD LIT EVERYTHING ELSE. NOW ALL THAT WAS LEFT WAS A BIT OF CHARCOAL AND SOME CAUTION TAPE. OOPS.

Christmas

WE FIRST KISSED ON CHRISTMAS EVE. THE OTHER PERSON IN THE BED GOT UNCOMFORTABLE AND HAD TO LEAVE. IT'S ALWAYS AMAZING THE FIRST TIME YOU KISS SOMEONE, BUT THIS WAS REALLY AMAZING. THE FIRE DEPARTMENT HAD TO COME PUT OUT THE BLAZE. REALLY. WE LEFT THE CANDLES

LIT AND BURNED MY HOUSE DOWN TO THE GROUND ON CHRISTMAS DAY.

SHE TACKLED ME, ROLLING AROUND ON THE STREETS AND IN THE PIT, RUNNING AND BIKING AND SWAPPING SPIT. WE GAVE EACH OTHER PET NAMES AND FAKE BLACK EYES. NOTHING WILL GET YOU AS MANY DIRTY LOOKS ON THE STREET AS WALKING ARM IN ARM WITH A RAD GIRL WITH A FAKE BLACK EYE.

THREE YEARS LATER IN ANOTHER TOWN EVERYTHING WAS GOING TERRIBLY WRONG, WORSE THAN EVER BEFORE, AND AFTER WORKING ALL NIGHT AT MY SHITTY JOB I WENT TO VISIT MIKE AT THE MAGAZINE STORE. TURNED OUT HE WASN'T THERE THAT DAY, AND SOMEHOW THAT WAS JUST THE LAST THING THAT COULD GO WRONG, THE VERY LAST STRAW. I WAS IN TEARS AND THOUGHT I WAS SEEING THINGS WHEN OUT OF THE BLUE, ON THE STREET, SHE APPEARED, NURSING A 64 OUNCE BOTTLE OF O.E.. AT 8:00 A.M. THAT SEEMED SORT OF STRANGE, BUT WHAT THE HELL, I WAS THIRSTY AND SHE WAS TIRED FROM A LONG NIGHT HOPPING TRAINS. SOON WE WERE AT MY BASEMENT TOMB, UNBELIEVABLY DRUNK, AND JUST LIKE CHRISTMAS EVE AGAIN HER FRIEND HAD TO LEAVE THE ROOM.

I THOUGHT SHE WAS MY SAVING GRACE, COME TO LIFT ME OUT OF MY PATHETIC, HELLISH STATE, BUT SHE LEFT THAT DAY AND DIDN'T CALL AGAIN. A WEEK LATER I SAW HER AT THE CAFE AND SAID I NEEDED HELP BAD, BUT SHE SAID SHE HAD OTHER PLANS. I WENT ACROSS TOWN AND CHECKED INTO THE HOSPITAL. I WAS A WRECK. THE DOCTOR ASKED IF I HAD BEEN THINKING OF KILLING MYSELF. I SAID YES.

YOU NEVER FORGET THE PEOPLE WHO STAND BESIDE YOU IN YOUR TIME OF NEED. UNFORTUNATELY YOU NEVER FORGET AND NEVER FORGIVE THE ONES WHO WALK AWAY. IF SHE HAD ONLY STOOD BESIDE ME BACK THEN MAYBE EVERYTHING BETWEEN US WOULD STILL BE THE SAME. WE COULD CELEBRATE OUR ANNIVERSARY TONIGHT, AND I COULD WAKE UP BY HER SIDE ON CHRISTMAS DAY.

This aint no @?#! Zoo

IT WAS RAINY SEASON AND THE RAIN WASHED THE SURFACE
SCUM OFF THE STREETS. ALL THE WEEKEND DRUG DEALERS
AND THE PANHANDLERS WITH MORE MONEY THAN ME AND ALL
THE POSERS AND FAKES AND FOOLS, THEY ALL STAYED HOME.
WHAT WAS LEFT ON THE STREETS WAS AN ODD COLLECTION OF
THE MOST INTERESTING, SINCERE, AND GENUINE PEOPLE AROUND.

EVERYONE WAS FRIENDLY IN THE RAIN. I'D GO DOWNTOWN AND
SIT AROUND ALL DAY BY MYSELF JUST WATCHING THE BUILDINGS
AND OCCASIONALLY MEETING SOMEONE ELSE PRETENDING TO BE
ANTI-SOCIAL. ONE GUY NAMED COACH EXPLAINED HOW EVERY-
THING IN LIFE RELATED TO STAR TREK. ANOTHER GUY TRADED
HIS MAG FOR ONE OF MINE. HIS WAS A DETAILED PLAN OF
EXACTLY WHAT WE NEEDED TO TAKE WITH US IN THE SPACESHIPS
WHEN IT WAS TIME TO ABANDON EARTH. I BROUGHT IT BACK
TO MY HOUSE AND STUDIED IT AND TOOK SOME NOTES. WHEN I
SAW THE GUY AGAIN I TOLD HIM I LIKED HIS PLAN EXCEPT FOR A
FEW THINGS. MELTING DOWN THE WEIGHT LIFTING EQUIPMENT
AND TURNING IT INTO FARMING TOOLS ONCE WE GOT TO A NEW
PLANET, THAT WAS A GOOD IDEA. BUT COCA LEAVES AND PARSNIPS
INSTEAD OF, SAY, PENICILLIN AND WHEAT, WAS A BAD IDEA. HE
JUST STOOD THERE IN SHOCK, NODDING IN AGREEMENT. I WAS
OBVIOUSLY THE FIRST PERSON TO READ HIS PLAN AND RETURN TO
DISCUSS THE FINE POINTS.

SLUGGO LIVED IN A SQUAT RIGHT BY DOWNTOWN, AND SOMETIMES
I'D DUCK IN THERE TO ESCAPE THE RAIN, AND ATTEMPT TO GET
SOME WRITING DONE. THE HIDDEN BACK DOOR LED TO THE FIRST
FLOOR, WHICH WAS VACANT. THE TRAPDOOR LED TO THE SECOND
FLOOR WHICH WAS OCCUPIED BY PISSBUCKETS AND THE PIGEONS
WHO STARED AT YOU WHILE YOU PEED. THE STAIRS LED TO THE
THIRD FLOOR, WHERE SLUGGO AND SAL LIVED. THE HOUSE HAD
BEEN PARTLY DESTROYED BY A FIRE, THEN PARTLY REMODELED,
AND NOW TOTALLY ABANDONED FOR QUITE SOME TIME. SLUGGO
AND SAL HAD FIXED IT UP SO BEAUTIFULLY, BUILDING A KITCHEN,
PUTTING UP PICTURES, PAINTING MURALS. GIVE THEM A NICE HOME
AND THEY WOULD TRASH IT, REDUCE IT TO RUBBLE. BUT GIVE
THEM RUBBLE AND TRASH, AND THEY HAD TURNED IT INTO
ONE OF THE NICEST, COOLEST, MOST BEAUTIFUL HOMES I HAD
EVER SEEN.

ONE DAY I WAS AT THE SQUAT WITH SLUGGO, AND WE WERE

TRYING TO WRITE. WE SAT IN THE SUNNIEST ROOM, THE ONE
WITH THE SKYLIGHT, AND SPREAD OUR NOTES EVERYWHERE.
I WAS SICK AND FEVERISH FROM SITTING IN THE RAIN TOO
MUCH. WE BOTH FELT LIKE HELL. SLUGGO DECIDED TO GO OUT
TO TRY TO FIND THE CRACKHEAD WHO STOLE HIS BIKE. I SAT
ALONE IN THE SQUAT, WRAPPED UP IN BLANKETS, DRINKING TEA
AND CROSSING OFF LINES AND CRUMPLING UP PAPER. I LOOKED
OUT THE WINDOW AND SAW SOMETHING ON THE BACK DECK.
IT WAS A PEACOCK. THEN TWO PEACOCKS. I CHEWED MY
NAILS AND MADE FUNNY WORRIED FACES, LOOKING AROUND
THE ROOM HOPING SOMEONE ELSE COULD CONFIRM WHAT
WAS HAPPENING. BUT NO ONE ELSE WAS HOME. I STARED
AT THE PEACOCKS IN DISBELIEF, AND THEY STARED BACK
AT ME. IT WAS WEIRD ENOUGH THAT PEACOCKS WERE
WANDERING AROUND, BUT IT WAS TOO STRANGE THAT THEY
WERE ON THE DECK, THREE FLOORS UP, STARING AT ME.
IN FACT, PEACOCKS WERE THE WORST THING THAT COULD
POSSIBLY SHOW UP AT A SQUAT. SLUGGO AND SAL HAD TAKEN
EVERY PRECAUTION TO REMAIN DISCREET AND SECRETIVE
ABOUT LIVING THERE, AND NOW THERE WERE PEACOCKS
ON THE PORCH.
 I FIGURED MAYBE THEY WERE JUST THIRSTY, SO I FILLED
UP A DISH OF WATER. I OPENED THE BACK DOOR QUIETLY
SO AS NOT TO SCARE THEM OFF. THE PEACOCKS WERE NOT
SCARED. THEY CHARGED TOWARDS ME SQUAWKING, TRYING TO
GET IN THE DOOR. I JUMPED BACK INSIDE AND BARRICADED
THE DOOR. I TRIED TO IGNORE THEM AS THEY BANGED ON
THE WINDOWS. IT IS HARD TO WRITE WHILE IGNORING
PEACOCKS. I LOOKED AROUND AND LAUGHED. I KNEW SLUGGO
WOULD NEVER BELIEVE ME WHEN HE GOT HOME.

You Just Don't Do That

NOW IT WAS ANYTHING GOES, AND OAKLAND WAS
BURSTING AT THE SEAMS. I'D NEVER SEEN SO MUCH
COLOR AND MOVEMENT AND SEX. IN EVERY ROOM,
ON EVERY WALL, AND EVERY WEEKEND AT EITHER
CLUB. EVERYTHING AND EVERYONE WAS COVERED IN
PAINT, SWEAT, TRINKETS AND TRASH. EVERYONE WAS
DANCING, NOT JUST TO HAPPY UPBEAT STUFF BUT ALSO
TO THE MOST BRUTAL, RAGING HARDCORE. BOUNCING
ON THEIR HEADS, WRITHING ON THE GROUND, LITER-

ALLY FUCKING ONSTAGE WHILE THE BAND PLAYED ON.

WE WERE DRINKING ON THE PORCH, IT WAS RAINING THROUGH THE ROOF, AND THE POWER KEPT GOING ON AND OFF. BEER, DRUGS, SPRAYPAINT, PISS BOTTLES, MOLDY CLOTHES, FREEZING COLD, HANGING OUT, AND ROLLING WITH YOUR RIB IN THE BLUEDUSTY TWILIGHT. WE HAD IT ALL. CANDLES, TATTOOS, FAKE GLASSES, AND EVERYWHERE YOU WENT, THE SOUND OF SWEET, SWEET MUSIC.

THE BAND PLAYED STEELY DAN SONGS WHILE DOUG BRODY SANG AND, SHITFACED DRUNK, TOLD EVERYONE WHO WAS WALKING OUT TO WRITE THEIR NAME DOWN SO HE COULD BEAT THEM UP LATER. WHILE I WAS WATCHING PEOPLE LINE UP TO PUT THEIR NAME ON THE LIST, DOUG SNUCK UP AND FLATTENED ME. JUST OUR WAY OF DANCING. I CROUCHED IN A CORNER, PREPARING MY ATTACK, BUT HE DOUBLED BACK AND STEAMROLLED ME AGAIN, WITH A SMALL BUT HEAVY TANGLE OF DANCING FREAKS TRAMPLING ME IN HIS WAKE. FINALLY I PICKED HIM UP, STILL SINGING, AND, SEEING SLUGGO CALMLY ENJOYING A CIGARETTE AT A NEARBY TABLE, RAN AND JUMPED. CHAIRS AND TABLES WENT FLYING THROUGH THE AIR, FOLLOWED BY ME, DOUG, AND SLUGGO. I WAS LYING ON THE FLOOR WHEN THE CLUB OWNER CAME OVER AND TOLD ME TO GET THE FUCK OUT. ON MY WAY TO THE DOOR I LOOKED BACK AT DOUG, AND HE WAS STILL SINGING. HE HADN'T EVEN NOTICED.

THERE WERE PUNKHOUSES NAMED AFTER EVERY STATE IN THE UNION, EXCEPT FOR NEW MEXICO. NEW MEXICO HAD A VAN, WHICH THREE PEOPLE LIVED IN. THERE WERE WEEKENDS EVERY OTHER DAY, AND TEN SHOWS EVERY WEEKEND. AT ONE, I MADE A CONCERTED EFFORT TO GET DRUNK ENOUGH TO PUKE, BUT ONLY ENDED UP KICKED OUT OF ANOTHER CLUB, THEN IN BED FOR THREE DAYS FROM ALCOHOL POISONING. ELSA JOINED ME, BUT WE WERE TOO DRUNK TO EVEN MOVE.

ALL THE RULES WERE OUT THE DOOR. JIMMY DUG UP A BODY FROM THE GRAVEYARD AND FIRST BROUGHT IT OVER TO ONE OF THE HOUSES, THEN HID IT AT THE CLUB. EVERYONE WAS OUTRAGED. NOT AT JIMMY FOR DIGGING UP A STIFF, BUT AT THE FACT THAT SOMEONE AT THE HOUSE HAD THE NERVE TO CALL THE COPS. THEN ERIC BROKE DANA'S NOSE

SO BAD SHE HAD TO HAVE RECONSTRUCTIVE SURGERY.
WHEN SHE CALLED THE COPS, SHE WAS SHUNNED
BY NEARLY EVERYONE. "YOU JUST DON'T DO THAT".
I WOKE UP FROM MY STUPOR TO FIND THAT MY OLD
FRIENDS HAD INVITED ERIC TO STAY AT THEIR PLACE
TO HIDE FROM THE POLICE. THAT WAS ENOUGH
TO SOBER ME UP FOR GOOD.

Letter from Sluggo

DEAREST AARON,
I COULDN'T DECIDE WHAT I WAS GOING TO SAY IN
THIS LETTER. I'VE BEEN THINKING ABOUT IT FOR A FEW
DAYS. AT FIRST I WAS GOING TO TELL YOU HOW EVERY-
THING WAS SHIT, HOW MY MAGAZINE WAS LARGELY
IGNORED, HOW I DESPISED EVERYONE, HOW FUCKING
BROKE I WAS. THE NEXT DAY I FELT BETTER AND I WAS
GOING TO WRITE ABOUT HOW INSPIRED I WAS, AND TELL
YOU ABOUT MY PLANS. TODAY I'M IN MY ROOM LISTENING
TO THE DICKS.
THINGS ARE CHANGING AROUND HERE. THINGS CHANGED
MORE THAN I COULD HAVE EVER IMAGINED. AND THEY
CHANGED AT THE WORST POSSIBLE TIME, WHEN I
WASN'T LOOKING. AFTER I FINISHED THE MAGAZINE,
I THINK I FORGOT WHAT I WAS SUPPOSED TO BE DOING.
I DIDN'T WALK ON THE RAILROAD TRACKS.
I DIDN'T DRINK ENOUGH COFFEE.
I WORKED. I SLEPT. I DIDN'T PLAY MY DRUMSET.
I DIDN'T WRITE. NOT EVEN ONE WORD.
TODAY I FEEL BETTER. A FEW DAYS AGO, I GOT A
TATTOE. SAL GAVE IT TO ME WITH A SEWING NEEDLE.
IT LOOKS LIKE THIS:
AFTER SHE DID IT, I KEPT LOOKING AT IT BECAUSE
I THOUGHT IT WAS MISSPELLED. I MUST HAVE SOME
SORT OF PERPETUAL EDITOR'S SYNDROME.
I BOUGHT A 20 YEAR OLD TIMEX WIND-UP WRIST-
WATCH FROM A GUY WHO SMELLED LIKE CISCO AT
THE FLEA MARKET. THEY PAINTED OUR OLD SQUAT
YELLOW. IT LOOKS DISGUSTING.

Letter from Sluggo #2

DEAR AARON,

IT'S COLD AND RAINY OUTSIDE TONIGHT. THE RADIO SAID IT WAS A LUNAR ECLIPSE AND I WENT OUTSIDE AND LOOKED AT THE MOON. IT LOOKED LIKE IT ALWAYS DOES. WINTER IN BERKELEY HAS BEGUN ONCE AGAIN.

I'M WRITING A BOOK OF SHORT STORIES, SORT OF. SO FAR I HAVE THE MAKINGS OF FOUR STORIES; UNCLE JESSE, A STORY ABOUT HANGIN OUT WITH TWO TRAMPS IN THE JUNGLE IN ROSEVILLE, A STORY WHERE ME AND MY FRIENDS OVERTHROW AND DESTROY TWO EVIL BERKELEY BUSINESSES, AND THE EPIC TALE OF GETTING ON G.A. IN S.F. A YEAR AGO. WRITING AND EDITING THESE STORIES SHOULD KEEP ME BUSY FOR AWHILE. IT'S GOOD TO BE WRITING AGAIN. IT GIVES ME A SENSE OF PURPOSE.

DURING THE WEEK, I MAKE DELIVERIES ON MY BICYCLE. I GOT A STEADY GIG WITH A BERKELEY COMPUTER SOFTWARE DEVELOPER AND THE CITY OF BERKELEY. MOST OF THE DELIVERIES TAKE ME BETWEEN NORTH BERKELEY (ROSE+SHATTUCK) AND SOUTHSIDE (DWIGHT+ TELEGRAPH) OR FROM BERKELEY CITY HALL (THE OLD ONE) TO THE OAKLAND COURTHOUSE (FALLON STREET, BY THE LIBRARY).

ABOUT A MONTH AGO, WHEN THAT CHINESE SPACESHIP WAS SUPPOSED TO CRASH, SAL AND I BROUGHT BEER AND A RADIO TO THE WATERFRONT AND WAITED FOR THE SPACESHIP TO CRASH ON THE BEACH. WE WAITED ABOUT AN HOUR, LISTENING TO THE REPORT ON THE RADIO AND DRINKING HARLEY DAVIDSON BEER. THEN IT HAPPENED, THE FUCKING CHINESE SPACESHIP CRASHED ON THE FUCKING WATER- FRONT. INCREDIBLE. WE GO AND LOOK AT IT EVERY WEEKEND. I EVEN STOLE A FEW PIECES OF IT FOR MY WALL.

WELL, WILLEY SAYS YOU'RE COMING HOME SOMETIME. THAT'S GOOD. I'LL EXPECT YOU. I'LL HAVE GREEN TEA WAITING FOR YOU, SUPER EXTRA FUCKING HOT WITH SUGAR HOW YA LIKE IT. OH YEAH, I SAVED A COUPLE THINGS FOR YOU, OR TRIED. UHH, REMEMBER WHEN

YOU GAVE ME YOUR OLD SHOES AND TOLD ME TO SAVE THEM. WELL I DID. I STILL HAVE THEM. AND REMEMBER WHEN YOU TOLD ME TO SAVE YOUR BIKE FOR YOU. WELL, UHH, I TRIED AND UHH, I TOOK IT TO WILLEY'S FOR SAFEKEEPING AND UHH, WARREN TOOK IT APART INTO TWENTY MILLION PIECES WHILE HE WAS ON SPEED. SORRY. BUT I DID FIND A TEN SPEED THAT'S ACTUALLY YOUR SIZE. AND IT WORKS, SO I'M SAVING IT FOR YOU AT MY HOUSE.

O.K. AARON, I HOPE THIS LETTER WAS WORTH WALKING TEN MILES FOR. I TRIED, PAL.

YOURS FOR THE REVOLUTION,
SLUGGO

P.S.: I MISS YA MAN

Sluggo

I SHARED A SMALL ROOM WITH SLUGGO. EVERY NIGHT WHILE I WAS IN THE MIDDLE OF IMPORTANT WORK, SLUGGO WOULD COME HOME AND TELL ME ABOUT HIS DAY. HIS STORIES WERE POINTLESS, ENDLESS, AND LONGER THAN THE DAY ITSELF. HE COULD TAKE FIFTEEN MINUTES TO EXPLAIN DRINKING A CUP OF COFFEE, AND WOULD DETAIL EVERY STREET HE WALKED DOWN AND EVERY PERSON HE'D SEEN.

I TRIED TO LISTEN, GRINDING MY TEETH AND CLUTCHING MY DESK IMPATIENTLY. FINALLY I WOULD SNAP AT HIM TO GET TO THE POINT, AND HE WOULD LAUGH, SHRUG, AND SCRATCH HIS HEAD, THEN TELL ME AN UNRELATED STORY ABOUT CLEVELAND. THIS CONTINUED NIGHT AFTER NIGHT, WITH EACH NEW DAY'S STORIES NOT MUCH DIFFERENT FROM THE PREVIOUS DAY. POSSIBLY EVEN LONGER BECAUSE HE COULD REMINISCE ABOUT NOT ONLY CLEVELAND, BUT ALSO YESTERDAY OR LAST WEEK IN BERKELEY. IT WAS DRIVING ME CRAZY. SOMETHING HAD TO BE DONE.

SLUGGO CAME HOME ONE NIGHT AND I STOPPED HIM RIGHT AS HE WAS ABOUT TO LAUNCH INTO HIS DAY, STARTING WITH WAKING UP AND ENDING WITH ME FALLING ASLEEP. STOP, I SAID. JUST TELL ME WHAT IT IS YOU'RE TALKING ABOUT

AND SKIP ALL OTHER DETAILS. HE LOOKED AT ME CONFUSED.
I SAID, IF YOU'RE GOING TO TELL ME A LONG ENDLESS STORY
JUST SAY "LONG ENDLESS STORY", AND THAT'S ALL. IF IT'S A
DETAILED ACCOUNT OF NOTHING, JUST SAY THAT. IF YOU ARE
WORRIED ABOUT US GETTING KICKED OUT OR ARE GOING TO
COMPLAIN ABOUT YOUR JOB, JUST GIVE ME THE PUNCH LINE.

FROM THEN ON, THINGS WENT SMOOTHLY, AND I EVEN LOOKED
FORWARD TO SLUGGO'S NIGHTLY HOMECOMING. "ME EMBROILED
IN WORK, NOT ASKING ABOUT YOUR LONG AND STUPID DAY", I
WOULD SAY. "ME TAKING YOUR GREETING AS AN INVITATION TO
RAMBLE ON ENDLESSLY", SAID SLUGGO. "FEIGNED INTEREST," I
WOULD SMILE, "WHILE ACTUALLY HARBORING A DEEP GRUDGE THAT
YOU ARE KEEPING ME FROM MY IMPORTANT WORK". "LONG
BORING STORY ABOUT MY DAY, SPRINKLED WITH BITTER AND
GOSSIPY INSIGHTS ON OUR COMMON FRIENDS", HE WOULD REPLY.
"ANYTHING JUICY?". HE SHOOK HIS HEAD NO, AND THEN WE
BOTH WENT ABOUT OUR WORK QUIETLY.

IN THE MORNING, SLUGGO WOULD WAKE UP IN THE TOP BUNK
AND I IN THE BOTTOM. "LONG RECOUNT OF DISTURBING DREAM",
HE'D SAY. "YOU OKAY AND WANT PANCAKES?", I'D ASK, AND HE'D
SAY "YES, BUT ATTEMPT TO STALL YOU WITH BOYHOOD STORY OF
COLORADO". "ME STAYING AND LISTENING INTENTLY WITH
UNDIVIDED ATTENTION", I'D SAY, WHILE CLOSING THE DOOR AND
HEADING OUT TO THE KITCHEN. VISITORS TO OUR ROOM WERE
VERY CONFUSED.

ONE AFTERNOON, SLUGGO AND I WERE ON THE COUCH, SMOKING.
HE TURNED TO ME, "CONFIDING IN YOU MY USUAL SECRETS AND
PROBLEMS". I PUT MY HAND ON HIS SHOULDER, "MY WISE AND
SAGELY ADVICE WHICH HAS BEEN PROVEN TIME AND AGAIN
TO INCREASE YOUR PROBLEMS AND DESTROY YOUR LIFE".
HE LAUGHED, AND WITH HIS CIGARETTE, ACCIDENTALLY SET
FIRE TO A PILE OF GARBAGE BEHIND THE COUCH.

"URGENT WARNING OF DANGER!", I CALLED OUT. MISTAKING
MY FERVOR AND NOT NOTICING THE GROWING FIRE, HE YELLED
"MISUNDERSTANDING YOUR URGENCY AND RELATING IT TO A
BORING, UNRELATED STORY ABOUT CLEVELAND!". WE REALLY HAD
THE SYSTEM DOWN PAT. HAD I SAID "THERE IS A FIRE BEHIND
YOU", HE REALLY WOULD HAVE MISUNDERSTOOD AND TOLD ME

ABOUT THE TIME THE RIVER IN CLEVELAND CAUGHT FIRE
BECAUSE IT WAS SO TOXIC. BUT IN THE MEANTIME, THE FIRE
RIGHT BEHIND HIM WAS GETTING BIG.

I GRABBED HIM AND SAID "URGENT WARNING OF DANGER
EXTREMELY NEARBY, REQUIRING IMMEDIATE ACTION". HE
LAUGHED AND SAID "ME LAUGHING AT YOUR USUAL PARANOIA.
WAIT, DO YOU MEAN, LIKE, REAL DANGER NOW?.". HE TURNED
AROUND AND SAW THE FIRE AND WE BOTH LAUGHED AS WE
RAN TO FILL POTS AND PANS WITH WATER AND EXTINGUISH
THE BLAZE THAT ALMOST BURNED DOWN OUR ROOM.

Gripes

ONE THING THAT SUCKS ABOUT MY FRIENDS BECOMING TRAIN HOPPING
EXPERTS IS THAT THEY RUIN THE SIMPLE PLEASURE OF WATCHING
A TRAIN PASS BY TELLING ME ALL THE TECHNICAL INFORMATION I
DON'T WANT TO KNOW. WHERE THE TRAIN IS HEADING, WHAT KIND
OF LOAD IT'S CARRYING, EVEN WHAT YEAR AND MODEL OF LOCOMOTIVE.
IT TAKES AWAY ALL THE MYSTERY AND CHARM THAT TRAINS HAVE
IN MY MIND. AND NOW WHEN I THROW ROCKS AT THE TRAIN, MY
FRIENDS GET MAD. THEY SAY I MIGHT ACCIDENTALLY HIT ONE OF
THEIR FELLOW HOBOS. SO, I'LL SAY NOW, IF YOU HOP A TRAIN
AND I THROW A ROCK AND IT HITS YOU, I AM REALLY SORRY,
BUT I JUST CAN'T STOP. LIFE WITHOUT THROWING ROCKS AT
TRAINS IS A PALE IMITATION OF LIFE.

ANOTHER SUCKY THING IS PEOPLE WHO YELL AT YOU FOR RIDING
YOUR BIKE ON THE SIDEWALK. WILLEY SAYS NOT TO WORRY ABOUT
THEM BECAUSE THEY ARE THE SAME PEOPLE WHO TRY TO RUN
YOU OVER IN THEIR CARS WHEN YOU RIDE IN THE STREET. THOSE
PEOPLE ARE ESPECIALLY COMMON IN CHICAGO, LAND OF THE
DEADLY SEVEN-WAY INTERSECTION. THAT I SURVIVED TEN DAYS
THERE ON A BIKE, I STILL CANNOT BELIEVE.

I THINK IT COULD BE SHOWN IN SOME STUDY OF DEMOGRAPHICS
THAT CERTAIN ANNOYING CHARACTER TRAITS ARE MORE
PROMINENT IN CERTAIN AREAS. FOR INSTANCE, PER CAPITA, I
THINK THE EAST COAST HAS MORE PEOPLE WHO THROW AWAY
PENNIES. THE WEST COAST HAS MORE PEOPLE WHO AGREE WITH

YOU BEFORE YOU HAVE SAID ANYTHING, AND PEOPLE WHO SPEND ALL OF THEIR WAKING HOURS TALKING ABOUT THEIR DREAMS. CLEVELAND AND WASHINGTON D.C. ARE AN EXCEPTION TO THE RULE, EACH WITH AN EQUAL NUMBER OF DERANGED KNIFE-WIELDING MANIACS. D.C. IS THE WORSE OF THE TWO BECAUSE PER CAPITA, IT HAS THE MOST CHRISTIAN MIMES.

ONE LAST THING THAT I WOULD LIKE TO COMPLAIN ABOUT, AND THIS ONE IS WORSE THAN EVEN TIN FOIL ON YOUR FILLINGS. IT'S WHEN YOU'RE WALKING DOWN UNIVERSITY AVENUE AT MIDNIGHT ON YOUR WAY HOME, AND THE GUY WITH ONE ARM NEAR JAY VEE STOPS YOU AND ASKS YOU FOR A SMOKE, AND YOU GIVE HIM ONE, BUT THEN WHEN YOU ARE GIVING HIM A LIGHT HE TRIES TO STALL YOU FOR TIME WHILE YOUR BACK IS TURNED. HE LETS OUT THIS BIG WHISTLE CUZ HE SAYS THERE IS A BEAUTIFUL LADY PASSING BY DOWN THE BLOCK, BUT YOU KNOW IT'S MIDNIGHT ON LOWER UNIVERSITY AND THERE'S NO BEAUTIFUL LADY, ONLY THE GUY WITH ONE ARM'S GANG OF MURDEROUS THUGS WAITING FOR THE SIGNAL THAT A SUCKER IS COMING DOWN THE BLOCK. I HATE THAT ALMOST MORE THAN ANYTHING ELSE, CUZ THEN YOU HAVE TO CROSS THE STREET AND WALK REALLY REALLY FAST WHILE LOOKING LIKE YOU'RE WALKING SLOW, AND BY THE TIME YOU GET HOME YOU'RE A NERVOUS WRECK.

Houseguests

SERGIE WAS SURPRISED TO FIND JUSTINE ON TOP OF ME ON THE KITCHEN FLOOR WITH OUR BELTS FASTENED TOGETHER. JUSTINE WAS THE GIRL HE HAD BEEN TRYING TO SCAM ON ALL NIGHT. JUSTINE ALSO HAPPENED TO BE THE GIRL I WAS INVOLVED WITH. MAYBE SERGIE WOULD HAVE KNOWN WE WERE HAVING A FLING IF HE HADN'T BEEN SLEEPING SO MUCH. HE HAD SLEPT ALL THROUGH THE NIGHT AND ALL THROUGH THE DAY. HE WAS MY "FRIEND" FROM TEXAS WHO HAD COME TO STAY. I HAD LEFT HIM THE ONLY KEY. HE SLEPT HAPPILY INSIDE, IN MY BED, WHILE I POUND-ED AND YELLED AT THE DOOR, LOCKED OUT.

STELLA LEFT A MEAN NOTE SAYING I WAS A HYPOCRITE AND NOT AT ALL THE IMAGE I PRESENTED IN MY WRITING. SHE WAS DISAPPOINTED. I WAS SORRY TO DISAPPOINT HER. I CHECKED MY BACK ISSUES TO SEE WHEN I HAD

WRITTEN ANYTHING INVITING PEOPLE TO STAY AT MY
HOUSE FOR A WEEK, BRING GUESTS, EAT MY FOOD, AND
DISREGARD MY ATTEMPTS AT EITHER CONVERSATION OR
A MUTUAL UNDERSTANDING. IT WAS A STRESSFUL TIME
AND I HAD ASKED THEM TO STAY AWAY FOR ONE NIGHT.
WASN'T GETTING KICKED OUT TO SLEEP ON THE STREETS IN
THE COLD ACTUALLY PRETTY CONSISTENT WITH MY WRITING?
THEY IGNORED MY PLEA AND SHOWED UP BACK AT THE HOUSE.
HADN'T I WRITTEN SOMETHING ABOUT PEELING OFF SOME-
ONE'S SKIN AND ROLLING THEM IN SALT? I WAS DISAPPOINTED
TOO. DISAPPOINTED THAT SHE WASN'T INTERESTED IN
FINDING OUT WHAT I WAS LIKE IN REAL LIFE, EXCEPT
WHERE IT CONTRADICTED HER IDEA OF HOW I WAS
SUPPOSED TO BE.

HANS, ERNST, AND BRIDGET CAME TO STAY. GERMANS. THEY
WERE SURPRISED TO FIND THAT MY HOUSE WAS A CRAMPED
SHITHOLE AND MY ROOMMATES WERE INSANE. I WAS
SURPRISED AT THEIR SURPRISE. HAD I NOT WRITTEN AND
TOLD THEM, "MY HOUSE IS A CRAMPED SHITHOLE AND MY
ROOMMATES ARE INSANE"? YES. THEN I HAD WRITTEN AND
SAID, "MY HOME IS YOUR HOME, BUT WHEN YOU GET HERE
YOU'LL WISH IT WASN'T". I HAD TALKED TO THEM ON THE
PHONE AND SAID, "THIS IS THE WORST POSSIBLE TIME TO COME
AND STAY. PLEASE COME AND STAY". YET, WHEN THEY WALKED
IN THE DOOR, THEIR EYES GREW WIDE TAKING IN THE PICTURE
THAT WAS FOUR RUINED LIVES SHARING A ONE-BEDROOM
FLAT. IT WASN'T A PRETTY PICTURE, BUT IT WAS HOME.
WE WELCOMED THEM INTO OUR LIVES, AND SOMETIMES THAT'S
A LOT MORE IMPORTANT THAN CLEAN SHEETS TO A TRAVELER.
SO MY ROOMMATES STAYED UP ALL NIGHT DRINKING AND
ARGUING AND YELLING ABOUT GUNS. THE GERMANS COULD
HAVE STAYED UP ALL NIGHT DRINKING AND ARGUING AND
YELLING ABOUT GUNS TOO, INSTEAD OF GRUMBLING AND
TRYING TO SLEEP. I OFFERED THEM EARPLUGS, BUT THEY
REFUSED. WHAT COULD I DO? THIS WAS OUR LIFE AND TO
CHANGE IT I WOULD HAVE TO GET A TIME MACHINE AND
GO WAY BACK. I STARTED TO GET ANGRY AND DEFENSIVE.

IT WAS ALL TOO FAMILIAR TO ME. HOUSEGUESTS WHO AREN'T
RESPECTFUL OF SUBTLE LINES OF ROMANCE AND FRIENDSHIP
AND JEALOUSY THAT AN OUTSIDER SHOULDN'T CROSS. HOUSE-
GUESTS WHO LOCK YOU OUT, EAT YOUR FOOD, STAY TOO LONG,
BREAK EVERYTHING IN SIGHT, AND THEN GET MAD AT YOU.
HOUSEGUESTS WHO COME INTO YOUR PERSONAL SPACE AND
ARE JUDGEMENTAL ABOUT HOW YOU LIVE. I KNEW IT ALL
WELL, BECAUSE I HAD BEEN THAT HOUSEGUEST SO MANY
TIMES OVER THE YEARS.

NOW, WHEN I HAVE HOUSEGUESTS OF MY OWN, I TRY TO BE LESS UPTIGHT THAN SOME OF THE PEOPLE I HAVE STAYED WITH. IT DOESN'T WORK. I TRY TO BE AS LOOSE AND UNDERSTANDING AS SOME OF THE PEOPLE I HAVE STAYED WITH, AND THAT DOESN'T WORK EITHER. EVERY NEW HOUSEGUEST I HAVE MAKES ME ALL THE MORE THANKFUL FOR THE PATIENCE AND HOSPITALITY OF PEOPLE WHO HAVE LET ME CRASH ON THEIR FLOOR. SO, HEY! THANKS AGAIN!

Men

I THINK THE PROBLEM WITH ME AND MY GUY FRIENDS IS THAT WE ARE BECOMING MEN. FIRST EVERYONE DISCOVERED PRIDE. NEXT, EVERYONE'S PRIDE SWELLED UP LIKE A BALLOON. NOW WE DO NOTHING BUT WALK AROUND HEADSTRONG AND CRAZY, EAGER TO DEFEND OUR SWOLLEN PRIDE. EAGER TO FIGHT AND PROVE OURSELVES, WITH FISTS OR WORDS OR AT LEAST BY GOOD EXAMPLE. TO DO THE RIGHT AND HONORABLE THING AS ACCORDED BY OUR NEW PERSONAL SYSTEMS OF MORALITY, EACH ONE COMPLETELY DIFFERENT FROM THE NEXT. ANGRY ANGRY ANGRY AT BEING DENIED, BELITTLED, CHALLENGED, OR IGNORED. EVEN ANGRY AT BEING LOVED, PAMPERED, CHERISHED, OR CARED ABOUT. ALL OF IT CAN GO, EVERYTHING BESIDES FRIENDSHIP AND HATRED, HARD WORK AND JUSTICE.

WE WALK THE STREETS LOOKING FOR SOMEONE TO CHALLENGE OUR NEWFOUND MANHOOD. NO ONE DOES, SO WE ARE FORCED TO TURN ON EACH OTHER. IN FRIENDSHIP, WE SCREAM AND SWEAR AND FIGHT. WE SENSE THE HIDDEN CRIMES BEHIND EVEN THE SMALLEST OF ACTIONS. EVERY LAST PERSON IS FOUND GUILTY OF NOT LIVING UP TO OUR EXPECTATIONS, NOT BEING A GOOD ENOUGH FRIEND OR WORTHY ENOUGH ENEMY. IN SMALL TRIBUNALS, WE DECIDE ON PROPER SENTENCING. NO ONE IS SPARED. IN SHORT TIME, NO ONE IS LEFT. NO ONE EXCEPT OUR FRIENDS WHO ARE GIRLS, AND THAT'S DIFFERENT, EVEN IF IT NEVER WAS BEFORE. MAYBE IT'S BECAUSE THEY ARE BECOMING WOMEN.

ALCOHOL, PRIDE, AND STUBBORNNESS. A BAD COMBINATION. THEY DO NOTHING BUT REINFORCE EACH OTHER, BACK EACH OTHER UP IN A FIGHT. BUT WE GREW UP WITH SO LITTLE OF ALL THREE, THERE IS LOST TIME TO BE MADE UP FOR. NO WONDER OUR FRIENDS WHO ARE GIRLS, OR MAYBE WOMEN NOW, I'M NOT SURE, THEY THINK WE HAVE FINALLY GONE OFF THE DEEP END. WE HAVE. ALL WE TALK ABOUT ANYMORE IS

THE STRENGTH OF FRIENDSHIP AND THE POWER OF TRUTH, AND HOW NONE OF OUR FRIENDS HAVE EITHER ONE. ALL WE TALK ABOUT IS HOW MUCH WE HATE EACH OTHER, AND THEN AT THE END OF EACH WEEK WE GET TOGETHER AND GET DRUNK ENOUGH TO FORGET ABOUT IT ALL. WE SLAP EACH OTHER ON THE BACK, SHAKE HANDS, AND GO OUT TO DESTROY STUFF. JUST LIKE MEN. I HOPE THIS IS JUST A PASSING PHASE, BUT I DON'T THINK THAT'S THE WAY IT USUALLY WORKS.

Our Office Sux

I RAN INTO SLUGGO AGAIN AT THE CAFE DOWNTOWN. IT'S FUNNY THAT THE CAFE IS WHERE I SEE HIM MOST. FUNNY BECAUSE ME AND SLUGGO ARE ROOMMATES. HE SAYS OUR LITTLE OFFICE IS SUFFOCATING HIM. HE IS TURNING BLUE, STARVING, GOING INSANE, CAN'T SLEEP, AND SO HE SPENDS MOST NIGHTS AT HIS GIRLFRIEND'S HOUSE. I CAN'T REALLY BLAME HIM BECAUSE IT'S THE SAME FOR ME.

I TOLD HIM I WAS GOING TO WRITE A SHORT LITTLE STORY ABOUT OUR OFFICE. HE SAID IT WOULD HAVE TO BE SHORT BECAUSE THE PLACE SUCKS SO BAD THAT THERE'S REALLY NOTHING TO SAY ABOUT IT. WE BOTH LAUGHED. BECAUSE IT'S TRUE, AND BECAUSE WE'VE GOTTEN USED TO LAUGHING AT OUR LIVES.

IT SEEMS LIKE THERE WAS ONCE A TIME, LONG AGO, WHEN THE PUNCHLINE TO EVERY JOKE WAS NOT US. BUT I'M NOT SURE. BEING JEWISH, MY JOKES HAVE ALWAYS BEEN IRONIC AND SELF-DEPRECIATIVE. MAYBE I ALWAYS LAUGHED ABOUT MYSELF AND HAVE ONLY RECENTLY INCLUDED MY GOOD FRIENDS. MAYBE IT'S NOT THE JOKES AT ALL. WE SMILE KNOWINGLY AT THE JOKES. WE LAUGH UPROARIOUSLY AT EVERYTHING ELSE.

SLUGGO WANTED ME TO MOVE IN WITH HIM AT HIS LAST PLACE, BUT I SAID NO. IT WAS A MISERABLE, HELLISH PIT THAT DRAINED YOU OF ALL ENERGY AND WILL TO LIVE. I KEPT TELLING HIM TO GET EVICTED SO WE COULD GET A BETTER PLACE TOGETHER. IT SHOULDN'T HAVE BEEN A SURPRISE WHEN HE ACTUALLY DID GET EVICTED, SINCE WE HAVE BEEN EVICTED FROM EVERY HOUSE WE HAVE EVER LIVED IN, BUT IT WAS.

HIS LANDLORD WAS A CRAZY MAN NAMED IKE. IKE WAS IN BAD HEALTH AND GOING IN FOR AN OPERATION. WHEN HE STOPPED SHOWING UP TO DEMAND THE LATE RENT,

THEY FIGURED IKE HAD DIED AND STOPPED PAYING IT.
A LONG TIME PASSED BEFORE IKE SHOWED BACK UP.
THEY LOOKED OUT THE WINDOW AND THERE HE WAS ON
THE SIDEWALK IN FRONT OF THE HOUSE. IN A WHEELCHAIR.
SCREAMING, "I'M SICK OF YOUR BULLSHIT! I WANT MY
MONEY! GET THE FUCK OUT!"

THAT'S WHEN WE STARTED LOOKING FOR A NEW PLACE TO
LIVE. WAREHOUSE OR OFFICE SPACE WAS ALL WE COULD
POSSIBLY AFFORD. THERE WAS ONE PLACE DOWNTOWN THAT
WAS NOT THE BEST DEAL IN THE WORLD, BUT NOT THE
WORST. EIGHT BY TEN FEET, TWO HUNDRED BUCKS. A LITTLE
SMALL, SURE, BUT WE HAD LIVED IN LOTS OF SMALL PLACES.
I LIKED THE IDEA OF THE TWO OF US WORKING ON OUR
MAGAZINES IN A ROOM THAT RESEMBLED A LARGE PIECE
OF PAPER. IT TURNED OUT THOUGH THAT THE LANDLORD
HAD LIED TO US AND IT WAS ACTUALLY EIGHT BY NINE.
YOU NEVER KNOW HOW MUCH ONE EXTRA FOOT OF SPACE
COULD MEAN TO YOU UNTIL YOU LIVE IN AN EIGHT BY NINE
WINDOWLESS ROOM WITH ONE ROOMMATE AND, OCCASIONALLY,
TWO GUESTS.

TO MAKE A LONG STORY INTO A SHORT LIST OF INGREDIENTS,
THE OFFICE HAS A FEW PROBLEMS. NO AIR. NO WINDOWS.
THE "GIRLS BRING PLANTS" RULE BACKFIRED BECAUSE OF
NO NATURAL LIGHT. REVERSE PHOTOSYNTHESIS. THE PLANTS
SUCKED UP THE LAST OF OUR AIR. NO AIR CONDITIONING.
TWENTY DEGREES TOO HOT AT ALL TIMES. FUCKING TRAVEL
AGENT GUY IS OUR NEIGHBOR. FUCKING FLUORESCENT
LIGHTS. NO DOORBELL. NO PHONE. NO CONTACT WITH THE
OUTSIDE WORLD. PANIC. CLAUSTROPHOBIA. DISORIENTATION.
ISOLATION. SUFFOCATION. NO REFRIGERATOR. NO STOVE TO COOK.
NO SPACE TO MOVE. HUNGER. WEIGHT LOSS. DEATH.

BEDS AND OTHER SIGNS OF LIFE MUST REMAIN HIDDEN.
APPEARANCES MUST BE MAINTAINED. CERTAIN WORDS
CAN NOT BE SAID ALOUD: SLEEP, WAKE, BED, HOME.
VISITORS CANNOT ARRIVE UNEXPECTED. TO WALK OUT OUR
DOOR, EVEN TO THE BATHROOM IN THE HALL, ONE MUST
LOOK AWAKE AND BUSINESSLIKE. LIVING IN THE OFFICE
IS, OF COURSE, ILLEGAL.

LAST WEEK WE CRAWLED INTO THE CEILING AND RIPPED
OUT THE VENTILATION TUBES GOING TO ALL THE OTHER
OFFICES. WE REDIRECTED THEM INTO OUR OFFICE. NO
NOTICEABLE CHANGE. THIS MORNING I WOKE UP TO THE
SOUND OF SOMEONE ELSE CRAWLING IN THE CEILING.
REPAIRMEN. TEN FEET ABOVE ME, AND THEY COULD SEE

RIGHT DOWN INTO OUR PLACE. I FOLDED UP THE BED
AND HID UNDER MY DESK. I TRIED TO SIT PERFECTLY
STILL, SHAKING WITH FEAR.

WHEN THERE WERE A FEW MINUTES OF SILENCE, I
SLAPPED MYSELF UNTIL I LOOKED AWAKE AND THEN
RAN OUT OUR DOOR CARRYING MY BIKE. ONE OF THE
TRICKY THINGS ABOUT LIVING IN THE OFFICE IS THAT
YOU NEVER KNOW WHAT THE WEATHER IS LIKE OUTSIDE
OR EVEN IF IT'S DAYTIME OR NIGHT. THE LANDLORD'S
OFFICE IS RIGHT NEXT TO THE FRONT DOOR, AND IT LOOKS
SUSPICIOUS TO COME DOWN THE HALL WEARING A JACKET
AND THERMALS ON A NICE SUNNY DAY. IT ALSO LOOKS
SUSPICIOUS TO RUN OUT THE FRONT DOOR WEARING A
SKIMPY T-SHIRT AND SHORTS, CARRYING A BIKE, WHEN IT'S
POURING RAIN. I TURNED AROUND AND RAN BACK INTO
THE OFFICE, TURNED OUT THE LIGHTS, AND HID.

I CAN'T WRITE AT THE OFFICE BECAUSE THE LIGHTS
ARE OUT AND I CAN'T BREATHE. I CAN'T WRITE AT THE
CAFE BECAUSE PIANO MANIACS SHOW UP AND I CAN'T
CONCENTRATE. THEY PLAY PIANO SO LOUDLY AND BADLY
THAT IT SEEPS THROUGH MY EARPLUGS AND I GO INSANE.
I PLOT TO KILL FUCKING TRAVEL AGENT NEIGHBOR AT
NIGHT AND THE PIANO MANIACS BY DAY. MY LIFE IS
DESTROYED. I SEE SLUGGO AT THE CAFE. HIS LIFE IS
DESTROYED TOO. WE BOTH LAUGH.

Calming Down

I WAS SICK OF SPENDING ALL MY TIME FIXING BROKEN
THINGS AND THEN BREAKING THEM AGAIN. SICK OF ALL THE
LITTLE TURNS AND CHANGES IN MY FRIENDSHIPS, EXPECTATION
IN MY ROMANCE, NEEDS AND DEMANDS THAT COULD NEVER BE
MET OR EVEN UNDERSTOOD. TIRED OF SEEING MYSELF ONLY
THROUGH OTHER PEOPLE, THROUGH THEIR EYES, THEIR
REACTIONS, THEIR LACK OF REACTION. I HAD DONE IT AGAIN.
COMPROMISED MY WHOLE WAY OF LIFE WITHOUT EVEN
REALIZING IT. TIME TO GO BACK TO THE WATERFRONT, BACK
TO LAND'S END. LOOKING FOR SOME ANSWERS OR JUST SOME
SOLACE. SITTING LOOKING OUT INTO THE OCEAN AT SOMETHING.
MAYBE DESTINY, OR TIME, OR NOTHINGNESS. JUST SITTING
THERE, LOST IN THE WEIRDEST SORT OF EXCITED TRANQUILITY,
WHEN THE ROCKS AROUND ME STARTED TO MOVE. THEY
LOOKED AT ME AND WALKED AWAY IN DISGUST. SEA TURTLES.
I HAD TO LAUGH. AT MYSELF AND EVERYTHING.

SOMEONE WAS TRYING TO RUIN MY LIFE AGAIN, THIS TIME BY THREATENING ME WITH LAWYERS. I WAS TRYING NOT TO LET IT WORRY ME, AND I THOUGHT THAT MAYBE IT WASN'T REALLY WORRYING ME UNTIL I CHECKED IN THE BACK OF MY MIND AND FOUND THAT I WAS MULLING IT OVER BACK THERE, OVER AND OVER, THROUGH ALL MY SLEEPING AND WAKING HOURS. I WISHED I COULD JUST TRADE IN ALL THAT BETRAYAL FOR SOME BEER, OR FOR ONE SUNNY SUMMER SLEEVELESS T-SHIRT DAY. EVERYONE KEPT TELLING ME IT WAS A LESSON, THAT THERE WAS SOMETHING TO BE LEARNED FROM IT ALL, BUT I WAS TIRED OF THOSE KIND OF LESSONS AND, YOU KNOW, THERE ARE SOME THINGS I DON'T NEED TO KNOW. I TOOK MY BIKE OUT TO PLEASANT HILL AND STARTED RIDING ON THE BIKE PATHS. SINCE I'M NOT FROM THE SUBURBS, I CAN ENJOY THEM. SLOWLY, EVER SO SLOWLY, RIDING ALONG IN THE COOL, DARK NIGHT. MAYBE ACTUALLY FREEZING BUT I TRIED NOT TO LET IT WORRY ME, UNDERNEATH THE BLACK OUTLINES OF THE HUGE LEAFY TREES. BREATHE IN, BREATH OUT. IT'S MY LIFE AND IF I BEND ANY MORE I WILL BREAK. BREATHE IN, BREATHE OUT. WALNUT CREEK, LAFAYETTE, MORAGA, ORINDA. CALMING DOWN.

SOMETIMES I WISH EVERYONE WOULD JUST SLOW DOWN AND SHUT UP. NO MORE MUSIC PLAYING, PHONE RINGING, NEIGHBORS KNOCKING ON THE DOOR. LET MY THOUGHTS HAVE A CHANCE TO AIR OUT, LET THEM BE MORE THAN A SERIES OF DEFENSIVE REACTIONS. GIVE ME A CHANCE TO STEP BACK AND TAKE IT ALL IN, FIGURE IT OUT, INSTEAD OF ONLY FIGURING IT OUT YEARS LATER IN HINDSIGHT. ONE THING ABOUT MOVING AWAY TO A TOWN WHERE YOU DON'T KNOW A SOUL IS THAT IT'S NICE TO DESPERATELY WANT TO MEET AND BE AROUND PEOPLE INSTEAD OF CONSTANTLY TRYING TO BE ALONE, WHICH IS WHAT I DO NOW. I'M JUST A BETTER PERSON, AND A LOT HAPPIER, IF I SPEND A DECENT AMOUNT OF TIME BY MYSELF. THAT'S WHY I CAUGHT A RIDE TO DAVIS. IF IT'S NOT YET TIME TO MOVE AWAY TO A WEIRD UNFAMILIAR TOWN, THE NEXT BEST THING IS A WEEKEND IN DAVIS. NOT ONLY DO I NOT KNOW A SOUL THERE, IT'S A GOOD BET THAT THERE ISN'T ONE TO BE FOUND. SITTING ON THE BLEACHERS AT NOON COUNTING THE JOGGERS LIKE COUNTING SHEEP. 1, 2, 3, 4, CALMING DOWN.

AND WHEN THE DAY IS DONE AND THE PARTY IS ALL OVER, I CAN FINALLY JUST SURRENDER TO SLEEP. BUT I DON'T. I LIE IN BED WITH ONE COFFEE AND ONE BEER, READING FOR HOURS, NOT CARING THAT I'M RUINING TOMORROW ONCE AGAIN. NO PEOPLE, NO PAST, NO FUTURE, JUST A LITTLE PEACE FALLING THROUGH THE CRACKS IN BETWEEN.

There Goes the Neighborhood

LAST WEEK THE NEIGHBOR'S PHONE WAS RINGING OFF THE HOOK AND IT WAS DRIVING ME CRAZY. I WISHED THEY WOULD STOP FIGHTING AND ANSWER IT SO I COULD GET SOME SLEEP. INSTEAD, SLUGGO CAME HOME AND STARTED DIGGING THROUGH THE LAYERS OF BEER BOTTLES AND BROKEN BIKES IN OUR "LIVING" ROOM. HE PULLED OUT THE PHONE I FORGOT WE HAD, AND ANSWERED IT.

A WRONG NUMBER. THAT MADE SENSE, SINCE OUR PHONE HAD BEEN DISCONNECTED MONTHS AGO. THEN IT RANG AGAIN. STILL THE WRONG NUMBER, BUT THIS TIME SLUGGO WROTE THE WRONG NUMBER DOWN, WENT TO A PAYPHONE, AND TRIED IT. WHEN I ANSWERED, WE WERE BOTH SURPRISED. A COMPUTER ERROR? AN ANONYMOUS DONOR? IT DIDN'T MAKE SENSE, BUT IT WAS NICE TO GET CALLS AGAIN, IF NOT SLEEP.

THE PROBLEM IS, WE CAN'T DIAL OUT ON OUR NEW PHONE LINE. I HAVE TO WALK TO THE "SURPRISING ECONOMIC RECOVERY" DISTRICT A MILE AWAY, WHERE THEY STILL HAVE PLENTY OF PAYPHONES. TO DISCOUR- AGE DRUG DEALING AND MAKE THE STREETS SAFER, THE CITY TORE OUT ALL THE PAYPHONES IN OUR NEIGHBORHOOD LAST MONTH. NO PHONES TO CALL FOR HELP IN AN EMERGENCY, AND THE ONLY OTHER PEOPLE OUT IN THE MIDDLE OF THE NIGHT ARE FRUSTRATED DRUG DEALERS.

BUT SAFETY ISN'T EVERYTHING. AT LEAST WE HAVE COMMUNITY. UNLIKE OUR OLD NEIGHBORHOOD, WHERE PEOPLE WOULDN'T SAY HELLO ON THE STREET. THEY ACTED LIKE WE WERE INVADING THE NEIGH- BORHOOD EVEN THOUGH WE'D LIVED THERE LONGER THAN ANYONE. THOSE WACKY YUPPIES AND THEIR SILLY IDEAS. JACKING UP THE PRICES OF COFFEE, THE PRICES OF RENT, AND EVENTUALLY THE PROPERTY VALUES TOO, SO THAT MORE COPS COME AROUND TO PROTECT THE PROPERTY AND HASSLE US.

NOW WE LIVE ON THE LAST STREET IN TOWN, AMONG THE WAREHOUSES AND BROKEN CARS. WE HAVE SEVEN AND OUR NEXT DOOR NEIGHBOR HAS FIVE, INCLUDING ONE WHICH ED LIVES IN. THE COUPLE NEXT DOOR SAY WE'RE THE BEST NEIGHBORS THEY'VE EVER HAD. "IF WE HAVE EXTRA FOOD, YOU COME EAT IT", THEY SAY. "IF YOU NEED ANYTHING, OR IF WE'RE TOO LOUD, YOU JUST LET US KNOW. WE'RE NEIGHBORS. WE'RE COUNTRY".

THEY SAY, "OUR HOUSE IS YOUR HOUSE". THE
FACT IS, THERE'S ONLY ONE HOUSE. WE LIVE UNDER
THE SAME ROOF, AND THE ONLY THING THAT KEEPS
OUR TWO HOUSEHOLDS APART IS ONE THIN WALL,
DIVIDING WHAT WAS ONCE A TWO-CAR GARAGE.
WHAT WE CAN'T SEE WE CAN HEAR AND SOMETIMES
FEEL. WHEN WE SAID, "OH, NO, YOU'RE NEVER TOO
LOUD", THEY LAUGHED. THEY KNOW WE CAN HEAR
THEM FIGHTING ALL DAY AND ALL NIGHT, SCREAMING
AND CURSING AND STABBING EACH OTHER. BUT IT'S
NOT OUR PLACE TO SAY ANYTHING ABOUT IT, OR TO
JUDGE. NOT ONLY ARE THEY OLD ENOUGH TO BE OUR
GRANDPARENTS, THEY ACTUALLY ARE GRANDPARENTS.
 ANYWAY, WE WOULDN'T THINK TO COMPLAIN ABOUT
THEIR FIGHTING BECAUSE THEY DON'T COMPLAIN ABOUT
OUR SMASHING BOTTLES, LIGHTING FIREWORKS,
DESTROYING THE PLUMBING, PLAYING DRUMS AT NIGHT,
OR LEAVING ROTTING GARBAGE ALL OVER THE YARD.
IN MANY WAYS WE ARE A PERFECT MATCH. WHEN WE
DUG UP THE LAWN AND PLANTED PALM TREES AS A
NEW TACTIC TO FUCK WITH THE LANDLORD, OUR
NEIGHBORS WERE SO HAPPY THEY STARTED BRINGING
US DINNER. THEY ONLY COMPLAINED ONE TIME, WHEN
THEY FOUND OUT I DID A MAGAZINE AND HAD BEEN
SO THOUGHTLESS AS TO NOT GIVE THEM ONE.
 THIS MORNING, WHEN I HEARD A RINGING SOUND,
I COULD TELL IT WASN'T THE NEIGHBOR'S PHONE.
I WAS SURE IT WASN'T OUR PHONE EITHER. THE
PHONE COMPANY WOULD HAVE TO PERFORM A MIRACLE
TO GET THROUGH A PHONE NOT ONLY DISCONNECTED
BUT ALSO UNPLUGGED. NO, THIS WAS MUCH LOUDER
THAN JUST A PHONE OR ALARM CLOCK. I WAS
HOPING IT WAS THE CANDLE FACTORY MELTING DOWN
AGAIN, BUT WHEN I LOOKED OUT THE DOOR I SAW
LOW-FLYING HELICOPTERS INSTEAD OF FIRE TRUCKS.
TROUBLE. IT WAS BAD THAT THE NEIGHBORS ON
ONE SIDE FOUGHT ALL THE TIME. IT WAS WORSE
THAT THE NEIGHBORS ON THE OTHER SIDE HAD A
DEFENSE DEPARTMENT CONTRACT TO PRODUCE ANTI-
PLAGUE VACCINE WITH GERM WARFARE APPLICATIONS.
 BEFORE I HAD TO CONTEND WITH YUPPIES IN MY
NEIGHBORHOOD. NOW IT'S LEGIONNAIRE'S DISEASE,
ANTHRAX, AND THE BUBONIC PLAGUE. THEY KEEP LIVE
SAMPLES OF ALL THREE JUST DOWN THE BLOCK, IN A
QUIET-LOOKING FACTORY COMPLEX WHICH IS ACTUALLY
ONE OF THE LARGEST BIOTECHNOLOGY PLANTS IN
THE WORLD. REALLY. I PUT ON MY SHOES AND
WALKED OVER TO CHECK IT OUT.
 RIGHT PAST ED'S CAR, ON THE OTHER SIDE OF
A LARGE BARBED WIRE FENCE, WAS A MAN IN AN
ORANGE JUMPSUIT. I FLAGGED HIM DOWN AND ASKED

IF THE WARNING SIREN WAS COMING FROM PART
OF THE PLANT. HE LOOKED AT ME ANNOYED AND
SAID, "PART OF IT".
 I WONDERED WHICH PART. PERHAPS THE PART
CLOSEST TO THE HAYWARD FAULT LINE? OR JUST THE
OLD INFECTIOUS DISEASES BUILDING? I ASKED, "ANY
DANGER?", AND HE SAID, "BEATS ME".
 THIS IS THE KIND OF THING WHICH USED TO
WORRY ME. NOW, INSTEAD OF WORRYING ABOUT ALL THE
TERRIBLE THINGS THAT MIGHT HAPPEN, I WAIT UNTIL
THEY DO HAPPEN, AND THEN START WORRYING.
KNOWLEGE CONQUERS FEAR, AND I'D DONE MY
RESEARCH. AN ACCIDENTAL AIRBORNE RELEASE
OF BUBONIC PLAGUE WOULDN'T KILL ME FOR AT
LEAST TWELVE HOURS.
 MY THROAT WAS PARCHED AND I FELT A LITTLE
FEVERISH, SO I WENT UP TO THE CORNER STORE.
I LIKE OUR NEW NEIGHBORHOOD BECAUSE I'M NOT
THE ONLY ONE IN LINE FOR SIX A.M. BEER. IN OUR
OLD NEIGHBORHOOD, I'D SAY, "BREAKFAST? SHIT, MISTER,
THIS IS MY DINNER. IT'S BEEN A LONG NIGHT OF
WORK AND A LONG WEEK OF NIGHTS BEFORE THAT.
IT MAY BE TUESDAY MORNING TO YOU, BUT I WORK
FOR A LIVING AND IT'S FRIDAY NIGHT FOR ME".
 I STILL SAY IT, BUT HERE EVERYONE SMILES. THEY
KNOW JUST STAYING ALIVE IS HARD WORK. THEY SAY,
"SUIT YOURSELF. BUT IT'S GOOD FOR BREAKFAST TOO".

Temescal, again

 WALKING THROUGH THE BUSHES, THE HIDDEN
TRAILS UNDERNEATH THE TANGLES OF FREEWAY IN
THE OAKLAND HILLS. WE USED TO RUN ALONG HERE
SMEARED WITH BLACKBERRIES FOR WARPAINT,
CHASING AND LAUGHING THROUGH THE IVY, KISSING
AS WE SLID DOWN THE STEEP DIRT SLOPES. WE USED
TO TALK ABOUT LIVING HERE, IN A SECRET SPOT I'D
FOUND. NOT JUST ROMANTIC, IT WAS PRACTICAL,
WE HAD NOWHERE ELSE TO GO. THEN, LIVING IN A
LEAN-TO IN THE BUSHES SOUNDED ROMANTIC EVEN
ALONE. NOW IT WOULD JUST BE LONELY. LONESOME.
 ONE OF THOSE TRICKS LIFE PLAYS ON YOU. GET
OLDER AND THEY CALL YOUR ANGER BITTERNESS.
YOUR ALIENATION BECOMES A BURDEN INSTEAD OF
A BADGE OF PRIDE. OH, I DON'T KNOW, MAYBE WE
COULD LIVE THERE TOGETHER STILL, MAKE STIR-FRY
ON THE COLEMAN STOVE AND WALK ON DOWN TO THE
LIBRARY IN THE MORNINGS. BUT YOU WOULDN'T WANT

TO DO IT NOW, AND WHAT'S WORSE, MAYBE I WOULDN'T EITHER. SOMETHING OF THE INNOCENCE IS GONE.

I WALK ALONG NEW PATHS, BUT WHEN I COME TO THE RAZOR WIRE I JUST TURN AROUND. BEFORE I WOULD HAVE MARCHED RIGHT OVER. YOU HAVE THE SCAR TO PROVE IT, FROM OUR FIRST DATE. YOU IMPALED YOUR WRIST ON THE RAZOR WIRE BY THE RESERVOIR, I CUT MY THUMB ON BROKEN GLASS TRYING TO BREAK INTO THE BLIND-DEAF SCHOOL. WE WERE REALLY SOMETHING. THE WAY YOU HELD AND COMFORTED ME, THAT BLOOD BROKE THE ICE.

WE WERE TUMBLING THROUGH THE BEDS OF FLOWERS OUTSIDE THE HOSPITAL WHEN THE SECURITY GUARD CAME AND TOLD US TO MOVE. PATIENTS INSIDE WERE COMPLAINING, WE RUINED THEIR VIEW. WHO COULD COMPLAIN ABOUT TWO PEOPLE VERY MUCH IN LOVE? I COULD NOW, PROBABLY. ADD IT TO THE LIST.

I REMEMBER LAKE TEMESCAL IN THE MIDDLE OF THE NIGHT, SPLASHING AND SO HAPPY JUST TO LOOK AT EACH OTHER IN THE MOONLIGHT. EVEN DAYS LIKE THIS, TOO SUNNY AND SHARP, STRESSED OUT LIKE YOU ALWAYS WERE, WE COULD DRIVE THERE AND JUMP RIGHT IN. I WALKED UP TODAY TO DO JUST THAT, BUT IT WAS CROWDED WITH HAPPY FAMILIES. I PICKED SOME ROTTEN BLACKBERRIES AND WALKED AWAY.

I USED TO GET SO JEALOUS EVERY SPRING, KNOWING YOU'D WANT TO GO SWIMMING IN THE SUN AND SO WOULD ALL THE YOUNG BOYS. BUT NOT ME. I SLEPT ALL DAY AND WROTE ALL NIGHT, GRUMPY AND MEAN. I LIKED SWIMMING AND SUNSHINE, BUT NOT WITH YOU. THEY MADE ME FEEL OLD.

I ALWAYS SAY HAPPINESS IS OVERRATED, BUT SO IS DEPRESSION AND REGRET. REMEMBER SITTING AT THAT PARK BY THE HOSPITAL YOU SAID, "THIS IS ONE OF THOSE PLACES PEOPLE COME RIGHT AFTER SOMEONE DIES, AND THEY SIT HERE LOOKING ALL WEIRD". THEN YOU SAW MY FALLEN FACE. I HELD UP FINGERS TO SHOW, NOT VICTORY OR PEACE, BUT THE NUMBER TWO.

WHAT CAN I DO? BETTER TO ADMIT IT OR PRETEND? SOMETHING OF THE INNOCENCE IS GONE OR AT LEAST TAPPED OUT AND DEAD TODAY. BETTER TO DRINK MORE COFFEE AND WALK THE DWIGHT WILDERNESS TRAILS. TRY TO SHAKE IT OFF, AGAIN.

September

I'M NOT FOND OF SHARING MY PROBLEMS, TROUBLES, WORRIES OR FEARS. IT DOES NO GOOD TO DISPLAY THEM, PARADE THEM, DISSECT AND EXPLAIN THEM. BUT PEOPLE ASK, AND I HATE TO LIE. CLOSE FRIENDS KNOW INSTINCTIVELY JUST BY LOOKING IN MY EYE.

I HATED TO SEE MY TROUBLES REFLECTED IN THEIR FACES, SO I AVOIDED THEM. FIRST THE EYES, THEN THE OLD FRIENDS ALTOGETHER. I CULTIVATED THE FRIENDSHIPS OF PEOPLE WITH WHOM I HAD A DIFFERENT SORT OF BOND. NATURAL, CHEMICAL, UNRELATED TO ANY SOCIAL FRAMEWORK OR SHARED PAST. INTIMATE YET COMPLETELY IMPERSONAL. LIKE THE SAN FRANCISCO PEN-PAL I'VE HAD FOR TEN YEARS BUT NEVER MET, THESE WERE PEOPLE I KNEW WELL YET NOT AT ALL. "LET'S MEET", I SAID. "ONCE A WEEK". I LOVE ROUTINES, AND WAS SORELY IN NEED OF A NEW ONE.

FRIDAYS I CAME TO THE FANCY RESTAURANT AND PICKED UP A WAITRESS THERE. DOWN AT THE CORNER OPEN-AIR CAFE WE SHARED HER LUNCH BREAK AND HEATED CONVERSATION WHICH TO A STRANGER MAY HAVE SOUNDED MORE LIKE WORD ASSOCIATION. PERHAPS SHE WAS A BIT INSANE, I DON'T KNOW. BUT IF SO, IT ONLY MADE IT EASIER TO TALK WITHOUT THE USUAL STIFLING PRETENSIONS AND LIMITATIONS. SHE COULD TAKE AN IDEA OR EMOTION AND LOOK AT IT FROM ALL SIDES WITHOUT NEEDING TO KNOW WHERE IT CAME FROM. PLAYFULLY.

NAMED, DESCRIBED, AND LET OUT OF THE BAG, MY PROBLEMS WOULD HAVE MULTIPLIED IN LEAPS AND BOUNDS. LIKE A GOLDFISH, GROWING TO THE SIZE OF THEIR SURROUNDINGS, SURROUNDING ME. BETTER TO KEEP THEM IN THE BAG. BETTER TO TALK ABOUT THE BAG, ITS SIZE AND COLOR AND SHAPE. THE INCONVENIENCE OF CARRYING IT AROUND AND THE FEAR IT MIGHT GET STOLEN OR MISPLACED. LESS BORING THAT WAY, AND SOMEHOW MORE TO THE POINT. THE WAITRESS SAID WHAT I CALLED THE BAG SHE THOUGHT OF AS TRAYS AND PLATES.

I RAN AND RODE CRISSCROSS ACROSS TOWN LIKE CLOCKWORK FOR PEOPLE AND CONVERSATIONS

THAT WERE COMPLETELY UNPREDICTABLE. A NICE DUALITY, LIKE THE SIMULTANEOUS ANONYMITY AND INTIMACY, CONNECTION AND ESCAPE. IT WAS A TERRIBLE MONTH BACK IN THE BAY, AND I WAS A WRECK. BUT TAKING A NEW APPROACH KEPT ME FROM FALLING OFF THE EDGE. BUILDING RAPPORT AND FRIENDSHIP ALONG NEW, IMPROVISED, UNUSUAL LINES ADDED AN ELEMENT OF THE SURREAL. IT SHOWED THAT MY OLD, FALLING APART WORLD WAS NOT SO REAL EITHER, JUST A DIFFERENT SET OF CONSTRUCTS I'D HELPED TO BUILD.

WE DIDN'T KNOW EACH OTHER'S FRIENDS, HISTORIES, HOMES, OR THE LANDSCAPE OF EACH OTHER'S LIVES. WE DIDN'T KNOW EACH OTHER'S PROBLEMS, AND IN THE CASE OF THE WAITRESS, NOT EVEN ONE ANOTHER'S NAMES. DESPITE THAT, OR IN SPITE OF IT, WE GOT ALONG, AND STARTED TO GET TO KNOW EACH OTHER WELL. SOMETIMES YOU FORGET THAT ONCE ALL THOSE THINGS ARE SHED AND SHAVED OFF, THERE'S STILL A WHOLE PERSON UNDERNEATH.

El Niño

SEAN CALLED IN THE MIDDLE OF THE NIGHT. "GOD DAMN!" HE SAID, IN AN ACCENT THAT CAME FROM BEER AND MANUAL LABOR RATHER THAN A PARTICULAR REGION. HE YELLED INTO THE PHONE AS IF I WAS ACROSS A CROWDED BAR. "AARON? AARON!! I JUST REMEMBERED! I LEFT A SIX-PACK IN THE BUSHES BY THE BAY BRIDGE! LET'S GO GET IT!"

IN THE MIDST OF ALL THE FIGHTING THAT HAD BEEN GOING ON, NO ONE WAS QUITE THE SAME AS BEFORE. A LOT WAS LOST. BUT SEAN LOSING A SIX-PACK. THAT WAS UNHEARD OF.

IT WAS JUST ME AND JAG AT HOME SITTING IN THE RUINS OF WHAT I'D FOUGHT SO HARD TO KEEP. I HAD WON, BUT SOMEHOW LOST EVERYTHING IN THE PROCESS. THAT'S WHAT KIND OF MONTH IT WAS. IT TORE OUR LITTLE GANG IN TWO. PITY THE FOOL WHO FACES THE CROWD TO STAND UP FOR HIMSELF. IT DOESN'T JUST MAKE YOU BITTER, IT MAKES YOU LONELY. THAT SEAN WOULD MAKE AN OVERTURE OF FRIENDSHIP AT THIS TRYING TIME MEANT A LOT TO ME.

IT WAS WAR, WITH MY LANDLORD, NEIGHBORS,

AND OLD FRIENDS ALL ON THE OTHER SIDE. THAT'S HOW IT FELT, ANYWAY. WE HAD THE DOORS LOCKED WITH NEW LOCKS, THE WINDOWS BOLTED, THE CURTAINS DRAWN, AND IT WAS ROUGH BECAUSE WE WERE REPAINTING EVERY WALL, COVERING GRAFFITI THE SUBLETTERS HAD LEFT. THE FUMES WERE SO STRONG YOU COULD ALMOST SEE THEM. OUR NEIGHBORS, WITH THEIR NEVER-ENDING DEMANDS FOR CIGARETTES AND MONEY, HAD EVEN LEARNED MY GIRLFRIEND'S SECRET KNOCK, SO I DIDN'T ANSWER THE DOOR AT ALL NOW. BUT SEAN IS SO LOUD YOU CAN HEAR HIM A BLOCK AWAY. HE DIDN'T NEED TO KNOCK.

JUST A WEEK EARLIER, WE'D GONE TO THE WATERFRONT. BUT THAT WAS DIFFERENT. A SPECIAL OCCASION. LIKE ALL OCCASIONS, HAPPY OR SAD, IT INVOLVED THREE CARLOADS OF FREAKED OUT DRUNK PEOPLE, ENDLESS PLANNING AND BICKERING, AND STALLING FOR TIME, AND THEN ALL THREE CARS DRIVING OFF IN SEPARATE DIRECTIONS TO GET LOST.

THE CAR I WAS IN MANAGED TO MISS THE LAST OAKLAND EXIT NOT ONCE BUT THREE TIMES, PAYING THE TOLL AND TURNING AROUND AT TREASURE ISLAND AGAIN AND AGAIN. FINALLY SEAN AND I WERE DROPPED OFF AND SENT OUT AS A SEARCH PARTY, BUT NO SURPRISE, WE COULDN'T FIND ANYONE FROM THE OTHER CARS, AND LOST HALF THE BEER LOOKING. IT TOOK A WEEK TO RECREATE HIS STATE OF MIND PROPERLY TO REMEMBER WHERE HE STASHED THEM. NOW WE DROVE TO THE TOLL-BOOTHS QUICKLY AND EFFORTLESSLY, AND IN TEN MINUTES I WAS STANDING AT OCEAN'S EDGE. HE REACHED IN A BUSH AND PULLED OUT SIX BOTTLES, NICE AND COLD.

FOR ONCE, I DIDN'T NEED TO CONVINCE ANYONE, DIDN'T NEED A SPECIAL OCCASION, OR A MOB, OR A TON OF ALCOHOL. THEY WERE MORE THAN HAPPY TO SET OUT ON A LONG WALK. JAG STALKING LIKE A SPIDER OVER THE DIRT ROAD AROUND AND UNDER THE BASE OF THE BRIDGE. SEAN STRAIGHT UP AND DOWN AND VERY SERIOUS, BUT WITH A BOUNCING STEP THAT MADE FUN OF HIS DEMEANOR. LIKE GODZILLA. I LOVE TO WATCH MY FRIENDS WALK.

TO BE TRANSPORTED FROM A DOOM AND FUME FILLED TOMB TO A MOONLIT BEACHFRONT ROAD IN MERE MINUTES OPENED MY EYES TO THE BIGGER PICTURE. ALL MY PROBLEMS MIGHT JUST BE A CAVITY NEEDING TO BE FILLED. AT WORST, A TOOTH WHICH NEEDED TO BE PULLED. I SHOOK MY HEAD OUT, RATTLING THE WORRIES AND FEARS AROUND

IF NOT KNOCKING THEM LOOSE.

WE CROSSED THROUGH THE TOLLBOOTH TUNNELS, TIPTOEING PAST THE TOLLTAKERS' FEET, THEN BACK TOWARDS THE OLD TRANSMITTER AND ITS HIDDEN BEACH. UNDER THE MOON AND ALONG THE CRAGGY ROCK PATH AND SANDY DUNES, THREE OLD FRIENDS TALKING AND LAUGHING EASILY, IN BETWEEN THE FREEWAY AND THE MARSHLAND AND THE BAY. CAN'T SPEND YOUR WHOLE LIFE FIGHTING AND WORRYING AND EVERYTHING NOT WORKING. BUT YOU DO ANYWAY. AH WELL.

"LET'S GO SWIMMING", SEAN SAID.

"FUCK YOU", I SAID.

"NO, IT'LL BE WARM", SEAN SAID. "FROM EL NIÑO"

"IF THE GOD DAMN SUPERFUND WAS AVAILABLE AS A WALK-IN CLINIC", STARTED JAG, "THEN I WOULD CONSIDER YOUR ASININE SUGGESTION A POSSIBILITY. AS IT IS I THINK I'D RATHER GET SHOT BY A BUNCH OF WATERFRONT GRINGO FISHERMEN ON THEIR WAY TO WORKINGMAN'S LUNCH FOR A, UH, OMELET AND TWO—"

"SHUT UP, JAG!!", WE BOTH YELLED. HE STAYED ON SHORE WHILE SEAN AND I STRIPPED DOWN. LAST TIME SWIMMING IN THE BAY I GOT HYPOTHERMIA AND ALMOST DROWNED. AND THAT WAS THE HOTTEST DAY OF THE SUMMER.

I'D THOUGHT ALL THAT TROPICAL STORM TALK WAS MEDIA HYPE, BUT FOR ONCE SEAN WAS RIGHT. THE WATER WAS THE TEMPERATURE OF HEALTH FOOD STORE COFFEE. LUKEWARM.

"FUCKING SHARKS! MICROBES! DON'T COME TO ME WITH YOUR EL NIÑO BULLSHIT WHEN THE GULF WAR SYNDROME COMES OUT AS A BEVERAGE! I'LL STAY HERE ON THE SAND, THANK YOU, AND WAIT FOR IT TO HEAT UP ENOUGH TO TURN INTO BROKEN GLASS"

I PUT MY EARS UNDERWATER AND FLOATED ON TOP OF THE SCUM AND DISEASE, WATCHING THE LIGHTS OF SAN FRANCISCO COME ON, LIKE A JOURNEY SONG. MY HOPE RISING LIKE THE SUN.

There's no Outside

I CALLED UP JED. HE WAS AT LYNETTE'S. I FELT BAD CALLING HER HOUSE AT THREE A.M., BUT AT LEAST HE WAS STILL AWAKE.

"JED", I SAID. "YOU GOTTA COME HOME SOMETIME.

CAN'T BE STAYING AT THE GIRL'S PLACE EVERY
SINGLE DAY. WE NEVER SEE YOU ANYMORE. IT'S
NOT FAIR. IT'S NO FUN LIVING OUT IN THE MIDDLE
OF NOWHERE WITHOUT YOU THERE, AND BESIDES,
WE GOT REHEARSAL AT EIGHT IN THE MORNING."

I WAS AT MY DAD'S HOUSE, TIPTOEING AROUND
WHILE MY DAD SLEPT IN THE OTHER ROOM. A
GREAT PLACE TO GET A LITTLE QUIET WRITING
TIME, BUT NO GOOD FOR THE TRADITIONAL
AMENITIES OF A PARENT HOUSE: FOOD. ALAS, THE
CUPBOARDS WERE BARE EXCEPT FOR SOME MEALY
OATMEAL.

NICE TO HAVE A LONG WALK, A CHANCE FOR
REFLECTION AND ADJUSTMENT BETWEEN YOUR
HOME AND THE REST OF THE WORLD. BUT A TWO
AND A HALF HOUR HIKE TAKES ENERGY. ACTUAL
NUTRITION, NOT JUST NERVOUS ENERGY FROM
CAFFEINE. I HADN'T EATEN IN TWELVE HOURS.
UNDER QUESTIONING, JED ADMITTED HE HADN'T
EATEN IN TWO DAYS AND HADN'T SLEPT IN THREE.
HE ALWAYS DOES THAT, PUSHING TOO HARD AND NOT
TAKING CARE OF HIMSELF. I DO IT TOO, BUT CAN SEE
IT IN JED EASIER, WHICH IS WHY I HUNT HIM
DOWN EVERY FEW DAYS AND BRING HIM HOME.

FIVE ON A SUNDAY MORNING WHEN WE SET
OUT, AND ALL THE STORES WERE STILL CLOSED. THE
SUPERMARKET WAS IN THE WRONG DIRECTION.

"DON'T WORRY", I SAID. "THERE'S A TINY LITTLE
MARKET RIGHT BEFORE WE GET INTO THE HILLS.
IT'LL BE OPEN. AND THERE'S A CAFE NEXT DOOR
WHERE THIS GIRL I WENT OUT WITH ONCE USED
TO WORK. MAYBE THEY'LL STILL GIVE ME FREE
COFFEE."

OF COURSE, WHEN WE REACHED THE STORE
IT WAS CLOSED. THE CAFE WAS BOARDED UP AND
DRIPPING WITH HUGE PAINTED LETTERS: "FUCK OFF,
CREEP!"

YOU KNOW WHAT I MEAN. BEING DENIED
COFFEE AND FOOD IN YOUR TIME OF NEED FEELS
LIKE A PERSONAL ATTACK EVEN WHEN IT'S JUST A
SIMPLE CASE OF BAD PLANNING.

WE HIKED ON DESULTORY, DESPONDENT, LIGHT-
HEADED AND CONFUSED. AND THEN, YOU KNOW THE
STORY OF THE MORMONS AND THEIR SALTY LAKE?
HUNTED AND BACKED INTO A CORNER, THEY SETTLE
AND STRUGGLE TO TURN THE DESERT VALLEY INTO
FARMABLE LAND. UNLUCKY BASTARDS, HERETICS
AND POLYGAMISTS THAT THEY ARE, THEY LOOK UP
TO SEE THE SKY BLACKENED BY A HUGE SWARM OF

LOCUST WHICH PROCEEDS TO GLEEFULLY ANNIHILATE
THE CROPS AND ALL THE MORMONS' HARD WORK.
OH, WOE UNTO GOD. OH, DOOM.
 BUT THEN, WHAT SHOULD APPEAR? SEAGULLS.
MILLIONS UPON MILLIONS OF SEAGULLS. POOR
MORMONS, TO HAVE THIS MOST FILTHY AND DIS-
GUSTING ANIMAL AS THEIR SAVIOUR. BUT THE
SEAGULLS DESCENDED UPON THE VALLEY AND ATE
ALL THE LOCUST. HALLELUJAH!
 WHERE DID ALL THE SEAGULLS GO? I DON'T
KNOW. BUT, WALKING UP THE CREST OF THE HILL,
JED AND I WERE SIMILARLY SAVED FROM
EXTINCTION. WE MIGHT HAVE WITHERED AWAY
RIGHT THEN AND THERE, DEAD IN OUR TRACKS, HAD
IT NOT BEEN FOR A CAMARO THAT DROVE BY BLAST-
ING BON JOVI AND LITTERING THE VALLEY WITH
SUNDAY PAPERS. TRULY A MIRACLE OF BIBLICAL
PROPORTIONS. ATTACHED TO EACH PAPER WAS A
FREE BREAKFAST CEREAL SAMPLE.
 JED, YOU MAY RECALL, IS MY PAL ENGAGED
IN A PRIVATE WAR AGAINST ANIMAL-RELATED
PRODUCTS AND FOOD ADDITIVES. HE GETS MAD AT
ME FOR EXAGGERATING HIS VIGILANCE, YET IT WAS
HE WHO JUST LAST WEEK, IN A CRUDE ATTEMPT AT
CENSORSHIP, CHECKED OUT TWO BOOKS, "GLYCEROL"
AND "GLUE, GLUE, AND GELATIN" FROM THE BERKELEY
PUBLIC LIBRARY AND WAS INTENT ON DESTROYING
THEM UNTIL I CAUGHT HIM IN THE ACT AND PUT
A STOP TO IT.
 JED IS EXTREMELY CAREFUL ABOUT WHAT HE
EATS, AND AS A RESULT SOMETIMES GOES DAYS
WITHOUT EATING. I'VE TAKEN TO KEEPING FOOD
FOR HIM RIGHT IN MY FILING CABINET IN CASE
OF EMERGENCIES. FILED UNDER "JED" ARE
SHEETS OF SEAWEED AND PIECES OF MATZOH.
INGREDIENTS IN MATZOH: FLOUR AND WATER.
THAT'S ALL.
 JED CHECKED THE INGREDIENT LIST ON THE
SUGAR CEREAL BOX, AND THAT WAS THE REAL
MIRACLE. NO ANIMAL PRODUCTS. BARELY ANY
FOOD PRODUCTS EVEN.
 ANGRY HOMEOWNERS BEGAN TO WAKE UP
AND FIND THE SANCTITY OF THEIR SUNDAY PAPER
VIOLATED. RUBBING THE SLEEP OUT OF THEIR EYES,
THEY SAW JED AND I FRANTICALLY DASHING UP
THE STREET, SHIRTS AND PANTS STUFFED WITH
UNCOUNTABLE BOXES OF SUGAR SMACKS AS WE
HEADED FOR THE HILLS.

 THE PLAN WAS THUS: DOWN TWO BOXES AT

THE DUCKPOND; TWO AT THE RIDGE BY THE SHOOT-
ING RANGE; TWO WITH THE COWS IN THEIR PASTURE;
AND TWO AT THE ALVARADO PARK PLAYGROUND IN
THE FINAL STRETCH FOR HOME. BY CAREFUL
PLANNING WE COULD PRESERVE AND SUSTAIN
OUR ENERGY LEVEL AND STILL LEAVE FOUR BOXES
LEFTOVER FOR THE HOUSEMATES WAITING FOR
US IN EL SOB, ASLEEP AND HUNGRY, WHO HAD
ENTRUSTED JED AND I WITH THE HUNTING AND
GATHERING OF FOOD.

WE WALKED HAPPY AND PROUD THROUGH THE
VALLEY, CREEPING WITH THE CREEKS, ROLLING
LIKE THE HILLS. NOT A SOUL IN SIGHT FOR MILES.
PEACEFUL, FREE, AND EASY, YET STILL PUNK AS FUCK.

WHEN I TIRED OF JED'S ENDLESS BANTER,
INSTEAD OF SCREAMING I JUST BEGAN TO RUN.
JED GAVE CHASE, HIS VOICE A MUTED, COMFORTINGLY
UNINTELLIGIBLE THROB IN THE DISTANCE, NOT
UNLIKE THE BLEATING OF A SHEEP.

I KNEW THE STEEP, NARROW PATHS WELL,
AND EVEN RUNNING I WAS ABLE TO DAYDREAM
AND PONDER THE BEAUTY OF LIFE. THE JOY OF
EARLY MORNING AND THE SOUND OF CHILDREN
PLAYING IN THE SWIMMING POOL. THE TOUCH OF
ICE CREAM ON YOUR TONGUE ON A HOT SUMMER
DAY AND THE STEADY RHYTHM OF SEX. THE
PLEASURE OF SOLITUDE AND BEING ABLE TO
ENJOY YOUR OWN THOUGHTS, THE EXCITEMENT
OF CONVERSATION AND BEING ABLE TO SHARE
AND SHARPEN AND COMPARE. THE PASSION OF
MUSIC, THE SWEETNESS OF SILENCE, THE CRISPY
DELICIOUS YET WHOLESOME TASTE OF SUGAR
SMACKS. LIKE LOVE AND LIFE, MADE TO BE
ENJOYED, NOT CAREFULLY SAVED. MADE TO BE
DEVOURED, NOT LUGGED AROUND WHILE YOU RAN
THROUGH THE COUNTRYSIDE FROM JED, WHO STILL
WOULD NOT SHUT UP. BUT I LOOKED BACK AND HE
WAS SUDDENLY QUIET. WE SEEMED TO BE OF
ONE MIND.

WE STOPPED, SHRUGGED, SMILED, AND THE
REMAINING BOXES WERE CONSUMED IN A BLIND
FURY RIGHT THERE ON THE BLUFF WITHOUT EVEN
STOPPING TO CHEW. THEN WE WALKED ON, FEELING
GUILTY BUT SURPRISINGLY HAPPY. WITHOUT ANY
BOXES WEIGHING US DOWN, WE MADE THE LAST
MILES IN RECORD TIME AND, ARRIVING HOME,
SNUCK AROUND TO THE BACKHOUSE. BETTER NOT
TO WAKE UP THE HUNGRY HOUSEMATES. BETTER TO
WAKE UP THE SIX PACK OF PABST INSTEAD.

JED SWEPT UP SEWAGE IN THE BACKHOUSE

BASEMENT WHILE I GREETED THE WAKING WORLD
FROM MY WINDOW. POINTING AND SHAKING MY FIST
MENACINGLY, BUT SMILING ALL THE WHILE.
 "ARE YOU READY?", JED CALLED UP.
 "SURE, WANT TO BRING THE BASS AMP UP OR
SHOULD I BRING THE DRUMS DOWN?"
 "WELL, WE WOULDN'T WANT TO WAKE UP THE
HOUSEMATES. DON'T WORRY ABOUT MUSIC, LET'S
JUST REHEARSE. THINK YOU COULD TOSS DOWN A
BEER?"
 AND SO, FROM THE OLD BACKHOUSE UP ON
THE HILL, IN THE MIDDLE OF NOWHERE, TWO
VOICES COULD BE HEARD. FROM JED'S SICKENING
DOOM DOWN IN THE BASEMENT AND THE SUNSWEPT
YET WRETCHED AND MOLDY TRASH HEAP OF MY ROOM
ON THE GROUND FLOOR, TWO VOICES BLENDED AND
ECHOED OUT INTO THE CANYON BELOW.

 "THERE ARE TOO MANY ANIMALS TO FEED
 IN THE CITY IT'S A CAGE
 ALL SLIMY, ALL SHITTY
 SLEAZY MODS AND STUPID FUX
 CREEPING CREEPS AND JAMES AND JUX
 SHOTS OF WATER GOING OUT OF MY HEAD
 MAKING FRENCH TOAST NOW HERE'S JED"

 "SOME PEOPLE LOOK FOR SOMEONE ELSE
 TO OPEN UP THE DOOR
 TO CHANGE THE WATER BUT
 NO ONE'S EVER SEEN ANYONE BUT THEMSELVES
 I KNOW THE TRUTH
 WE'RE EXPERIMENTS AND WE DON'T KNOW IT
 I KNOW THE TRUTH
 THERE'S NO OUTSIDE"

Ice Cream

 I'M LOOKING FOR THE ICE CREAM PLACE
WHERE I USED TO LIKE TO GO, BUT I JUST CAN'T
FIND IT.
 IT WAS DOWN A QUIET SHADED STREET, SO
DIFFERENT FROM THE FLASH AND SNARL OF THE
BUSY AVENUES WHICH SURROUNDED IT FROM ALL
SIDES, ENVELOPING IT, EFFECTIVELY HIDING IT FROM
THE OUTSIDE WORLD.
 THE RIVERS AND RIVULETS OF PEOPLE SWARMED
PAST THE APARTMENT I SHARED THAT SUMMER WITH
JED AND LYNETTE. JUMP IN AND YOU WERE CARRIED

THROUGH THE NUMBERS AND LETTERS IN A STEADY
FLOW, SOMETIMES GATHERING FORCE INTO A WAVE
WHICH SWEPT AWAY EVERYTHING IN ITS PATH. SUCH
WAS THE WAY OF THE CITY. AT ONE CRUCIAL JUNCTURE,
I WOULD TEAR MYSELF AWAY AND BREAK FROM
THE MOB.

DOWN A SIDESTREET, THEN A SIDESTREET OF
A SIDESTREET, AND SO ON. LIKE ONE OF THOSE
RUSSIAN DOLLS, THE CITY GOT SMALLER AS YOU
OPENED EACH PIECE AND LOOKED INSIDE. A CHANCE
TO SLOW DOWN AND SHAKE OFF SOME OF THE SWEAT
AND FEAR AND MURDER. TREE-LINED STREETS AND
BENCHES AND SMALL STOREFRONTS, WARM SMELLS
AND SMALL CHILDREN. THE NEIGHBORHOOD WAS AS
COMFORTING AND FREE AS THE ICE CREAM ITSELF.

THERE WAS A GIRL WHO WORKED AT THE ICE
CREAM PLACE. THERE WERE LONG LINES FOR ICE
CREAM THAT SUMMER, SO THE GIRL WAS ALWAYS
TOO BUSY TO TALK. SHE MADE EYES AT ME AND
HANDED OVER HUGE WAFFLE CONES, THEN I WOULD
RUN AWAY. PERFECT.

CONSTANTLY DEFLECTING AND PARRYING INSULTS
FROM THE NEW YORK CITY FOOD CLERKS WAS A GOOD
GAME. LIKE CHESS, EXCEPT YOU NEVER WON. I
LAUGHED RIGHT IN ONE GUY'S FACE WHEN HE ASKED
TO SEE I.D., BUT HE GOT THE LAST LAUGH. "YOU LOOK
SO DAMN OLD", HE SAID, "I WANTED TO MAKE SURE
YOU WEREN'T ALREADY DEAD".

CHARMING, AND YET SOME DAYS I WASN'T UP
TO THE CHALLENGE. FREE ICE CREAM FROM A
SMILING GIRL WAS A NICE CHANGE. I COULD LAY
DOWN MY DEFENSIVE SHIELD. IT MADE ME FEEL
AT HOME.

HOW DID I FIND THE ICE CREAM PLACE IN THE
FIRST PLACE? BY NIGHTS AND DAYS OF ENDLESS
WALKING, SEARCHING, SCOURING THE CITY? NO, THAT
BROUGHT ME ONLY ANXIETY AND EXHAUSTION. I
FOUND THE ICE CREAM PLACE, THE BEAUTIFUL
TREE-LINED NEIGHBORHOOD, AND THE GIRL TOO, ALL BY
STAYING HOME ONE DAY, WHEN SHE HAPPENED TO CALL.

"I HEARD YOU WERE IN TOWN," SHE SAID. "ALL
STAYING IN ONE CRAMPED LITTLE APARTMENT ROOM.
I'M HOUSE SITTING OVER IN THE WEST VILLAGE, AND
THERE'S PLENTY OF ROOM OVER HERE. A HUGE THREE
STORY HOUSE, AND I'M HERE ALL BY MYSELF." THE
LAST WORDS WERE IN ITALICS.

YES, WE WERE ALL IN ONE CRAMPED, STUFFY
LITTLE APARTMENT, AND I WAS SICK AND TIRED OF
BEING SCRUNCHED UP IN THE CLOSET WITH THE
DOOR HITTING MY KNEES EVERY TIME ANYONE CAME

IN AND OUT. BUT I'D LEARNED A THING OR TWO ABOUT LOYALTY. I HAD TO BITE MY TONGUE AND TURN DOWN THE INVITATION.

THE GIRL ON THE PHONE WAS LAURA. INFAMOUS LAURA, OF WHOM LEGENDS WERE MADE. LAURA, JED'S OLD GIRLFRIEND AND, CONSEQUENTLY, LYNETTE'S SWORN ENEMY. WHAT THE HELL WAS LAURA DOING IN NEW YORK? SHE HAD A WAY OF POPPING UP IN THE STRANGEST PLACES.

THIS INTRUSION INTO OUR ALREADY STRAINED LIFE WOULD DRIVE POOR LYNETTE OVER THE EDGE. SO, I HAD TO DO THE RIGHT THING. KEEP IT A SECRET. NO USE WORRYING LYNETTE, JED, OR MY OWN GIRL-FRIEND BACK HOME, ADA.

A LOYAL FRIEND AND BOYFRIEND, THAT'S ME. I RESISTED TEMPTATION AND A THREE STORY MANSION IN THE WEST VILLAGE. BUT WHAT HARM COULD THERE BE IN GOING TO GET A FREE ICE CREAM CONE? JUST ONCE. THEN TWICE. THEN ONCE OR TWICE A WEEK.

MANY FLAVORS TO CHOOSE FROM, BUT I PICKED THE FAMILIAR VANILLA EVERY TIME. LIKE COFFEE, WHAT GOOD IS THERE IN FOOLING AROUND AND ADDING FLAVORS? VARIETY IS THE SPICE OF LIFE, NOT THE SUSTENANCE.

BUT IT WAS BOUND TO HAPPEN. I SHOWED UP ONE NIGHT WHEN BUSINESS WAS SLOW, AND LAURA GOT OFF EARLY. I WALKED HER HOME. DOWN THE QUIET STREETS FILLED WITH WARM SMELLS AND LITTLE CHILDREN. INTO THE GUTS OF THE CITY, STEPPING OVER USED CONDOMS AND CRACK BABIES FROLICKING IN THE GUTTER. AMIDST THE SKYSCRAPERS AND BROWNSTONE CASTLES DIVIDED INTO A ZILLION BROOMCLOSET APARTMENTS STOOD JUST ONE REGULAR HOUSE. A GRAND HOUSE, COVERED IN VINES. IMPRESSIVE, BUT NOT FANCY. STATELY, YET HOMEY. RELUCTANTLY, I STEPPED INSIDE.

THE HOUSE BELONGED TO ONE OF THE COUNTRY'S TOP SELLING ROMANCE NOVELISTS, A FAMILIAR NAME WHOSE BOOKS CAN BE FOUND IN EVERY SUPERMARKET AND 7-11 IN THE COUNTRY. HER REAL NAME, HOWEVER, IS LESS FAMILIAR. LOYAL READERS MIGHT BE SURPRISED TO GO LOOKING FOR THE SPRIGHTLY, PERKY, FORTY-SOMETHING WOMAN WHO UNDERSTANDS HOUSEWIVES SO WELL, AND FIND INSTEAD THAT BEHIND THE NAME AND CAREFULLY MANAGED APPEARANCE IS AVRAM MOSKOVITZ, AN OLD JEWISH MAN WITH BUSHY EYE-BROWS AND AN IMPRESSIVE COLLECTION OF SIGNED FIRST EDITIONS. NO JOKE.

AVRAM'S WIFE, A GENTILE, IS THE HEIRESS TO

THE BLACK FLAG FORTUNE. THE BUGSPRAY, NOT THE
BAND. THEIR SON, NATURALLY, IS A STUDENT AT ONE
OF THOSE ANNOYING, PRECIOUS, SHELTERED, "EXPER-
IMENTAL" FINE ARTS COLLEGES WHERE EVERYONE IS
THE GOOD-FOR-NOTHING SON OR DAUGHTER OF THE
WEALTHY AND FAMOUS. HE IS A FRIEND OF LAURA,
WHO, FOR ALL I KNOW, MAY BE A ROCKEFELLER,
VANDERBILT, OR CARNEGIE. I DIDN'T ASK. I KEPT
CONVERSATION TO A MINIMUM AND KEPT A SAFE
DISTANCE.
 THE SON WAS IN INDIA SEEKING SPIRITUAL
ENLIGHTENMENT. THE PARENTS WERE AT THEIR
SUMMER HOME IN KENNEBUNKPORT, MAINE. LAURA
WAS ON THE FIRST FLOOR PLAYING PIANO. AS FOR ME,
I WAS SITTING AT THE LARGE OAK DESK OF AMERICA'S
FOURTH-TOP-SELLING ROMANCE NOVELIST, DEEPLY LOST
IN FANTASY, DRINKING HIS BEER.
 LAURA WAS A TRAMP, BAD NEWS, EVERYONE
HAD SAID SO. BUT NO ONE HAD MENTIONED THAT SHE
WAS WELL-VERSED IN RUSSIAN CLASSICS AND A
PLEASURE TO WALK WITH DISCUSSING LITERATURE
AND HISTORY. LIKE MOST EVIL TRAMPS, SHE HAD A
GOOD SIDE WHICH EVERYONE ELSE HAD OVERLOOKED.
 BUT MAKE NO MISTAKE. I'M NOT LOOKING FOR
LAURA. NOT FOR HER GOOD SIDE OR ANY OTHER PART
OF HER. I'M TIRED AND SICK AND MY THROAT IS A
DUSTY OLD GRAVEL ROAD. I'M LOOKING FOR ICE
CREAM. BUT I CANNOT FIND IT. THE ICE CREAM
PLACE SEEMS TO HAVE BEEN REMOVED FROM THIS
EARTH. NOT JUST REPLACED BY A STARBUCKS OR
SOMETHING, BUT ERASED, ALONG WITH THAT QUIET
TREE-LINED NEIGHBORHOOD AND THE COMFORT THAT
CAME WITH IT. HERE I AM, BACK IN NEW YORK, BUT
NEW YORK WITHOUT THAT LITTLE BIT OF COMFORT IS
TOO MUCH FOR ME. WALKING AND SEARCHING BRINGS
ME NOTHING BUT ANXIETY AND EXHAUSTION, AND THIS
TIME THERE'S NO APARTMENT TO ESCAPE TO AND
WAIT FOR THE CALL.
 KNOCK YOURSELF OUT BEING A TRUE FRIEND AND
LOYAL BOYFRIEND, AND WHAT DO YOU GET? IS ONE
ICE CREAM CONE TOO MUCH TO ASK? BUT WHO TO
ASK? NOT LYNETTE, WHO NEVER EVEN KNEW LAURA
WAS IN THE SAME TOWN. NOT JED, WHO SENT
REGARDS WHEN I WENT TO LAURA'S WORK, BUT
WISELY CHOSE NOT TO VISIT IN PERSON.
 NOT LAURA. SHE'S NO LONGER AT THE ICE
CREAM PLACE, AND NO LONGER IN NEW YORK. I
KNOW BECAUSE SHE WROTE ME ONCE FROM HER
LIBERAL ARTS COLLEGE. UNFORTUNATELY, I HAD
MADE THE MISTAKE OF MENTIONING LAURA TO ADA,

WHO MADE ME PROMISE THAT IF LAURA EVER
WROTE, I WOULD NOT RESPOND. SO, I DID NOT REPLY.
I THREW AWAY THE LETTER AND ANY CHANCE OF
EVER FINDING THE ICE CREAM PLACE AGAIN.

IT MAKES NO DIFFERENCE TO ME, ALL THE
GIRLS AND TROUBLES AND WORRIES. I WOULD BE
HAPPY TO BE ALONE AND PAY FULL PRICE, OR EVEN
DOUBLE, FOR THE ICE CREAM I ONCE RECEIVED
FREE. BUT IT IS NOT TO BE.

Photobooths

TODAY IS A SPECIAL DAY CUZ I TOOK A PHOTO-
BOOTH AND ALL THE PICTURES WERE GOOD, OR AT LEAST
OKAY. SLUGGO ASKED, "COULD I HAVE ONE?", BUT I
LAUGHED IN HIS FACE.

"SLUGGO", I SAID, "PHOTOS ARE FOR GIRLS. ANYWAY,
THERE'S ONLY FOUR". I COUNTED THEM OFF LIKE
PETALS FROM A DAISY. "ONE FOR THE LOVE OF MY LIFE,
ONE FOR THE FUTURE MOTHER OF MY CHILD, ONE FOR
MY CRUSH, AND ONE FOR MY GIRLFRIEND".

"SEE!", HE POINTED. "WHY DO YOU ALWAYS
COMPLAIN ABOUT ME BEING SLEAZY? YOU'RE THE
SLEAZY ONE!"

"SLUGGO", I CONFIDED. "THERE'S A DIFFERENCE
BETWEEN SLEAZE AND ROMANCE. PHOTOBOOTHS
HAPPEN TO BE ROMANTIC".

"I'VE SEEN SOME SLEAZY PHOTOBOOTHS", HE SAID.
"ON YOUR WALL".

IT WAS TRUE. I HAD MANY PHOTOS OF CRYSTAL,
BUT, SOMEHOW, NONE HAD HER HEAD IN THEM.

"SOMETIMES SLEAZINESS CAN BE ROMANTIC,
I ADMIT".

"YOU CAN TALK YOUR WAY OUT OF ANYTHING",
SLUGGO LAUGHED.

"BUT PHOTOGRAPHS DON'T LIE, IS THAT WHAT
YOU'RE SAYING? MAYBE THAT'S WHY YOU'RE DRUNK
AND HALF NAKED IN EVERY SHOT I HAVE OF YOU.
COINCIDENCE? EVERY PHOTO YOU HAVE OF ME IS A
PICTURE OF DIGNITY AND RESPECTABILITY".

"EVERY PHOTO I HAVE OF YOU, YOU'RE ALONE.
THAT'S WHY".

"IT'S TRUE", I SAID, "THAT I DON'T LIKE TO TAKE
GROUP SHOTS. REMEMBER THAT LAST TIME WE TOOK
PHOTOS TOGETHER? NO POINT HAVING BAD PHOTOS OF
MYSELF AROUND, SO I HAD TO RIP UP HALF OF THEM.
AND YOU LOOKED BAD IN THE OTHER TWO, WHICH

MADE ME LOOK EVEN WORSE. I COULD ALMOST HEAR THE GIRLS SAYING, 'IF HE'S SO DAMN SUAVE, WHY'S HE HANGING OUT WITH SOME SKINNY NEW WAVE CREEP WHO LOOKS LIKE LUNCH MEAT??' SO I HAD TO RIP UP THOSE TOO".

"YOU'RE SCARED OF THE COMPETITION IS WHAT YOU'RE SAYING".

"IT IS BAD POLICY", I ADMITTED.

"YOU KNOW WHAT I HATE?", HE SAID.

"WHY DOES EVERYONE ALWAYS WANT TO TELL ME WHAT THEY HATE?"

"I'M NOT EVERYBODY. YOU KNOW WHAT I HATE?"

"GETTING STRANDED IN EAU CLAIRE, WISCONSIN WITH JUX".

"BESIDES THAT".

"FALLING DOWN THE RAMP AT TOMMY'S DISHROOM IN CLEVELAND HEIGHTS BEFORE THEY REMODELED AND TOOK IT OUT".

"YES, YES, BUT JUST SHUT UP! I'M TRYING TO TELL YOU SOMETHING. NO ONE GIVES ME PHOTOS ANYMORE. THAT'S WHAT I HATE. ARE YOU LISTENING TO ME NOW? ALL I GET ARE XEROX COPIES".

"BECAUSE ALL THE GIRLS ARE GIVING ME THE ORIGINALS", I SAID.

"THAT'S WHAT I'M WORRIED ABOUT. NOW EVEN WHEN SOMEONE DOES ACTUALLY GIVE ME A PHOTO, I WORRY. IT'S NEVER THE WHOLE STRIP. JUST ONE, OR THREE. THE OTHER ONES WERE BAD, THEY SAY. THEY HAD TO BE RIPPED UP. BUT I WONDER. DID THEY REALLY KEEP THE BEST ONES FOR THEMSELF? OR GIVE THEM TO SOME OTHER GUY? AT LEAST YOU'RE HONEST ABOUT IT".

"I WOULDN'T LIE TO YOU, FRIEND".

"YOU DIDN'T REALLY RIP THOSE PHOTOS OF US UP", SLUGGO ASKED. "DID YOU?"

"INTO TINY SHREDS, WHICH I FLUSHED DOWN THE TOILET. I HAD NO OTHER CHOICE".

"YOU SHOULDN'T EVER THROW AWAY PHOTOS. EVEN UGLY ONES. THEY'RE A PART OF LIFE TOO, JUST LIKE UNHAPPY MEMORIES".

"SO YOU SAVED THAT LAST STRIP FROM SAL?", I COUNTERED.

"GOD NO. I BURNED IT AND BURIED THE ASHES".

I'D SEEN PEOPLE DO AMAZING THINGS WITH PHOTOBOOTHS, FROM RECREATIONS OF THE BRADY BUNCH INTRO TO REENACTMENTS OF THE JFK ASSASSINATION, BUT NONE AS CAUSTIC AS THE DEAR JOHN LETTER FROM SAL. FOUR FRAMES, SAL WITH THREE SIGNS: GOOD, BYE, SLUGGO. THE FOURTH FRAME WAS BLANK, JUST THE EMPTY BOOTH.

"WHAT A BAD TIME THOSE TIMES WERE", I SAID FONDLY.

"A TERRIBLE TIME", HE REMINISCED. "I BET YOU BURNED YOUR PHOTOS OF ELSA TOO?"

"NO, I NEVER DID". NEVER HAD ANY TO BURN. NO PROOF WE'D BEEN TOGETHER, NOT EVEN IN THE SAME ROOM, AFTER NINE LONG MONTHS. ON THE LAST DAY, WE SAT IN THE KRESS PHOTOBOOTH, BUT IT MALFUNCTIONED. CAME OUT AS A NEGATIVE FAST FADING TO BLACK. WE KISSED GOODBYE AND THE IMAGE WAS GONE, WITHOUT A TRACE. BUT WHY BOTHER SLUGGO WITH THE DETAILS?

"YOU'RE LUCKY", HE SAID. "I WISH I HADN'T BURNT MINE EITHER. I DON'T THINK I'D EVER WANT TO LOOK AT THEM AGAIN, BUT JUST THE SAME, THEY WOULD BE NICE TO HAVE. THAT'S WHY I SAVE EVERYTHING NOW".

"THAT'S WHY NOW I WANT TO RIP THINGS UP AND THROW THEM AWAY", I SAID. "BETTER TO LEAVE IT ALL TO MEMORY. LET IT CHANGE OVER TIME AND DISAPPEAR".

"YOU DON'T WANT THE GOOD TIMES TO DISAPPEAR, THOUGH".

"SLUGGO", I SAID. "WHO DOES?"

Closing Time

WOULD THEY KICK YOU OUT FOR SITTING ALL DAY WITHOUT BUYING A THING? FOR CURLING UP AND SLEEPING IN THE CORNER? FOR SMOKING WEED IN THE BATHROOM AND CUTTING LINES ON THE TABLES UPSTAIRS? NOPE. THE SIGN SAID, "NO MOOCHING OR DOSING", BUT IN PRACTICE THIS TOO WAS IGNORED. EVERYONE MINDED THEIR OWN BUSINESS, TALKING IN UNDERTONES, READING OR DRAWING OR JUST THINKING. ONLY ONE RULE APPLIED, UNSAID BUT UNDERSTOOD. NO PHOTOGRAPHS. NO CAMERAS AT ALL. THAT WAS THE ONLY WAY TO GET KICKED OUT OF THE VILLA.

TANYA MADE THE MISTAKE ONCE, SHOWING OFF HER NEWEST FLEA MARKET FIND, A TWIN-LENS ROLOFLEX. LIKE MOST MISTAKES, ONCE WAS ENOUGH. NEVER MIND THAT THE CAMERA WAS BROKEN AND WITHOUT FILM. TANYA'S PLEAS OF INNOCENCE ONLY FURTHER RILED THE MOB. THE VARIED AND HARRIED REGULARS IN EVERY SEAT SANG TOGETHER, A CRY OF SHOCK AND OUTRAGE. THE "ALL ARMED MEN ARE SCUM" GUY MIGHT EXPLAIN

IT THUSLY: "BRING A GUN TO SHOOT ME, YOU ARE SCUM. FORGET THE BULLETS, YOU ARE A FOOL AS WELL."

THERE MAY BE PHOTOS OF TANYA, FORCED FROM THAT DAY ONWARD TO BUY HER COFFEE AT THE HATED AND ENEMY CAFE, ESPRESSO ROMA. SNAPSHOTS OF HER SITTING ON THE PATIO AT A LITTLE, CROWDED TABLE. AS FOR THE REST OF US, ALONE OR TOGETHER AT THE BIG TABLES IN THE DARK, DANK CORNERS OF THE VILLA, NO PHOTOS EXIST. THE SCRAPBOOKS OF THOSE YEARS ARE ENTIRELY BLANK.

WHEN THE PLACE CLOSED, IT CAUGHT US COMPLETELY UNAWARE. WE PANICKED, TOOK EVERYTHING NOT TIED DOWN. CUPS, CHAIRS, SUGAR SHAKERS, YELLOW LIGHT BULBS, AND THE BATHROOM KEY. WE WISHED WE HAD TAKEN PHOTOS TOO, SET UP A TRIPOD AND JUST SHOT EVERYBODY FAST. AS IT WAS WE GOT KICKED OUT WITHOUT EVEN BREAKING THE RULE, WITH NOTHING TO PORE OVER AND COMPARE BUT OUR MEMORIES.

WE TOLD STORIES, BUT EVERYONE'S STORY PAINTED A DIFFERENT PICTURE. EVEN WALLS AND FLOORS MOVED FROM THE FORCE OF MEMORY, AND WINDOWS APPEARED OUT OF THIN AIR. A SINGLE SNAPSHOT MIGHT HAVE HELPED TO RECREATE THE PLACE FROM OUR HANDFUL OF MEMENTOS, AS WE VOWED TO DO.

WHAT ABOUT ALL THE PLANS TO MEET AT THE VILLA IN TEN, TWENTY, FIFTY YEARS? ROMANTIC TRYSTS OR OATHS OF FRIENDSHIP, EVERYONE HAD MADE DATES. SLUGGO AND SAL FOR THEIR FIFTIETH ANNIVERSARY. RAMSEY AND THE ANCIENT GREEK CHICK, SEE YOU IN TWENTY YEARS, BABY. WE ALL LIKED TO TALK ABOUT BEING OLD TOGETHER THERE. IT WAS THE ONLY FUTURE WE'D EVER PLANNED AND LOOKED FORWARD TO. HAD THOSE FUTURE PLANS STARTED TO BE OUTDATED AND EMBARRASSING? EVERYONE SEEMED HAPPY TO BURY THEM ALONG WITH THE PAST.

THE PLACE WAS DULY MOURNED, AND OUR TIME THERE ENCAPSULATED AND BURIED DEEP IN THAT HOLE KNOWN AS NOSTALGIA. EVERYONE SHED A TEAR THEN BREATHED A SIGH OF RELIEF, AND THE FUTURE PLANS WERE NEVER MENTIONED AGAIN. NOTHING LIKE A FUNERAL TO USE AS A CATALYST, OR EXCUSE, TO MAKE THE CHANGES IN YOUR LIFE YOU'D BEEN MEANING TO MAKE BUT SCARED OF WHAT YOUR FRIENDS WOULD SAY. CLAIM THEM IN THE SPIRIT OF THE DECEASED. LET'S DRINK TO THE

VILLA. REMEMBER THOSE TIMES? IF ONLY WE COULD DO IT ALL OVER AGAIN.

BUT, FUNNY THING, NEW OWNERS BOUGHT THE VILLA AND BROUGHT IT BACK TO LIFE JUST A FEW MONTHS LATER. THE NAY-SAYERS SAID, "NAY, IT IS NOT THE SAME," AND THEY WERE RIGHT. THERE WERE NEW, THRONE-LIKE HIGH CHAIRS WHICH MADE YOU FEEL WIZARD-LIKE AND FOOLISH. BUT IN ALL OTHER RESPECTS IT WAS THE SAME OLD CRUMMY DIVE. THE SAME WOBBLY TABLES AND NICOTINE-COLORED PAINT. THE SAME NAME, THE SAME INDIFFERENT OR PERHAPS BLIND WORKERS. THE SAME COFFEE, STILL THE BEST AND CHEAPEST IN TOWN. IN FACT, THEY HAD EVEN LOWERED THE PRICE. WHY BE PICKY ABOUT A FEW SILLY CHAIRS? THEY WERE BROKEN SOON ENOUGH, ALONG WITH ANY HOPES THE NEW OWNER HAD OF TURNING THE PLACE INTO A BREEDING GROUND FOR HIP AND HAPPY STUDENTS.

I LOVE THINGS GETTING WORSE JUST AS MUCH AS THE NEXT PERSON, BUT I HAD TO ADMIT, THE VILLA WAS JUST AS GREAT AS EVER. IT MOVED WITH ITS OWN MOMENTUM, REFUSING TO BE KEPT AND CONTROLLED LIKE A MEMORY. MANY PEOPLE DRIVING THIS CAR, AND MOST OF THEM ARE ON ACID. MANY TRAFFIC SIGNS ON THIS ROAD AND MOST ARE BEST TO IGNORE. KNOW WHAT I MEAN? I WASN'T LOOKING FOR AN EXCUSE TO START A NEW LIFE. I SETTLED IN HAPPILY BACK AT THE SAME OLD CORNER TABLE, AND THE YEARS STARTED ROLLING BY AGAIN.

ANYONE WHO KNOWS ME KNOWS I LOVE LEAVING, AND WEDDINGS AND FUNERALS, AND BREAKING UP, AND SAYING GOODBYE IN GENERAL. BUT WHY SAY GOODBYE TO THE VILLA? LIKE CALLING ANGEL FROM THE PAYPHONE IN BACK, WHEN I TOLD HER I COULDN'T TAKE IT ANYMORE. WE WERE BOTH CRYING AS I CROSSED THE STREET, TOOK ALL MY STUFF OUT OF HER APARTMENT, AND WALKED OUT FOR GOOD. BUT WHAT THE HELL, I CROSSED THE STREET BACK TO THE VILLA, GOT ANOTHER CUP OF COFFEE, AND SAT BACK AT THE SAME TABLE. LOVE COMES AND GOES, AS DO WE ALL, WITH DRAMATIC FLOURISHES. BUT SOME THINGS DON'T NEED TO CHANGE.

I SEE TANYA IN HERE SOME DAYS, WISER NOW AND HAPPILY UNKNOWN TO THE NEW OWNERS. EVERY-ONE ELSE STAYS HOME. WHY COMPLAIN ABOUT IT? I LIKE STAYING HOME SOMETIMES TOO. BUT NEUTRAL GROUND IS A HARD THING TO FIND, AND ESSENTIAL TO DEVELOPING AND NURTURING FRIENDSHIP. SEEING

PEOPLE AT THEIR SEPARATE HOUSES IS JUST NOT THE SAME.

WHAT WILL HAPPEN WHEN THE DISTANT FUTURE SHOWS UP ON THE DOORSTEP? WHEN THE DAY ARRIVES, WILL SLUGGO AND SAL SHOW UP AS PLANNED? BOTH? NEITHER? OR JUST ONE? AND WHICH ONE, I WONDER.

THEY WILL FIND ME IN THE CORNER, AS ALWAYS. FUNNY RUNNING INTO YOU HERE, THEY WILL SAY.